WAIT
FOR ME

*For my mother, Maria Theresa D'Eramo,
and for my father, Guerino Gentile*

For my brothers Lou, Dave and Rob

And for Esther

WAIT
FOR ME

TRUE STORIES OF WAR, LOVE
AND ROCK & ROLL

BILL GENTILE

Photos by Bill Gentile

WAIT FOR ME

TRUE STORIES OF WAR, LOVE AND ROCK & ROLL

BILL GENTILE

All photos by Bill Gentile unless otherwise noted
Cover photo by Taylor Mickal, "Bill Gentile at the Ambridge Reservoir."
Design by J. Bruce Jones

Published by Bill Gentile
www.billgentile.com
For additional content, including photographs and soundtrack,
visit WaitForMeBook.com.

TABLE OF CONTENTS

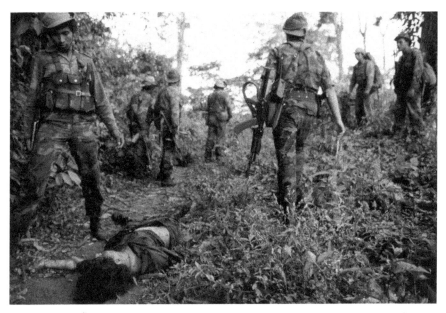

LA MONTAÑA, Nicaragua – Sandinista People's Army troops inspect the body of anti-Sandinista "contra" rebel.

PROLOGUE

"Ríndase!" (Surrender!)

A colleague and I are bombing down a dirt road in the mountains of northern Nicaragua when a couple of Sandinista army vehicles are coming at us from the opposite direction. These are the jeep-style vehicles used by Sandinista field commanders in the war against CIA-backed "contra" rebels and it turns out that the driver in the lead vehicle is Lt. Francisco Noel Talavera and we both slam on the brakes to say hello.

Talavera is a 19-year-old from the northern mountain city of Jinotega. He has a bad complexion and the habit of spitting through the gap in his upper two front teeth. He also happens to be the commander of three of the seven companies in the elite, Simón Bolívar Battalion of the Sandinista People's Army. Talavera has an extraordinary sense of himself, of the importance of his role and of his ability to execute that role. There is a cordiality between us from the start. By this time covering the conflict, I had been on so many missions with the soldiers and had gotten to know the battalion commanders so well that they would just take me out into the field with them whenever I

showed up. I'm a photojournalist covering the war any time I want to, as opposed to doing what the rest of the mooks in the foreign press corps are required to do before heading north to the mountains. They have to go through the Sandinista Defense Ministry with a written request that could take weeks, or forever, to get through the bureaucracy, before getting a written permit to go north where the war is being waged. On this morning Talavera asks if I would like to accompany him and his troops on a mission, so my colleague and I look at each other and go something like, "*Fuckin' A!*"

It is at the end of a long hike when Talavera's scouts spot the contras on a nearby hillside. He waits for his enemies to settle around their campfires on top of the hill, allowing his own men a more visible, and more compact, target. Talavera pulls his soldiers, all of them crawling on their stomachs up to the clearing on our hill, to positions that enable them a clear shot at the enemy. The peasants whose home is situated at the edge of the clearing where Talavera's men take positions crouch behind their rough-hewn board hut. Scratched into the slats of wood are etchings made by the hand of a child. They look like cave drawings left by Neanderthals in dark, European caverns. But these don't show wooly mammoths or sleek gazelles. These show gigantic birds, monsters really, breathing fire. Their huge eyes are made of glass. They have strange, circular wings mounted on their backs. Stick figures of people lie dead on the ground. Helicopters. Dead Sandinistas. Dead contras. Dead peasants.

Around dusk the Sandinistas open up with everything they own. Mortars. Grenades launched from the "spider," a wicked thing that sits on a tripod and spits out explosives at targets hundreds of yards away. Shoulder-held, rocket-propelled grenades. AK-47 automatic assault rifles. It's a five-minute barrage that shakes the trees around us. The mountains shudder and the peasants turn to stone, their bodies woven into one another in tight, protective embrace. Their eyes frozen wide. Not wanting to send his men into the darkness, Talavera has us wait out the night on the hillside from which they launched the attack.

As the sun comes up the next day we move down our own hill

and up the adjacent one to survey the damage. There are so many problems with moving into an area after an attack. Booby traps. Land mines that can kill or, worse, just rip off one or both of my legs. And my genitals. And there's no way to be sure the enemy has actually pulled out. They just might be waiting in ambush.

As usual, the scouts go first. They have radios. The rest of the troops come from behind. It's here where I always position myself. Right behind the scouts. Not too far ahead in the line that I'll get wiped out in the first volley of fire. But close enough to the front that I'll be able to make pictures of guys moving into position and firing.

The scouts are extremely cautious. As a younger man I hunted deer so I understand how the scouts operate, and sometimes while out on patrol with them I drift off into another time and place, back to the mountains and forests of western Pennsylvania with my brothers stalking through the snow and looking for anything wearing a set of antlers. I have a 30.06 hunting rifle that my older brother Lou gave me as a Christmas gift when I was about 15. I walk on the balls of my feet through the snow trying not to step on branches underneath because of the crunching noise. Deer have a keen sense of hearing and will take off long before we even see them. The hunt goes from slow motion to fast forward and I pull up the rifle and catch the animal in the crosshairs on his shoulder where the slender neck connects to the sleek body.

I squeeeeze off a shot, real easy, and feel the explosion inside the chamber jerk back my shoulder as the 180-grain projectile with a copper jacket and soft lead tip pulls away from its brass casing at 2,700 feet per second toward the animal and into its shoulder where it mutates and turns into a mushroom that gouges a horrible path through flesh and bone, breaking and hemorrhaging everything along the way. A shock wave ripples along the animal's body and then it's like somebody pulls out the plug from a wall socket and its knees buckle and he collapses straight to the ground and the snow billows up around his nose as he lets out his last breath. This is the place to which my mind sometimes drifts during the long journeys in the mountains of north-

ern Nicaragua. But the men I walk with today are not stalking deer. They are stalking other men.

I follow the scouts to the top of the hill where the contras had been camped and we find two bodies, one crumpled on the ground where he apparently had been caught in the barrage as he laid down to sleep. His camouflage uniform is shredded and soaked with blood. The other is plastered by the explosives against a clump of trees. I regroup with Talavera's troops while the scouts venture out to reconnoiter the area when a burst of automatic rifle fire cuts through the morning mist. One of the scouts calls back to Talavera over his radio that a contra lay wounded but alive in some underbrush 50 yards away. The contra had fired as the scout approached. Talavera and I head across the hill to get closer.

"Tell him to surrender," Talavera orders the scout over the radio, then spits through the gap in his two upper front teeth. And from our position we hear the young scout tell the contra to surrender by yelling, "*Ríndase!*" Then we hear the contra's response, a short burst from his AK-47.

"*Qué hago?*" the scout said over the radio, asking for further instruction.

"Tell him again to surrender," Talavera says. (Don't forget, this is a 19-year-old who's giving these orders.) "Tell the son of a whore he's surrounded."

The scout obeys the order and once again the contra fires his weapon in symbolic response, kind of like, "Here's your surrender."

"*Ahora qué?*" (Now what?) the scout radios back.

"*Mátalo,*" Talavera orders the killing, and there's a short burst of fire from the young scout's weapon.

"*Ya.*" (Done.) the scout radios back.

Just minutes later this drama repeats itself with a second contra who was laid out no more than 20 yards from the first one, also wounded too badly during the Sandinista attack to be carried away by his fellow rebels.

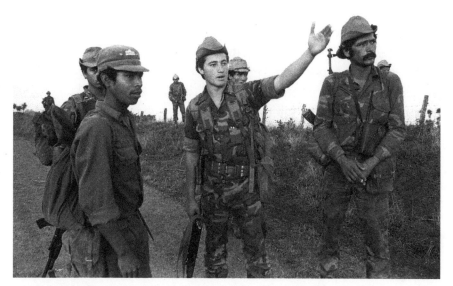

LA MONTAÑA, Nicaragua – Sandinista Lt. Francisco Noel Talavera commands troops.

We walk up to the first contra, laid beside a tree, and there is a huge hole in the top of his skull where the young scout had finished him off. It is still early in the morning and steam floats up from the warm brain tissue into the chill morning air. The second dead contra lays sprawled out along a trail, face up, and the Sandinistas gather around this one. At this point I'm chilled as much by what I had just seen as I am by the cool morning air. I bang out pictures of the Sandinistas standing around the dead contra. *Newsweek* will run one of the shots in the magazine the following week.

These two men lay there wounded all night, close enough to talk with each other and certainly lucid enough to know that the Sandinistas would be all over them in the morning, and they make a very conscious decision to die there rather than surrender to their enemies. Just thinking of the night-long drama between the two still turns me quiet. Pushes me into myself. I spend a long time wondering what the two men talked about that night. I guess the usual stuff. Wives and girlfriends. Maybe kids. Life "back home" in what used to be their real

world. Warm food and cold beers. The same things that men of any country or color talk about during any war in any part of the world.

And I thought about what this meant in terms of this conflict itself. Here it is. Two wounded contras wait all night for the Sandinistas to show up in the morning. Their worst fear, what they've been taught to believe by their commanders, is that the Sandinistas will take them prisoner, torture them, kill them, or all of the above.

But they must also hear a voice, a whisper, from somewhere in these tropical highlands, telling them that maybe, just maybe, the Sandinistas will spare them. "Don't die," the whisper says. "Maybe you can make it back to us. We're waiting for you." But the darkness wins, and these men decide instead to take no chances. So they refuse to be captured and insist on being killed outright. And they are.

It is 1984 and this is my second war, the groundwork for which having been laid just five years previous when I covered the 1979 Sandinista insurrection to overthrow the U.S.-backed dictatorship of Nicaragua's Anastasio Somoza.

This current war, the Contra War, would become my refuge. I came to understand that I had been prepared for it by the people and the places of my youth. By those who waited for my return.

I would find shelter in this conflict because it was clear and simple, particularly in contrast to what my life in the capital city of Managua would become, cluttered and complicated with work and relationships. There is a purity to war. A clarity. An honesty that I've found nowhere else. In war, men are either strong or they are weak. They are either courageous or they are cowardly. Either loyal or treacherous. They either live or they die. War is absolute. It is black and white.

I went to the mountains to cover the war in part, because it was there that I found peace. Peace within myself. The grueling rigor of the mountains cleaned out my body. The absolute, razor-edge singularity of survival cleaned out my mind. The forthright dealings with the troops cleaned out my spirit. And this was *before* combat, which is the single most pure and most purifying experience of my life. When we are in combat there is nothing else in the universe. Everything,

every thought, every fiber in one's body, every particle of energy is focused on the here and now. On the point of a needle. Not the head of a needle. The point. The tip. Make a mistake and lose an arm. Turn the wrong way and lose an eye. Don't keep up and lose a life. It is a discipline imposed by an emotion perhaps even more powerful than love: Fear.

AUTHOR'S NOTE

I first attempted to write this book in the late 1980s to document my unique role in what I knew were historic events in Central America. Those events resonate in the U.S. to this day. As a correspondent for United Press International (UPI) and photojournalist for *Newsweek* magazine, I witnessed, documented and lived those events from a perspective perhaps more intimate and more privileged than any of my colleagues.

The demands of the changing craft of journalism and the scramble to adapt as a practitioner of the craft forced me to put the book aside. I resurrected the project in 2019, as I reviewed and organized my photographic files and print documents to install in the Archives and Special Collections section of the library at American University (AU) in Washington, DC. I've been a full-time faculty member of AU's School of Communication (SOC) since 2003.

The people and the events in this book all are real and, to the best of my recollection and cross-checking with various sources, occurred as they are stated here. These sources include my own memory and the tens of thousands of photographic images and documents in my

archives that have served to ignite and to clarify my memory. The sources also include the field notes I wrote in reporter's notebooks while on assignment, as well as captions that I wrote for pictures I sent to UPI and to *Newsweek*.

Over the years I've conducted lengthy interviews, most of them recorded and transcribed, with many of the subjects mentioned here, including members of my family, friends and professional contacts. I also drew from a series of interviews I conducted with then Vice President of Nicaragua, Sergio Ramirez Mercado. The edited version of these interviews with Sergio constitutes the epilogue of my book of photographs, *Nicaragua*. I cite sections of the capstone research paper I wrote for my master's degree at Ohio University. I drew from letters, both professional and personal, to and from family, friends and associates.

The conversations that I include in quotation marks are taken directly from recorded interviews or have been reconstructed from notes and my memory. I have changed the names of some individuals and circumstances to protect people's anonymity.

Most of the source material mentioned here is now installed in the Archives and Special Collections section of the American University library in Washington, DC.

INTRODUCTION

The stories of our lives describe what is meaningful to us. They help define who we are. The stories I pass on in this book form the account of one man's embrace of, and struggle with, war, love, family, a profession and self. I have carried these stories with me for decades, and for decades they have yearned to be released. To be shared. To be told.

I tell these stories now because I believe they contain something of value to researchers seeking information about the historic events that swept over Central America in the late 1970s, 1980s and early 1990s; value to young men and women who aspire to use the craft of journalism, especially photojournalism, video journalism and other forms of visual communication to engage and to document their own times and experiences; value to all who might learn something of the human condition seen through the prism of one man who lived through those times and those experiences and who is willing to write about them.

These are more than just stories about war. They are a collective statement about journalism and the men and women who practice it. About the decisions we make. About what we aspire to achieve. About the people and the stories that we tell.

Perhaps more importantly, this book introduces the American people, who sponsor those faraway conflicts, to the victims of U.S. military intervention abroad. We intervene in foreign countries supposedly for "freedom" and "democracy," but few Americans see the faces of "collateral damage" or know the names of the dead and wounded in those battles. *Wait for Me* is a firsthand, frontline account of the human cost of war.

Hopefully others can learn about the tragedy of war from these stories. To be clear, the information, opinions and conclusions presented here do not represent those of my current or former employers. They are mine and mine alone.

I make no pretenses. Though I have devoted significant time and effort to covering the conflicts in Central America and the Caribbean, in the Persian Gulf, Africa, Iraq and Afghanistan, I do not pretend to be a "combat photographer" or a "war correspondent." I say this out of respect for many of my colleagues who have invested much more time, effort and risk covering conflict around the world than I have. I do not pretend to do what they have done.

Nor do I make any claim of righteousness. I have no shortage of human flaws, shortcomings and failures. Some of those deficiencies may have offended or even hurt others along the way. If so, I apologize for that.

Finally, I offer this book as one person's contribution to the collective memory of family, friends and colleagues with whom I share some of the most vibrant, meaningful and enduring experiences of our lives. May we remember and relive them in the pages of this book. I apologize for lapses in memory or failure to include persons who otherwise should be listed here.

The title of this book comes from a poem that I stumbled upon during the final days of assembling the manuscript. Written by Konstantin Simonov, the Russian poet and playwright turned war correspondent, *Wait for Me* is one of the best known Russian poems of World War II. Simonov wrote it in 1941 after he left his love, Valentina Serova, to take on the duties of war correspondent on the battlefront.

I adopted the title because the poem so accurately describes how the love and support of so many helped ensure my own return from the edge of human experience to a more "normal" or "mainstream" existence. They waited for me.

A translated and compacted version of the original Russian poem is included here, as seen in *The World at War*, a 26-episode, British television documentary series chronicling the events of that conflict.

> *Wait for me to return.*
> *Only the wait will be hard.*
> *Wait when the grief invades you, while you watch the rain fall.*
> *Wait when the winds sweep the snow.*
> *Wait in the suffocating heat,*
> *when others have stopped waiting, forgetting their yesterday.*
> *Wait even when letters do not reach you from far away.*
> *Wait even when others have tired of waiting.*
> *Wait even when my mother and son believe that I no longer exist,*
> *and when friends sit by the fire to toast my memory.*
> *Wait.*
> *Do not rush to offer for my memory you too.*
> *Wait, because I will defy all deaths,*
> *and let those who do not wait say I was lucky.*
> *they will never understand that in the midst of death,*
> *you, with your wait, you saved me.*
> *Only you and I know how I survived.*
> *It's because you waited, and the others did not.*
>
> *Wait for Me, by Konstantin Simonov*
> (seen in The World at War)

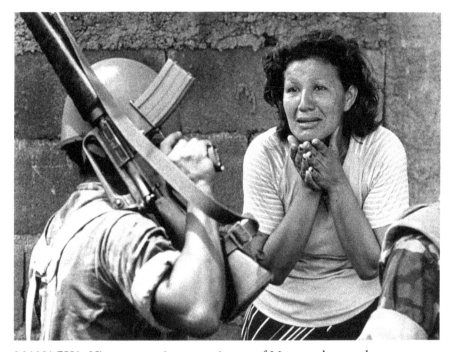

MANAGUA, Nicaragua – A woman in one of Managua's poor slums pleads with members of the National Guard to stop the bombing of the neighborhood where her husband and son are holed up during the 1979 Sandinista insurrection.

CHAPTER 1.

FIRST WAR

I was up late one night listening to Guy Gugliotta, a Florida-based correspondent for the *Miami Herald*. Tall and lanky with a soft voice and tired eyes, he didn't easily fit my preconceived notion of a Vietnam veteran and former Swift Boat commanding officer. But he was.

I smoked Marlboro reds while Gugliotta and I worked on a bottle of *Flor de Caña* rum and he talked about how he kept himself and his men alive in Vietnam while executing one of the most dangerous assignments of that decade-long conflict; how he anticipated and calculated for every contingent; how his eyes scoured every curve in the rivers that he and his men were assigned to patrol; how a flash of light off a metal surface or a reflection from the river bank could be the precursor of an ambush and the death of him and the men under his command; and, ultimately, how he would help get himself and all his men back home.

I've never been to Vietnam, but I grew up on pictures of that war in the pages of *Life* magazine. Huge color photographs made by some of the most courageous and most talented photojournalists of the era arrived each week at my home in the steel town of Aliquippa,

Pennsylvania, about a 40-minute drive northwest of Pittsburgh. I still have a copy of Larry Burrows' iconic photograph of a Black Marine, a bloody bandage wrapped around a head wound, reaching out for his white comrade, who is covered with mud, blood and trauma, slumped down against the blown-out stump of a tree. Pictures like that planted within me a lifelong fascination with imagery, journalism and war.

Nicaragua's 1979 Sandinista Revolution was the first time I had seen violence used as a political tool, the last resort after all peaceful means of change were exhausted. It was my first war. My baptism under fire. And like Gugliotta, I was there to cover it.

I was a stringer correspondent and photojournalist for United Press International (UPI) and for ABC Radio News. We were staying in the Hotel Ticomo, a small complex of *cabañas* tucked away under coconut trees on the outskirts of the Nicaraguan capital, Managua, where a contingent of international journalists had set up a base of operations. On a cassette recorder I used to file reports for ABC Radio, Bob Seger sang songs from his album *"Night Moves."*

I didn't know then that Gugliotta's lessons on guerrilla warfare might help save my life in the not-so-distant future.

A Bullet in the Head

The Nicaraguan revolution was a six-week national convulsion, a popular uprising by an impoverished people and a leftist guerrilla organization fighting to cast off a cruel, oppressive dictatorship supported for four decades by the most powerful nation on the planet, i.e., the United States of America. As it became clear that the dynasty of Anastasio Somoza and its National Guard were in trouble, journalists from around the world converged on Managua to cover this "David vs. Goliath" story. These journalists included a team led by ABC Television correspondent Bill Stewart, and since I was a stringer for ABC Radio, I briefly worked with Stewart and his team as a translator.

By 1979 I was pretty fluent in Spanish, a skill essential to negotiate one's freedom or one's life with mostly young, scared, poorly trained,

often exhausted and sometimes very pissed-off soldiers. Stewart had arrived on the scene after covering the revolution in Iran. He spoke no Spanish.

On June 20, 1979, a squad of Somoza's national guardsmen manning a Managua checkpoint stopped the van carrying Stewart and his colleagues. (As it happened, I had left the ABC team two days earlier.) Stewart and his Nicaraguan translator approached the soldiers as the camera and sound men in the van secretly filmed the event through the windshield. One of the guardsmen made Stewart kneel, then lie face down on the city street. He kicked Stewart once in the ribs and then, with a high-powered automatic assault rifle, pumped a single bullet into the back of his head. Guardsmen also killed Stewart's Nicaraguan translator, out of sight of the cameraman recording the killing from inside the van.

The global broadcast of that footage crushed support of the Somoza regime. For decades, the Somoza family's role as defender of Central America against communist incursion had guaranteed military and political support from the U.S. Congress. But even the regime's most stalwart, anti-communist U.S. congressional leaders could not continue to support the Somoza family's rule. They had become radioactive.

Suicide Stringers

In response to Stewart's killing, the vast majority of journalists covering the revolution evacuated the country, some in protest and others out of concern for their own safety. One of my print colleagues, a highly esteemed veteran correspondent working for a major American news outlet and who stayed to cover the war, said of those who left, "They're not supposed to do that sort of thing. Our job is to be here, not to move out of the fucking place."

I was one of the stubborn handful who stayed. John Hoagland was another. I was working for UPI. Hoagland, a freelance photographer, was working for the Associated Press (AP). The two agencies were bit-

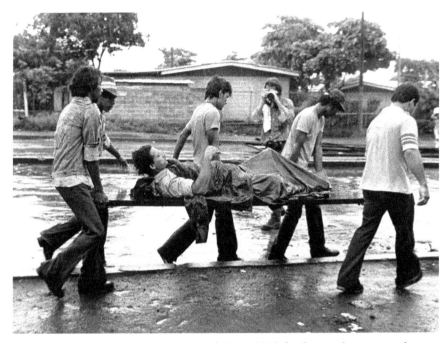

MANAGUA, Nicaragua – Associated Press (AP) freelance photojournalist John Hoagland makes pictures of Nicaraguans evacuating a wounded civilian in Managua during the 1979 Sandinista Revolution.

ter rivals, always competing to deliver the best print and photo coverage — and to deliver it sooner than the other. John and I met during the conflict and became friends.

At the time, most of the journalists still in the country were staying in the Intercontinental Hotel, a pyramid-shaped building overlooking Managua. (It was here on the top floor that the aviation pioneer Howard Hughes spent some of his final days, until 1972 when an earthquake wiped out most of the capital and took about 30,000 Nicaraguan souls with it.)

In addition to the remaining press corps in the Intercontinental were *Somocista* types and their families who blamed the international media for ruining the country and bringing down the wrath of Washington upon their tropical paradise. All day and half the night these people lurked inside the building, afraid to leave because of the

fighting outside, hoping the situation would get better, so they could return to their homes. Some had guns. They were ministers, congressmen, government officials who for the past four decades had been systematically ripping off the country and her people and now that the place was coming apart they were pissed at us because we were telling the world what they'd been up to all those years. And the media types were getting pretty nervous being around these people, who were increasingly vocal and hostile as the outcome of the war became clear.

One evening some of the maids and other hotel employees came around and whispered to some of us in the foreign press corps that the entire staff of the hotel was going to disappear that evening and if we had any sense we should disappear as well. The *Somocistas* were going to be even more upset in the morning when there's no service at all since "the help" had abandoned the place. So we packed up and slid off to the Ticomo Hotel, a self-contained compound with trees, a tennis court, a swimming pool, a restaurant, the works. It became our command post for the rest of the war.

Covering the final offensive was a relentless scramble for information as fighting between the National Guard and the Sandinista-led insurgency moved from one city to another on an almost daily basis. Death tolls. Body counts. Casualty reports. Refugees. Press conferences. Sandinistas seizing control of towns and cities across the country. More casualty reports.

At the time I was stringing as UPI's print correspondent with skill as a photographer. But during the war, the agency sent in more seasoned correspondents to cover the conflict and I took on more responsibility as photojournalist and occasional contributor to the print side of the operation. As photojournalist, my job was to follow the constantly changing reports, predictions and wild guesses by colleagues, local media outlets, tipsters and my own gut, and to document the conflict in black and white pictures. In other words, figure out what's happening and where. Get there. Make the pictures. Get back to base alive and unhurt.

Especially when covering conflict, part of a journalist's job is to

figure out who to work with. Who can I trust? Who can I depend on? If I get into a really hairy situation, who do I want at my side? Is it him? Or her? We make these decisions on the spur of the moment. At breakfast while listening to the latest radio report. In the afternoon on the side of a road while deciphering information from refugees fleeing combat in a nearby town. Perhaps luckily for us at this time of the Nicaraguan insurrection, the field of candidates from which we had to choose had been whittled down by the execution of Bill Stewart and subsequent evacuation of the vast majority of media from the country. Most of the fakers and bullshitters had already gone. It was in this diminished field of candidates that John Hoagland and I chose each other.

Hoagland was getting 25 bucks for each of his pictures transmitted to the Associated Press headquarters in New York. That meant that he might go out and risk his life all day long but if he came back and the AP guys in charge didn't like the work, then they didn't transmit anything and John didn't earn anything that day. My arrangement with UPI seemed a little more generous. Lou Garcia, one of UPI's great photo editors and one of my best friends and mentors, paid me 60 bucks a day to go out and risk death and permanent disfigurement no matter how many of my pictures he transmitted to the UPI headquarters in New York. For much of the war, however, I was one of the few UPI photo guys in the country and Garcia was transmitting a ton of my pictures every day. UPI's photo coverage during much of the Sandinista Revolution was mostly Lou Garcia and me. Lou would hand me a bunch of raw, black and white film every morning. I would head out to cover the conflict. I would come in once a day to drop off the morning's work, pick up more film, grab something to eat, then head back out until the day was over. Lou got up early and stayed up late developing, printing and transmitting my work to UPI headquarters. We were a great team.

Hoagland was a surfer type from San Diego. Tall and muscular, over six feet, with sandy, half out-of-control hair, he sported a big Fu Manchu mustache that kind of said, "Do not mess with this person,"

and I don't remember anybody ever having done so. I don't think people were necessarily afraid of him, but I think they realized that John was wound tight enough so that if you pushed him just a little there might be serious consequences. John looked like the Marlboro Man and the fact that he smoked a pack or so a day of Marlboro reds actually enhanced that comparison.

I think these physical attributes masked what was at his core. The reality is that John was an extremely kind, gentle, soft-hearted guy, with a deep and genuine sense of moral outrage at how cruel the world could be. I don't claim to have known him very well, since we only covered one war together and shared an apartment for a brief period in Mexico City after the war was over, but it seemed that John had come from a difficult past and was carrying a lot of baggage from it and was still trying to sort it all out. Rumor had it that he had once been a bodyguard for Angela Davis during the violent period of the late 1960s civil rights movement in America and had carried a .357 Magnum while on the job. He left that scene and moved to the desert with his young son, Eros. Somewhere along the line there was a breakup with a girlfriend and John pulled away and into himself. By the time he reached Central America he seemed a bit of a loner. I think he was saddened and a bit cynical but not bitter. Later, there would be a Salvadoran girlfriend named Laura, who made him happy and became his wife.

Journalists who work for competing outlets normally don't work together, but Hoagland and I teamed up (1) because we didn't yet fit in with the big dogs who were shooting for *Time* and *Newsweek* making $300 a day, and (2) because we were hungrier than wild animals and would do anything to get a picture, sometimes doing stuff a lot more daring (more foolish) than the magazine folks were willing to do. There's another element to all this. When young journalists first go to war, we don't think anything bad could ever happen to us. We are invincible. At least that was my case. Only after I'd seen war and what bullets and shrapnel do to human flesh and bone, only after I'd seen people bleed and die in war, and only after I got scared to my core a

few times, did I really believe that something bad could happen to me.

Hoagland and I still believed we were indestructible because neither of us had seen enough war to know otherwise, to believe that we could get hurt. Neither of us understood this process. I don't know about John, but I was so green that I didn't even realize there would come a time when I would be less willing to go out and risk my life for a picture. That would change.

In the latter days of the Sandinista's Final Offensive, the foreign press corps knew from experience that every afternoon Somoza's planes would bomb and rocket the poor *barrios*, or slums, in the northeastern part of the city through which a major highway, the *Carretera Norte*, or Northern Highway, connected Managua to the International Airport. The bombing was absolutely indiscriminate. The National Guard conducted these raids because the strategic areas were held by the Sandinistas, who were aided by much of the civilian population. Because of daily bombing, most members of the foreign press corps stayed away from this area until the raids were over.

But not Hoagland and me.

We spent all morning one day making our way through Sandinista trenches to their barricades along the highway at a major intersection where National Guardsmen were holed up in a warehouse right across the street. I still have the black and white prints of young Sandinista guerrillas, male and female, passing cans of food back and forth among themselves, neighbors bringing out pails of water in the sweltering tropical heat.

Women played an important role in the revolution, taking up arms to fight alongside their male counterparts against the dictatorship. The barricades consisted of pavement blocks, square and about eight inches wide, ripped out of the highway and piled one on top of another. Right on time each afternoon the government planes started rolling in. John was smart and jumped straight into a ditch, but I ran for the door of the nearest house. Just a half second before I could turn the corner into the front entrance a rocket from one of the planes ripped through the zinc roof of the house and turned its insides into

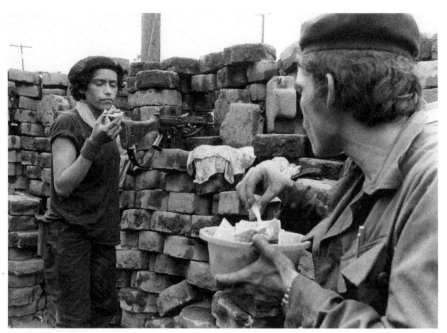

MANAGUA, Nicaragua – Sandinista rebels occupy barricades, built with street pavement stones, along the Northern Highway.

rubble. I stopped in the doorway with dust billowing into my face. Three steps faster and I would have eaten a shrapnel sandwich.

It was that day that some of our colleagues started calling John and me the "suicide stringers." But Lou Garcia loved the pictures. And that's all I cared about.

El Hombre

To stay abreast of the constantly changing events, the UPI team relied heavily on our "secret weapon."

In his early '60s and blessed with an authoritative demeanor, Leonardo Lacayo Ocampo was a veteran journalist and local Nicaraguan stringer for UPI. When conversing with him via long-distance phone calls from our UPI bureau in Mexico City, my colleagues and I addressed him using the respectful Spanish honorific of *Don*, mean-

ing "gentleman" or "sir." It was *Don* Lacayo's dispatches and long-distance telephone calls that I had translated and edited over the previous months to follow and report on the situation in Nicaragua. It was during the Final Offensive that we finally would meet.

At his home a short walking distance from the Hotel Ticomo, *Don* Lacayo had a short-wave radio system he used to monitor communication between Somoza and his guardsmen in the field. So, we often knew what was happening before it actually happened. *Don* Lacayo was such a closely guarded secret in the super competitive world of breaking news coverage that my UPI colleagues and I were absolutely forbidden to use his real name even in private conversation, out of concern that our competitors would find him out, and then buy him out and use his skills to bolster their own coverage of the conflict.

We were allowed only to refer to him as *El Hombre* —The Man.

"Nobody Runs!"

We were looking for dead bodies.

It was deep into the final offensive and I was with a handful of journalists in a poor neighborhood on the edge of Lake Managua just off the *Carretera Norte.*

We had word that President Somoza's National Guard had been dumping the remains of Sandinista fighters and suspected collaborators in the lake after having tortured, interrogated and killed them. I don't remember who else was in the group besides Bernie Diederich, but it had to have been members of the tiny and stubborn corps of journalists still in the country after the execution of Bill Stewart.

Considered the unofficial "dean" of the foreign press corps in the region, Diederich was Mexico City bureau chief for *Time* magazine. His area of coverage included Nicaragua. Tall and probably in his early 50s at the time, Diederich, a New Zealander, cut an imposing figure.

While we searched for human remains dumped among the weeds and the garbage lining the shores of the lake, a group of National Guardsmen in an open-roof vehicle mounted with a .50-caliber ma-

chine gun came haulin' ass down the sloping dirt road toward us and began firing above our heads. (The muzzle velocity of projectiles blowing out of this weapon is 2,910 feet per second and can take an arm off with a single shot or eat up a brick wall from a mile away.) Water shot into the air as the bullets pounded into the lake.

Our collective first reaction was to run to our vehicles and make a break for it but in a short, commanding voice, Bernie belts out: "Nobody runs!"

Bernie understood that our best defense was to stand our moral and physical ground. Running would only incite the soldiers. Piss 'em off. Give 'em a reason to shoot *at* us, not just over our heads. We had press cards and permission from President Somoza to do our work as journalists. We had a right to be there. We were the international media. We wouldn't be intimidated.

Nobody ran.

"If They Don't Bother Us, We Won't Bother Them"

On the highway connecting Managua to the western Nicaraguan city of León, the nation's second-largest city after the capital, was a school run by Maryknoll Sisters from the United States. During the war, hundreds of Nicaraguan civilians sheltered in the school to escape the fighting. Mothers, especially, brought their young sons to the place, as a refuge from National Guard soldiers who might come looking for young men collaborating with the Sandinistas – a determination that could be fatal for their children. I stopped at the school on one of my trips from Managua to report on fighting in the city.

During the build-up of civil strife in León the year before, the *Washington Post* published a front-page story headlined, "He Was Crying, 'Don't Kill me, Don't Kill Me.'" It was emblematic of the repression of civilians across the country. It began:

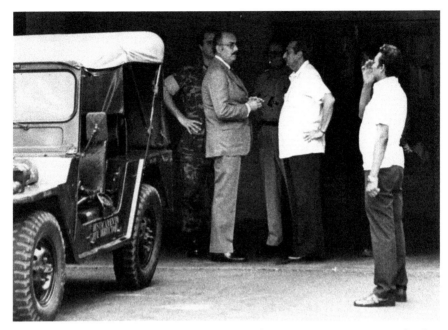

MANAGUA, Nicaragua – Nicaraguan President Anastasio Somoza Debayle (center in suit) consults with members of his government during the peak of a national insurrection to oust him.

"LEON, Nicaragua – At least 14 young men were killed last Friday afternoon on a two-block stretch of Santiago Arguello Avenue here. All of them, according to family members and neighbors, were executed by submachine gun at point-blank range by the Nicaraguan National Guard and all of them begged for mercy, some on their knees."

The article quoted Adela Alvarez, wife of a *chauffeur* and mother of four, who was hiding in her home when four soldiers burst in and took a son out to the street and shot him. One of the soldiers came back to the house after the shooting. The story continued:

"He said, 'You are pretty. Maybe I'll come back and visit you.' Then he told me to go to the middle of the street, where they had dragged three of the bodies, and to take a watch off one. He told me to wash it and put it on him. I did it, because I was afraid."

So, the Sisters running the school the day I visited had good reason to be concerned. They had heard stories like this before. They knew what the National Guard was capable of. More worrisome was the fact that they had seen airplanes used by the government to bomb rebel-held neighborhoods flying close to the school.

The Sisters also understood that Somoza was extremely aware that continued support from Washington was contingent on appearances. Over the years, the dictatorship had assembled an infamous team of media-savvy public relations men, advisors and political allies cultivating the Somoza image and its ties to U.S. power. It was called the Nicaragua Lobby. But Jimmy Carter had become president of the United States in 1977 and insisted on talking about "human rights," placing the regime under real scrutiny for the very first time.

The Sisters asked me to help. Make pictures. Publish a story. Get the word out. Do anything to keep the feared National Guard and the planes away from the school, the women and their children.

When I returned to Managua that night, I rang the bunker that Somoza maintained just a stone's throw from the Intercontinental Hotel. I actually got through to the president, who was always eager to meet and to influence foreign journalists, because he understood that we were the ones who created those "appearances" crucial to his grip on power. I told him about the Sisters at the school, assuring him that the location was filled with refugees, not guerrilla fighters, so please don't harm them.

In her inspirational book, *The Same Fate as the Poor*, Maryknoll Sister Judith M. Noone later wrote of the Sisters at that school:

> The raging conflict, it seemed, had effectively cut off all normal means of communication with the outside world. Julie and six other Sisters in Leon found themselves running a spontaneously organized refugee center for 400 people with 20 cots, a small supply of rice, beans, medicines, and 5,000 gallons of water. Their only contact with the world beyond the bound-

aries of Nicaragua was an occasional brave reporter through whom they were able to send letters assuring family and friends of their safety while trying to camouflage their fear. One reporter, Bill Gentile from ABC and UPI, called President Somoza when he returned to Managua from Leon to tell him that if anything happened to the seven North American Sisters in the refuge center in Leon, he would make sure it received worldwide publicity. "If they don't bother us," Somoza assured him, "we won't bother them."

Somoza's National Guard did not bother the Sisters or the refugees. Nor did he remain in power.

Anastasio Somoza's bunker, or command post, was a two-minute walk from the Intercontinental Hotel in what remained of Managua. On the morning after the dictator and his family fled the country, Nicaragua's National Guard disintegrated as its members stripped off their uniforms and disappeared. Many tried to pass themselves off as civilians and headed north to the border with Honduras.

A few yards from the bunker, two national guardsmen were trying to jump-start a car to join their fleeing colleagues. They asked me and colleague David Helvarg to help them push their car so they could be on their way. As Helvarg and I took our places behind the trunk of the car, we could see the bodies of two guardsmen piled onto the back seat. The fleeing guardsmen were taking their dead with them as they retreated from the incoming Sandinista fighters. Next to the bodies was a case of Scotch.

Happy Birthday

The following day and not far down a main street from Somoza's bunker, the plaza in front of Managua's metropolitan cathedral filled with thousands of Nicaraguans welcoming the incoming Junta of National Reconstruction, victorious Sandinista fighters, and their followers. The date was July 19, 1979.

That night, I sat alone on the upper ledge of the Intercontinental

Hotel, contemplating the still-smoldering country and her citizens exhausted and spent after six weeks of tearing at each other's throats and sacrificing an estimated 30,000 souls in the process.

I called my older brother, Lou, to congratulate him on his birthday, which is July 20. I tell him I regret not being there to celebrate the event, but that his birthday gift is the liberation of 3 million Nicaraguans.

"That's good," he said. "Thank you."

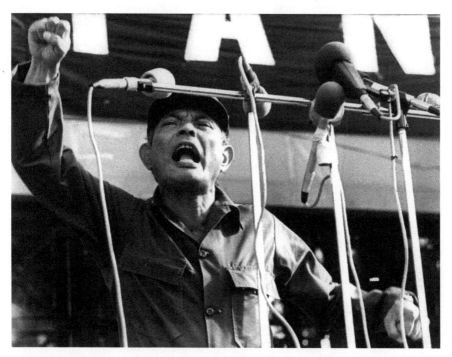

MANAGUA, Nicaragua – Tomás Borge, one of nine Sandinista Commanders of the Revolution and the new Sandinista government's Minister of the Interior, delivers a rousing speech warning Nicaraguans of the "terrible and glorious days" that await them.

"Terrible and Glorious Days Await Us"

Tomás Borge was a small man, but one not to be taken lightly. The only surviving member of the group that founded the Sandinista National Liberation Front (FSLN) in 1961, he was cunning and resilient. He had been tortured in the prisons of the Somoza dictatorship but lived long enough to help overthrow the regime.

One of the nine Sandinista Commanders of the Revolution and the new government's Minister of the Interior, Borge was addressing tens of thousands of Sandinista supporters in Managua's newly re-named *Plaza de la Revolución.* Just months after the Sandinistas seized power and David Helvarg and I helped jump-start that car loaded with dead national guardsmen and Scotch, many of the surviving guardsmen were in Honduras plotting their return to power. They would become *contra-revolucionarios* (counter-revolutionaries). "Contras" for short.

Borge delivered a rousing speech warning Nicaraguans what to expect in the wake of the overthrow of the Somoza dictatorship. A fiery orator, he understood that Washington would not quietly accept the demise of a long-time client and supposed bulwark against the advance of Cuba-supported communism in its own "backyard." While Washington was not eager to participate in another Vietnam, it might not be averse to fighting a proxy war in Central America.

This was 1979, and the Cold War still raged. To the great misfortune of the people of Central America, their countries, particularly Nicaragua and El Salvador, would become one of the last major battlegrounds of that global conflict.

Borge understood his own people, the Sandinistas as well as the contras. He knew how malleable, how intransigent and how tough both sides could be. And I think he designed this speech to brace his followers for the storm he saw just beyond the horizon.

"Nos esperan días terribles y gloriosos," Borge warned in a phrase that would make the next day's banner newspaper headlines. "Terrible and glorious days await us," he said. Perhaps not even Tomás Borge could imagine how terrible the coming days would be. I certainly did not.

Nor did I understand that I would be in Nicaragua to live them.

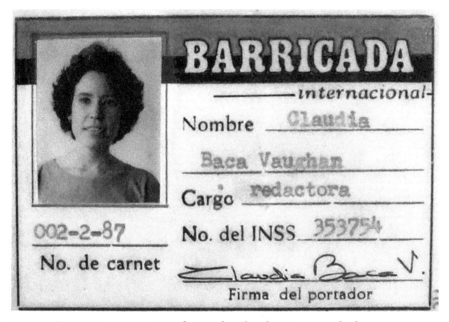

MANAGUA, Nicaragua – My first wife, Claudia Baca, worked as an editor for Barricada Internacional, the international version of the official Sandinista newspaper, Barricada.

CHAPTER 2.
CLAUDIA

Masachapa

We had a cooler full of cold beer between the bucket seats. We usually packed bread and cheese and fruit. I had mounted a great sound system with huge speakers in the back of my vehicle, a 1969 International Harvester Scout off-road vehicle that muscled its way up the hills and around the curves until Claudia and I pulled into our destination on the far edge of the Western Hemisphere. Jackson Browne, Bob Seger, the Pointer Sisters, Phil Collins, Bruce Springsteen, Bob Dylan, Dire Straits, The Cars, The Who, Tom Petty, the Rolling Stones and others serenaded us along the way.

Masachapa was, at the time, a pristine village on Nicaragua's Pacific Coast, inhabited by fishermen who made their living on the open sea in rickety outboard motorboats that you and I wouldn't cross a pond in. The village was built right on the water's edge, where powerful waves pounded dark, volcanic sand. Along the beach were private *cabañas*, or beach huts, separated by bamboo fences. The huts were made either of wood slats or bamboo. The roofs were either *palma*, the long, sun-dried "leaves" of palm trees, or sheets of corrugated

zinc. No indoor toilets and no indoor water supply. Claudia's father, Alberto Baca Navas, owned one of the huts, which was where Claudia and I would stay. There was one "restaurant," if I can call it that. Very impromptu, just a few yards from the water's edge.

Bar Lorena. It was one of my favorite spots on the planet. It was a kitchen built of concrete, with a small serving area and a tiny storage shed. The floor was faded red tile. The dining area involved four round tables and a bunch of chairs, all on the sand. There was a juke box in a corner. The whole affair was surrounded by a thigh-high concrete wall. It was all covered by a zinc roof. In the daytime, dogs slithered around to escape the broiling daytime sun and to mooch scraps of anything tossed at them by customers. When it rained, the roof sounded like a non-stop avalanche. And leaked. The place always smelled like the wood fire on which Lorena cooked the food. And stale beer.

On weekends Bar Lorena filled up with local fishermen, accompanied by women (a lot of them not their wives) and – best of all – no foreigners. In all the time we visited this place, I don't remember seeing a single white face. No gringos. No Euro anything.

Lorena had skin the color of a Milky Way chocolate bar, weathered by the sea but beautiful still. Her face was plump, soft and round, features that distinguish most Nicaraguan women from their leaner, harder-edged Central American neighbors. She carried her weight well. She had clear, quick eyes, curly hair and a pair of gold earrings. Her two young daughters danced to *salsa*, *ranchera* and *mariachi* tunes blaring from the juke box. I didn't know where her husband was. Or even if she had a husband, marriage in Nicaragua a bothersome formality not required for passionate lovemaking or for bearing children.

In Lorena's eyes I could read the weariness, the sadness, the joy, the bottomless well of *entrega* (love, devotion, surrender) of the Nicaraguan female. Her eyes were reserved. Understanding. Tired but very much alive. Sparkling. Mischievous.

She told me she was only 26 years old and I almost fell off my chair.

One of her clients, Luis, shuffled over to the juke box to play yet

another round of *Grupera* tunes by the Mexican band *Los Bukis*. This song is, "*Falso Amor*," or Fake Love. He was already half lit up from the beers he'd been downing and Lorena pointed her puckered lips in his direction and rolled her eyes, meaning, "I've seen this movie before. It doesn't end well."

One evening at Lorena's I was having a weighty discussion with Juan José, who was 12 years old. He was one of the village urchins and he'd dropped by to check out the white guy (me) having a few beers at the bar. We were talking about fishing and swimming in the ocean. Juan José said nobody goes swimming at night because the sharks come in close to the beach to look for food.

How close do the sharks come in?

"They come real close but don't ever come onto the sand," Juan José explained. "Because if they did, they can't get back into the water."

Oh. I see.

Masachapa is 90 minutes from our home in Managua and it was here where Claudia and I came to escape, to be one. To celebrate our lives together. Claudia worked for *Barricada Internacional*, the English-language version of the Sandinistas' official newspaper, so we visited Masachapa to break the routine of covering the U.S.-led assault on her country. I always woke up earlier than her, heading to the beach in time to glimpse the sunrise and to welcome the fishermen as they pull onto the shore with their catch. It was then that I selected one of the fish for Lorena to prepare for our lunch.

Claudia. I had noticed her during the final days of the 1979 Sandinista offensive. The Intercontinental Hotel had become a frenzied hub of activity featuring *Somocista* politicians who had yet to flee the country, journalists and Nicaraguan citizens searching desperately for clues regarding the outcome of the conflict and the country's immediate future. Trying to read the tea leaves of what was going to happen.

She was diminutive, light-skinned and shapely, dark eyes behind lids that seemed to move in slow motion when she opened or closed them. They reminded me of a long-ago Christmas tale in which reindeer with long lashes blinked shyly. She had a determined demeanor

and a low tolerance for fools. She was 19 years old. She moved around the hotel with her father, Alberto, whose olive skin and straight, black hair revealed that his veins ran thick with the Native American blood of his ancestors whom Christopher Columbus encountered when he stumbled onto the so-called New World some 500 years previous.

After the Sandinistas seized power in July 1979 and on the basis of my coverage of the conflict, UPI made me a "local hire" staff correspondent with photography as my backup skill and then sent me back to Managua to cover the post-war "reconstruction" period led by the Sandinista government. ("Local hire" means you get a full-time job but are not granted the salary, the support, or the security given to staff correspondents hired in the United States.) It was during this period that I met Claudia. She was working at the *Casa de Gobierno*, or, Government House, in Managua, as an assistant to the press spokesman for the newly formed *Junta de Reconstrucción Nacional*, or Junta of National Reconstruction.

It was during this immediate post-victory period in Nicaragua that I broke the story about the Sandinistas' introduction of the *Comites de Defensa Sandinista*, or CDS, the Spanish acronym for Sandinista Defense Committees. They were a carbon copy of Cuba's *Comites de Defensa de la Revolucion* (CDR). These are block-by-block government-run neighborhood organizations designed to keep an eye out for "counter-revolutionary" activity, which means the government uses them to spy on its own people. They never really worked that well in Nicaragua, which I think is a measure of Nicaraguans' stubborn rejection of that kind of control.

Though I had seen her working with some European journalists as their Nicaraguan contact and guide during the Hotel Intercontinental and Hotel Ticomo days, we had never really met. But after the war I had to go to her office every day or so to nag and badger Claudia and her colleagues for details of the new leaders' daily schedules, press handouts, interviews, whatever. One day I asked her if she wanted to go to lunch some time and she said, *"Cómo no?"* (Of course!)

After spending a month in Nicaragua covering that critical post-

victory transition, I returned to my base at UPI in Mexico City. By October of that same year, I had decided to visit my family in Pittsburgh, so from the UPI office in Mexico City I called Claudia in Managua to ask whether she would like to go with me to visit my family in the United States. At this writing in the late summer of 2020, here's how a message from Claudia described what happened next:

> I received your call from Mexico at the Government House inviting me to travel with you to the United States to show me that "not all gringos are bad." I asked for permission to travel but they denied it for work reasons. There was a lot to do. Barely three months had passed since the triumph of the revolution and I was a press assistant for the Junta of National Reconstruction and the Commanders of the Revolution, who still did not have their own press team.

One morning after attending class at the university, Claudia arrived for work and found her mother waiting for her. Claudia's mother told her:

> "Get ready, Tomás is going to Mexico and will take you." She was referring to Commander Tomás Borge, a friend of hers since the 1960s. Together they conspired to start an adventure that perhaps they didn't think would last a lifetime. In two hours I got an exit visa from the country and a tourist visa for Mexico. I ran to the airport runway where Tomás, Moisés Hassan, a member of the Junta and Lea Guido, Minister of Health, were waiting for me. We left for Mexico on a jet that belonged to Anastasio Somoza, renamed "July 19." It was its first flight since the fall of Somoza. On the way to Mexico I found out that we were not going to Mexico City but to Oaxaca, in the south,

hours away from the capital. We were late for an official lunch of Latin American parties presided over by Tomás Borge. In the middle of the meal, a Mexican official approached our table and asked: "Who is the person traveling to the capital?" Shy, I raised my hand after nobody opened their mouth. I saw Tomás again in the distance at the presidential table and he winked at me. "The plane is waiting to take you when you want." I flew to Mexico City in the Boeing of the PRI (*Partido Revolucionario Institucional*, the ruling party in Mexico at the time) Secretariat and we landed in the presidential hangar. A limousine from Foreign Relations was waiting for me on the runway to take me to my destination: the UPI offices. The Mexican officials were perplexed and even more so when (you) not only did not (initially) come down to greet me but also wanted to tip them without knowing who they were.

At the time, I was sharing an apartment with John Hoagland, my "suicide stringer" colleague with whom I worked during the revolution. John and I were still cooling down from having covered that story. He was trying to figure out what to do with his career in the aftermath. El Salvador was shaping up to be the next big story in the region so maybe he would go there. In the meantime, we were living in a high-rise apartment in, as I recall, the Tlatelolco sector of the capital, overlooking the *Plaza de Tres Culturas*. There were a few towering apartment buildings clustered in that complex and I can remember waking up a couple of times during the night when earthquakes would rumble through the city's soft foundation. Mexico City is built on the bed of a lake drained by the Spaniards following their conquest of the Aztecs.

So, Claudia, Hoagland and I go to the U.S. Embassy in Mexico City to get a visa for her so that I can take her home to visit my family. And it's on this visit to the embassy where I get a sense not just of John

Hoagland's core of decency and fairness but also of his volatility. The consular official is telling us how he can't give Claudia a visa and she has to go back to her country of origin, Nicaragua, and apply for one there before proceeding to the United States.

Remember that John is this tough-looking surfer dude from California. He is unpredictable, unrestrained and unafraid. It's one thing to get into firefights alongside troops or rebels. I think that takes a special kind of bravery. It takes another kind of bravery to deal with difficult people on a one-to-one basis, being aggressive enough to keep them from walking all over you, jacking up the stakes of an otherwise peaceful confrontation and being willing to bang heads if it gets out of control. John has this kind of unpredictable and dangerous bravery as well. And John is protective of Claudia. While I spent most days working at UPI, John and Claudia toured the city and hung out together, becoming close friends.

So the embassy clerk is sitting behind his desk telling Claudia that she can't go with me to visit my family in Pennsylvania because of policy and Hoagland is just steaming beside me and I can feel the energy build up in him and all of a sudden he leans half way over the table and raises his voice demanding to know what kind of U.S. policy gives visas to assassins like the *Somocistas* but can't give a visa to someone like Claudia who never hurt anybody in her life and the embassy guy is visibly shaken while I'm only half-trying to calm John down.

We got the visa. And the lifetime adventure between Claudia and I began.

(For the record, I've come to believe that the vast majority of U.S. State Department employees whom I have met over the years are dedicated professionals doing their best to represent and to further U.S. interests around the world. I respect them for that.)

Beginnings

My older brother, Lou, and my mother pick up Claudia and me at the Pittsburgh International Airport for the 20-minute ride to Lou's

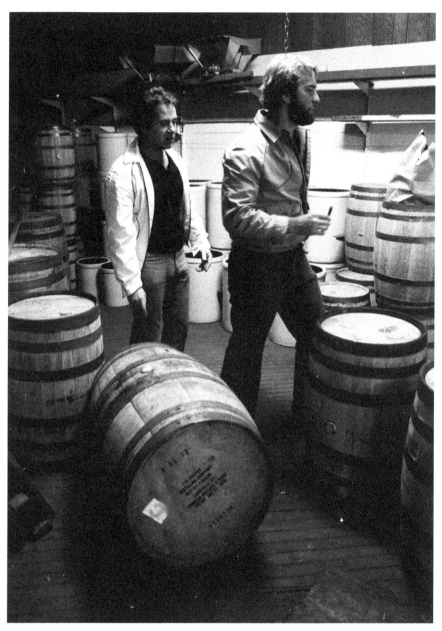

PITTSBURGH, PA – My older brother, Lou, (on right) and my cousin, Tony, purchasing oak barrels to be used to ferment and to store homemade wine.

CENTER TOWNSHIP, PA – Bill Hickman (on left), husband of my niece, Lisa, and I helping to make wine.

home while I translate back and forth between Spanish and English. I hadn't visited the place where I was raised in quite a while. It's Claudia's first visit ever to the United States. Claudia peers through the car windows. There is a cowlick in her hair at her forehead. Her lips, to quote a friend of mine, "look like they're tied in a bow." Snowflakes the size of ping pong balls streak through the darkness past her window. They crash into the windshield without a sound. This is the first time Claudia has ever seen snow. She is young and beautiful and warm beside me, under my arm, and as the car plies through the snow, through the lapses of conversation and the silence, it does not occur to me that this woman and I would share so many peaks of happiness, pits of despair, and so much in between in years to come.

At his home, my brother takes me down to his wine cellar. A single yellow bulb hangs from the beams that support the main floor of the building. Strung from those beams are home-made Italian sausages and great legs of prosciutto, all products of the hands and the energy of my older brother.

It is a place from another era. It smells of fermentation, old wood, pepper and raw meat. In the corner is an ancient press that my brother acquired from an elderly Italian friend. He had it refurbished with new slats of hardwood. It is this press into which he and a very select handful of friends and relatives each year dump bushels full of grapes to force from them the juice that eventually becomes wine. After pressing the grapes my brother treats the group to his homemade sausage and prosciutto, cheese and bread, and plenty of the previous year's brew. There usually is a bottle of Crown Royal Whiskey close by, in case somebody wants to offer a toast to friends, family and good times. And there's always somebody who wants to. Stacked along one wall are 55-gallon oak barrels originally made to store hard liquor but now are used to ferment next year's wine.

Places and ceremonies like these don't just happen. They are built on mutual respect, integrity, physical strength and the power of personality. Trust, loyalty and conviction nourish and sustain them. Whenever I could, I joined the privileged few to take part in this wine-making ritual.

"How much wine did you make this year?" I ask my brother.

"Three barrels," he says, moving among them to fill a one-gallon jug. He draws the dark liquid from one of the wooden kegs. I lean my back against a concrete wall and drift down to a crouch.

"What's the matter?" Lou asks.

"Nothing," I lied. "Just tired." In reality, much was "the matter." The fact that I am no longer part of what I see around me is "the matter." That I am so distant from my mother, my brothers and my extended family is "the matter." That his two daughters, Teresa and Lisa, are growing up and I hardly know them is "the matter." I live in Mexico City and I'm missing the milestones of so many lives, the birthdays, the Thanksgivings, the Christmases, the weddings, even the funerals. All of this is "the matter."

I take Claudia to the reservoir, a man-made body of water about 30 minutes from the place where my brothers and I were raised. It stretches along the bottom of a meandering valley and supplies the

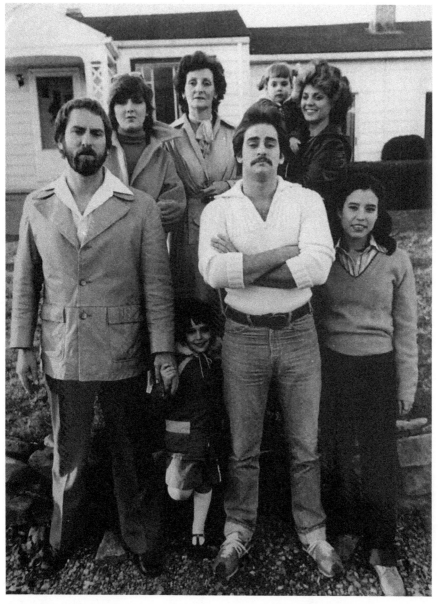

CENTER TOWNSHIP, PA – Claudia, who would become my first wife, on her first visit to the United States. In front and from left to right are my older brother, Lou, his daughter Teresa, my younger brother Rob, and Claudia. In the back are my cousin Mary Jo, my mother, and Lou's wife, Carol, holding their second daughter, Lisa.

nearby city of Ambridge with drinking water. The land around it is protected by law against development, and one of the only two buildings on the property is a red brick Presbyterian Church built in 1790.

The other building is the home of a warden charged with guarding the place against fishermen and hunters. (Apparently this restriction does not apply to the warden or to his close friends.) A graveyard with tombstones dating back 200 years dots a hillside overlooking the church and the water. The woods around it are refuge for deer, wild turkey and Canadian geese. The parking lot is a nighttime favorite of clandestine lovers, their used condoms tossed onto the gravel from car windows. The latex discards are antithesis to the pristine surroundings but are completely in tune with the passion and the intimacy they conjure up.

It is here, at the water's edge, where I find solitude and refuge in times of trouble or doubt. It is here, where my brothers and I come to jog along the water's edge and to draw close to each other. And it is here, where I celebrate life, love and renewal. And where one day I will come to mourn.

Also on this trip, Claudia and I went to New York where I touched base with colleagues at UPI headquarters, and we explored the city. I took Claudia to see the newly released, *Apocalypse Now*, Francis Ford Coppola's classic film on the war in Vietnam, starring Marlon Brando and Martin Sheen. It was perhaps not the most appropriate film for a young woman whose country just experienced a revolution that claimed an estimated 30,000 lives. She was offended by the film's treatment of the Vietnamese, whose horrific suffering she felt the filmmakers failed to consider.

"It could have been Nicaraguans," she told me. "I may be wrong."

"No," I responded. "You are absolutely right. It was America that was wrong."

Foreign correspondents spend careers figuring out how *we* feel about other people, their cultures, their politics, the things that motivate them. But it was through Claudia that I began to figure out how *Nicaraguans* feel about *us*, our culture, our politics and the things that

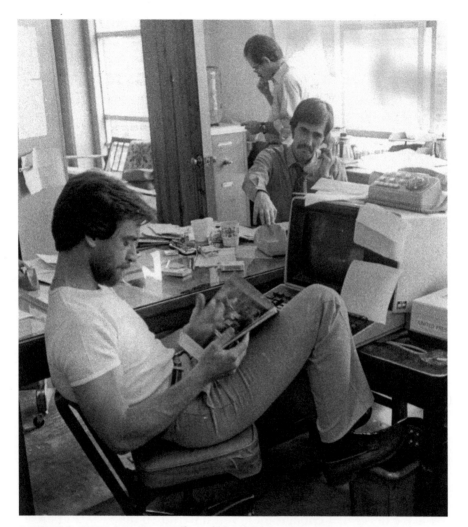

MEXICO CITY, Mexico – Office of United Press International (UPI) in Mexico City. I'm seated in front. In the middle is Bruno Lopez Kupitsky. In background is Juan Tamayo. (Photo by Oscar Sabetta)

motivate us. It didn't take me long to figure out that I loved her.

Claudia had brought with her a pair of brown suede, ankle-high boots and she wore them out on the streets and sidewalks of the city that never sleeps. By the time we ended our journey, we would call them *Las Botas Heroicas,* for having survived the punishment of our extended excursions. The Heroic Boots.

Mexico City

It was during that month-long trip to Pittsburgh and New York that I asked Claudia to come and live with me in Mexico City. She returned to Managua, where her mother and Commander Borge put up stiff resistance to the idea that she would leave the country and their revolution.

In that summer of 2020 message Claudia sent to me describing the sequence of events, she wrote:

> Borge visited me at home a couple of times at least and offered me whatever position I wanted in the government so I wouldn't leave. "The country needs you." The truth is that I was no longer sure that I wanted to leave. At that moment (you) came to ask my parents very formally to take me to live together in Mexico. Most likely, my life would have been another if you did not persist. And also yours.

Claudia was referring to a work trip I made to Nicaragua during which I visited her home to ask her parents for her hand. And it was here that began a storybook period of happiness in our lives. Claudia arrived in Mexico City in January 1980 and we moved into a tiny apartment in the swank Polanco district of the metropolis. She attended the National Autonomous University of Mexico while I worked at UPI. We never had enough money and we dined on pasta and bread three or four times a week. I had to walk to work as opposed to ride the metro, and we rationed everything in our lives except our love for each other. We had no money, but we had ourselves and a sense that we were sacrificing for a purpose and dedicating our lives to something more than a simple quest for legal tender.

At that time, we could travel around the country in relative safety, before Mexico drifted into a bloody drug war that would claim hundreds of thousands of lives. There was revolution in the air. I was 28

years old. We had our health. We had work. We had ourselves. We made new friends.

I first came to Mexico in 1977 to finish up a master's degree with a 10-week internship at the *Mexico City NEWS*, an English-language newspaper. The idea was to do the internship, return to the United States where I would write a research paper about the internship to finish off the requirements, get the degree, and go looking for a job. But I was learning and having fun, so I stayed at the paper for a year and by 1978 started to work as a "stringer" for UPI. My ties to the agency began the day I walked into the bureau to meet John Virtue, who was managing the place. I pitched a story and photos about a scribe who worked in one of the city's main plazas. It was actually a story about Mexico's high rate of illiteracy. Men and women who couldn't read or write hired scribes who sat around with mechanical typewriters to bang out love letters or official documents for their clients. This old scribe was special. He was blind. Virtue liked the story, paid me a pittance and shortly after, started calling me to fill in for staff correspondents on weekends. At the time, UPI was a major, global wire service and main competitor of the Associated Press (AP).

Mexico City was, and still is, a "hub" for journalists. Geography, history, language, culture, economics, technology, logistics and politics collude to make the Mexican capital the natural epicenter of a broad region from which journalists can cover every corner of it. So, we did. Our region of coverage included not just Mexico. Rather, the bureau was responsible for covering Mexico, Central America and the Caribbean. And part of our job was to translate and edit the stories sent us by local stringers or freelancers in the region, and file them to UPI's headquarters in New York for a final edit and distribution to clients around the world.

Mexico was good to me. It was here where I broke into the world of international journalism, where I forged life-long friendships, where I connected to UPI's Nicaraguan stringer Leonardo Lacayo Ocampo, to Nicaragua and to Claudia.

One of my colleagues and very best friends at UPI was Bruno Lo-

pez Kupitsky, a young, extremely bright reporter whose father worked on one of the mass circulation papers in the capital. Bruno had been brought into UPI by Juan Tamayo, a Cuban-American sent by UPI headquarters in New York to bolster and to mold the Mexico City bureau into something that could handle the world's increasing interest in the region. Lou Garcia, one of my early mentors, was UPI's regional photo editor with whom I worked so well during the Sandinista Revolution and who would influence my decision to move away from what he called the "word herd," or the print side of UPI, toward the photo side. We all were based in Mexico City.

The UPI bureau was a place to which I actually looked forward to being every day, a place where I'd go even when I didn't have to. To see my friends and colleagues. To find out what was happening in the world. To feel the electricity of the place. Bruno was part of that electricity. Big round head with full moustache. An easy smile and a giddy laugh. Tight. Nervous. Chain-smoking. The innocence of a child in a young man's body. We became friends instantly. And so did he and Claudia. Bruno was a frequent visitor to the humble apartment where Claudia and I lived.

Today, Bruno remembers those days fondly. In response to my query about his recollections, Bruno emailed:

> We both smoked cigarettes like crazy. We also got stoned and drank good rum together. I ended up a couple of times under the table of your home laughing like crazy. Claudia was really good to me, although I think she was at times fed up that I used to tag along and go to your house so frequently. We discussed a lot what was happening in the region we covered, the situation of our stringers and correspondents in their different countries and whatever news was emerging from the area that we got to edit for the service. For me those years were super special. Juan Tamayo made me a really good journalist teaching me the craft of produc-

ing solid balanced stories, which for us, surrounded by so much injustice and corruption in our region, was always hard. My friendship with you meant a world and gave me at the time a much needed hermano, a brother.

UPI at that time was housed on the eleventh floor of a building in downtown Mexico City. I stepped out of the elevator and walked to the end of the hall and through a door that was steel on the bottom half and glass on the top, the glass being frosted or cut through which you could see only outlines or forms or silhouettes on the other side. On it was painted "United Press International" and the UPI logo. Inside that door was another world. The place came alive with the clatter of old teletype machines rattling out UPI stories from around the globe, piles of newspapers and files, desks covered with clippings, stories we had written, coffee cups, ashtrays overloaded with still-smoldering cigarettes, a separate room with huge panels of electronic gear, wires, bulbs, plugs and stuff that only "Chino," the Mexican technician of Chinese descent, could understand and control. But most importantly the place was filled with purpose, youth, energy, ideas and fun.

It was electrifying. A wonderland where anything was possible.

"No, Yanqui, no!"

Aside from young, idealistic journalists, the place was peopled with Mexican assistants. Angel was mid-50s, rail-thin, curly hair, clunky glasses, fewer than a dozen teeth in his head but an easy smile anyway. Victor, early 40s, short, heavyset and slicked-back hair, with his pencil-thin moustache, a bit too smart and cunning to be doing this kind of work. Mario, early 50s, more formal than the other two, taller than both, balding and dark-skinned, with the high-pitched voice of an adolescent, and a bit too slow to be doing this kind of work.

When I first got there, these guys were responsible for typing our English-language stories into teletype machines for transfer to UPI's

world headquarters in New York. With the advent of computers by the end of my three-year stint there, they had to do everything else, like make sure the newswire machines had paper in them, keep the files squared away, and go out and get us tacos and soft drinks for lunch or dinner at our favorite place across the street.

Angel was my favorite. He was the most open. He had the best sense of humor. One night when he came back late from an errand, I feigned anger with him for his tardiness, picked him up in my arms and held him halfway out of one of the large, open windows, threatening to throw him out of the 11-story opening.

"*No, Yanqui, no!*" he screamed, using a term for U.S. citizens normally employed as an insult but one that he typically used to tease me. "*No, Yanqui, no!*"

Weeks later Angel would come to work with a confession. He told me that during the previous night, his wife had shaken him awake during what apparently had been a terrible nightmare. Angel's wife said he was screaming, "*No, Yanqui, no!*" until she woke him up.

New York City

Claudia and I separated in 1981. I had soured on Mexico, on the nation's corruption, on the smog, and on the demands of wire service work. I could no longer resist the pull of my family in Pennsylvania, always waiting for my return. She and I still were not married, and our relationship was strained. So, Claudia returned to Nicaragua and I went back to the States to finally finish the thesis and master's degree for which I had come to Mexico in the first place.

I piled my things into foot lockers and boxes and boarded a bus taking me from Mexico City to Dallas, where my youngest brother, Rob, was living at the time. Bruno dropped me off at the bus station and I can still see his face, contorted and sad, standing on the curb as the bus pulled away.

I returned to the United States with so much more than just clothes and keepsakes in those footlockers and boxes. My four years

in Mexico City had given me a taste of what it's like to be out there making a go of it outside of the structure of a J.O.B. or the delusional security of a company. Perhaps more importantly, I was convinced that life didn't have to be a surrender to the money/car/status/marriage/mortgage/job/children routine with which I was so familiar in the States. I told myself that I didn't have to compromise. My exposure to Latin America, particularly to Nicaragua, made me believe that I could do something else with my life, not just buy into the same old game. I had experienced revolution. War. Love. Life. Death.

And I wanted more. Of everything. Faster. And harder.

I landed up in New York City working on UPI's Foreign Desk in early 1982. It was a crash course in history, international affairs and politics. When I first started, I was assigned to work on stories from Latin America but one of my immediate superiors, a chain-smoking guy with a raspy voice and a profound understanding of not much at all, felt that my experience covering Nicaragua's Sandinista Revolution had warped my perception. He felt I was too soft on communism.

"Who the fuck are these Sodanistas in Nicaragua, anyway?" he asked me. "And how do they get that name? Sounds like they fuck themselves in the ass."

Eventually I earned enough trust to be put on the Middle East detail, receiving and rewriting stories from correspondents in the field. This involved reading the raw dispatches from bureaus in Israel, Lebanon, Egypt, Washington and the United Nations, then re-writing the stuff into a "Middle East Lead" story to be sent out to UPI clients around the world. Some of the copy coming in was somewhat disorganized. Incoherent. Some would come in from thousands of miles away via frantic, patchy conversations over bad telephone lines from correspondents under tremendous pressure in life-threatening situations.

By the Spring of 1983 the "Sodanista" chain-smoker had elevated me to "slot man" on the overnight shift. The slot man was the guy who reviewed the "lead," or first paragraph of stories pouring in from around the world (the lead being the key paragraph since according to

wire service style it has to encapsulate the rest of the story), prioritized the stories coming in on his or her shift and either edited and sent the story out him/herself or assigned it to another editor on the desk. And "overnight" meant that I worked from 11 p.m. until 7 in the morning.

Try working under really heavy pressure in front of a computer all night long, tearing through coffee and cigarettes just to stay awake and to keep the adrenaline flowing, then going home and trying to sleep. I lived on the second floor of a ratty old building on the corner of 31st Street and Park Avenue. On the first floor was a greasy-spoon diner and I knew at any given time what the chef was cooking down below because I could smell it in my apartment, if I could dignify the place by calling it an "apartment." It was a one-room box that included living room, office, kitchen and dining room all in a single space, with a bathroom set apart. I lived there because I wasn't making enough money to move into better digs. I slept on the floor on a futon that I rolled up into a "couch" in the daytime. My "office desk" was a door I found abandoned in the street and propped up on four poles. The building was constructed right over a subway line and every 15 minutes or so the trains rumbled through underneath. On my nights off I'd try to recuperate from lost sleep and catch up a bit, but my corner was a favorite hangout for hookers and at 3 a.m. I'd hear them arguing with their johns, "I want my money!"

Claudia came to New York to visit once and was not impressed by my living arrangement.

I hung out with a smart, young colleague working on UPI's local desk, and he and I occasionally would roll out of the building at 7 a.m. and head straight to the corner bar for some beers and a chance to wind down. There's nothing like a stomach full of beer at 9 o'clock on a cold New York morning. He and I would leave the bar and I'd walk the dozen or so blocks to my apartment watching through dark sunglasses the men and women in empty suits plodding their way like zombies to another day's work in the coal mines.

My Mother Told Me: Go To War

I waited to tell my mother during her visit to New York City. So I took her out to dinner on the last dying breath of my credit card, wanting to keep the intensity and the drama of the discussion within the accepted parameters of a restaurant full of people. It's not every day that you break the news to your mom that you're leaving what appears to be a decent job and going away. Not only was I leaving a decent job at UPI and a city that's only an hour's flight from her home, but I was leaving the entire country. And this is only 18 months or so after I had returned from four years in Mexico. To top it off, I'm going to a country where there's war going on.

My mother was born and partly raised in an Italian village of fewer than 3,000 people. She came to the United States without a word of English, finished high school when she was an adult and went to college as a middle-aged student. She was a product of World War II and of the Cold War, times when her newly adopted country could do no wrong. At this time, she was a widow.

The second of her four sons is with her in a restaurant in the city where she first came ashore. And he's telling her that he's going to Central America to cover a war. Not just *a* war but *a series* of wars, that he says are caused in large part by the United States – which might even invade the country that he's going to be based in. And she knows that Americans are being killed there because she remembers the Bill Stewart incident. She saw the news footage when the Nicaraguan national guardsman made Stewart lie down on the hot pavement and then put a bullet into the back of his head with a high-powered military assault rifle. And she knew I had been working with Stewart.

As a child, my mother watched three of her four brothers march off to serve in World War II, so she was no stranger to the heartbreak of war. And she wanted no part of it.

By this time my mother had either completed or was working on a college degree and had opened a job placement business of her own. She had purchased a new car. She'd traveled light years from the time she first saw the Statue of Liberty in New York harbor. Along the way

CENTER TOWNSHIP, PA – My mother basks in the shadow of her four sons.

she flourished into her true calling, the vocation that would give her the deepest gratification, endless purpose and meaning, which was to be a great mother.

She seemed to draw from a bottomless well of Old Country wisdom. She believed in "tough love," never afraid to stand up for what was right or to point out to her sons that we were wrong. That we made a mistake. That we should fix it. Now.

It is times like these that are the truest measure of people. This is the time when people define themselves, when they make decisions under pressure, the consequences of which can bring pain no matter what choice they make. My mother was not very good with directions, sometimes forgot to pass on phone messages, and occasionally was disorganized. But what she did best, what she was put on this Earth to do, what she excelled at, and what she most loved doing, was being a mother. It's not even a decision. It's an instinct. An innate, spontaneous condition. She always came down on the side of whatever was "best" for us - as long as it was "right" for us, as well.

During this visit, she had seen my so-called apartment and she understood the treadmill that I lived on, and she knew it all was wearing on me. I felt shackled by bosses, corporate rules and confinement in an office. I am a man of the field and that's where I should be. I was removed from what I knew were historic events in Central America. Claudia was a million miles away. This is not what I wanted to do with my life. I needed to follow my instincts. Follow my dreams. I needed to return to Nicaragua.

"Go," she said, her eyes watery and glistening in the yellow light of the restaurant. "If you have to go, then go."

I left New York City for Central America and transformed my life from the gray office routine at UPI to the vibrant tropics of Managua, where I arrived on June 13, 1983. Claudia had converted her mother's sewing shop into a little apartment. We would live there for about a year. Despite the fact that she and I still were not married, I became part of her family.

UNKNOWN LOCATION – My maternal grandfather, David D'Eramo, his wife, Felicia, and children.

CHAPTER 3.

"MY PERMANENT CONSTITUTION"

The Mills

The poster, larger than life, was positioned near the tunnel that led into the mills. It featured a man holding a bar of red-hot, molten steel in both hands, bending the metal into shape. As he did so, his muscles flexed and the soft metal seeped through his fingers, like a bar of butter might do if grasped in a similar fashion. This was, of course, only an illustration, but it captured well what the men who passed through that tunnel did every day. They made and shaped steel. In return, the mills gave them money to sustain themselves and their families.

I envisioned a fantastic, perilous world on the other side of that tunnel. At the time, my three brothers and I could see only the mills' exterior from Franklin Avenue, which ran through Aliquippa, Pennsylvania, about 30 miles northwest of Pittsburgh. We could see the mills from Ohio River Boulevard that runs parallel to the waterway, or from one of the bridges that span the river and the valley through which the Ohio River flows. At the time, Pittsburgh was the steel capital of the world. And Aliquippa was the home of the Jones & Laughlin Steel Corporation (J&L).

In a November 2015 series in the *Washington Post*, titled, "The Life and Slow Death of a former Pennsylvania Steel Town," photographer Pete Marovich recounts his youth in Aliquippa, and in the neighboring town of West Aliquippa where my mother lived and where she met my father. One picture in the *Post* series shows the tunnel through which the men of my clan passed on the way to work. The poster of the steel-bending laborer is nowhere to be seen. Instead, there is a statue of Jesus, perhaps placed there to watch over the souls of men who walk through that tunnel no more. The series is a eulogy of love and lament for the way things used to be. And for the things that might have been.

From our vantage point in our 1956 Plymouth, the mills were black monsters, dinosaurs lounging along both sides of the river, coughing smoke and flames. My memories of them, and of this period of life with my family, are mostly black and white, with shades of gray in between. Almost never in color. The river is wide and black, with white fringes along the shore where ice has formed, and silver where light glances off its surface. The river oozes through a wide valley with trees that look like victims of a nuclear blast. They are black and leafless, ashamed of their nudity on the steep hills that roll down to the water. Only a few patches of white snow cover their feet. We are on top of the river now, our Plymouth passing over a bridge that connects one steel town to another. As we slow down for traffic, I can feel the bridge's spine of black metal and concrete tremble under the rumbling of giant machines. Dump trucks carry equipment and raw materials into the mills and tractor trailers haul newly made steel beams out. I hold onto the seat. Above us the sky is a gray metal lid, the sun too weak to muscle its way through the winter firmament made even thicker by the soot that the mills belch into it every day and every night of every year. The monsters never sleep. The inside of our car is black and white. Us four sons. My father at the wheel and my mother in the front seat, my youngest brother, Robby, sitting between them. We are all the color of a photograph from a time long ago. My mother's imitation leather coat, which I know is the yellow of daisies, appears black

and white in this memory. Her earrings, a shiny stone mounted in a leaf of gold, are ashen.

"See that smokestack with the fire?" our father pointed as our car passed. A red and yellow flame, the only thing of color in this memory, licks the gray sky. "That building is where your father works."

WEST ALIQUIPPA, PA – The J&L steel plant, where my family members and I worked in West Aliquippa. (Photo courtesy of Beaver County Industrial Museum)

My mother may have turned her head away from the factory in bitterness and with a deep sense of foreboding. She may have stared at my father's dry, rough hands on the steering wheel. Both my parents saw the mills as a trade-off, a give and take: It was a place where men toiled away a quarter of their adult lives forging the steel to make America's bombs, buildings and automobiles. In return, their newly adopted country, for like my father most of the men were immigrants, gave them the means to defend their families, their families being the core of, and the sole reason for, their existence. Those mills provided the men their sustenance against the numbing rigors of mass production. My father accepted the exchange as reasonable and fair. But my

mother thought it grossly inequitable, the "give" always paling in comparison to the "take." What the mills extracted from these men as part of the deal. As I recall, my mother felt this way even *before* the mills had finished taking from our family.

The stories that I have salvaged from my own memory, from pictures and documents associated with my family and from interviews with various relatives, form much of the foundation of what I am today, and what I have written here. To use a term that my older brother first introduced to me as a young man, they have become part of my "permanent constitution."

Narratives like the ones included here help us define ourselves and how we fit in the world. They instruct us. They become part of our internal wiring. They form part of the very foundation and the filter through which we perceive and engage life and the world. I share them so that you, and I, can better understand ourselves. And I do so in the hope that they elucidate and help to inform those making critical decisions about their own lives. So here we go:

Immigrants

I am the proud grandson and son of Italian immigrants who came to the United States to forge lives for their sons and their daughters better than their own. My ancestors and relatives were willing and able to work hard and to play by the rules. Some were willing to fight and even die in defense of their newly adopted country and The American Dream.

It was mills like the one in Aliquippa that drew both my parents from Italy to this town in southwest Pennsylvania. They were born in the village of Bugnara, a four-hour drive east of Rome in the province of Abruzzi. Somehow in the hillside village of only 3,000 people, they managed not to know each other, probably because my mother was nine years younger than my father.

Founded in Medieval times, Bugnara was built on the folds of a hill to better defend itself from marauding bands of invaders. This

BUGNARA, Abruzzi, Italy – Located in the province of Abruzzi, the village of Bugnara is a four-hour drive east of Rome. My mother and father were born there.

meant that the townspeople, most of them small farmers, descended from their homes each morning to work their fields and then in the evening climbed back up to relative safety to spend the night. Both my maternal and paternal grandparents owned land there and my father knew that staying in Bugnara meant repeating the lifestyle of his ancestors. If you've ever been to Italy you can imagine that one can do a lot worse than to have the life of a small farmer. The Abruzzi region of Italy is especially beautiful and famous for its cheeses, wine and bread. When I visited Bugnara years later, I could appreciate the quaint little village but could also imagine how the mentality of the inhabitants could be as narrow as the streets and alleyways that zigzag through the place. I guess small towns are small towns, no matter where you go. When I visited Bugnara, its inhabitants numbered fewer than 900, most of them either very young or very old. According to those still in the village, an entire generation, my parents' generation, had departed, almost all of them to the United States.

Italy in the early part of the 20th century was stagnated and stumbling from one war to the next, while America's economy would absorb any number of immigrants who washed up on her shores. The lure of going to another land to make a new life must have been irresistible. It seemed like everyone was going to America. Most of my father's friends and relatives would eventually leave for what they considered the promised land. So, in 1937, Guerino Gentile (that was my father's real name and it was the name that I myself was given at birth) left the Old Country behind. He was 17.

"It Was a Palace"

My mother's story is a little more convoluted. Though she was born in Italy on October 1, 1929, she was actually conceived in the United States, her own father having come to this country in 1907, marrying here in 1916, but enlarging and then dragging parts of his family back and forth between Italy and the United States depending on the exigencies of war, the Depression and more war.

My mother's father was named David D'Eramo. I remember him only in faded black and white photographs that my mother kept. A big man. Very formal. Everybody called him Tada. In 1936 Tada rounded up his wife, (We called our grandmother Nana. Her real name was Felicia.) his third and fourth sons Tony and Ernest, respectively, and his daughters Mary (my mother) and Jessie, and shipped them to America. Tada's two oldest sons, Pat (Pasquale) and Vince, were born in the States, and though they had spent part of their youth in Italy, by this time probably were working at lucrative jobs in the steel mills.

My mother was seven years old then but still remembers the trip to America as an odyssey from the Old Country to the New, from one century to the next. On the three-week journey across the Atlantic, space was so limited that, "We had to sleep in bunkbeds cramped up against the ceiling." Her brother, Tony, broke his arm while horsing around on deck. From the ship her memory takes her to Ellis Island, past the Statue of Liberty to train stations in New York and then Pitts-

WEST ALIQUIPPA, PA – My mother said when she first came to America when she was seven years old. My grandfather had purchased this house on River Avenue in West Aliquippa, Pennsylvania. "It was a palace," mother said when she first saw it. "The biggest house I had ever seen."

burgh, and finally to the three-story house along the Ohio River in West Aliquippa. Tada had purchased the home at 520 River Avenue.

"It was a palace," my mother recalled decades later, "the biggest house I had ever seen. I remember standing there in the living room, staring at the chandeliers. I had never seen anything like it." The house had been purchased from a former mayor of the town. His last name was Hoffman. Doctor Miller lived two doors away. The Andersons, a retired couple, lived next door. My mother had moved from living among peasants to sharing the riverfront with professionals. Ah, America!

In one of my mother's photo albums there is a picture of a young family. Her father, Tada, is too big for his suit and his hands are too big for his body. Her mother, Nana, is heavy-set and sturdy. She married my grandfather when she was 15 years old. And the children look like, well, they look like the children of Italian immigrants.

Tada had become a foreman at the Jones & Laughlin Steel plant and a kind of "godfather" but not a Mafia don in the local Italian community, the vast majority of the community being deeply afraid of that criminal organization. Relatives remember him as standing six feet two inches and 260 pounds. Perhaps because of this imposing figure and his ferocious capacity for work, Tada rose quickly through the ranks of mostly immigrant laborers. He became a working foreman, still performing physical tasks but in charge of a team of men. As his friends and relatives in Bugnara learned of his success in America, one by one they wrote Tada asking about jobs and opportunities in the New Country, and one by one my grandfather sponsored them and got them work in the mills. My mother's father was a man of respect, something that he gave generously but demanded in generous return. And this ability to secure jobs ensured Tada all the respect he demanded. His manner was withdrawn. Never a show-off. Because his house was only two stone throws from the front gates of the steel mill, Tada lumbered off to work every day where he helped re-line the insides of vessels into which molten steel was poured, returning for a "lunch" of his homemade wine, then back again for the remainder of his shift. My mother remembers him coming home every evening covered with the white lime used in re-lining the vessels, looking "like a big snow man."

Twice each day my grandmother swept the concrete sidewalk connecting the family's new home to River Avenue. It was a task necessary to keep the thick, black soot spewed constantly by the mills from being tracked into the house. But Nana never complained about having to do it.

"As long as there is soot on the sidewalk, there is bread on the table," I remember her saying in her typical, Old World wisdom way of explaining things.

Tada was the keeper of Italian tradition in West Aliquippa. He purchased a life-size statue of St. Mogno, the patron saint of his village in Italy, and had it shipped to the United States so that each year the local Italian community would carry it through the streets of West

Aliquippa in processions honoring their holy patron. I remember walking with my family, years after Tada had passed, as the procession cruised the brick streets of the town. It was like a scene from the film, *Godfather II* but in real life.

"Our whole social life revolved around the church," my cousin Joanna would recall in an interview decades later. Joanna is the daughter of my grandmother's sister, my great Aunt Carmela. And mass on Sunday at the local St. Joseph's Church was compulsory (except for Tada and his sons, who were not churchgoers. Even at family weddings, the women would be inside the church, but the men stayed outside smoking cigarettes). Parishioners had the option of three separate masses: an Italian-language mass at 7:30 a.m., an English-language mass at 9 a.m., or a Polish-language mass at 10:30 a.m.

Aunt Carmela worked with a group of women to make covers for the altar at St. Joseph's Church. The adult women in the extended family were members of Christian Mothers, a group founded in 19th century France by women struggling against secular forces undermining family life and challenging Catholic Christian values. The young girls belonged to The Sodality, a Christian organization devoted to a variety of spiritual and corporal works of mercy and dedicated to the Blessed Mother. The young Sodality members wore blue veils to church doings.

"Everybody was involved in the church," Joanna told me. And the church could do no wrong. "They never questioned a thing," my cousin told me of her extended family. "The church was the church. Like the priests. They were like gods."

This devotion came with some unsettling components. Along with the strong faith imported from the Old Country came beliefs that there was real evil in the world and some people were equipped more than others to see it and to deal with it. My relatives recount stories that defy logic and reason. They firmly believe in that "other" world, the "evil eye," and in mysteries that we just don't understand. And some of my relatives had special access to that world.

Aunt Carmela was one of those persons. Both Nana and Carmela were stout, heavy-set women made so by shared genes, a lifetime of hard work, bearing children, and more hard work. Carmela also was the one we called the Queen of Pastries, one of the reasons that my brothers and I loved to visit her home. Her husband, my Uncle Guy, was a slender, silent man. Thick Italian accent. Slightly bent over from too many years working on the railroad that serviced the booming steel industry, a job procured for him by my grandfather, Tada.

WEST ALIQUIPPA, PA – Three sisters. My maternal grandmother, Nana, is on the far left. On the far right is my Aunt Carmela, on whom I relied for her otherworldly connections to ensure my safe return from war. In the middle is the third of three sisters, Sunta.

Aunt Carmela and Uncle Guy were big fans of the old *Studio Wrestling* program on local TV in Pittsburgh, broadcast in the 1960s and '70s. Their favorite wrestlers were Bruno Sammartino and "Jumping" Johnny De Fazio, both local heroes and champions of the World Wide Wrestling Federation (WWWF).

Precursors of today's Mixed Martial Arts (MMA) fighters, Sammartino and De Fazio were pitted against other wrestling stars like

Andre the Giant and Haystack Calhoun. Despite the fact that the wrestlers were good actors, everybody knew and understood that the fights were fake. Except Aunt Carmela and Uncle Guy. They didn't care. *Studio Wrestling* was broadcast on Saturday nights, and by Sunday morning, it was back to the Catholic church for Aunt Carmela and her sister, my grandmother Nana.

"She believed a lot in dreams and foretelling something," Joanna said of her mother. "She would see something and say, 'That's not a good sign.'"

Because my Aunt Carmela believed in "the evil eye," she had equipped her home to protect herself and her family from it. In her bedroom were statues of the Blessed Virgin Mother and of St. Anthony. A picture of St. Mogno hung from one of the bedroom walls.

Her family was protected. And family was everything.

"They believed that your family is with you all the time," Joanna told me. "That's what they believed. That your loved ones are still with you. Even after their death. I can feel my mother all the time. You can feel their spirit. I have her bread board and when I use it, it's like she's right there with me. The people who you have a close attachment to, they're always with you. You talk to them. When you're in trouble, you talk to them."

Despite the fact that as a young teenager I was an altar boy assisting priests during mass at our church, I never really understood or believed in the church doctrine. I never had the faith that my relatives relied upon in their struggle against evil. Nor did I understand then that one day I would call upon Aunt Carmela and her special abilities to safeguard me from that evil. I didn't know that she would wait for me. For my return.

The late 1930s and early 1940s were robust years for the country and for the families of my father and my mother. Everybody worked in the steel mills. My grandfather Tada, my father and my mother's four brothers all worked in the mills. And eventually, so did my three brothers and I.

Sundays were special in my mother's new home. Nana, like her sister Aunt Carmela, started each Sunday by going to mass. After mass, people started to file in, ostensibly to pay respects to my grandfather but also to mooch. These were mostly the recipients of Tada's goodwill, the ones who had followed him to America. Tada donned a crisp white shirt and spent the day eating and drinking with friends and relatives, perhaps reminiscing about the Old Country and discussing their lives in the New. Nana spent the day in the kitchen dishing out the pasta in shifts. My mother, on orders from Tada, was charged with running down to the wine cellar to dip into the 13 barrels of wine he made each year. When the wine began to take its toll, Tada slipped quietly away and into bed. My mother says she never saw her father drunk. My mother's four brothers dipped into the wine as well, there always being an open bottle on the table. My mother loved her parents but feared her four brothers who saw her as their private property, something to be protected against the badness of the outside world. Her brothers, my uncles, would threaten boys who dared even to speak with my mother or her sister Jessie. In this sense, my uncles still lived in the Old Country, where women were second-class citizens with few rights. Still, my mother's childhood was not an unhappy one.

My Uncle Vince is my mother's second oldest brother. He had become the operator of the heavy cranes used to pour molten steel from the giant ladles into huge billets, or rectangular blocks, that would later become beams. It was one of the best, and best-paying jobs, of all the mills.

Vince was a stout, solid man with a memory so sharp that even in his 80s and early 90s he could recall minute details of events that occurred half a century before, dating them to the week in which they occurred. The muscles on his forearms, built by decades of manual labor, moved like thick cables under his olive skin. His voice was raspy and nasal. His eyes were steady and black, made even more penetrating when he leaned toward me during conversation, sticking a finger into my shoulder or arm to emphasize a point, something he did with unnerving frequency. He had piercing intellect and was a great con-

versationalist. His intelligence and sense of humor made him the center of attention wherever he went. I called him (out of earshot) "The Tasmanian Devil" because of his limitless energy and mischievous nature. He was a product of his time and his environment. He sometimes ate dinner wearing a baseball cap. He was impossible not to like.

My Uncle Vince claimed that his family's last name, D'Eramo, is evidence that his clan is a descendant of Remus, twin brother of Romulus (D'Eramo = Of Remus). In Roman mythology, Romulus and Remus are abandoned by their parents but rescued and suckled by a she-wolf. They later founded the city of Rome and the Roman Empire. The killing of Remus by his brother, and other tales from their story, have inspired artists for centuries.

Uncle Vince mastered the trades of plumbing and electricity, and contracted work as a home remodeler. He played the piano and the clarinet. He was competitive. His high school band included the famous composer Henry Mancini, who would go on to write the theme song for *The Pink Panther* as well as *Moon River*, about the Ohio River that flowed just across the street in front of Tada's house, where my uncle lived.

"I got better grades than Mancini did in every class except music," my uncle told me. Indeed, Mancini would "cross that river in style one day," as the musician wrote in one of his most famous songs.

Uncle Vince became the musician of the extended family.

"Every Sunday I played the piano and everybody would sing," Uncle Vince told me. "The whole family, my father, everybody," including those who "came to pay homage and to freeload at the same time. It was a happy home."

Uncle Vince's eldest son, my cousin Dave D'Eramo, remembers riding Tada's shoulders as our grandfather toured their happy, riverfront home.

"He's Gonna Die"

Vince's chorus dwindled in size and in volume with the advent of World War II, as no amount of Nana's prayers could keep the U.S. government from taking her sons away. First was Pat, the oldest, still single, drafted into the army. A big, burly man, Pat (Pasquale was his real name) had a voice that sounded more like a growl. Vince was deferred because he was married and had children. My mother's brother, Tony, was drafted when he turned 18. My mother said Tony was a brooding, moody kind of guy who turned mean when he drank too much of his father's homemade wine. And he drank a lot. My mother said she was afraid of him. Ernest enlisted in the navy. Ernie was the youngest of the sons and the most relaxed, perhaps because he was so handsome that life was easier for him than it was for the others.

LOCATION UNKNOWN – Anthony D'Eramo, my Uncle Tony, was one of my mother's four brothers. He was drafted into the U.S. Army during World War II.

My mother watched as her brothers went off to fight a war against the Axis Powers which, of course, temporarily included Italy under the rule of Benito Mussolini. My father, a friend of my mother's family but who still had not met my mom, was drafted and shipped off to the army.

My cousin Joanna looked out a rear window of the grand house that Tada had purchased. She watched my Uncle Tony walk through the wooden gate on his way to war. Joanna's younger brother, at the time just seven years old, sat on her knee, also watching Tony.

"He's gonna die," the boy said.

As summer cooled into fall of

1944, a young man in uniform stepped up and onto the wooden porch of the house at 520 River Avenue. He held an envelope in a hand extended to the heavy-set Italian woman staring at him through the screen door, trembling, eyes wide with terror and heart cracking with dread. My grandmother must have found the envelope so ominous that not even the saints and the Blessed Virgin Mother to whom she prayed every day could lighten its load. It was in that envelope that she would learn of a beach in France called Normandy.

In everyone's life there are events that sear the memory so deeply that one can remember the most minute details surrounding them even decades after they occur. For my generation, that event was the day President John F. Kennedy was assassinated. For more contemporary generations, it might be the day of the 9/11 terror attacks. For my mother, it was the day that telegram arrived and her family learned that her brother Tony had been killed in the war.

Only 12 years old then, my mother remembers her home "was chaos. Just complete chaos. My mother was wild with pain. Wild. She could hardly take it." The news roared like a locomotive through the extended network of family and friends.

According to a conversation I had with my Uncle Vince half a century after Tony was killed, a relative telephoned him to say his brother had been "wounded." Running up to the porch, Vince said he heard my grandmother "screaming like the devil" and when he stepped inside, "Nana had blood all over her face. She scratched her face all up. I knew Tony was dead right then and there," Vince told me. Tada was summoned from the mill, his normally lumbering step quickened now because there was news about his son, and when told what happened he "cried like the dickens too. I never seen my father cry except that time," my Uncle Vince recalled. "It broke him."

"The whole house was upside down," Vince said. "Tony's death changed everything."

Two weeks after having received the news, my grandmother walked as if in a trance from her bedroom on the second floor down to the kitchen to make breakfast. "They shot Tony in the head," she

announced. "I dreamt it last night." Not long after her dream, a letter arrived from one of Tony's army buddies who was with my uncle when he was killed. The letter said a German prisoner had pulled a pistol from his clothing and shot my uncle in the head.

For my mother's family, the death of her brother was a double trauma.

"First we heard that he had died and everybody was at the house and we had to go through this with all the friends and relatives and everything, and then they brought the body back and it was another time," my mother told me. "It was twice."

A year after Tony was killed, his body finally arrived home. My grandfather, a man so reserved that many considered him downright shy, asked angrily, out loud and to no one in particular, what kind of country is this where the government takes a year to bring home a man's son who's been killed in a war defending it?

Tony's death cast a pall over my mother's once-happy home. My mother said it was as if the house had somehow been filled with water, from the basement to the rooftop, and everybody inside it moved around in slow motion, in silence, barely able to breathe.

"If I would play the piano, Nana would say, 'Please. No. No more,'" Vince recalled. "It was the sorrow. This lasted a couple of years. Until the war was over and Pat was home and all that."

"All that" was like the aftermath of a hurricane, when survivors return to their natural station after having been hurled afar or forced to take refuge deep underground. They come back numb, changed, even the animals, humbled, knowing, with ghosts in their eyes, altered forever by what they'd seen, and perhaps by how they themselves behaved while seeing it. In one way or another all of them had been changed, never to return to their former selves because, if for no other reason, they had been part of the most monumental event of their century.

My mother remembers "all that": Her oldest brother Pat, the tank commander with a barrel chest so huge that he barely fit through the hatches of his fighting machines. Like his brother Tony, Pat participat-

ed in the invasion of Normandy. He had landed on Omaha Beach on D-Day, a place and a time where the life expectancy of an American soldier was measured not in hours or minutes but in seconds. He was awarded four Bronze Stars for bravery.

Eventually, a brass plaque was placed on the front wall of the West Aliquippa Panther Club listing Anthony D'Eramo, my Uncle Tony, as one of the town's sons cut down in the war. He was posthumously awarded the Silver Star Medal, the United States Armed Forces' third-highest personal decoration for valor in combat. My mom remembers Ernest, the sailor who bore an uncanny resemblance to Ernest Hemingway, coming down the street in Navy whites with a duffel bag over his shoulder.

"He looked like a movie star," she recalled.

"All that" included the return of my own father. He had been a sergeant and relatively unscarred by the war perhaps because he had participated in little or no fighting but having witnessed the Battle of the Bulge.

My mother recalls the first time she saw him. He was on leave from his unit.

"He was still in his uniform," she recalled nearly five decades later. "I was on the sun porch ironing clothes and he was visiting relatives and friends. He came into the house with his brother, Paul, and walked past me. He just said, 'Hello' and I said, 'Hello', and I was very shy and I kept ironing clothes and they went outside to talk to my dad in the garden. He had a nice smile."

I look at the pictures of my father today and I can see that he really was a handsome man. He had wavy, light-brown hair and a thin mustache worn by the famous actor, Clark Gable. (Actually the actor Clark Gable had belonged to an Army unit that my father also had served in. I don't know who copied whose mustache, but the fact is the mustaches were similar.) My father had been stationed in Miami Beach during what appears to be most of 1942 and from the pictures of him and his army buddies, I can see that my dad was well built, with strong shoulders and thick arms. Also, from the pictures and from

what everybody who ever knew him tells me, he had a nice tempera-ment. "Easy-going" is how his contemporaries describe him.

After that initial encounter with my mom on the porch, my father returned to his base. About a year later he was discharged and came home to West Aliquippa and like everybody else went to work in the steel mills.

Though my parents had not known each other in the Old Coun-try, their families knew each other quite well. In fact, my mother's brother Vince and my father were childhood friends back in Bugnara. And since in America Tada's house had become the point of reunion for people from Bugnara, my father would stop over for the occasion-al visit, where it seems he was sniffing around for my mother as well.

At the time my mother was still in high school, and one day after class she got onto a bus to return home and it was there that my father ambushed her.

"He was standing right beside me and he said, 'Let me hold your schoolbooks' and I said, 'No, I can hold my own schoolbooks.' I was always afraid." Before the bus arrived at its destination my father came out with it: "He asked me right out, 'I'd like to go steady with you,' and I said 'What?' and he said, 'I'd like to go steady with you.'"

The Wedding

They married less than a year later, in the Knights of Columbus hall in West Aliquippa. My parents' marriage was the first happy event in her family since the beginning of the war. It lifted the cloud that had gathered over the riverfront house brought on by Tony's death.

Tada was "ecstatic," my mother told me. "He loved your father." Nana was disappointed that my mother would have to leave high school, but she, too, was happy to see her daughter marry my dad.

"It was a beautiful wedding," my mother told me.

SAN JUAN DEL RIO COCO, Nicaragua – Mural of Augusto César Sandino, from whom Sandinistas take their name. Sandino led the struggle against U.S. Marines occupying the country during the 1920s and 30s. This image is taken from my book of photographs, Nicaragua.

CHAPTER 4.

"TERRIBLE AND GLORIOUS DAYS"

The Somozas and Sandino

It was 1979 and I was a freelance journalist on a trip through Central America to see first-hand the stories from El Salvador and Nicaragua that I had been editing on the desk of United Press International (UPI) at my base in Mexico City. It was on this trip that I would finally meet *Don* Leonardo Lacayo Ocampo, our local stringer in Managua, whose dispatches I had been translating and editing over the previous year before sending his work to UPI headquarters in New York. Before being transmitted to clients around the world, those stories were edited again by journalists on UPI's Foreign Desk. I also freelanced for ABC Radio News, the *Baltimore Sun*, and the *Kansas City Star*. At the time, I was more a print guy than a photo guy.

I landed in Managua only days before the Frente Sandinista de Liberación Nacional (FSLN), or Sandinista National Liberation Front, declared its "final offensive" against the U.S.-backed rule of President Anastasio Somoza Debayle, who had inherited the regime from his father in 1957.

Nicaragua was a victim of its own geography. Its position on the Central American isthmus, with its huge Lake Nicaragua, made it an ideal spot for a canal connecting the Atlantic and Pacific Oceans. Even after the Panama Canal was completed in 1914, Nicaragua was considered an alternative site for a wider, more efficient waterway – an endless source of income and influence bestowed upon its owners by the international shipping industry. In recent years, China has expressed interest in building a trans-oceanic canal to accommodate super vessels too large for the Panama waterway.

The United States' role in Nicaragua is not one that Americans can be proud of. U.S. Marines invaded and occupied the country on numerous occasions and for various periods of time beginning in 1909, to protect American business interests there. The first Somoza, Anastasio Somoza García, known as "Tacho," was installed as the head of the Nicaraguan National Guard, set up by the U.S. as a supposedly non-partisan constabulary. It wasn't "non-partisan" for long. Tacho seized all power in 1937 and protected that power with brute force. In his groundbreaking book, *Guardians of the Dynasty,* Richard Millet describes how the National Guard became the private army of the Somoza dictatorship.

In return for its role as staunch U.S. ally and anti-communist bulwark in Central America, the United States supported the Somoza dynasty for four decades. (In 1939, Franklin Roosevelt is supposed to have said of Tacho, "He's a son of a bitch, but he's our son of a bitch.") This despite the regime's consistent record of grotesque human rights violations. Indeed, the Somozas sided with the United States during World War II, declaring war against Germany and using the alleged Nazi threat in Nicaragua as an excuse to confiscate land owned by German nationals. After the conflict and with the onset of the Cold War in the late 1940s, the Somozas vowed to be the bastion of anti-communism in Central America. They allowed the CIA to train Guatemalan rightists on Nicaraguan territory for the 1954 overthrow of Guatemala's popularly elected President Jacobo Árbenz Guzmán. And it was from Nicaragua that U.S.-backed Cubans launched their failed

April 1961 Bay of Pigs invasion against Fidel Castro's regime. As the United States sunk deep into the quagmire of Vietnam, the Somozas volunteered to send troops to fight alongside American forces.

In 1956 Somoza García was assassinated by a young Nicaraguan poet. Somoza García's son, Anastasio "Tachito" Somoza Debayle, would take the reins of the dynasty. Popular opposition to the dictatorship only grew.

The Sandinistas take their name from Augusto César Sandino, the illegitimate son of a local landowner and a young Native American girl. In a research paper that I would write to complete a master's degree at Ohio University, I reported that Sandino's "mostly uneventful life changed in 1920 when, after wounding a man in a fight, he fled to Mexico. There he worked in oilfields around Tampico, became a Freemason, and was impressed by the recent Mexican Revolution and its respect and glorification of the Indian heritage."

He returned to Nicaragua in 1926 and a year later led a guerrilla war against the U.S. Marines occupying the country. The Somoza regime referred to the Sandinista rebels as mere "bandits."

In that master's degree research paper, I noted, "Some of the parallels between the original Sandinista movement and its modern offspring are striking. Both enjoyed substantial support from liberal sectors in the United States. Both lobbied in the United States against 'Yankee intervention.' Both were accused by American policymakers of being communist-inspired, terrorist and criminal movements. Both tried to enlist the American media in their struggle."

I cited a March 28, 1928 interview of Sandino by Carlton Beals, the first American journalist ever to visit the rebel leader's hideout in northern Nicaragua. In that interview, Sandino would respond to U.S. government charges that his organization consisted of common bandits, void of political significance. Sandino's words would resonate a half-century later:

> We are no more bandits than was (George) Washington. If the American public had not become calloused

to justice and to the elemental rights of mankind, it would not so easily forget its own past when a handful of ragged soldiers marched through the snow leaving blood tracks behind them to win liberty and independence. If their conscience had not become dulled by the scramble for wealth, Americans would not so easily forget the lesson that sooner or later, every nation, however weak, achieves freedom and that every abuse of power hastens the destruction of the one who wields it.

Sandino agreed to make peace in 1934. It was the first guerrilla war that U.S. forces had ever fought. Shortly after the peace agreement, Sandino was murdered, with U.S. complicity, by Tacho's National Guard.

Over the years, opposition in Nicaragua survived the Somoza dictatorship's political maneuvering, middle class apathy and, when necessary, ferocious military repression. Then in 1961 a handful of dissidents, convinced that peaceful opposition to the regime was fruitless, took up the banner of *Sandinismo* and founded the Sandinista National Liberation Front to topple the dynasty through armed struggle.

By the time I first arrived in Managua in 1979, the Somozas were reported to either own or control "tobacco, sugar, coffee and rice plantations; dairy, meatpacking, salt, fishing, refining and distilling industries; cooking oil, cement, construction materials, textiles and packaging industries; the local Mercedes Benz distributor, a newspaper, radio stations and the nation's one television station; banking and insurance outfits, savings and loan companies as well as construction and industrial finance," according to a report by the prestigious North American Congress on Latin America (NACLA). The Somoza empire was calculated to be worth somewhere between $400 million and $500 million. (In today's dollars that means between $1.4 billion and almost $1.8 billion.)

And the regime protected its riches with the support of its National Guard and the United States, which helped train the Nicaraguan military.

The Masaya Volcano rises from dark, volcanic ash and scrub brush off a main highway about 12 miles southeast of Managua. The crown jewel of Nicaragua's first and largest national parks, the volcano's molten bowel glows orange and red from a deep and active crater, spewing sulfur dioxide gas up past the rim and into the open air. It is said that during the dark and closing days of the Somoza regime, members of the National Guard would take political prisoners in helicopters and dump them – still alive – into the volcano's mouth.

A popular insurgency against Somoza family rule had been festering for years and I got there only days before the Sandinistas declared a "Final Offensive" in the spring of 1979 and the whole place caught fire. There still is debate as to whether the FSLN incited the insurrection or just managed to place itself in front of it when it happened. Regardless of that debate, for six weeks Nicaragua suffered a violent, national convulsion that left some 30,000 of her citizens, in a country of only about 2.5 million inhabitants at the time, dead.

Los Contras

Some of those men from the Somoza dynasty's National Guard fleeing the Sandinista fighters in July 1979 found their way to the neighboring country of Honduras and into the welcoming arms of U.S. supporters. When President Ronald Reagan took office in 1981, and William Casey took over the Central Intelligence Agency, the search began for ways to assist the defeated "Guardians of the Dynasty" and anybody else who would fight to overthrow the Sandinistas.

Using secret (and illegal) funds to support the effort, the U.S. government financed and directed the war against the Sandinista government even after Congress tried to stop it. Washington's new allies would come to be known as "contras," as in "*contrarrevolucionarios*" or counterrevolutionaries, declaring the new organization's stand

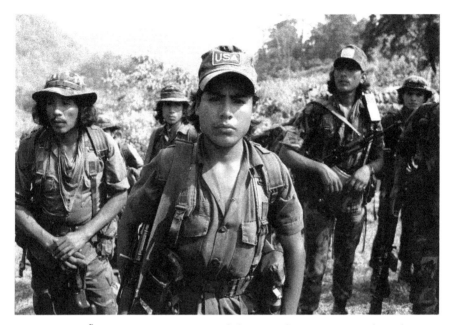

LA MONTAÑA, Nicaragua – Contra fighters in the mountains of northern Nicaragua. This image appears in my book of photographs, Nicaragua.

against Sandinista rule and outlining the scope of its purpose and singular reason for being.

The Contra War bore little resemblance to the 1979 revolution. Unlike the 1979 popular uprising that swept through small towns and large cities across Nicaragua, the Contra War unfolded almost exclusively in the country's northern mountains bordering Honduras with minor incursions from Costa Rica led by Sandinista defectors. Fighting never really came to the capital, which posed special challenges for people like me who wanted to cover the conflict. To do so, I had three options: (1) Insert myself into units of the Sandinista People's Army fighting in the northern mountains; (2) Embed with contra fighters infiltrating Nicaragua from bases in Honduras; (3) Respond to reports of fighting or other conflict-related activity that too often became public days after the event had occurred.

To really cover the conflict, I had to spend inordinate amounts of time roaming the mountains with one or the other of the armed

groups, sometimes for weeks, before seeing any real action. And "real action" means the ugly reality of men killing and being killed with high-powered weapons capable of tearing through human flesh and bone with ferocious, stunning, horrifying efficiency.

I was based in Managua from 1983 through 1990, so I spent most of my time on unpaved mountain roads searching in northern Nicaragua for stories and images in my 1969 International Harvester Scout (I called it *La Bestia*, or The Beast) and tramping through hills and valleys with Sandinista troops. (*La Bestia* is pronounced Lah BEST-ee-yah). Most journalists didn't have the luxury of time, the physical and mental stamina, or the will to spend long days or weeks in the mountains, risking death and permanent disfigurement, drinking untreated river and stream water, eating cold rice and beans or the occasional cow or monkey that the young Sandinista soldiers or contra rebels hacked up for meat, and relieving themselves in awkward, semi-public circumstances.

There were very few pitched battles between the two armed groups. Instead, the war played out in a series of ambushes or surprise attacks preceded by long stretches of slogging through tropical highlands through ankle-deep mud wearing the same wet, filthy, stinking clothes and humping backpacks stuffed with everything I could carry inside plastic bags to protect my precious camera gear and film from the elements. I walked for days under a burning sun or a tropical downpour in the middle of the jungle and in an instant, fights erupted and men began to bleed. Then I slogged again, sometimes documenting young Sandinista soldiers or contras hauling their wounded and their dead.

The Contra War resembled the Vietnam War more than it did the Sandinista-led revolution of 1979. And it was on those long journeys in Nicaragua's tropical highlands that I would begin to implement some of the lessons of Guy Gugliotta, the Swift Boat commander turned newspaper man, for surviving guerrilla warfare.

Perhaps as importantly, I drew deeply from the examples and the standards set by the men and the women who informed my "perma-

nent constitution." Those who labored in the steel mills, who made things with their hands, who coaxed food from the land, took care of their families. Those who went off to fight for their country in times of war, the men and women who stood their ground and never backed down, and who waited for their loved ones to return.

When embedded with the Sandinistas, the best place to position myself was at the tail end of the *exploradores* (explorers or scouts), a handful of men trained to lead a column of soldiers in single file through the mountains without stumbling into an ambush and untimely demise. If an encounter did take place, the explorers ordered the men to fan out to the flanks and counterattack. Placing myself at the end of the scouts gave me the chance to make pictures of men actually firing at the enemy, without exposing myself to the extreme risk of being at the front of the column to be taken out like a duck in a shooting gallery. Positioning myself too far to the rear of the single-file line could make it impossible to capture powerful images.

Covering the war from the contra standpoint was a bit trickier because, unless I accidentally ran into them or was stopped by them at a checkpoint in the northern mountains, I had to go to Honduras where they were based and get permission from the U.S. Embassy to enter those bases along the southern border with Nicaragua. Why? Because it was the U.S. Embassy that was directing and supplying the anti-Sandinista operation. With embassy permission, I could enter the contra training camps along the border and, if I wanted to, head south into Nicaragua with the contras on what could be a grueling and perilous incursion into the war zone. And that could take weeks.

La Montaña

The mountains of northern Nicaragua enjoy a mystique all their own. Nicaraguans refer to them not in the plural, "the mountains," but in the singular, "*La Montaña*," or "The Mountain," as if the rugged backbone of the country were a single entity, one special realm apart from, but still within, Nicaragua.

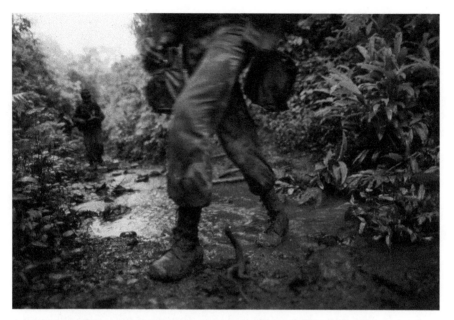

LA MONTAÑA, Nicaragua – Sandinista soldiers trudge through muddy trails while on patrol in the merciless mountains of Nicaragua.

Prior to the Sandinista takeover, *La Montaña* was a place where Somoza's hated National Guard conducted some of its most heartless repression against peasants who collaborated with, or who were suspected of collaborating with, the Sandinista guerrillas. It was a dark place of persecution, torture and solitary death.

Despite the hardship and danger, *La Montaña* occupies a special niche in Sandinista lore, the legendary tales of any guerrilla group being part of the heart and soul of that movement and the reason why men and women risked torture and death for that movement. It was to *La Montaña* that the Sandinista Front sent its guerrillas for physical, psychological and political training. It was in the merciless *Montaña* that the Sandinista cadres endured a sun that causes blisters on foreheads and noses; cold, damp nights that shake the body 'till dawn; hunger that disorients and actually hurts; solitude that makes men talk to themselves; and fear that steals their breath away. In *La Montaña* lurk typhoid, malaria, hepatitis, anthrax and "mountain lep-

rosy," a parasite that embeds itself in human flesh and eats away at it in concentric circles leaving pain and ugly scar tissue.

At night *La Montaña* comes alive with sounds that spooked the hell out of me. Howler monkeys do exactly that. They howl, or roar, with voices both lamenting and intimidating that ricochet for miles through dense rain forest. I woke up in my hammock one night while on patrol with the Sandinistas, startled by the chorus of animals talking to each other. They were sounds I hadn't heard since my university days, when fraternity brothers and I listened to the 1969 Pink Floyd song, "Several Species Of Small Furry Animals Gathered Together In A Cave And Grooving With A Pict."

The low-lying plains at the base of *La Montaña* is cattle country and home to nasty, inches-long pests, worms really, that Nicaraguans call, *tórsalos*. They normally thrive under the skin of free-ranging cows but sometimes take up residence in humans. One of my colleagues had to have them removed by a physician who sliced open his skin to dig them out. I contracted a case of anthrax while working in the same region.

Perhaps it was Omar Cabezas, a popular Sandinista combatant and hero of the 1979 revolution, who best captured and defined the mystique of *La Montaña* in his book, *Fire from the Mountain*. For Cabezas, *La Montaña* was an anvil upon which one tested, forged and molded oneself into a true revolutionary.

"When I left for the mountain," Cabezas writes, "I left with the idea that the mountain was a tremendous power." His comrades "always talked about the mountain as a sort of mythical force. It was where our power was, and our arms and our best men; it was our indestructibility, our guarantee of a future, the ballast that would keep us from going under in the dictatorship; it was our determination to fight to the end, the certainty that life must change, that Somoza must not go on polluting every aspect of existence. The mountain was our refusal to believe that the (National) Guard was invincible."

If an aspiring revolutionary made it through *La Montaña*, he or she earned a place in the tiny group of cadres leading the rebellion against the Somoza dictatorship.

(For the record and in the spirit of full disclosure, Omar Cabezas initially collaborated with me on my book of photographs, *Nicaragua*. During a series of recorded discussions, I interviewed him for what I hoped would be the epilogue of that book. However, at an early stage of that collaboration, Omar told me that the *Frente* had imposed restrictions on him and that any earnings from the book would have to be shared with the Sandinista government. I pulled out of the arrangement and worked instead with then Vice President Sergio Ramirez Mercado for a series of interviews that would constitute the epilogue.)

For me, *La Montaña* was a place of purification. It was a place where I sought refuge from pack journalism, from staged press conferences, from the constant stress of chasing the latest picture for any given story, from the painful distance from my family in the United States, from the lure of time and energy wasted at Managua social gatherings pounding down *Flor de Caña* rum. I longed for, and then basked in, the purity, the discipline and the rush of the anvil.

Like many of the journalists working in Nicaragua at that time, I felt that our work was more a "humanitarian mission" than a "job." We gave voice to the poor working class, the peasants, the laborers, whose voices would never be heard in their own country, and certainly not beyond the borders of their country, had it not been for us, the international media. With passion and empathy, we told their stories and revealed to the world their misery, in the hope that outside forces could help change their lives for the better.

You will find journalists today who scoff at this notion that our craft is something more than just a job. They will tell you that those who practice it with altruistic passion, even reverence, are soft-hearted idealists whose judgement may be skewed by emotion and therefore are not to be trusted. Don't believe them. Journalism is more than a craft. It is a calling. It is a manner in which one engages life. This is what I believe. This is what I practice. This is what I teach.

It was a different time then—before our society was infected by pathological liars and sycophants, before Fox News poisoned the media landscape with "alternative facts," and before 40 percent of the

mostly white, starry-eyed and stupefied American public relinquished all capacity of critical thinking and swallowed the Kool Aid of "fake news" and "enemies of the people."

I had the extraordinary privilege of having practiced the craft of journalism when the international media were largely regarded as independent observers and unbiased professionals seeking truth in some of the darkest and most complicated corners of the world. We were respected. When I applied, as a representative of United Press International or *Newsweek* magazine, for an interview or permission to accompany troops in the field, the recipients of that application understood they were playing with a member of the Major Leagues. They took me seriously.

Even the most uneducated or unsophisticated peasants and workers took us seriously. They wanted us to tell their stories. They understood that the media in their own countries were largely controlled by the same powerbrokers who had overseen and were responsible for the mess that we, the international media, were there to expose. We came from countries that were regarded as functioning democracies where Truth and Right mattered. We believe in facts, verifiable truths and science. We value critical thinking and basic, common sense.

When I entered a restaurant or a city plaza with professional cameras worth more than most people earned in a year hanging from my neck, people took notice.

We were even feared. On a highway in Honduras, I was pulled over by a policeman who tried to squeeze me for money because I did not have reflectors used by motorists on the shoulder of a highway while fixing a flat tire or cooling an overheated radiator.

"Is this how the police in Honduras treat international journalists?" I asked the cop as I brandished my *Newsweek* identification card. He let me go.

We were regarded with suspicion by protagonists on both sides of the political spectrum. For example, the Sandinistas saw us as possible undercover CIA agents while the contras suspected we might be communist sympathizers. But each side knew they had to play ball with

us because we controlled, to a great degree, how the world perceived them. We controlled how they would appear to their benefactors in the U.S. Congress and administration – upon which they depended for their survival.

We were sought after.

At a demonstration in San Salvador, an attractive young woman walked up to me and pushed a piece of paper into the pocket of my photojournalist vest, then walked away. On the paper she had written her name, her telephone number and this request: "*Llámame.*" (Call me.)

Covering the war with either side presented me with a powerful moral quandary. I want it to be over. I want to be there only long enough to get decent pictures of the drudgery of patrolling through the mountains, but I also need pictures of war. Shooting. Fighting. Dead and wounded. Once I get that, I can return to my base of operations where I will find safety, decent food, a real bed and, fortunate as I was, the love and support of a family like Claudia's.

So, I want to document fighting. But I don't want any of the people in my group (or the opposing group, for that matter) to get hurt. I want to make pictures of dead and wounded. But I don't. I want to capture powerful images like the ones I saw growing up in *Life* magazine during the war in Vietnam. But I don't. I want to show the suffering that U.S. foreign policy is inflicting upon this poor, underdeveloped country. I must. I will. I did.

The Contra War was a series of sporadic encounters, some of them completely by accident, brief explosions of adrenaline, gunfire, then injury or death. It was a war of attrition, not territory. And because everybody was Nicaraguan and therefore looked pretty much the same, it got very confusing. To make it even more confusing, Sandinistas and contras often wore similar uniforms. They were American-made uniforms provided to the contras and taken from the contras by Sandinistas either following combat or after the Sandinistas intercepted cargo drops over Nicaraguan territory.

To be clear, the weaponry and firepower unleashed during the conflicts in Central America during the 1980s in no way measure up to the industrial level killing machinery and ferocity of Vietnam. But the wars in Central America were deadly nonetheless.

"Quiénes son?"

I'm on patrol with the Simón Bolívar Battalion when one of the explorers, or scouts, walks along a trail to the top of a hill and sees an armed man dressed in military garb walking toward him from the opposite side of the hill.

"*Quiénes son?*" (Who are you?) the Sandinista explorer asks.

"*Quiénes son USTEDES?*" (Who are YOU all?) the other fighter responds.

"Batallón Simón Bolívar," the Sandinista soldier says, citing the name of his elite unit.

And the killing begins.

Simón Bolívar, Lt. Talavera, *El Cuervo*

I was waiting in the small northern town of Waslala for eight days with members of the Simón Bolívar Battalion, the elite counter-insurgency unit of the Sandinista People's Army, for what would be the largest offensive to date by Nicaragua's special forces. It was August 1984.

I was back again with Lt. Francisco Noel Talavera, the 19-year-old who oversaw the drama of the two wounded contras taken out by his soldiers. *Miami Herald* Photographer Murry Sill was along for the trip and Talavera didn't seem to mind two gringos hanging around to make pictures of his guys waging war.

Talavera told us this could be a great trip depending on how much "bang bang" we saw and, knowing that he would give us total access to do our job, Sill and I decided to ride this thing out to the very end, no matter how long it took us.

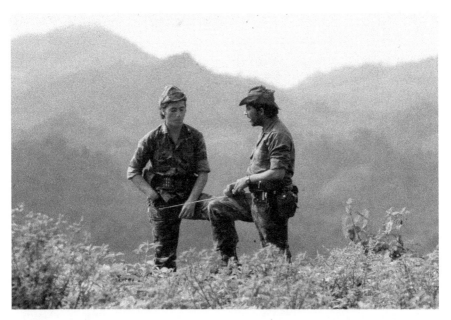

LA MONTAÑA, Nicaragua – Sandinista army Lt. Francisco Noel Talavera (on left) and Augusto César Pineda (El Cuervo) discuss strategy while on patrol.

The Simón Bolívar Battalion was the oldest of Nicaragua's special forces battalions. When formed in 1982, it was called the "Choir of Angels," after the group of children who accompanied Sandino in his guerrilla war against U.S. Marines occupying Nicaragua during the 1920s and '30s. Legend has it that the children were mostly orphans of the war, and their primary function was not to fight but to accompany Sandino's forces in combat and by shouting or using mechanical noisemakers to make the American enemy believe that Sandino's forces were more numerous than they actually were.

As the Reagan administration's secret Iran-Contra funding of the war against Nicaragua gathered momentum, the Simón Bolívar Battalion was expanded from about 500 men to about 1,300 soldiers in 1984. And the Simón Bolívar Battalion, named after the famed South American Liberator, was the elite of the elite.

Sill and I were hanging around waiting for this thing to happen. There wasn't a hell of a lot to do in Waslala, which was less a town than

just a bunch of houses lined up on both sides of a muddy mountain road. It was a scene from a cowboy movie set in the 1800s, complete with some raggedy-ass horses but also with young men dressed in camouflage uniforms carrying lots of guns. There were some stores and what they call "restaurants" with broken-down tables and chairs arranged haphazard on uneven wooden floors but that's it. What I did in places like this was try to establish some kind of trust with the soldiers whom I'm to accompany in the field, pick up some shots of the guys before they go out, let them get used to the cameras, keep my clothes and equipment clean and dry, not get sick on the local cuisine and not run out of cigarettes and granola bars that are part of the reason why a lot of these guys put up with me in the first place.

So we're just lounging around outside a building where Talavera and some of the other commanders are talking strategy when this dark-skinned guy with a bit of a pot belly and straight but unkempt jet-black hair rolls up to us and demands, *"Quiénes son ustedes?"* (Who are you?), and the first thing that runs through my mind is this guy has some authority plus attitude regarding Americans (with good reason) and is going to 86 both of us from the entire operation and say, "Go back to Managua you don't have proper authorization to be here."

So I responded with, *"Quién es USTED?"* (Who are YOU?) and he says, *"Contra-inteligencia Militar."* (Military Counter-Intelligence.)

Oh.

Sill and I whip out our IDs and while this guy is looking them over, I'm trying to be as nonchalant as possible, so I start trimming my fingernails with the scissors on my Swiss Army Knife. This guy looks over the top of the documents and sees what I'm doing and yells, "NO!" He goes on to tell me that if we're going into *La Montaña* with the troops, we'll need everything we have in order to deal with the place. Yes, even our fingernails.

Turns out the guy's name is Augusto César Pineda, but everybody calls him *"El Cuervo,"* or *Cuervo* for short, which is Spanish for "crow." Soldiers often give each other *noms de guerre* and they called this guy *Cuervo* because of his wild "caw, caw, caw" kind of laugh that resembled the high-pitch call of the bird of the same name.

Cuervo and I were so suspicious of each other in the beginning that I'm surprised we ever got to be friends. But we did. Big time. *Cuervo* would visit the home where Claudia and I lived whenever he came to Managua. Claudia and I got to know his wife, Aleyda.

It is curious to note that *Cuervo's* first two names, Augusto César, are the same as those of the Nicaraguan hero after whom the Sandinistas named their movement. Augusto César Sandino. I do not know whether *Cuervo's* parents gave him this name in honor of the man who led the struggle against U.S. Marines occupying the country, or if it's a coincidence. After all, the name Augusto César is somewhat common in Nicaragua. Having said that, *El Cuervo* was born and raised in the mountain city of Jinotega, located in the heart of the region where his guerrilla fighter namesake prosecuted his struggle against the Marines.

Talavera finally got orders to move his men into *La Montaña*, which lived up to every bit of its reputation as merciless. I moved in with the Simón Bolívar's 1st, 3rd and 6th Companies, a total of about

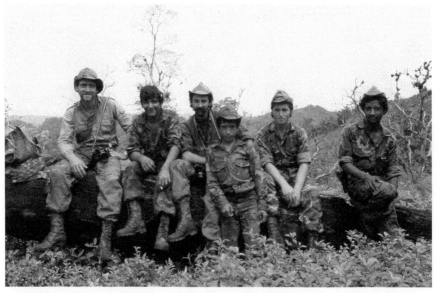

LA MONTAÑA, Nicaragua – From left to right, Bill Gentile, Sandinista army officer, Murry Sill of The Miami Herald, The Mascot, Lt. Francisco Noel Talavera, and Carlos, a Sandinista army scout.

450 men, including *La Mascota* (The Mascot), a kid of about 12 or 13 years old who ran little errands for the commanding officers but who seemed to be there mostly as a good luck charm. Each soldier carried between 50 to 100 pounds of equipment: a Soviet-made assault rifle, 1,000 bullets each, mortars, rocket-propelled grenades, radios and small portions of C-rations. Most of them were poor kids in their teens or early 20s. They spent days and part of the nights under a broiling sun, pounding rain, hiking up and down the mountains, fording rivers and trudging through mud.

Crossing those rivers really spooked me. In some of them the water was chest high, and the bottoms were smooth, slippery rocks. I'm carrying a couple of camera bodies and a few lenses, plus film, batteries and everything else I need to sustain myself and do my job in the mountains. One slip on the rocks in a quick-moving river meant I could lose or damage everything. And then, of course, I had the contras to be worried about. If they catch us crossing a river we're finished. Period. End of discussion.

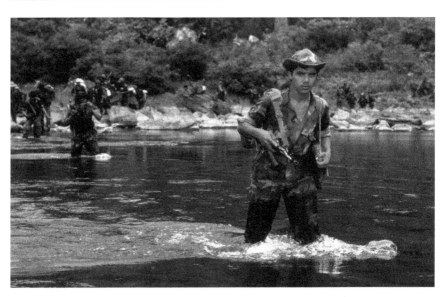

LA MONTAÑA, Nicaragua – Crossing rivers with either these Sandinistas or the contras was especially dangerous. The lack of "cover" made me an easy target for the opposing fighters. Like ducks in a pond.

"*Cuervo* was right," I told Sill during a break along the trail as I dug fingernails into my skin to pull out some splinters. "I do need the nails." Never the fool, *Cuervo* had decided not to go on this mission.

Green Mountain, where we expected to encounter as many as 1,000 contras, was only about 20 miles away in a straight line on a map. But because the mission took us up and down mountains and in zigzag patterns around natural obstacles, we walked between 10 and 15 miles each day during those 12 days in the field. Green Mountain was light years away.

On the fourth day in the bush, 10 of the scouts were moving about a mile ahead of the three companies when two contras waiting in ambush opened fire. The rebels were killed during the exchange. The rest of Talavera's men rushed into forward positions and Talavera called in fire from Waslala by Soviet-made Katyushas, a truck-mounted set of rockets with a range of 18 miles and so powerful that they rip the bark off trees 100 yards from the point of impact. Talavera and I watched the rockets pulverize the top of a mountain where the rebels were believed to be encamped.

Each day's march toward Green Mountain took us deeper into *La Montaña*, an increasingly eerie place of abandoned hamlets, of peasant huts burned to the ground, of timid mountain dwellers trying to stay out of the fray, of men and women with whom I could talk for 20 minutes but whose eyes would never meet my own. An old peasant woman emerged from a shack as the troops filed past. She shook uncontrollably. She could barely hold herself in one piece. Trembling. On the verge of tears. Frightened to the core. I don't know who she thought we were. Contras? Sandinistas? Or maybe she was merely frightened by all the men with guns. What had she seen men with guns do? I tried to calm her by making small talk. I couldn't get through to her. We continued filing past.

It was here that I witnessed a Nicaragua unseen by most outsiders, or by most Nicaraguans, for that matter. It was a Nicaragua not of just poverty. It was a Nicaragua of misery and hopelessness. I lived in the 20th century but what I witnessed on those excursions into *La*

Montaña was a time and place where people live as they did centuries ago. They lived in huts with thatched roofs, dirt floors, no electricity and no running water. It was a place where children walk barefoot through yards of mud mixed with chicken and pig feces. Where they grew up without ever seeing the inside of a classroom, much less the interior of a decent hospital or library. It was a place where the lack of proper nutrition and education stunts their physical and intellectual development. Where their teeth rot out by their 30s and where their bodies give up in their 50s or 60s. Their hands will never touch a computer keyboard. They will never fly in an airplane. Their lives will play out in nearly complete anonymity and will end prematurely. Young girls, especially, may endure the horror of sexual assault, sometimes by members of their own family. These people will be victimized by neglectful and corrupt government officials, by the whims of weather and nature, by forces they can neither see nor understand.

No wonder there was a revolution. How could there not be?

From the tracks in the mud and from conversations with the peasants, Lt. Talavera deduced that his three companies were chasing between 200 and 400 contras, but when we finally reached Green Mountain the rebels had not taken a stand as Talavera had hoped but had broken up into small groups and slipped away during moonlit nights.

Some 4,000 Sandinista soldiers were involved in this operation, which would last for months and represent a tremendous expenditure of money and manpower for a country of 3 million people. An agricultural country where so many young men up in the mountains fighting a war was a huge disruption of the labor force and in the cycle of working fields and harvesting crops.

But if Nicaraguans paid a high price in blood and money for defending their country, the ideological harvest in political good will for the Sandinista government also was high.

During the journey, I made friends with a 34-year-old lieutenant, a big man well over six feet tall (rare for a Nicaraguan) with bear-like hands and the tinny voice of a 14-year-old. Everybody called him "*Se Busca*" (Wanted) since one of the soldiers said he looked like a picture

on a post office wall. And the name just stuck. *Se Busca* showed me a picture of himself made only three years previous, but I looked at him that day and thought the photo had been made long before. The vitality was sucked out of his eyes by the 40 firefights he counted with the contras, by the bullet that two years before tore into his left shoulder, by the wife who left him for a man who could spend more time at home and not in the mountains chasing a war and relinquishing his youth. *Se Busca* read me some of the poetry he wrote in the mornings and between military operations. A line from one of his poems read: "As long as there is intervention in Nicaragua, there will be honest men capable of defending her."

Danilo

It's 1 o'clock in the morning and I'm working on a story for the *Baltimore Sun*. Claudia is asleep only a few yards away. We are still living on her family's property, in the building apart from the main house that her mother used as a workshop for her sewing business.

I'm sitting on the floor and my manual Olivetti portable typewriter rests on the footlocker we use as a table. The door to the apartment swings open. It's Danilo, Claudia's youngest brother, recently released from an institution after apparently having suffered an emotional breakdown. He is 18 or 19 years old.

He's standing there dressed in his camouflage uniform, jungle boots and a black beret. And he's carrying an automatic assault rifle, an Israeli-made Galil, delivered to

MANAGUA, Nicaragua – Danilo, the youngest brother of my then Nicaraguan partner and first wife, Claudia.

the Somoza regime after President Jimmy Carter suspended military aid to Somoza because of repeated and serious human rights violations. Danilo looks very much like he must have looked the day he was shot in the mountains a few months ago. He stares at me, and I can't tell whether he's angry, paranoid, just curious, or what. He's looks pretty agitated.

"Qué pasa, Danilo?" I ask him, (What's up, Danilo?) He just stares at me. I'm not quite sure how to handle this. Does he think I am the enemy? My country certainly was indirectly responsible for the killing of his friends. Will he turn the weapon on me?

In retrospect, this incident seems to be part of Danilo's pattern. His parents say he was an "introverted" child, more interested in playing with puzzles or one-kid games than in playing with other kids. He would array his toys in a circle, surround himself with the toys, locking himself into his own little world and locking the rest of the world out. It was like he wanted to protect himself from something unseen out there, perhaps something evil.

When his family lived in downtown Managua, Danilo was just a few years old. It was before the 1972 earthquake that leveled most of the city, killing and injuring tens of thousands. Every morning the milkman came around and dropped off glass bottles filled with fresh milk and took away the empties. On his truck, the milkman carried a pet monkey and Danilo, like most of the kids on the route, would run out to play with the animal while his owner made his rounds. So, one morning Danilo went running out of the house to see the monkey and he slipped and landed on top of the empty bottles, one of which shattered and nearly sliced off the calve of his left leg. His leg laid there, splayed completely open and bleeding hard, when his mother came out of the house. She grabbed a piece of cloth and a pencil and made a tourniquet and ran to the drug store across the street for two Kotex sanitary napkins, strapped them on each side of the wound, called the hospital for the emergency surgeons to get ready, then drove Danilo to the hospital, where the surgeons saved his leg and his life.

The leg healed and Danilo, the youngest of Claudia's three male

siblings, reached his teens without major incident, growing into a handsome, lean young man with an easy, shy smile and long eyelashes.

After the Sandinista victory of 1979, Danilo, like thousands of other Nicaraguan youths, joined the Literacy Campaign, which was launched to teach a huge sector of the Nicaraguan population how to read and write. The kids were put into "brigades" and sent out to the farthest reaches of the nation where Nicaraguan teachers and doctors traditionally had refused to go.

In 1980, Danilo was sent to the department of Nueva Guinea in southeastern Nicaragua, near the border with Costa Rica. The place had a reputation for being super-hostile to the Sandinista presence. The area was founded in the 1960s and the population exploded in 1971 as the US Peace Corps and the Nicaraguan government resettled some 1,000 peasant families affected by a volcanic eruption near the western city of León. The peasants were given free land and agricultural assistance and were therefore pro-Somoza. The antipathy of the peasants toward the Sandinistas was deepened during the 1979 insurrection by the presence of Sandinista guerrilla fighters staging incursions into Nicaragua from its southern neighbor, Costa Rica. It is rumored that, only months prior to the Sandinista takeover, peasants in the area had tangled with a small group of Sandinista rebels, killing every one of the Sandinistas and dumping their bodies into a well. On top of all this, add the Nicaraguan peasants' traditional suspicion and distrust of outsiders, and you've got an extremely volatile situation. And finally, the literacy campaign workers were equipped with textbooks and an approach that was heavily ideological, heavily political, and oriented toward the Cuban, communist, and atheist doctrine which was diametrically opposed to the U.S., capitalist and Christian line that these people had essentially been raised on. This was the boiling cauldron into which Danilo was dropped, to educate peasants. It was not a promising situation.

According to Claudia, Danilo was there only a few months before it happened. And nobody knows exactly what did happen, pieces of the puzzle still emerging years later. What's known for sure is this:

Danilo was staying with a peasant family, the father of which apparently thought Danilo was messing with his daughter. According to Danilo's father who quotes people on the scene, Danilo was alone in the house when he began to scream, sounding like he was fighting off an attacker. When he was pulled out of the house, he had multiple, vertical wounds on his forehead from a machete. But the wounds were put there by the back of the machete, not the sharpened edge. It was as if Danilo was striking something, or someone, with the sharp edge of the machete and on the backswing of every stroke had hit his own forehead with the blunt side of the tool. Again, he had been alone in the house. Nobody else was hurt. He was taken to his home in Managua, where they found out later that he had contracted cerebral malaria, a disease that would embed itself permanently in his brain.

In the earliest days of the Sandinista Revolution when I moved in with Claudia's family in 1983, the ideological fervor was at its peak, the errors and weaknesses of the regime had yet to become so apparent, and U.S. intervention in the process had yet to spoil it. Danilo had always been "*muy pegado*" (very attached) to his mother, Norma. How much of what he did in those days was of his own natural volition and how much was subconsciously designed to please her is not totally clear, at least not in my mind.

It was at that time that I learned about Norma's relationship with the Sandinista Front. And I figured out why some foreign journalists hung out with Claudia, her mother, and her father, Alberto. Aside from being smart, stylish and sociable, Norma had been a secret collaborator with the Sandinistas years before they came to power. She had been a close associate of Carlos Fonseca and Tomás Borge, two of the founders of the FSLN. Fonseca was killed in combat in 1976 near the northern town of Waslala. Borge had become Interior Minister in the new Sandinista government. And Claudia's father, a lawyer renowned for his mastery of his profession, became an assistant to Borge.

So, the seeds of revolution had been planted in the family years before the Sandinistas actually seized power.

According to a report issued by Nicaraguan military authorities and a photocopy of which Claudia sent me decades later, Danilo in 1981 joined the *Batallones Estudiantiles de Produccion (BEP)*, (Student Production Battalions) and went to the northern mountains to work on the coffee harvest.

In 1982 Danilo volunteered with a dozen members of his graduating class of the Instituto Rigoberto Lopez High School to go north to Nicaragua's border with Honduras and defend the nation from increasingly bold incursions by U.S.-backed contra forces. He and his peers joined *Batallón 50-10* of the Sandinista People's Army. This is when the Contra War was really beginning to pick up steam but was still very much a conflict of defending the border region from incursions. It would be a few years before the fighting would extend deep into Nicaraguan territory.

Claudia and I attended the sending-off ceremony for Danilo and his fellow volunteers. It was held in a *barrio*, or poor neighborhood, of Managua called San Judas.

I've been to a lot of these affairs because they had become so much a part of what was happening in Nicaragua and because there I could make some powerful images of mothers and wives and girlfriends seeing their youth off to war. Normally one of the Sandinista chieftains comes to the plaza and addresses the crowd, calling the young volunteers "patriots" and lauding them for their bravery. They play revolutionary anthems. The crowd cheers them on.

It's probably one of the most moving days of these kids' lives. Imagine, their family, friends, their entire neighborhood and some of the nation's leaders come out to see them off, all to the tune of rousing revolutionary music. It's the same scene in so many cultures in so many countries in so many wars. Just like in the movies. Robert De-Niro and his buddies, in the award-winning 1978 film *The Deer Hunter*, getting all liquored-up with friends before going off to Vietnam.

The women are left standing there with their faces in their hands, tears seeping through their fingers. Nicaraguans must have short memories. At least Nicaraguan men do. Either that or their sense of

romanticism is terribly exaggerated. For the men, these sending-off ceremonies seemed more like these guys were headed out to a game of soccer as opposed to the mountains to fight a war. The revolution, in which tens of thousands of people were killed, had ended just a few years previous, so it wasn't like nobody knew what war was about or that people got killed while waging it. The women knew better. Nicaraguan women always seem to know better.

The young volunteers pile onto military trucks or into yellow buses and head off to learn how to kill fellow Nicaraguans. Later, they will be assigned to units to carry out their tours of duty. How many of these young men, I wonder in silence, will be blown up or gunned down by their own dreams of valor and victory in war? Which of these mothers will suffer the pain of losing a young son? Like my grandmother suffered when my Uncle Tony was killed on Normandy Beach.

Danilo and his 12 high school buddies were assigned to defend positions in the Department of Nueva Segovia, right across the border from contra camps in Honduras. On May 1, 1983 at a place called *Las Lomas de Makarali*, contra forces attacked the hilltop that Danilo, his high school friends, and members of the standing army were defending. Danilo was hit by a bullet that passed from behind, through the right pectoral muscle at the armpit, and out of his chest. He must have gotten hit while running crouched over and away from the fighting. Or he could have been hit by accident by one of his own guys. Or he could have gotten hit by enemy fire while turning to see what was going on behind him. It is this sense of mystery, or uncertainty, that would forever haunt the circumstances of Danilo's life. None of his 12 buddies was killed or wounded.

That same night Danilo called his mother to tell her he'd been shot and the next day his father pulled some political strings and got on a military plane to fly up and bring him back to the *Hospital Militar* in Managua. It was a Soviet-built troop carrier with no seats, only benches lining both sides of the fuselage. Alberto came back to Managua with a total of eight kids, Danilo being the only one from the

group of volunteers of his high school class. The other wounded are from different units. Alberto held one seriously wounded kid under his arm during the entire flight. His own son, Danilo, was out of danger. At least this time.

Two or three days after his return to Managua, Danilo gets a phone call. The caller advises him that his 12 buddies, whom he left on the hilltop in Nueva Segovia, had been wiped out during a contra attack. They're all dead. There's more. Danilo's good friend Alejandro "Tuti" Jerez, the caller says, was captured alive while trying to pull a wounded lieutenant to safety. Tuti was a tall, dark-skinned, athletic, marathon-runner type who Danilo's father once called *un adolescente precioso* (a precious adolescent). The contras cut off Tuti's ears, his nose and his tongue, the caller said. They gouged out his eyes and were hacking off his arms and legs before Tuti finally died.

Danilo suffers an emotional breakdown and is institutionalized for three months.

There is a *barrio* in Managua that, after the war, was renamed, *Héroes y Mártires de Makarali* (Heroes and Martyrs of Makarali) for Danilo's buddies who were killed up in the mountains that day. I don't know if Danilo has ever been to that *barrio*. I don't know if Danilo even knows if he's ever been to that *barrio*.

It was shortly after Danilo was released from the institution that he appeared that night at the door where Claudia and I lived, dressed like he was going back to war.

"*Qué haces?*" (What are you doing?) I pressed him that night.

"*Vigilancia revolucionaria,*" (Revolutionary Surveillance) Danilo said, referring to the neighborhood watch system the Sandinistas had imposed in anticipation of a counter-revolution.

"*Quieres un trago?*" (Would you like a drink?) I ask, thinking maybe a glass of rum will chill him out.

"*No,*" he says. He turns around and leaves. I lock the door behind him.

"They Had Faces Like Dogs"

It was deep into the war and I had established relationships with fighters on both sides of the conflict. Sandinista as well as contra. During a conversation with one of the fighters, he told me about having dispatched prisoners captured during battle in the northern mountains.

"They had faces like dogs," he said. As if that were true. As if that made it all OK.

And I wondered what this young man was like *before* the war.

La Penca

I had first seen him in July 1979 as he rode into Managua on the wave of celebration that followed the departure of Anastasio Somoza Debayle, his cronies and members of the hated National Guard just ahead of the victors of a popular insurrection. He was riding on the rear, fold-down door of a pickup truck with some of his combatants of the *Frente Sur*, or Southern Front of the Sandinista no-longer-clandestine organization. He was by far the most recognizable, charismatic and soon-to-be controversial member of the Sandinista leadership. Edén Pastora was eating a can of peaches.

Legend has it that, when Edén Pastora was eight years old, members of Somoza's National Guard murdered his father over a land dispute. Pastora grew up to be a hunter who also fished for sharks in the fresh waters of Lake Nicaragua, one of the largest fresh-water lakes in the world. He ran a shrimp business in Costa Rica as well as Sandinista logistics and in August of 1978 he led the most daring assault in the history of the Sandinista Front. He would be called *Comandante Cero* (Commander Zero).

Early one morning one of Pastora's collaborators returned to his Managua "safe house" with word that the National Palace, a drab, sprawling building covering an entire city block, would be full because Somoza's rubber-stamp congress was to discuss the national budget.

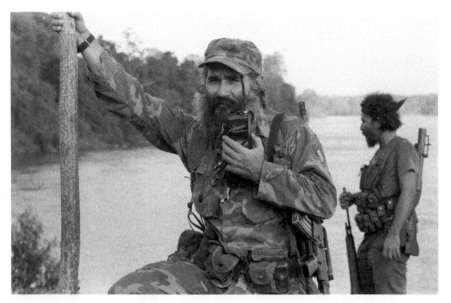

ON THE BORDER WITH COSTA RICA – Eden Pastora with anti-Sandinista fighters at his camp along the shores of the San Juan River separating Nicaragua from Costa Rica.

"This is it," Pastora told his aides.

That morning Pastora and 24 guerrilla fighters disguised as members of the Nicaraguan National Guard raided the National Palace, held some 2,000 hostages for 68 hours, secured the release of 59 political prisoners and $500,000 in ransom, and broadcast over national television and radio a lengthy *communiqué* denouncing the government, outlining their own policies and calling for Somoza's overthrow.

"This operation is a blow to the knee," Pastora would later tell reporters. "A shot in the knee, as we hunters say. This will hasten the process" to oust the Somoza regime.

And it did.

Tens of thousands of cheering Nicaraguans lined the *Carretera Norte* as Pastora's caravan of guerrilla fighters and newly released political prisoners made their way from the National Palace to the international airport. They boarded a plane to fly them from Managua to Panama. All wore handkerchiefs over their faces to hide their identi-

ties. But once all had boarded the plane Pastora, standing on the ramp at the jet's door, ripped off his mask and held his automatic assault rifle high for an iconic picture, perfect for television, newspapers and magazines around the world. Pastora and the Sandinista palace raid had captured the imagination of Nicaraguans desperate for a government that would not treat its population as if its members were slaves on a private estate. The Sandinistas re-defined themselves more as Robin Hoods than as the communist assassins Somoza said they were.

There was no turning back. Just weeks later, Nicaragua exploded in a spontaneous popular insurrection against the regime. The September 1978 insurrection, quelled with ferocious repression from the Somoza regime, laid the groundwork for the Final Offensive in the spring of 1979, when I first landed in Managua.

By 1984, however, Pastora had been passed over for any important government post and had fallen out of favor with top Sandinista rulers. He abandoned Nicaragua and gathered a group of anti-Sandinista rebels willing to fight against his former brothers in arms. Stated differently, Pastora had started his own little contra guerrilla group, which was big news. He established a base in southern Nicaragua on the banks of the San Juan River that separates Nicaragua from Costa Rica. Knowing that pictures of Pastora in his new role as anti-Sandinista would be valuable, I advised *Newsweek* photo editor John Whelan that I was headed out to find him. Whelan agreed to look at my pictures if I actually made contact with the rebel leader. He might even purchase some for publication in the magazine.

Finding Pastora was not difficult. I flew from Managua to San Jose, the capital of Costa Rica, rented a car and drove up to the border area right across the river from where Pastora's contras were rumored to have been based. I paid a local *campesino,* or peasant, to take me on his outdoor boat to where all the Costa Ricans in the area knew Pastora and his men were operating from.

I spent a couple of days with Pastora, who was happy to have an American photojournalist around to chronicle him and his men. Mostly him.

It was on this journey that Eden Pastora taught me how to walk across logs, either fallen or placed, across streams, without losing balance and falling into rushing water. As he instructed, I step forward with the right foot pointed about 2 o'clock and come down on the log with the arch of my foot between the ball and the heel, therefore giving it more traction and giving me more balance. Then it's the left foot with toes pointed at about 10 o'clock, and so on. It's awkward at first, but it really does work.

John Whelan loved the pictures. The May 21, 1984 issue of *Newsweek*'s domestic edition features one of my pictures showing heavily armed contras making their way through dense jungle. The picture sprawled across two pages of the domestic edition of the magazine, the much-preferred venue for a photojournalist's work, as the paper was high quality, slick and allowed great reproduction of color images.

Although *Newsweek* had published a couple of my pictures during the 1979 revolution, this was the first time I scored a large-display color image in the domestic edition. To my eyes, the picture was about 10 feet tall. Under it was my byline: "William Gentile."

Newsweek published the same image in the foreign edition, which was made of coarse paper suitable only for black and white versions of the original, color-slide images. In addition to the images published in *Newsweek,* I included one of the images I made on the trip in my book of photographs, *Nicaragua*. It shows some of Pastora's fighters wading up a tributary of the San Juan River.

It was a successful journey. I was on my way.

Not long after my trip to find Pastora, I heard that he had scheduled a press conference at a jungle camp at La Penca, not far from where I had been with him. This was important news because Pastora reportedly had fallen out of favor with his CIA sponsors, a matter of interest to the media. But still a freelancer, I thought the cost of getting to the event would have been prohibitive. And since I had only recently covered the rebel leader, I saw no need to hustle down there on the hope that I could make the trip profitable.

And so goes the beginning of just one of many strokes of blind

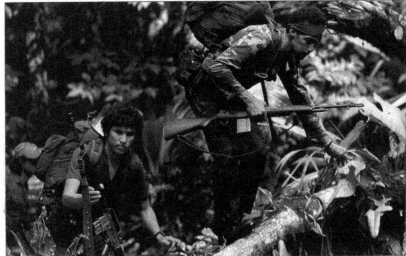

Contras on the prowl inside Nicaragua: Faced with the threat of a widening war, will Congress continue to pay for the 'secret'

Mr. Reagan Has It His Way

Duarte wins in El Salvador, and the president gets his aid bill on Capitol Hill.

For once, Ronald Reagan had it his way on Central America last week. El Salvador concluded its first fraud-free presidential election in 50 years, and, as expected, moderate José Napoleón Duarte managed to defeat the candidate of the oligarchical right. Reagan himself went on television to deliver a smoothly one-sided speech, warning that communists were on the march in Central America and would "likely succeed" unless Congress provided enough money to stop them. Duarte's heartening victory and the implicit threat of scapegoat treatment combined to change some minds in the House of Representatives. The day after Reagan's speech, the House voted, just barely, to authorize a new dose of military aid for El Salvador. So the president had what he wanted: a Salvadoran government worth supporting and the means with which to support it. In a way that left him on the spot. Now if things don't work out in El Salvador, Reagan may have no one to blame but himself.

Despite the president's oratorical gifts, the public's support for his policies in Cen-

tral America remains shallow at best; the approval rating generally hovers at less than 40 percent. To the extent that they think about the region at all, many U.S. citizens seem to believe that Reagan puts too much emphasis on fighting communism and not enough on curing the social and economic ills that give rise to leftist insurrections. Congress still has to appropriate military-aid money for Central America. Some funds are expected soon for the Salvadorans, but the president may get little or nothing for his most controversial protégés, the anticommunist contras who have been waging his "secret" war against the Sandinista government in Nicaragua.

The contras may be

doing more harm than good. Their activities helped to stir up new trouble last week between Nicaragua and its neighbors, Honduras and Costa Rica. And the American-directed mining of Nicaraguan harbors drew an embarrassing rebuke from the World Court. In time Duarte also could turn out to be a diminishing asset for Reagan. He will take office on June 1 with high hopes for ending the war and promoting social justice. But as it wages war on "communism," the Salvadoran military establishment may not tolerate a serious effort at reconciliation.

After five days of punching local vote tallies into a Wang computer, Salvadoran election officials formally proclaimed Duarte the win-

Seeking support: Dire warnings

ON THE BORDER WITH COSTA RICA – My first major photograph published in Newsweek magazine shows Pastora's fighters making their way through thick jungle in southern Nicaragua.

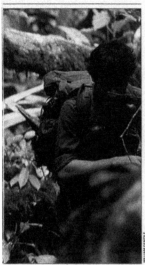

campaign against the Sandinista regime?

ner by a margin of 54 percent to 46 percent over his right-wing opponent, Roberto D'Aubuisson, the alleged godfather of the "death squads." Duarte's share of the votes was considerably smaller than the 60 percent or more that some of his supporters had predicted. Even so, D'Aubuisson refused to accept the outcome. Accusing Duarte of "fraud," he claimed that *he* had won the election. D'Aubuisson also charged that Washington had "fixed" the runoff. His supporters cited a speech by Republican Sen. Jesse Helms of North Carolina, who accused the CIA of funding Duarte's campaign. "We did everything but stuff the ballot boxes," Helms charged.

Funding: Later, White House spokesman Larry Speakes admitted that, like its predecessors, the administration had given money to labor unions, business groups and other organizations that supported political candidates. The objective, he said, was to foster "democratic institutions," and he insisted that the recipients were not told which candidates to back. Although Speakes named no names, one major beneficiary of U.S. support was the Salvadoran Communal Union (UCS), the largest peasant organization in the country, which receives most of its $2 million annual budget from Washington. Members of Duarte's Christian Democratic Party said UCS agents had knocked on every door in the

NEWSWEEK/MAY 21, 1984

country to drum up votes for their man.

Whether or not it actually tried to stack the deck, the administration clearly wanted Duarte to win, if only because Congress was unlikely to vote much money for the hard-line D'Aubuisson. Three days after the election, Reagan went on prime-time television to seek money for Duarte and support for his own Central American policies. The speech was anything but subtle. With scarcely a word about right-wing repression in Central America, Reagan implied that most of the trouble in the region resulted from "a bold attempt by the Soviet Union, Cuba and Nicaragua to install communism by force throughout the hemisphere." He described the contras as "freedom fighters" and the Sandinistas as "Cuba's Cubans." Although he said there "definitely" were no plans to send U.S. combat troops to Central America, he maintained that the United States had a duty to "support both the elected government of El Salvador and the democratic aspirations of the Nicaraguan people"—in short, the contras.

Cross Fire: So far, the contras' raids have not put the Sandinistas in any real peril, but they have created the danger of a wider war in Central America. One contra group has attacked from sanctuaries in neutral Costa Rica, which has no army. When the Sandinistas fired back across the border, the Costa Ricans requested emergency U.S. military aid for their small police force and ragtag militia. Some officials in Washington hope that Costa Rica can be drawn into closer military cooperation with the United States. But even with much more U.S. assistance, Costa Rica would be heavily outgunned by the Sandinistas, and its leaders seem determined to preserve the country's neutral status.

On their northern frontier, the Sandinistas shot down a Honduran military helicopter, killing all eight people on board. The craft had strayed across the border near the port of Potosí, which has been attacked repeatedly by Honduran-based contras, apparently because of U.S. suspicions that the port is used by small boats carrying arms to the Salvadoran rebels. In reply, Honduras recalled its ambassador from Managua, expelled the Sandinista envoy and warned Nicaragua to change "its warlike and aggressive attitude."

In The Hague, meanwhile, the International Court of Justice issued a unanimous interim ruling that called on Washington to stop mining or blockading Nicaraguan

ports. In a second nonbinding decision, the World Court ruled by 14-1 (with the sole American judge dissenting) that Nicaragua's political independence "should not in any way be jeopardized by military or paramilitary activities." Washington already had put a stop to the mining, but the rulings gave the Sandinistas a symbolic victory.

Reagan's victory on Capitol Hill was more tangible. House Democrats led by Speaker Thomas P. (Tip) O'Neill tried to put stringent restrictions on U.S. military aid to El Salvador, requiring closely monitored progress on human rights. But the second ranking Democrat in the House,

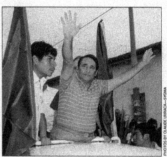

Duarte: A new president searches for 'dialogue'

Vides and Pickering: Questions about human rights

Majority Leader Jim Wright of Texas, argued against setting "a standard that we do not require of any other nation in the world." With 56 Democrats lining up against O'Neill, the House voted, 212-208, for a measure that contained much milder requirements on human rights. It authorized $49 million in new military aid to El Salvador this fiscal year and $132.5 million in fiscal 1985. The next step is for Congress to actually appropriate funds. One measure to provide $21 million in aid to the Nicaraguan contras may be cut by as much as two-thirds, if it survives at all. But final approval is likely for most or all of a $62 million

luck that saved me from being killed or seriously wounded. It was as if someone had been watching over me. Waiting for me to return.

During that May 30 press conference, a blast tore through Pastora's command post, killing seven people and wounding 21 others, some losing eyes or limbs.

The seven dead included three journalists: Costa Ricans Jorge Quirós, a cameraman for TV's *Channel 6*, his assistant, Evelio Sequeira, and U.S. citizen Linda Frazier, reporter for the English-language Costa Rican newspaper, The *Tico Times*. The blast had blown off Linda's legs.

Pastora was one of the wounded.

Had I attended that news conference, I probably would have been standing close to Pastora or the colleagues killed and wounded during the blast, making pictures of the guerrilla leader.

Juan Tamayo, my editor and immediate superior at UPI in Mexico City, is a close friend of Linda Frazier's husband, Joe Frazier, who worked at the Associated Press. Juan's wife and Linda Frazier also were good friends.

In an article published in 2013 in ReVista, the Harvard Review of Latin America, Juan wrote that the attack, "made me angry. And I felt a special debt to Linda, Joe and their young son Chris." So, for Juan Tamayo, the killing of Linda Frazier was not just business. It was personal, and he began a decades-long search for Linda's killer.

"It turned out that the bomb had been brought into La Penca and detonated by a 'journalist' using a stolen Danish passport in the name of Per Anker Hansen," Tamayo wrote in ReVista. "He was not injured, was evacuated to Costa Rica with the other survivors and immediately vanished."

Over the years, Tamayo and a group of journalists from diverse countries and backgrounds cooperated closely and unselfishly to identify the bomber as Argentine citizen and Sandinista sympathizer Vital Roberto Gaguine, a confirmed member of a leftist guerrilla group whose services were contracted by Sandinista intelligence and Interior Minister Tomás Borge. Gaguine was killed during a 1989

failed attack against the La Tablada military base in Argentina.

In a message to me in the summer of 2020, Tamayo wrote, "There is no uncertainty, at least in my mind, that the La Penca bombing was a Sandi-sanctioned operation."

May 30 now is the "National Day of the Journalist" in Costa Rica, first proclaimed in 2010 by then-President Óscar Arias, the architect of the 1987 Esquipulas II Central American Peace Accords. The popular Costa Rican president established the date to honor those killed and wounded in the bombing.

On June 16, 2020, Eden Pastora died at a military hospital in Managua. He was 83.

"Yes. It's him."

John Hoagland, my "suicide stringer" partner from the Sandinista Revolution days, had moved shortly after the Nicaragua conflict to El Salvador where an ugly, savage civil war had erupted, and where he would earn the coveted post as *Newsweek* magazine's Contract Photographer for Latin America and the Caribbean.

It was 1984 and John had recently come back from Beirut where *Newsweek* sent him to cover the aftermath of the October 1983 terrorist bombing of the U.S. military barracks that left 241 service personnel dead, including 220 Marines. (A high school friend of mine was one of the Marines who perished in the bombing.) As a result of the bombing, President Reagan pulled all U.S. military out of the country, and John was there to document the withdrawal.

John's time in Beirut apparently was transformative. There are a few theories as to what happened to him in Beirut. One theory holds that he came back to Salvador talking about "a real war" with immense fire power and massive loss of human life, as opposed to the dinky little firefights and death squads in El Salvador that took lives a drop at a time. This theory went that John had lost respect for the Salvadoran conflict and for how deadly it could be, and he therefore got careless.

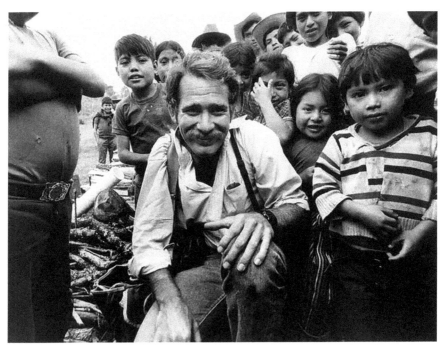

LOCATION UNKNOWN – John Hoagland, my "suicide stringer" colleague from the Sandinista Revolution. Author of this photograph is unknown.

Another theory goes that John woke up one morning after Beirut and found himself cast in the ironclad role of hardcore combat photographer and that this was the role he felt compelled not only to live up to but also to exceed in. So, to continue being "The Real John Hoagland," John would have to take even more risks than ever before.

The third theory is that the Beirut assignment bolstered John's confidence, making his aspirations to become a world-renowned combat photojournalist more within reach than ever. This is the theory most favored by David Helvarg, one of my colleagues who was closest to John. It was Helvarg who produced an Emmy-winning film about John's life that was broadcast nationwide on PBS.

So, on that day in El Salvador, John and a small group of colleagues responded to reports of a firefight not far from the capital of San Salvador. The scene was chaotic as the journalists tried to get close

enough to the fighting to make powerful pictures. One of the government soldiers shot and killed Hoagland.

I was in the Hotel Maya in the Honduran capital of Tegucigalpa one morning when somebody paged me. The colleague on the other end of the line told me that Hoagland had been killed in a firefight not far from the Salvadoran capital.

"Are you sure?" I said. "You know how confusing these things are and you know how sometimes it's somebody else or he's just wounded and not dead."

"Yes, I'm sure," was the answer.

"Did anybody actually see the body?" I pressed him.

"Yes. It's him. John's dead."

Two days later I arrived back in Nicaragua and at the sewing shop that Claudia and I called our home I read the article about John's death in one of the pro-Sandinista, Nicaraguan newspapers. The people who put the article together just couldn't resist the temptation to use his death as another bit of cheap propaganda against the "imperialist" occupation by U.S. military forces in El Salvador and American complicity with the Salvadoran regime in John's death. Never mind that all of this was true.

"Now why do they have to use the death of my friend as a pawn in their propaganda war?" I demanded of Claudia. "They just can't leave him alone. Why can't they just report what happened and just leave him alone?"

My poor Claudia had few answers for any of this and she knew this was not the time to discuss it with a man burning up with rum and rage.

"Call the newspaper and tell them," she ventured.

About a year after John's death, I signed my first contract with *Newsweek* magazine, in effect, stepping into Hoagland's shoes as *Newsweek* magazine's Contract Photographer for Latin America and the Caribbean. Few events in my life have been as bitter-sweet as this one. I was honored by the extraordinary recognition and coveted contract with one of the elite, highly respected news and information out-

lets on the planet. But this honor came, in part, because the previous recipient of this good fortune was a friend of mine killed while carrying out the responsibilities of the craft.

Central America at the time dominated international news and journalists from around the world came to cover it. At least 18 journalists were killed covering Central America between, and including, Bill Stewart in 1979 and John Hoagland in 1984. That's 18 dead journalists in five years. Of that total, 12 were killed in El Salvador.

A Letter From My Mother

My family, of course, followed the conflicts from a distance in the pages of *Newsweek* magazine. In a letter to me dated January 1, 1986, and invoking the memory of her brother Tony who was killed during World War II, my mother pleaded:

"Well my Son – how can I tell you that you must be careful in that country with all the danger? What can I say or do to help you to be ultra careful? I worry but I know that it is up to you and the good Lord. I'm happy you are doing so well but your safety is all I'm concerned about. Don't get careless Bill. If something happens to you – you will take part of my life with you, as my brother took part of Nana's life with him. She was never the same. I need you to be happy in my life. My children mean that much to me."

ALIQUIPPA, PA – This is the blast furnace of the J&L Steel Corporation in Aliquippa, Pennsylvania. It is in this sprawling plant where my grandfather, my father, my uncles, my three brothers and I all worked at one time or another. (Photo courtesy of Beaver County Industrial Museum)

CHAPTER 5.

THE MILLS GIVETH AND TAKETH AWAY

Early Days

My parents were lucky to have met each other. In those days women, especially Italian women, didn't have the luxury of shopping around too much for husbands. Men were coming back in droves from the war and it seemed like the natural thing to do. Find a partner, get married and have kids. Hence the Baby Boom. More, my mother's family thought my father was the greatest thing since sliced bread and once his intentions became known, "it was a done deal," as my mother put it. Even Nana couldn't, wouldn't stop it because, in part, the marriage was an escape for my mom from a home that was dominated by her brothers, who may have lived in the United States but whose minds were trapped in an Italy from a previous century. The marriage could have been a disaster but my father turned out to be pretty much the husband that my mother had always wanted.

"He was always with me," she said. "He never wanted to go anywhere else. He never went to bars. He never drank away from the house. He smoked socially."

Their first son was named Lou after my father's father. I came next. Then there was David and, finally, Robert.

My mother was a classic beauty straight out of the 1950s. Well-built and tall. Strong cheeks and full lips. Flowing hair. She enjoyed the music of her post-World War II era, the big-band sounds of horns, the velvet crooning of Frank Sinatra and the gravelly, straight-from-the-heart voice of the beloved Louis Armstrong. She sang at home. She sold her homemade bread to pick up extra money. In the summertime with the doors and windows open, neighbors delighted in listening to her singing as she prepared the bread they purchased from her. At Christmas time we sang carols in the car on the way to visit family and friends. My mother knew all the lyrics. She was a member of the church choir. When she did a solo of the classic, "Ave Maria," I remember seeing grown men reach for handkerchiefs to discreetly touch their eyes.

I suspect it was from my mother that I inherited the talent to become a photographer. As a child, she aspired to be an artist, drawing and painting her favorite Hollywood movie stars. She drew and painted even beyond her school years but eventually dropped the craft to care for her family. Some of her artwork hangs today in frames in my home. She was a woman of her time and a mother of all times.

Like all the men in our extended family, my father toiled in the steel mills. He worked swing shifts. One week from 8 in the morning until 4 in the afternoon. The next week from 4 in the afternoon until 12 midnight. The next week from 12 midnight until 8 in the morning. And then he'd start all over again. Imagine the strain that this regimen imposes on the body and the mind. It takes a couple of days for a person's body to get used to working an odd shift and, just when it's learned to eat, sleep and relieve itself at unaccustomed times of the day or night, it's time to change shifts.

At this time Pittsburgh was the nucleus of America's industrial might. It was the steel-making capital of the world. An aerial photo of the city would show a hot, smoldering core of mills fed by rivers, railroad tracks, highways, bridges and tens of thousands of men like

my father feeding into, and then bleeding out of them, in eight-hour shifts. The city and its surroundings were built on top of one of the world's largest deposits of iron ore and coal, these being key ingredients for making the metal with which America would build itself and much of the world beyond. Steel beams made in Pittsburgh, for example, are what constitute the skeleton of the Empire State Building. And the region's topography was ideal for the industry. Pittsburgh is built along the confluence of three rivers. Raw materials for making steel flowed into Pittsburgh and surrounding areas on massive barges plying the Allegheny, the Monongahela and the Ohio rivers. Finished products left the region to market on those same rivers and over the railroad tracks running parallel to those waterways.

My father worked near the blast furnace where the new steel rolls out in sheets or beams onto "hot beds," sprawling iron-gridded platforms where the new metal turns as it cools from searing white-hot to yellow, orange, red and finally to its familiar gray color. On the hot beds, men use massive circular saws with blades as big as wagon wheels to cut the metal to specified lengths. The teeth on those blades are tipped with diamonds, and when they bite into metal a hose attached to them shoots cold water over the cutting edge to keep the heat under control to avoid fires. The noise is so loud that, when I worked in the mills I could hardly hear myself scream. Sparks fly 10 feet away. Next, men wrap thick, heavy chains around the steel and then, with overhead cranes that glide along roof-high rails, they lift the tons of still-warm metal onto trucks or railroad cars for shipment. In the wintertime they pull the trains out of the huge garage-like structures, and the railroad cars look like their insides are on fire because of the steam rising from the metal.

I worked my way through college in these mills, and I learned very quickly that the mill assaults one's senses. Wipes them out. I remember hearing the workplace long before even seeing it. Coming through the tunnel that feeds workers into this Dantesque world, a deep rumble is punctuated by train whistles, the crashing of railroad cars linking together and the horns of riverboats crying sadder than

loons on the nearby river. I get through the tunnel and see it all laying along the horizon. Huge black, rectangular steel buildings connected by wires with smokestacks taller than the buildings jut into the sky, eating up men and machines, spitting out smoke, fire and steel. I step into a black-and-white world where everything is oversized, exaggerated and lethal. In the summertime, the heat from the furnace and the metal that rolls out of its mouth comes at me like the wave of an explosion. In the wintertime steel coming out of the furnace warms the air half a football field away. At nighttime the white-hot steel turns the half-lit buildings to daytime.

I understood that this was the fire that my father pointed out to us when, as kids, we drove past the place in our '56 Plymouth. It's a menacing place. Just about everything around me can kill or maim, so I kept my eyes open and my limbs under control. I watched every move. Because I can lean against the wrong thing and get electrocuted. I can take a wrong step and fall to my death. I can put my hand in the wrong place and a machine will bite it off. I can look too close, or in the wrong place, and sparks will burn my eyes out. One of the other workers can bump against a stack of steel beams that will topple and crush my legs like a heavy boot on paper cups.

Especially during the 12 midnight to the 8 a.m. shift, I would take the opportunity to doze off on some of the wooden benches provided for workers during "down" time. I was especially careful to keep my hands from hanging down to the ground out of concern that the rats populating the place would take a bite. Big rats. And I hate rats.

Once I more or less got used to the physical demands of the place, I had to deal with what we call the "mill hunks." My co-workers. And I thank these guys because I learned from them, mostly about what I did not want to do with my life. They are the salt of the earth, the muscle of what used to be this country's industrial might, and I love being around them for their authenticity and lack of pretention. But not for eight hours a day over extended periods of time.

Butch was a tall, heavy-set dude with buck teeth and a bad complexion. He played guitar in a country music band when he wasn't

working in the mill. We talked about God one night during a pause on the midnight to 8 a.m. shift. It must have been about three in the morning. Butch told me that God must have long fingers because the world's finest GEE-tar players have long fingers, and he couldn't imagine the Almighty not being able to make music.

Most of the mill hunks were pure working class, raised on hard work and without the luxuries of a good education or decent opportunity. They worked there because they had to. Most of them were rough before they even got to the mills. And the mills made them even rougher. (I don't remember a single female working in the mills.)

There was a West Virginian who one night told me that just before coming to work, he had an argument with his wife. He showed me his right hand. His fingers were stained with nicotine from too many cigarettes. His knuckles were scraped. He said he left his wife slumped like a rag doll against their kitchen wall.

"It looked like she was peeling tomatoes," he said with a smile that revealed a missing front tooth and a deep emotional imbalance. Having grown up in a household where there was *never* any physical violence, I was really shaken by this. It was like somebody punched me hard in the core of what I believed was good and bad, right and wrong, in the world. And it hurt.

I get through eight hours of this and I leave the place and not just my ears but my whole body, my entire being, is still ringing. Numb. After working there a couple of weeks, I understand why guys went straight out of the place through that tunnel and right into one of the bars that lined both sides of Franklin Avenue to knock down shots and beers no matter if it was 10 minutes past midnight or 10 minutes past eight in the morning. Because it was the shots and beers that rescued our senses, that brought feeling back to us. It was a reward for having survived the place. I joined those guys after work more times than I'd like to admit. A couple of shots and beers after work isn't too bad. Guys got into trouble when they needed a couple of shots and beers *before* going into the mills.

Jungle Julie

One night after the 4 p.m. to midnight shift, Butch and I slide off to a bar where they stay open late, where management looks the other way if you're underage (I was not yet at the drinking age of 21 years) and where some pretty sketchy stuff goes down on a fairly regular basis, all of which is precisely why we go there.

The place usually is filled with mill hunks, strung-out old guys and just plain people who don't have much better to do with their lives. They're all hunched over a heavy, dark wooden bar, strewn with beers, shot glasses, smoking ash trays and loose money.

This night (I don't remember the name of the place) the sketchiness features "Jungle Julie." She's only marginal in terms of looks but pretty wild in other categories, so I'm guessing that's where the "jungle" part of her name comes from. I suspect "Julie" is not her real name, either.

So "Julie" hits the juke box with Bob Dylan's "Like a Rolling Stone," and for the next six minutes and 50 seconds she mounts the old, wooden bar and rips off every piece of clothing right down to her birthday suit and a couple of rings on her fingers and she's dangling her no-longer-private jewels *in. our. faces.*

And by the time Dylan is done with his riff the boozers, losers and regulars at the bar are mesmerized with their mouths hanging open, and Butch bets me that they are so horny that every one of them can pound metal spikes into that wooden bar with their own God-given tools.

As Dylan himself might ask, ah, how does it feel?

The Fall

It was to the mill and its culture that my father relinquished part of his life so that every day when it was over, he could return home and work on what was really important to him: His family, which he and my mother began to build only hours after that wedding at the Knights of Columbus hall in West Aliquippa.

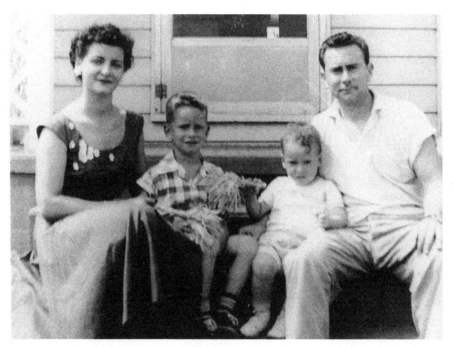

CENTER TOWNSHIP, PA – My mother and father on the front porch of our new home. My older brother Lou is on the left. That's me on the right.

My mother was pregnant with me when in November 1950 she, my father and my older brother moved from West Aliquippa to a new house in a rural area. It was wood frame and had only two bedrooms, but it was built on an acre of land and, with the help of a loan from the Veterans Administration, it was theirs. At the time, there was only one other house on the dirt street. My mother recalled how the house smelled brand new. Because it was. I was born the following February 1951.

My parents were on a roll. The war was over. My dad had a stable job in the mills. They just bought a new house. And now they had two sons.

Italy was far away, but my parents were part of the burgeoning Italian community in the New Country. We would be the only Italian family on the increasingly populated street, so we were something of a novelty. We referred to the other residents as "cake eaters." I don't

know where this name came from, but I suspect it had something to do with what we perceived to be their bland, unnatural diet. We got along with them anyway.

It must have seemed like we were on a streak of good fortune and grace. Everything was so possible here. My parents might even have been tempted to believe that nothing could go wrong with our lives in America.

I don't know many of the details surrounding this part of our story because most of the people who were close to it have since passed away. In fact, the guy who was friendliest with my father in the mill and who was nearby at the time had died about six months before I started to research this book in earnest. This is what I know:

My father was working above the hot bed, training a rookie co-worker who pushed the wrong switch and accidentally knocks my father off the overhead scaffolding. My dad fell. I don't know how far the drop is. It could have been just a few feet and he might not have had much time to think of much. Just react and maybe brace himself. Try to get balance and land on his feet. But I suspect it was a longer drop, since the ceilings in those buildings are 50, 60 feet high, in which case a lot of things could have whipped through his mind. One's mind moves so fast, and at the same time so slow, during accelerated motion that culminates in trauma. Like a car accident that you see coming. While it's happening, everything moves in an instant. But it unfolds in slow motion. Slow enough to see it coming, but too fast to react. It's the same way with falls. If it was a long drop, my father could have looked at the steel glowing red beneath him and considered the consequences of landing on top of it. Being a God-fearing man, he probably thought of his Maker and maybe even had time to call out to him, probably in Italian, "Oh, Di." There might have been an instant to think about his new wife and their new home and their new sons. I had been born only a few months before. Maybe he thought of me.

My father fell on his back. He hit the hot steel and his clothes ignited like they were made of dried straw. This is what my mother was told, or at least what she remembers, or maybe what her psychological defense mechanisms allow her to remember.

"He was quick enough to fall off the rolls onto the ground and he rolled himself on the ground to put the fire out," she told me decades later. "And I guess his friends, they picked him up and they took him to the doctor over there. They bandaged him up and everything but I do remember that the next day, when he came home, he urinated blood. And we put it in a container and we brought it to the company doctor the next day."

"That's not blood," the company doctor told my mother.

"Well, what else could it be?" she said.

These were the days before the United States became the most litigious nation on the planet and before "The American Dream" mutated into a nightmare that meant getting hurt, or nearly getting hurt, and suing somebody or some corporation for a pile of money then sitting on one's butt and doing nothing constructive for the rest of one's life.

When the mills denied any responsibility for the accident, my mother recalled, "Your father didn't want to push it. He never wanted to do anything about it because, he said, 'I have sons that have to go to the mills, that have to depend on these mills, so I'm not going to push it.'"

(My father was right. All of his sons eventually worked in the mills, mostly to put our way through college. If my father had sued the company, it's doubtful that we ever would have been hired. Old Country wisdom.)

My father went straight back to the mills after the accident, having missed a couple of days but not many. The external wounds healed pretty quickly. The interior wounds did not.

By the time my brother David was born in August 1954, the discomfort and fatigue my father experienced as a result of the accident had gotten worse. The fall in the mill had damaged his kidneys, and in 1955 he underwent an operation to remove a clot in the urinary tract. In the beginning my father was never real sick. He'd go to work despite not feeling 100 percent and otherwise lived a normal life.

Everybody in the family worked, and I think this was a result

not of my father's injuries or subsequent illness but of a work ethic brought over from the Old Country. We never had luxuries when I was a kid but we never wanted for necessities, either. My father kept a garden on the land behind our small house, and we all took part in the yearly ritual of preparing the land and then planting it. While the neighbors spent their time prissying their lawns, we'd horrify them every spring by tearing up our own back yard with shovels and then, to make matters worse, we'd go to a nearby horse farm and haul manure home in the back of the old station wagon and spread it out on the freshly plowed earth.

Every year we planted tomatoes, beans, corn, swiss chard, onions, carrots and parsley, and I can still see my father kneeling on one knee in the jungle of green, using strips of cloth to tie tomato plants to poles to prevent the weight of the plants from pulling them down to the ground. I can smell those plump, red tomatoes to this day. He even built a trestle and planted grapevines around it and while we never had enough grapes to make wine, I think he did it just as a matter of preserving the Italian tradition of growing grapes. I remember they were the dark ones with thick skins and big, hard seeds. He trimmed the house with daisies, his favorite flower, and I see them now as a symbol of himself, nothing fancy, just simplicity, plain beauty and grace. He built a big wooden lounge chair, painted it an awful turquoise color, and basked in the opportunity to review his vegetables and his daisies from his homemade turquoise throne.

My mother spent Saturdays making Italian bread and from the garden behind the house and across the neighborhood, we could hear her singing in the kitchen, and late in the afternoon we'd take to the big green picnic table my father built and eat huge salads and devour loaves of my mother's bread. I think it was from my father that I inherited my sense of ritual. Once at the dinner table the plate of bread was beyond my reach, so I stuck one of the slices with my fork.

"Never do that to bread," my father said. "It's a sin to do that to bread."

There was a special regard in our house for bread and to this day I don't know if that regard has its roots in the Catholic religion and

the miraculous conversion of the communion host to "the body of Christ" during Sunday mass. But we never threw bread away, not even when it got stale. In fact, my father liked it stale. He would wet it just a bit with cool water, pour olive oil over it and then salt and pepper and eat it with a salad or a couple of fried eggs or just by itself and it was great.

On weekends we were allowed to stay up late and wait for my father to come home from the 4 p.m. to midnight shift. My mother would prepare him something simple for his dinner, maybe just a couple of fried eggs and bread, but I can remember him eating the food with uncommon gusto and afterward putting his feet up on one of the heavy wooden chairs in the kitchen. He'd talk for a while and maybe smoke a filterless Lucky Strike cigarette, and then my mother would send us boys off to bed so that she could be alone with the only man she ever wanted to be alone with.

My older brother was good-natured despite a thick frame that others found intimidating. His appearance masked a self-awareness normally attained at a much later age. I was skinny, freckled and shy, eventually with a cowlick at the forehead, my hair unmanageable, defiant of even the most potent sprays and creams of the day. From his early days David was broad-shouldered, muscular and wild, uncontrollable despite the threat of my father's belt.

In 1948, my maternal grandfather, Tada, suffered a massive stroke. It was as if he had never recuperated from the wartime death of his son Tony, his own health sliding downward since the day that letter arrived at his front door only four years prior.

Tada lay in bed for three days, his massive body wasting away. He was lucid. Always a neat man, Tada felt unkempt because of the stubble on his face and said he wanted to shave but could hardly move his arms, so somebody asked him, "Who do you want to shave you?"

"Tell Guerino to come," my grandfather said, my father being the only person Tada would allow to cut away his whiskers. It was the last time that he would ever be shaved.

After the accident in the mill my father was getting sicker, too. His

kidneys were failing little by little, and I remember his visits to the hospital. With each bout of "sickness" and as his general condition worsened, my father became increasingly depressed.

One summer day I heard my father's yelling coming from inside our house. My mother and her sister, Aunt Jessie, were in there trying to convince him to go with them back to the hospital, a place he despised because of the pain, the needles, the feeling of powerlessness, the separation from his family. I stood outside the hospital building, waving at my father in his window way up in the top floors of the hospital. Because I was too young, I couldn't go inside. I'm sure this is where I developed my phobia for hospitals.

So my parents came up with the idea to have another child, the objective being to inject new life into the household. My parents' fourth child was conceived with one purpose in mind: Try to cure my father's deepening depression over his recurring illness, children of course being the most effective antidote for sickness and death.

The Perfect Medicine

Robert (we call him Robby) was born in 1959 and turned out to be the perfect medicine.

"Robby was a gift child for us," my mother explained years later. "He was irrepressibly happy." She told me how, when holding Robby in her arms up against her shoulder and patting him on the back, Robby would actually pat her back in return. He was, and still is, the sweetest and best-natured of her four sons.

I remember when my brother began to walk. Actually, he began to run before he began to walk. It was one evening in our house in the country and the folding bed was open, and for some reason Robby just got up and ran to the kitchen. I can see him running back and forth, from the living room to the kitchen, barely able to stabilize himself on wobbly legs, but totally exhilarated by his ability to run, squealing and laughing as he sped back and forth from one room to the other.

"He was a pet!" my older brother, Lou, would later say. Robby's

arrival did, in fact, lift my father's spirits and for a while his health improved.

Now there were four sons, to some perhaps a quirk of nature or an accident of human reproduction, but to my father a measure and affirmation of his own manliness. I suspect his not-so-secret desire to have sons as opposed to daughters was rooted in the tradition of men who work the land, in places and times before retirement or Social Security ever existed, when the only insurance a man had against loneliness and abandonment during old age was the number of sons he had to work the fields for him when his health gave out. And I guess a lot of it was just old-fashioned Italian machismo. I can remember my father walking into family reunions with the four of us in tow as if he were the head coach of a football team walking into a stadium for the big game, and I can still see the looks of envy on the faces of my relatives holding daughters in little pink dresses.

Work in the mills had its ups and downs, these being the days when the labor unions were beginning to challenge the absolute control of the mills over the workers' lives. They began to strike, which in the long run meant better conditions for the workers, but in the short run meant harder times feeding their families. I grew up listening to my father and my uncles recounting stories of men fighting in the streets against corporation "scabs" brought in from other cities to replace striking steelworkers. I don't recall if my father was laid off or on strike at this time, but I do remember that my parents had bought a new washer and dryer. But because of the labor disputes and my dad's increasingly failing health that further restricted his work, they began missing bill payments, something my mother called a "monumental" problem. So, she convinced my father that she should take a job as a cashier at a supermarket in town, something that violated the basic creed of my father's existence.

My mother arrived home for lunch one day less than a week after having begun her new job. My youngest brother Robby stood waiting for her in a soiled diaper. The house was a disaster, sabotaged by my father's Old World beliefs. He had purposely allowed the house to fall

into disarray and had even stopped my brother Lou from cleaning up.

"When I saw Robby there in front of the door, I'll never forget, I thought I was going to break down and cry right then and there," my mother said. "My kids, just like orphans without their mother."

My father stood in the doorway and, just in case my mother hadn't already gotten the message, he read her the new constitution: "Even if we have to eat bread and water we're going to be home together with our kids, and you're going to be the mother and I'm going to go to work," my mother recites his words as if it were yesterday. "To hell with the bills. This is the way it's going to be."

My mother quit her job the next day.

My father was not opposed, however, to my mother making bread at home and selling it to outsiders. We ended up with three ovens in

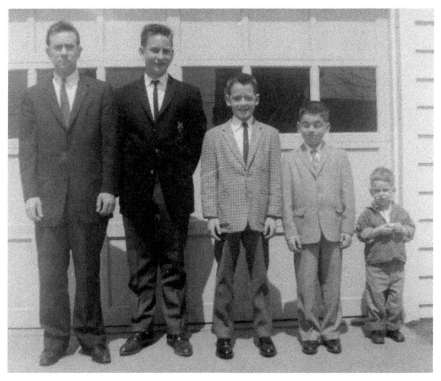

Dad, Lou, Bill, David and Robby, the Gentile boys.

the house, and on weekends you could smell the bread half a block away. My mother slaved to make a few extra bucks by selling the bread to neighbors and friends of the church.

We all put our shoulder to the wheel. Lou acquired a newspaper route as soon as he was able to manage the papers' weight, and I got one myself when I was 10 years old. He carried the *Pittsburgh Press* and I delivered the *Beaver County Times*. Every day after school, while our school friends were studying or cuddled up in their homes, my brother and I hiked for the hour and a half it usually took us to deliver our separate papers. On Saturdays this was particularly disruptive because instead of playing ball or going to the swimming pool, our days were broken up by the demand to deliver the papers on time. Neither Lou nor I ever saw any of the money we generated from this work. It all went back into the family coffers. And this was OK with us. We were helping out.

Sundays were fun. Especially the winters when my father, Lou and I got up before dawn to retrieve the papers that were wrapped in bundles with twine by the delivery man who left them in a big wooden box at the end of our street. We cut open the bundles and assembled the papers from each of their components, which were wrapped separately. But the Sunday editions were too thick and heavy for Lou and me to carry the entire distance on the long routes. So with our father we'd pile them up in the back of the station wagon and with the rear door opened wide so that the back of the car looked like a big mouth with the tongue hanging out, my father would drive along the route while Lou and I snatched the papers out of the gaping back door and ran them to the homes of our respective subscribers.

Winters in southwestern Pennsylvania were brutally cold and having to run through the snow carrying newspapers is hard work but I enjoyed those Sundays because they were a team effort and because they always posed the threat of risk and danger. There is a steep hill at the end of Ivy Lane, and our father had to either take the chance of getting stuck in the snow while driving the station wagon all the way to the bottom of it or make us carry the papers all the way down

and then burn up time running back to the car. Normally he took the chance driving down the hill, and I remember Lou and me pushing the old station wagon back up the grade with my father behind the steering wheel, holding open his door while watching his sons heave the jalopy up the street and smiling all the way because he knew that, partially because of this, his boys were becoming men.

And at the time, of course, I could not understand how these lessons of determination, hard work and love of family would someday serve me so well in a place called Central America.

As childhoods go, it was a happy one, free from the dark stories of abuse, alcoholism, drugs or violence that you hear about families today. That never happened in our home. We were kind of on the edge. We always had plenty of food, partly because we produced much of our own. But we didn't have much more.

One of my newspaper customers lived on Chapel Hill Road, the outer limit of my delivery area. They were a middle-aged couple, no children. It was wintertime. Every two weeks I'd come around to collect the 84 cents I was owed and this collection day was a particularly cold one.

"Where's your gloves?" the lady asked as she passed a dollar to me, my hands stiff from the cold. She was one of my favorite customers because she always let me keep the change. Some customers even gave me a quarter tip on top of it.

"I don't have any," I said. I was still a little too young to feel ashamed that I didn't have any gloves but I remember, at the very least, thinking that I was different. "Thanks for the tip."

That Christmas the woman gifted me with a pair of gloves.

What I found disturbing about growing up was not that we had "less" than others but the fact that there was "sickness" in our house, the recurring bouts of our father's kidney failure caused by the accident in the mill. And for me, these unexpected, totally unpredictable periods of sickness and stays in the hospital, were profoundly confusing. Why us? Why did we have to be different like this?

Once after sickness had come into our home, I remember my fa-

ther sitting in front of the black and white television watching one of those preacher/huckster, snake oil salesmen hawking salvation and miracles for a small donation. "Put your hand on mine. Touch my hand and you will be healed," the huckster said. Desperate for a normal life, my father put his hand on the TV screen and began repeating whatever the preacher was saying. My mother walked into the room and, horrified by what she saw as blasphemy, tried unsuccessfully to pull my father's hand from the screen. It was then that I learned to distrust TV evangelists.

At the time I never understood what this all meant, never grasped the ultimate consequences. How it would end. My father would eventually come back home from the hospital, and our lives would resume. We always got back together. In retrospect, I think my father understood what it meant. I remember resting in his arms while he rocked me back and forth, touching my head with a tenderness uncommon for hands that shaped steel and forced life from the land, and whispering, "My son, my son" over and over, as if these words were holy scripture or a magic mantra and by just repeating them he could keep all evil from me or somehow forestall what he knew had to come.

These were incredibly formative years during which I first began to understand the concept of family, how each member fit into our family, and how our family fit into the larger world around us.

This also is a time of interacting with members of the extended family.

Uncle Vince and his wife, Bertha, had four children, my cousins Dave, Tony, Vincie and Angela. Vincie had a permanent smirk on his face that made him always look like he had just taken a bite of a lime. He was so mischievous that his own mother referred to him more as "that little devil" than she did by his real name. Named after my Uncle Tony killed in Normandy, my cousin Tony was beyond mischievous, some of his behavior reportedly bordering on the delinquent. Lou and Vincie hung out together, a lot of their time spent on the periphery of Tony's antics. I was a distant observer.

We all looked up to Tony because he was the typical local tough

guy, a star running back on his high school football team, always working on a hot rod and always hanging out with loads of friends. And he smoked cigarettes, at that time the ultimate teenage cool. We went to visit once at his place. Tony was sitting on the radiator of his latest car, the engine between his legs, the hood leaning against a wall in the garage, his friends hunkered around. It's cold, and Tony reaches into the pocket of his football jacket and pulls out a pack of smokes. The cellophane wrapper makes a crinkling sound. "Gimme a light," he says to nobody in particular, and about five guys fumble in their pockets to give Tony a light.

Tony was a bit of a tormentor known for getting into trouble and we respected him for it even though he spent a lot of time tormenting and making fools out of his younger brother Vincie and my brother Lou. I was kind of on the sidelines of all this because I was younger but was around enough to see what was happening and to even be part of the follies.

There's the story about Tony and one of the steel workers who parked his car right across the street from the house on the riverfront where Tony and his family lived. Tony tied one end of a bull rope to the car's bumper and the other end to a guard rail, somehow got into the guy's car, released the emergency brake and pushed the thing over the bank of the river, and when the guy came out after work he found his car hanging halfway down the slope to the Ohio River. A group of steelworkers hauled the victim's car back up the riverbank as Tony and some friends watched with smiles on their faces. My Uncle Vince didn't take stuff like this too lightly and had warned Tony about any repeat stunts like this one, underlining his displeasure by brandishing a razor strap, those heavy leather belts that barbers used to sharpen razors for shaving clients. The ultimate punishment.

There was another time, when Superman was the rage and every American kid wanted to fly, and Tony came up with what he called a magic formula that, when sprinkled on one's back, enabled people to take to the sky. So, Tony gave a bottle of this "fly oil" to his younger brother Vincie and my brother Lou. I followed them through the back

yard to the garage. I can still see Tony standing there watching the three of us, after having sprinkled the "magic formula" on our backs, taking turns jumping off the roof of the garage trying to leave the earth in flight. I was the youngest and the most afraid of heights, so I stayed on top and watched Vincie and Lou plummet to the ground first and remember falling to the ground myself and can still see Tony standing there laughing and yelling, "You're not doing it right, try it again," and then laughing some more as we followed his instructions. We found out later that the magic oil was really a mixture of Tony's urine and plaster dust.

One night coming back from Uncle Vince's home it was Vincie driving his brother Tony's dilapidated car. I was sitting in the back seat with Lou. Nana, who my mother had asked to come out to the house for some unknown reason, was up in the front seat. The muffler on the car had given up long before and the thing was a continuous roar going down the road, especially when Vincie floored it, which he did every couple of minutes just to get a rise out of our grandmother. Every time he hit the accelerator the car sounded like it was going to explode and Nana would wail something to her Italian saints and beg Vincie not to do that again, which of course he promptly did, setting off another plea to the saints and another round of squeals and laughter from us all the way home.

I knew something was wrong as soon as we walked into our house. Somebody pulled Robby away and hustled him off to a neighbor's house. I came through the door next and Lou was after me. I drifted into the kitchen a bit bewildered by all the people in the house and my mother met Lou at the door where he stood frozen. She bent over and said: "Your father's gone, honey. Daddy died."

And that was the day I lost all trust in the world.

"Protect the Family"

I wouldn't know it until I was well into middle-age but my father had actually laid the groundwork for his own departure long before

we walked into the kitchen that evening when we were kids. And it is a measure of how difficult it is to discuss the subject with my older brother that it's taken so long for me to find this out. To really probe him for answers.

It was in those final days of his life, when the sickness in his kidneys had triumphed over all the doctors and their medicines, when it had defeated even the "perfect medicine" of my brother Robby, that my dad began to confide in my older brother. My mother tells me that even toward the end neither she nor my father realized that he was going to die, that they always held out hope for kidney transplants despite the fact that in those days the operation was completely experimental. This was my mother's version but I think it is not accurate, not from what my brother tells me. Deep in his heart my father must have known he was dying. Lou tells of how my father would slip into our bedroom at night and, believing my brother to be fast asleep, take a seat on the bed beside him.

"He used to stroke my head and tell me what to do after he was dead," my brother told me. "'Protect the family. You're the oldest one. Protect the family.'"

There is a picture of my brother that my mother kept apart from all others of my childhood. It was taken when Lou was 13 or 14, before this dark period of "sickness" really began to take its toll on our family. She treasured this image of my brother when, as she put it, "He was confident and serene," serenity being something that would elude him for much of his life and confidence being something he would build along the way. Because that day when my mom told Lou that "Daddy died" and the world caved in, it came down mostly on his shoulders. Because he was the oldest, Lou would have to do the heavy lifting for the rest of us.

(In an envelope my mother marked to be opened "only after my death" was a note saying she loved all her sons equally but gave special thanks to Lou for being "my rock." I had actually found the unsealed letter while organizing my mother's belongings while her health was slipping. I did not open it. I sealed it and left it in place.)

So, by the time my father died my brother had become more than a brother. In the vacuum left by our father, Lou stepped into the paternal role as well. He had assumed the mantle of our family. Luckily for everybody, he was suited for it. None of the others would have been able to take on that responsibility. I suppose there's a certain "growing" into that position but looking at it really cold and hard, I don't think any of us had the internal moral compass; the crystal-clear sense of right and wrong; the sound measure of himself and of his role in the family; and the physical strength and stamina to execute that role. I don't believe David, Robby or I possess all of those attributes. Only one of us did. And that was Lou. I was the next in line, but I think genes and the events of our youth had a different impact on me. I believe they made me, on some level anyway, more reflective, sometimes more unsure.

Lou went off to the Navy in 1968, at the peak of the war in Vietnam, and I was left at home to hold down the fort. I was just moving from high school to college at Penn State University, but I spent the first two years at a "branch" or local campus, partly because I couldn't afford to go away and partly because I didn't want to. With my brother gone, my mother needed me to stay close. It was my turn to step into the breach.

And it is here, I think, that I began to see my role emerging as the one to expose the rest of the family to new things, to new ideas, both on a direct level and vicariously through the experiences that I sought out. Recognizing my younger brothers' need for sources of self-esteem just like any normal kids, I took David and Rob to their first karate lessons, something that David immediately thrived on, Robby less so. David was not only a natural athlete, but karate also seemed to provide him a place to channel energy and aggression. Robby was more contemplative. Unlike all of his brothers, Robby never wanted to be a tough guy.

I eventually found my way to Penn State's main campus in central Pennsylvania, where hunting and fishing thrived. When hunting season came around, I made sure David had a high-powered rifle with a

scope and took him to the mountains where he killed his first buck, a six-pointer. When small game season rolled around, I borrowed a friend's car, drove home from college for four hours to pick up Robby, and then returned again to traipse through corn fields hunting for rabbit and pheasant. My contribution to the family would be different from that of my older brother, perhaps not as concrete or as practical but hopefully as long-lasting. My job was to be a conduit between my family and the rest of the world. I wanted to expand our world to make my brothers understand that the walls around our existence at home were neither too thick nor too high for us to punch through or scale over.

It was during this awkward time of growing up and finding my place in the world that I concluded I didn't like the place where we lived. This conclusion was based on what I perceived to be "all the problems" that affected us after our father died and on the reality of the place itself. Partly because the memories of my childhood are so black and white, I wanted to get out and find some color in life. Some vibrancy. I felt that something was missing. It felt like I didn't have enough space. The ceilings of our home were too low. The walls too close together. I felt the community we lived in was too unconnected to the rest of the world. I wanted to get out, and I wanted my brothers to know that there *was* a way out.

Saved

My brother returned home from the Navy in 1970 and stepped off a Greyhound bus into a real danger zone. For lack of anything better to do, he took a job at the Center Township Road Department, fixing potholes in the summer and plowing snow in the winter. He started to take courses at the local community college but was hardly interested. He took the advice of a friend and applied for a job with the Pennsylvania State Police. It was a long shot but what the hell. Nothing else was happening.

When not working at the Road Department he spent most of his

time at the Skyview Lounge, a dark and dusty little place on a back road not 10 minutes from our home. Lou became pretty good friends with the owner of the place, Dominic, a former professional football player with enormous hands and a face to match, something like you see on a horse. Long. Dominic gave my brother a part-time job as a bartender, not really a positive development according to my mother who chided my brother for spending so much time there, saying the place was called "Skyview" because its patrons spent so much time wiped out on their backs staring up at the heavens. Viewing the sky.

On his workdays and even on his off days, especially weekends, my brother hung out at the Skyview with guys I'll call Mo, Johnny and Matt. Mo came from a hard-working, mill-hunk family. Dark-skinned and burly, Mo was known for the muscle cars he used to drive. Monsters with 440-cubic-inch engines, fuel injected carburetors, headers, four-on-the-floor stick shifts, geared-down crankcases, dual exhaust, the works.

Johnny had no family. His mother died when he was a kid. While they were in high school his younger brother died, I think of some form of cancer. He was Johnny's only sibling. And a few years after that, his father left town. Johnny was really charismatic, a nice-looking kid and, despite all the loss, always smiling. Except when he got in a fight. And beside chasing skirts, that's mostly what Johnny did. Fight. Of all the guys down at the Skyview, I liked Johnny the most.

Then there was Matt, whose father was an alcoholic who stumbled around from bar to bar. Matt and his father would travel from their home in Pittsburgh just to be with the gang at the Skyview. Matt was morose, brooding, a victim of his father's embarrassing behavior.

These were some of the main characters at the Skyview. It was one of those places that you didn't go into if you didn't know the people inside. Because you could get into trouble. I don't think I've ever seen a Black person in the place. One night Johnny got into a fight with a guy who wandered into the bar, I guess from another town. They were fighting outside in the parking lot and the guy, who was bigger than Johnny, was on top of Johnny pounding the shit out of him and

Johnny says, "OK OK enough." So the guy lets Johnny up and Johnny sucker punches the guy right in the face and it sounded like a grapefruit thrown against a brick wall and then Johnny gets on top of him and leaves him in the gravel parking lot in a puddle of his own blood and a couple of teeth. Johnny could be really mean when he wanted to. It was kind of scary watching him fight because Johnny hated the world that took his family away and he wanted to hurt it back.

Johnny showed me his new knife. A shiny black switchblade.

"When you fight with a knife, Billy, you never hold the thing by its handle," he said. "You hold it here, on the blade, about an inch and a half, maybe two inches back from the tip. That way you cut 'em but you don't kill 'em."

That was some of the "advice" I got while growing up.

So, my brother was riding the edge with these guys, never really getting into trouble but never really finding an avenue for all the energy, or the frustration. These were the days when he and his Skyview buddies thought they were invincible, when they could drive, fight, eat or drink anything. And drinking was a measure of manhood. Guys who could drink got respect. The more you drank, the more respect you got assuming, of course, that you handled drink well, assuming you didn't get sloppy drunk.

In everyone's life there is an event, or a person, or a series of events or persons, that determine the course of that life forever. It can be a teacher who has a profound influence on a student. It can be a relationship with a friend or a lover. It can be an auto accident, a heart attack, or any number of things. In 1972 one of those events occurred in the life of my brother. It would change his life, and him, forever.

The yellow phone with the knotted-up cord hanging from our kitchen wall rang. I watched my brother pick up the phone and listen to a voice on the other end of the line. It was as if fate herself had called that day and with a firm voice told my brother, "Now, you come with me." When he put the phone back down on the receiver my brother would never be the same.

"It was the State Police," he said. "I've been accepted."

And saved.

At the time, and even today, the Pennsylvania State Police is considered one of the elite law enforcement organizations in the entire United States. Its officers are tough but fair, utterly professional. The force was extremely selective in terms of whom they allowed into its Academy. Acceptance to the Academy meant the beginning of a six-month training course, a test not only of physical stamina and endurance but also of intelligence and emotional toughness. In some ways it was tougher than military boot camp.

There is a photograph, cracked and blemished by moisture that seeped into the plastic sleeve of the wallet that still holds it, in a cigar box on my desk. There's my brother, leaner than I've ever seen him, in a pressed gray uniform wearing the classic Smoky the Bear hat, his face still untouched by the chronic exhaustion that would mark it in later years. I was in my last year at Penn State and I still had fairly long hair. My lovely college girlfriend Diane is standing there with

HERSHEY, PA – My brother's graduation from the Pennsylvania State Police Academy, where he graduated first in his class. On the left is my college girlfriend, Diane. (Photo by Rob Gentile)

those legs that stretch from here to New Jersey. My mother couldn't make the graduation ceremony and I thought it unacceptable that my brother be without family that day so Diane, my youngest brother Robby and I went. It turned out good that we did. The troopers who had no attending family were made to set up and take down chairs used during the event, a chore that, half a century later, I still think would have been unbecoming of my brother – especially since he graduated at the top of his class.

The State Police would give form, shape and purpose to Lou's internal design that had yet to find an avenue of expression. My brother would disagree with the following analysis, but I'm convinced that I am at least partially right:

My brother's graduation from the Academy forever reinforced his perception of himself and of the world around him. Having become one of the best and the brightest of the nation's law enforcement officers deepened his sense of righteousness and mission and confirmed his belief that he lived in a world that is essentially hostile, at least toward us. Toward him. Utterly convinced of himself, he steamed full speed ahead through a world that was almost completely black and white, devoid of subtleties or grays. And he did so with an aggressiveness appropriate for a man into whose head had been drummed the conviction that he was a highly trained and professional law enforcement officer and that the world around him was a hostile place to be dealt with by using appropriate force, or at least the threat of appropriate force.

And I sympathize with this position. If you've ever worked closely with police, and if you've ever seen not just the scum criminal element that they have to deal with every day, but the normally law-respecting citizens transformed by drugs, alcohol or emotion into something resembling that scum criminal element, then you can understand why guys like my brother have emotional and psychological hair triggers. Cops inhabit a world of extremely personal aggression and unpredictable violence. And the survivors learn that if someone even hints that he's going to hurt you, then you either have to hurt him first or let him

know that you are absolutely ready, willing and actually praying for the opportunity to hurt him first. Fire with fire.

My brother is working the Pennsylvania Turnpike, inaugurated in 1940 to promote commerce. It is a crucial roadway for truckers moving everything from oranges to automobiles across the state and the country.

He pulls over a trucker because of some infraction and asks the trucker to step out of the cab.

"I'm not getting out of the cab," the driver responds.

"Please get out of the cab."

"Fuck you, I'm not getting out of the cab."

My brother reaches up through the open window and pulls the guy – by the neck through the window – down to the pavement and places him under arrest.

Leaving for California

If my brother's new-found career saved him and solidified his role as guardian of the family as my father had requested, it also complicated the relationship between him and me. Even before graduation from Penn State, I had secured a job as a salesman for a paper company in Charlotte, North Carolina. It was there that I deepened an interest in photography. A friend of mine was an avid photographer who spent as much time as possible on the Outer Banks making pictures of surfers.

My professional life there lasted about a year and a half. I was completely unfulfilled by the job and clueless as to what I wanted for my future. I quit, sold a bunch of my belongings, bought an old Volkswagen bug and set out for San Diego, California, to hook up with Penn State fraternity brothers who were out there in law school.

I headed west, alone in my brand-new, second-hand bug. I fasted during the four-day drive to California, cleansing my system of frustration and watching the movie that featured myself as the only man

on the planet rolling through the southern desert, high on hunger, determination and expectation.

My family was in shock and my older brother was particularly unhappy, seeing the decision not just as an irresponsible departure from the plan he inherited from our father, but also as an abandonment of familial responsibilities. And of himself. It would be a long time before we would reconcile.

NASCO

In San Diego, I hand in an application to a clerk at the National Shipbuilding Corporation (NASCO) employment office. The guy looks over the application and says, "You have a college degree. What are you doing here?"

So I explain, need a break, blah, blah, blah, try something new, blah, blah, blah, check out California, blah, blah, blah, and he hires me as a heavy crane operator and for the next couple of years I work in the shipyard where we build giant oil tankers. It's an anthropological experience. High school dropouts, former and current abusers of alcohol and illicit drugs, Jesus freaks, atheists, extreme leftists and rightists, zealots of every imaginable endeavor or creed, desperately lonely souls, African-American, Mexican immigrant, Asian, white, black, brown and everything in between mostly men and very, very few women, from just about anywhere in the country and all wrapped up in a culture of tough, working-class, Otis Redding sittin'-on-the-dock-of-the-bay, nostalgic but proud kind of stuff. And insular. Protective. Wary of outsiders which, in the beginning, I was. An outsider.

And I'm fine with that.

A Ticket and a Tool

It is during this experimental period that my interest in photography crystallized and I decided to attend graduate school for a masters degree in journalism.

I had figured out that journalism could be a ticket and a tool, both of which I yearned for. A ticket in that it could deliver me from a life in the steel mills where I never wanted to return after working my way through college; and a tool to engage in, and hopefully impact, the world around me, as those *Life* magazine pictures from Vietnam had made an impact on me. This was just after Watergate, when journalism still was held in high regard.

I drove my old Volkswagen back to the East Coast, this time over the northern route that is Interstate 80, stopping off in Boulder, Colorado, to visit a friend.

While waiting to be accepted to graduate school I worked on a crew repairing the highway between the Pittsburgh International Airport and downtown Pittsburgh. My brother, the State Trooper, got me a coveted membership in the union associated with that project, and I worked 10-hour days, six days a week for $10 an hour. Good money at the time.

The team I worked with were mostly Italian immigrants. They used shovels, balls of string and rudimentary levels to lay the rivers of concrete connecting the airport and the city. I saw them as descendants of the Romans who began building aqueducts in Italy some 300 years before the birth of Jesus. Some of those structures still are in use.

One of the men asked me in broken English about the book jammed into my blue jeans' back pocket. "Hey college boy. What you read?"

I held it up for him to see. A copy of David Halberstam's, *The Best and the Brightest*, about how the Kennedy administration stumbled into Vietnam on the advice of some of the finest minds in the country.

A shovel in one hand and a classic of foreign war correspondence in the other, I stood there at a major juncture. I had found the ticket and the tool that would define the rest of my life. And it was called, *journalism.*

MANAGUA, Nicaragua – My Nicaraguan family includes (left to right) Claudia's father, Dr. Alberto Baca Navas, his wife, Norma, Claudia, her sister Gabriela, and her youngest brother, Danilo. Missing are brothers Jorge and Guillermo, and sister Johanna. The home where Claudia and I lived for much of the 1980s is in the background.

CHAPTER 6.

NICARAGUA AND NICARAGUANS

Chickens, Bats and Journalism

I had arrived back in Nicaragua on May 13, 1983, four years after covering the revolution and only weeks after that fateful dinner with my mother in a New York City restaurant when I announced my plan to leave my job at UPI and take up residence in a country at war.

I landed in the capital city of Managua with a few hundred bucks in my pocket and I went to work the very next day. The movies depict the lives of foreign correspondents as all glamour and adventure and, while some of that is true, my first year in Nicaragua was anything but fashionable or tantalizing.

I had a retainer with NBC Radio, initially $600 a month, to feed them as many stories as possible. The *Baltimore Sun* was paying me $100 for each article I filed, and these weren't spot news stories. These were analyses that would take me days to report and a couple of days to sit down and write. I had a decent string arrangement with UPI photos. My old friend Lou Garcia, with whom I covered the Sandinista Revolution in 1979, was UPI's Latin America photo chief based in Mexico City. And I had a friendly but barely existent relationship

with *Newsweek* magazine. They had used some of my photos during the revolution and knew who I was, so before returning to Nicaragua I stopped in at the magazine's headquarters at 444 Madison Avenue in New York City to show them my portfolio. But by this time my "suicide stringer" friend John Hoagland was on contract for the magazine, covering all of Latin America and the Caribbean from his base in El Salvador, so they really didn't need anybody in neighboring Nicaragua. Not yet.

Claudia was working at a Sandinista government-run publishing house but that didn't pay much, and I had come to Central America with more debits than credits so during that first year Claudia and I lived on her family's plot of land on the outskirts of Managua. It was a small compound with a garden and monster mango trees hovering over everything, and when in season the mangos crashed down from the trees onto the corrugated metal roof of our "apartment" and it sounded like the Reagan administration had begun the bombing of Managua. The property included a small patch of land in the back where Claudia's family had planted coffee. There was a main house where the family lived. We converted her mother's sewing shop, which sat apart and up a little hill, into an apartment/office.

It was out of this office that I used to feed radio spots to NBC in the mornings after having read and listened to the local, regional and national newspapers and radio stations, and after speaking with *Don* Leonardo Lacayo Ocampo, whom I had hired as my tipster/advisor. Downtown Managua had to be one of the most rural city centers in the world, with horse-drawn carriages, wagons and cows fighting for space alongside cars, trucks, taxis and buses. We lived 10 minutes from downtown, and it was like being in the countryside. All the neighbors owned cats and dogs, plus chickens and pigs and some of them even had a few cows and horses. Two blocks from where we lived was a *chanchera*, or pig farm, where the portly woman who owned it had a bunch of pigs in a pen and killed one every so often to sell along with cold beer. So, there's me in the morning with a towel over my head to block out the noise and a microphone under my chin filing radio

reports to NBC in New York and the guys in Manhattan saying, "Hey wait a minute I can hear chickens in the background," and me saying, "Hold on a second," then running outside to whip stones at the chickens, chase them away then run back and finish the spots.

"Quiet!" I yelled, blowing through the cottage door. "I can't work with you guys around here. Out! Get out!" I pick up a handful of gravel and throw it at them. They scatter across the yard. I go back inside, pick up the phone and continue my report to the NBC Foreign Desk in New York.

"Sorry," I say into the phone. "They must be contra chickens," I joked. "Trying to overthrow me."

The darkroom where I developed and printed photos for UPI was a separate little building that had been used as a kitchen, and I blocked off one section of it and sealed it with sheets of black plastic around the space that included a sink. Of course, there was no air-conditioning or even a draft of wind, so when I'd seal myself into this place and it was 90 or 100 degrees outside it got a helluva lot hotter inside. Once Claudia's mother drove up the driveway into the lot when I had just stepped out of the darkroom to get some air and she looked at me soaked with sweat and asked me with a straight face if I had been hosing myself down to beat the heat. I'd go in to develop photo prints and the chemicals would be so hot that I'd slap the paper into the developer liquid and then a couple of seconds later bang it into the stop bath to freeze the image from over developing but the photos would still come up with grain the size of moth balls. One night I was making prints in the red hue of the darkroom's "safe light" and I saw something flickering around and then half in a panic I realized what it was and turned on the light to find out that my workspace had been occupied by bats. Rats with wings. Really freaked me out.

Not terribly glamorous but it was a beautiful part of my life, and I shared everything with this family, a warm, intelligent, welcoming family. Claudia's father was one of the finest attorneys in Nicaragua. He is a swarthy man of medium height and what appears to be pure Native American extraction, which makes him tougher than nails. He

is smart, funny and can go an entire weekend drinking with no sleep while he plays whatever game he's currently into, be it chess, pool, cards, whatever. The guy has an incredible level of intellectual agility. Claudia's mother is a magic woman. Smart, attractive, social, and a longtime collaborator with the Sandinista Front. Claudia is the first of six children. After Claudia are Guillermo, Jorge, Johanna, Danilo and Gabriela, in that order.

Claudia and I are alike in so many ways. One of her most prominent characteristics is her straightforward manner with people. Call it bluntness. There's never any doubt about where one stands with Claudia. She makes it immediately clear. I liked this about her though it made some people uncomfortable. I always knew exactly where I was with her. And I found it reassuring to hear from Claudia that my own bluntness with people was acceptable – at least to her. In this sense, we reinforced each other's behavior.

When I think about all this now, I am touched by the courage with which these people accepted me into their home. It is a measure of their generosity. Of their valor. I was the enemy. Or at least my country was the enemy. But these people had the character and the grace to distinguish between me and my country's foreign policy. And they did so not grudgingly, but with absolute conviction.

Reagan Administration

It's important to remember the context of my time in Nicaragua.

The Reagan administration's policy against the Sandinista government had really begun to impact the entire country, and all the positive things the Sandinistas wanted to do were put on hold just to defend itself. Nicaragua was on a war footing, the government forced to shovel 60 percent of its gross national product into defense, and with the help of the Soviet Union, Cuba, East Germany and other Soviet bloc states, the Sandinistas trained, armed and shipped off their youth to the mountains to fight the contras who were being recruited, trained and armed by the United States.

The war, the devastating U.S. trade embargo, the draft, the killing, the fleeing of the youth, the exodus of the middle class, the capital flight, brain drain, the abandonment of farmland by peasants who sought safety in cities, the subsequent disruption of the labor force and of the nation's agricultural production, all of this was happening at the same time.

To the north, American military forces arrived in Honduras for "exercises" that bore an uncanny resemblance to U.S. preparations for invasion. Many of these forces, rotated through the country, managed to leave behind tons of war matériel, stuff that mysteriously but inevitably found its way to contra forces fighting the Sandinistas. U.S. military "advisors" arm, train and advise the contras staging raids into Nicaragua. CIA advisors teach the contras how to "neutralize" Sandinista activists. In this context, "neutralize" means "kill."

To the south, Costa Rica hosts former Sandinista war hero Edén Pastora. Pastora didn't like the way the Sandinistas were going so he launched his own war against them. He was also getting sporadic American aid and advice.

In El Salvador, the U.S.-backed government is busy fighting a civil war that in 10 years will claim about 75,000 lives, most of them innocent civilians killed by government forces and right-wing death squads. In nearby Guatemala, the regime is busy carrying out a scorched-earth policy against the indigenous population that supports or is suspected of supporting anti-government guerrillas. And "scorched-earth" in Guatemala means just that. It means soldiers surround a village, then go in and kill everybody and everything. Men, women, children, dogs, cats, chickens, cows, monkeys, parrots. Soldiers bury the victims in mass graves or throw them into wells. Then they burn down the village. And that's how the earth gets "scorched."

To the great misfortune of her people, Central America had become one of the final battlegrounds of the Cold War. I believe it was Salvadoran Archbishop Óscar Arnulfo Romero who once most fittingly described Central America's dilemma, caught in the middle of a struggle between two superpowers:

"They provide the weapons and we provide the dead."

In 2018, Pope Francis canonized Romero, who was assassinated in the capital city of San Salvador as he celebrated mass in a hospital chapel on March 24, 1980. He now is known as Saint Óscar Romero.

This is the scene that I flew into when I took up residence in Nicaragua in May of 1983. And Nicaragua was the key to the whole region. At the time of my arrival in Managua the Salvador story dominated the headlines because the American presence was more visible there, because the body count was higher there, and because the war was a lot more accessible to cover there. But it was always Nicaragua that Washington perceived as the rotten apple that was spoiling the entire barrel, the source of all "evil" in the region. And it's not difficult to understand why. With help from Cuba and the Soviet Union, the Sandinista rebels in Nicaragua were the first in Central America to overthrow a repressive, U.S.-backed government. Look at a map. All of Central America is about the size of California and, at that time, with about the same number of people, 20 million or so. Everything in the region happens in tandem. If the American administration thought the Sandinistas were helping Salvadorans fight the U.S.-backed government, they were right.

The Sandinistas took over in 1979 and made no secrets about their ideological ties to Cuba and the Soviet Union. They did, however, deny that they were training and arming leftist guerrilla movements in the region, which was a lie. On the other hand, the United States denied it was advising, training, financing, and arming the contras who were trying to overthrow the Sandinistas, which of course was another lie. Because of this ideological confrontation between the superpowers, and the corresponding low-intensity, surrogate military conflict throughout the region, people of just about every political stripe and intention flooded into Nicaragua from all over the world.

The Media

The conflicts in Central America were different in many ways from others. They were fairly clear-cut, good-versus-bad, David and Goliath morality plays. Especially Nicaragua. Young, charismatic idealists supported even by progressive members of the Catholic church, struggled to overthrow a brutal, thuggish, U.S.-backed military regime accused of consistent and serious human rights violations by legitimate, non-partisan, non-governmental organizations. Pretty compelling stuff.

And for a variety of reasons, the foreign journalists in Nicaragua were different from other groups of journalists covering other conflicts around the world. One of the key reasons for this difference was the fact that Central America is so close to the United States that

MANAGUA, Nicaragua – Members of the press corps in Nicaragua, both domestic and foreign, were friendlier, less cut-throat than their colleagues in, for example, El Salvador. Perhaps the nature of the story attracted a different genre of journalist. Italian photojournalist Paolo Bosio (center) was one of the most beloved of our guild. Dutch correspondent Jan Van Bilsen (right) still lives in Managua. I don't recall who made this picture.

real or aspiring journalists could literally drive from Arizona, California, Texas or anywhere else in the States, to the war zone. During other conflicts or big, ongoing stories like Vietnam, the Middle East or South Africa, major news outlets invested serious money to send mostly seasoned, veteran correspondents overseas to cover the news. And although many of those outlets covering Central America did, in fact, fly in a lot of their "big guns" from New York, Washington and Miami to cover the region, there also were a lot of very green aspirants trying to break into the business. Like James Wood and Jim Belushi in the Oliver Stone movie *Salvador*, many of these aspiring journalists actually drove from the United States to Central America, always keeping enough gas money on hand to get them back home in case things did not work out. Many of these rookies were good, honest, hard-working people who made good journalists and today work for major outlets around the world. Others, despite good intentions, lacked the talent, the skill or the discipline to do a proper job with a story that at times could be very challenging.

All of this made Central America a powerful draw for many young, dedicated men and women who wanted to be a witness, or even to participate in, what was arguably the most momentous era since Vietnam. In fact, for my generation, Central America was *our* Vietnam. And it was right in our own backyard.

There is a hierarchy associated with journalism and journalists. That hierarchy is unofficial but most of us practitioners recognize and understand that it exists. We are categorized into layers of seriousness, professionalism and influence. In other words: prestige, power, authority.

At the top of the list, at the time and, I believe, even today, is The New York Times, commonly regarded by members of the guild as the maximum in all the above categories. Again, using metrics of the 1980s, the television networks come next. The major magazines like *Newsweek* and *Time* follow. The wire services, like the Associated Press (AP) and United Press International (UPI), come next. The wires are the work horses of journalism, especially in the realm of foreign cov-

erage. *National Public Radio (NPR)* and regional newspapers like the *Miami Herald* and the *Los Angeles Times* occupied lower rungs on the ladder.

If news outlets occupy specific rungs on that ladder, so do its practitioners. At the top, of course, are the correspondents, be they for large newspapers, major television outlets or the big magazines. The wire service correspondents, usually scrappier and less flashy than their colleagues from more prestigious outlets, follow. Photojournalists like me come after the correspondents. Producers for television crews come next. Technicians live in the basement.

One last clarification. Although the terms "stringer" and "freelancer" often are used interchangeably with no distinction between the two, I would argue that there is, in fact, a difference. Though neither is a member of an outlet's staff, the term "stringer" normaly is used to describe a journalist who has a tenuous attachment or connection to an outlet with which he or she has worked. This person is connected by a "string" to that outlet.

A freelancer, on the other hand, is a journalist with no such attachment to any outlet and is free to pitch his or her services to any outlet he or she chooses.

I fought hard to break through this journalistic caste system. I was multi-skilled. I had been a newspaper reporter and photographer. I had been a freelance radio correspondent for ABC and NBC News. I was a correspondent for United Press International. I was contract photographer for *Newsweek*, a major outlet in the world of international journalism.

The World Is Watching

In the late 1980s a team of documentary filmmakers from Canada shows up in Nicaragua to do a film on Western media coverage of the Contra War and especially the peace process led by Costa Rican President Oscar Arias. Directed by Peter Raymont, who also co-wrote the script with Harold Crooks, the hour-long film examines what hap-

pens behind the scenes of news gathering, editing, and assembling information presented to audiences about the Arias Peace Plan negotiations to end the U.S.-sponsored Contra War.

Titled, *The World Is Watching* the film features ABC News television anchor Peter Jennings and an ABC News crew in Nicaragua led by correspondent John Quiñones, plus senior editors in their New York newsroom. It also features *Boston Globe* editorial writer Randolph Ryan, Edith Coron of the Paris newspaper *Libération*, and me, at the time a contract photographer for *Newsweek* magazine.

The award-winning film does a good job of pointing out the pressures that men and women on the ground face when covering stories, as well as the tension that sometimes exists between news gatherers in the field and their editors thousands of miles away, many of whom have never set foot in the place we cover.

To be clear, I *never* had to deal with overpowering editors at *Newsweek*. I was extraordinarily fortunate to work with Karen Mullarkey, Jim Colton, Guy Cooper, Hillary Raskin, Dave Wyland, John Whelan, Jim Kenney and others who, at the time and to this day, are regarded as some of the finest in the business.

The film also provides viewers with a sense of the conflicting perspectives between journalists living on the ground in Central America and our colleagues living in the United States who were assigned to visit the region to cover special events or issues. Many of these colleagues were more susceptible to influence or even pressure by the Reagan administration and conservative, special interest groups extremely active at the time.

And this was *before* Fox News showed up with its truth-challenging, science-denying, conspiracy theory-spreading, outright-lying, parallel-world, poisonous version of reality that I believe is a dangerous insult to the United States and to her people.

As I tell those who ask about my career, I had the great good fortune of having worked our craft during the final years of The Golden Age of Journalism when truthful, verifiable information was more important than political affiliation or entertainment. That Golden Age

ended, in part, when Fox showed up and took a poop on our craft.

I believe there are many honest, hard-working journalists working at Fox. Some of them are my former students, doing the best they can to report the truth. But as any honest, non-partisan research organization will attest, the overall intent and impact of Fox coverage is to mis-inform in favor of their owners' political and financial interests. The organization's so-called coverage of the Trump administration's handling of the COVID-19 pandemic is just one sickening example.

The World Is Watching also touches on, perhaps unintentionally, another feature of journalism and journalists. And this is the importance of background and how it influences a journalist's perception of what he or she reports on. And this is not a moral judgement. It is simply a generalized, anecdotal observation: Men and women who come from rough circumstances are more willing and more likely to dig deeper into, can understand and have more empathy for stories and subjects than can men and women who come from more comfortable circumstances. John Quiñones is the son of Mexican migrant workers who travelled the American southwest harvesting crops. Peter Jennings never attained a college degree. Both of them are known for their powerful, heart-felt reporting, analysis and presentation. Joe Contreras, not featured in the film but a close friend and colleague, is a Chicano known for his brilliant and humane reporting. They may not be members of the unofficial, mostly white, Ivy League band-of-brothers correspondents' club, but they are great journalists. And I, well, you already know where I come from.

At a press briefing at the U.S. Embassy in San Salvador during the early days of the civil war, I asked a question of the embassy spokesperson who, in turn, asked me to identify myself.

"I'm Bill Gentile," I responded in front of the group of correspondents. And to mock some who might believe photojournalists are second-class citizens as opposed to equals among them, I added, "But I'm just a photographer."

Anne-Marie O'Connor was one of our guild's most respected and beloved print correspondents. She fought like a tiger for respect and

for her post as Reuters bureau chief in Honduras. She understood what it's like to be on the outside of the elitist club and, in that sense, we were allies. She turned to look at me. And giggled.

Benjamin Linder

Benjamin Linder was a California-born engineer raised in Portland, Oregon. He graduated from high school in 1977, and while in college at the University of Washington, he practiced juggling and rode a tall unicycle around Seattle. He graduated in 1983 and that summer, inspired by the Sandinista Revolution, moved to Managua.

In 1986, Linder moved to the northern Nicaraguan village of El Cuá, where he helped form a team to build a hydroelectric plant to bring electricity to the town. He also participated in vaccination campaigns and entertained local children with performances as a clown, juggler and unicyclist.

On April 28, 1987, Linder and two Nicaraguan colleagues were killed in a contra ambush while traveling through the forest to scout out a construction site for a new dam to be installed for the nearby village of San José de Bocay. An autopsy showed that Linder had been wounded by a grenade, then shot at point-blank range in the head. The two Nicaraguans travelling with him also were executed.

At her son's funeral in Nicaragua, Elisabeth Linder reportedly said, "My son was brutally murdered for bringing electricity to a few poor people in northern Nicaragua. He was murdered because he had a dream and because he had the courage to make that dream come true. Ben told me the first year that he was here, and this is a quote, 'It's a wonderful feeling to work in a country where the government's first concern is for its people, for all of its people.'"

It was this kind of optimism and hope that drew not just Benjamin Linder to Nicaragua, but a whole generation of young and old idealists from around the world.

At Linder's funeral, Nicaraguan President Daniel Ortega helped carry his coffin. Ben was 27 years old. He was beloved by all who knew him. Sadly, I never met Benjamin Linder. I wish that I had.

Emergency Sex

Nicaragua was a delicious, exciting mixed salad of nationality, language, culture, race, religion, ethnicity and political persuasion bound together mostly by a desire to be a part of something larger and more important than the daily struggle for legal tender, as Jackson Browne, one of my favorite songwriters of that time, might say.

American, Canadian, European and Latin American volunteers, mostly young, urban and idealistic, submitted themselves to the rigors of agricultural labor alongside Nicaraguan peasants picking cotton in the searing heat of the Pacific coast region or harvesting coffee in the lethal, contra-infested plantations of the northern highlands. They protested Reagan administration policy in front of the U.S. Embassy in Managua. They held vigils at the northern border with Honduras, risking their own lives to deter attacks by U.S.-backed contras. They worked and they lived alongside the poorest of the poor. They were referred to as *internacionalistas* or *Sandalistas*, a derogatory play on words to describe the sandal-wearing activists as stooges of the Sandinista government.

In addition to the activists, the storm over Central America, and particularly the eye of the storm in Managua, attracted assorted adventurers, armchair revolutionaries, soldiers of fortune and misfortune, wannabes, cowboys and cowgirls, phonies, groupies, one-last-chancers and shady characters across the spectrum.

One of them was a kid I picked up in the mountains on the way home from a reporting trip. He was hitchhiking, standing on the side of a dirt road with his thumb out. He was dressed like a Sandinista soldier. Camouflage. AK-47. The works. The kid got into *La Bestia* but didn't say much. He just listened to the conversation between a colleague sitting shotgun and me. He was light skinned but so are a lot of Nicaraguans. I figured he was just another Nicaraguan soldier on his way home to visit family and I dropped him off an hour or so down the road. I found out weeks later that the kid was an American who came to Nicaragua to support the Sandinistas, and that he was bitching to one of my friends that the conversation in my vehicle was po-

litically incorrect. So, an American kid comes to Nicaragua to support the Sandinistas by going to the mountains and playing soldier by killing contras, other Nicaraguans, even though he probably never even met a contra and, I suspect, is utterly ignorant of any of the reasons that any Nicaraguan might be opposed to Sandinista rule. I have a big problem with this. I never saw him again. I suspect he had enough of his excellent adventure and went back home to mommy and daddy.

There were a few people who supposedly were former members of Italy's Red Brigades terror group and who were hiding out in Nicaragua because they could not go back to their country. There was a German fellow who reportedly was a member of the Baader-Meinhof organization and was on the run from German authorities. There was a guy who claimed that in Spain he was linked to ETA, the Basque separatists, and had to flee his country because the heat was right behind him. There was at least one American who needed to take a seven-year vacation to meet the statute of limitations to beat accusations of a crime he allegedly committed back in the U.S. There was a contingent of Europeans who came to Central America to get away from heroin. Kind of like the American statute of limitations, the word was that if you could stay away from heroin for seven years, then you beat it. Some folks came down to Central America to escape the AIDS virus that was killing friends up north.

Some came to work or to find themselves, some to get away from themselves, some to renew themselves, others to take on new identities, still others to modify themselves. Obviously, the ones who showed up already knowing themselves and to work fared the best. Assuming, that is, that we ever completely know ourselves or ever stop learning about ourselves. I think the ones who came to find themselves fared second best, certainly better than the ones who came to get away from themselves, because no matter how hard the people in this last category ran, they could never really get away from themselves. Their real selves were always just a step behind and would catch up one way or another. When the storm finally abated, the folks in the last category had to face themselves once again.

I guess I traversed two categories, the one which came to work pure and simple and the one who came to probe their own limits.

There was a dark side to the crowd coming to Central America and everybody, particularly the governments and the combatants, was keenly aware of it. In El Salvador, for example, the government suspected foreign journalists, especially American journalists, of being linked to what they considered the communist guerrillas. But the communist guerrillas always suspected American journalists of being CIA agents. In Nicaragua it was a different story. The contras suspected us of being sympathizers with the *Sandino-Comunistas* and the Sandinistas suspected foreign journalists, especially Americans, of being CIA agents.

Most of the journalists assumed that some of the people working in the embassies in Managua, particularly the U.S. Embassy, were spies. CIA or whatever. And we accepted the notion that some of the people who claimed to be activists or students, or even journalists, could be spies.

There existed a level of intrigue, because we could never be sure who was who, who was doing what, who was really what he or she claimed to be. It wasn't until years after it was all over that I would find out that an attractive Nicaraguan woman who worked in the government press office was also an informant for State Security; that a friendly Nicaraguan taxi driver routinely was de-briefed by State Security about his work with American television journalists; and that a friend of mine was an informant for the Sandinista government.

There was a Western European woman who claimed to be a journalist, always working on some mammoth, multi-part, super-complicated project for some major newspaper or television outlet with global distribution. But for some reason nobody that I knew had ever seen any of her work or knew very much about her. (This was before the Internet provided access to most people's public and even private lives.) Some of my colleagues did see her popping in and out of houses in Managua that were supposedly "safe houses" run by Sandinista State Security, and the assumption was that she was either an infor-

mant for the Sandinistas or a double agent for some European intelligence agency or the CIA. Even after I got to know her fairly well, I never figured out exactly what she was up to. And one day she just disappeared.

I was photographing marchers protesting U.S. intervention, I think it was in the city of Masaya and, as usual, was at the head of the march as the protesters moved along a main street. And I noticed more than once that a light-skinned guy in clothes too new and too fashionable that marked him as definitely not Nicaraguan, was making pictures of me as I walked toward him just a few yards in front of the marchers. Real photojournalists don't do this. We don't wait until a colleague is walking face-on toward the camera to make pictures. Real photojournalists try to work *around* colleagues, whose presence in a photo can distract from the main point of the image. We try to avoid these "photo bombs." Why would this guy, whom I had never met and who I would never see again, want pictures of me? Which intelligence agency might he have been working for?

It would be years after all this was over that I would come to understand how high the stakes were in the geopolitical/military game being played out on the bloodied grounds of Central America.

To really appreciate how complicated, dangerous and treacherous the region was at that time, one has to remember that this was still in the Cold War era, before the collapse of the Soviet Union, and the USA and the USSR were still engaged in a deadly struggle for dominance. Washington saw Nicaragua as an expansion of Soviet power through Cuba – and the Sandinistas actually saw their overthrow of the U.S.-backed Somoza regime as proof that the demise of the American Empire was imminent and that they, the Sandinistas, would be a key force to hasten that demise.

It was geography that plagued Nicaragua from the beginning. This tiny, poor country in earlier years had been coveted as a site for a trans-oceanic canal linking the Atlantic and Pacific. And this was *before* the Panama Canal was completed in 1914. But now, Washington could not tolerate an insolent little neighbor in its own backyard,

still the potential site of a more modern passageway but possibly controlled by communists.

It was the year 2000, about 10 p.m. I had just left a restaurant on a street in a capital city somewhere in Latin America. I heard a "Psssst" behind me. I turned around to see a man standing beneath a streetlight. I can't see his face but he's a pretty big guy.

"You are Bill Gentile, aren't you?"

"Yes, I am."

"You used to live in Managua, correct?

"That's correct."

And he proceeded to tell me that, during the 1980s, he had worked for the intelligence agency of his native country. During that period, his agency had picked up intelligence that the KGB had instructed its operatives in Nicaragua to investigate me and an American colleague, because the KGB was convinced that we were "*agentes muy peligrosos de la CIA.*" (very dangerous CIA agents.) And in fact, the operative that this man described had become friends with Claudia's family, and had actually accompanied her mother and her father into the living room of the home that Claudia and I lived in.

The guy invited me to a drink and he told me the whole story about foreign agents who infiltrated my Nicaraguan family and my home. I was stunned.

To envision what this "mixed salad" of Central America was like, think of Oliver Stone's *Salvador* (1986) with James Woods, Jim Belushi and John Savage; and *Under Fire* (1983) based on the Sandinista Revolution, starring Nick Nolte, Gene Hackman, Joanna Cassidy and Ed Harris; plus *The Year of Living Dangerously* (1982) starring Mel Gibson and Sigourney Weaver about political turmoil in Indonesia. Throw in a bit of *Hurt Locker* (2008) with Jeremy Renner as a specialist in defusing Improvised Explosive Devices (IEDs) in Iraq. For the dressing, pour on some *Whiskey Tango Foxtrot*, (2016) the title of which is based on letters of the military phonetic alphabet, and whose acronym, WTF, is a euphemistic substitution for "What The Fuck." In the film, actress Tina Fey portrays journalist Kim Baker who agrees

to take an assignment as war correspondent in Afghanistan during Operation Enduring Freedom. Now, sprinkle this all up with the book, *EMERGENCY SEX (AND OTHER DESPERATE MEASURES)* by Kenneth Cain, Heidi Postlewait and Andrew Thomson. Subtitled, *True Stories from a War Zone*. The book documents the funny and sad adventures of three young civilians working for the UN and the Red Cross in conflict areas around the world.

Across Latin America, from the Rio Grande River to the southern tip of the hemisphere, social movements challenged the existing power structures of right-wing, military-backed regimes and savage, rapacious, insatiable capitalism, most of them supported by the United States. Eduardo Galeano's book, *The Open Veins of Latin America*, had become the intellectual foundation of the region's leftist activists. In it, the Uruguayan author described the five centuries of pillage of his continent.

"They came," Galeano wrote of the *conquistadores*. "They had the Bible and we had the land. And they said to us, 'Close your eyes and pray.' And when we opened our eyes, they had the land and we had the Bible."

Of course, the *conquistadores* of the late 20th century and today are no longer Spanish invaders. Rather, today's conquerors include the World Bank, AT&T and Monsanto. And they are not selling the Bible. Instead, they are hawking "progress" and "modernity."

Nicaraguan troubadour Carlos Mejía Godoy provided the soundtrack for the violent days and desperate nights of struggle endured by Nicaraguans and their the tiny, poor, beloved and newly liberated country, calling it, "The most beautiful flower of my love."

I had already read the novels, *100 Years of Solitude* and *Love in the Time of Cholera*, by Colombian author Gabriel García Márquez, the former about life's lonesome futility in the fictional Latin American hamlet of Macondo, and the latter about eternal, undefeatable love. They are masterpieces of the "magic realism" of Latin American fiction that infuses fantasy into otherwise realistic situations.

All of this is where I found myself in Nicaragua in the 1980s. If

Mexico was my introduction to Latin America, Nicaragua was my social and political awakening. And my test of fire.

It was an intoxicating mix. It was real revolution, and tens of thousands of corpses piled up to prove it. But people came anyway. They swarmed to Nicaragua wearing Che Guevara shirts, sandals, full beards, unshaven armpits and no bras. During the rainy season we could count on the sky opening up at about two in the afternoon when God emptied his swimming pool on Managua. Thick water pulled the temperature down a few degrees and as the sky cleared, heavy mist rose from hot pavement. In the evening, leaves hung low and glistening, and the moist air clung to our clothes. Sultry women and their partners danced so close together that it was difficult to distinguish where one ended and where the other began. History tells us that revolutions blow away not just political and class structures, but sexual norms as well. Nicaragua was no exception. Stated differently, revolutionary Nicaragua was an incestuous, promiscuous place, the violence, perhaps, a constant reminder that tomorrow belonged to no one, so make love as much and as often as possible today.

I came to Nicaragua mostly to work. In the early days right after the Sandinista Revolution I was suspected of working for the CIA, probably because I broke a story about *Comités de Defensa Sandinista (CDS)* or Sandinista Defense Committees, a carbon copy of the *Comités de Defensa de la Revolución (CDR),* Cuba's state-sponsored tools for surveillance and repression. I heard later that Interior Minister Tomás Borge was unhappy with my reporting. Even some of my colleagues at UPI questioned the veracity of my story until I presented them with a copy of the official Sandinista document defining the CDS and its functions.

In the December 2, 1979 edition of *The New York Times Magazine,* there is an article about Nicaragua written by Alan Riding. At the time, Riding was the *Times'* bureau chief in Mexico City and one of the most respected correspondents in the region. The leading picture accompanying his article is an image I made for UPI showing a young Sandinista militant, closed fist held about head high, leading a CDS meeting.

Later I was accused of being a Sandinista sympathizer, especially because of my relationship with Claudia and her family. Both charges were inaccurate, uninformed and stupid. Was I a Sandinista sympathizer? To the degree that I thought the Sandinistas, and all Nicaraguans, should be left alone to determine their own destiny without foreign intervention, yes, I was. Did I support all their policies? Absolutely not. Did I oppose U.S. government policy toward Nicaragua and the region in general? Yes, absolutely, because it was cruel, inhumane, short-sighted and counter-productive. My country deserved better. My allies were not governments or movements. My allies were people like Claudia who just wanted to live a peaceful, productive life. My allies were people like Lt. Talavera and *El Cuervo*, trapped in uniforms, either government or rebel, forced to defend other people's interests. My allies were kids like Claudia's brother, Danilo.

For the most part I tried to stay away from the intrigue, having a lot of friendly colleagues in the foreign press corps but very few real friends. I would see all these people at news conferences, official functions and at parties but, with very few exceptions my world was Claudia, her family and friends, Nicaraguans in general, and the war.

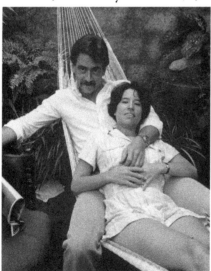

MANAGUA, Nicaragua – Claudia and I in our early days

There must have been half a dozen or so visitors sitting around, discussing the war, the country and the future, at the house where Claudia and I made our home. And as usual they were spouting off about this and that, blah, blah, blah. After they left, I asked Claudia:

"What do they know about Nicaragua? Nicaragua isn't here in air-conditioned homes and offices. Nicaragua isn't in our living room or on our patio in bottles of rum. Tell them to go to the moun-

tains and walk for two weeks with a battalion of soldiers. Tell them to go to Matagalpa and live for two weeks with some peasants picking coffee and who don't know how they're going to feed their families tomorrow. That's where Nicaragua is. Nicaragua is there. Not here."

Claudia just looked at me and she said, "This is why I love you."

Nicaraguans

Nicaraguans are the most gratifying component of working in Nicaragua. In contrast to my experience with the inhabitants of other Latin American countries, Nicaraguans mix easily with foreigners. They are not intimidated by people from other countries. I think it has something to do with their self-esteem. Some observers might argue that Nicaraguans have an exaggerated sense of their own importance. I find them to be refreshing.

The cultural barrier between Nicaraguans and foreigners was almost non-existent. I lived openly and unmarried with Claudia for years and nobody ever raised an eyebrow. Many of my colleagues married Nicaraguan men and women.

To probe the Nicaraguan character for the epilogue of my book of photographs, *Nicaragua*, I conducted a series of long interviews with then Vice President of Nicaragua, Sergio Ramírez Mercado. He is an internationally renowned author considered to be among the most knowledgeable sources of information on Nicaraguan history. He is an astute observer of his people.

We discussed the Nicaraguan character which, according to Ramírez, "took shape on the Pacific."

"Well, it seems to me that the Nicaraguan from the Pacific is talkative, gregarious, extroverted, and compassionate. You see this in daily life. My father was a man of the Pacific, from Masatepe, a mestizo city, with Spanish and Indian roots. When I was a little boy, if he was standing at the door of our house and somebody drove by and was looking for such and such a house, my father would give him directions, but this wasn't enough. He would call for me. 'Wait,' he would

say, 'take him with you.' And I would get in the car and show him the way. This is typical of people from the Pacific. They have a tremendous sense of neighborliness."

Ramírez said, "Here's another important element. Who colonized Nicaragua? Mainly Spaniards from Extremadura and from Andalusía, with its Arabic heritage. An Andalusian is more open than a Galician or a Catalonian. He is more talkative, more of a reveler. Knife in hand, he goes looking for a fight. He's a womanizer, he is macho. These are the men who colonized Nicaragua, along with those from Extremadura, who were poverty-stricken. In Extremadura the land is dry dirt; farming is minimal; it doesn't rain."

I asked Ramírez whether the *Macho Ratón* character in the *Güegüense* drama, a traditional Nicaraguan comedic, folkloric dance, is a symbol of the Nicaraguan spirit, or attitude toward life. In the dance, local indigenous people wearing hand-crafted masks ridicule their Spanish conquerors.

"Yes. The *Macho Ratón* helps explain an aspect of the Nicaraguan character, the Nicaraguan sense of humor. The Nicaraguan puts on an armor of humor when facing difficult situations. Life here is incomprehensible without humor, without irony. True humor allows you to laugh at yourself. If you can't laugh at yourself, you really have no humor at all. I think we have the ability to make light of the most difficult, of the most uncomfortable situations. Humor is really an attitude of self-criticism, an attitude that provides distance and allows us to laugh at ourselves and at each other."

During the interview, I recounted an incident that occurred during the 1979 revolution. It was in Masaya, a city less than an hour's drive southeast of Managua and scene of some of the heaviest fighting between Sandinista rebels and Somoza's National Guard. I was with a CBS television team.

Masaya is home to the indigenous neighborhood of Monimbó, populated mostly by Nicaraguans largely untouched by European genes brought to this part of the world five centuries ago. Nicaraguans refer to the neighborhood as *"La Cuna de la Revolución,"* or "The Cra-

dle of the Revolution," because it was here that these Native Americans, sick and tired of the repression, first rebelled against the regime. And it was here that, no matter how many young men and women they threw into the crater of the Masaya volcano, the National Guard could not suppress the local population.

We were stooped down along the walls of buildings lining a narrow street, making our way closer to where we could hear the fighting and trying not to draw fire from the National Guard snipers. We wanted to document the combat, but not get picked off by snipers along the way. The city seemed to be locked down and behind closed doors. No kids playing in the streets. No cars moving at the intersections. Nobody walking to or from the market. No dogs scrounging for food. I learned very quickly that these all are warning signs that something very bad is happening. Or is about to happen. So be ready.

In a doorway across the street, two young women peered out to watch us moving cautiously down the opposite side.

"Ay, qué hermosos son estos hombres," one of them said to the other. (Wow, how handsome these men are.) The women put hands to their mouths and chuckled.

Sergio Ramírez and I had a good laugh.

Nicaraguan-ese

Nicaraguans are visual. Their language resonates so much with me because I am a "visual journalist." And they can be profane. And funny. Here are some examples of expressions, literal translations and meaning. They are not exclusive to Nicaragua and Nicaraguans. But they are more widely used in Nicaragua than in other Latin American countries where I have worked or lived. My evidence to support this assertion is strictly anecdotal:

- *"Con la lengua en el piso."* With tongue dragging on the floor. "Tired, exhausted."

- *"Con los ojos cuadrados."* With square eyes. "Shock, surprise."

- *"Con el pelo parado."* With hair standing up. "Surprised, shocked, afraid."

- *"Como una gallina comprada."* Like a (recently purchased) hen. "Anticipation. Concern. Nervousness. In an awkward position."

- *"Palomita."* Little dove. Baby dick.

- *"Caras de queso."* Faces of cheese. "White people."

- *"Cheles."* White people. "White people."

- *"Un cachimbo."* "A lot of. A bunch of."

- *"Un cachimbazo."* "A whole lot of. A big bunch of. A hit. A big bunch."

- *"Un cachimbeo."* "A fight. A combat. A battle."

- *"Fumando como una puta presa."* Smoking like a whore in jail. "Nervous."

- *"Sin dos dedos de frente."* Without two fingers of forehead. "Neanderthal. Sub-human. Stupid."

They are profane:

- *"Puta."* Whore.

- *"Hijo de puta!"* Son of a whore!

- *"Hijo de las cien mil putas!"* Son of 100,000 whores!

- *"A la gran puta!"* To the great whore!

- *"A la puta madre!"* To the mother whore!

- *"Comé mucha mierda!"* Eat a lot of shit!

- *"Comemierda"* Despicable. Full of shit.

- *"Verga."* Male sex organ. Dick.

- *"Hijo de la verga!"* Son of a dick!

- *"Vergazo."* A hard hit or blow.

- *"De a verga!"* Swell! Excellent! Perfect!

- *"Turca."* Penis.

- *"Turcazo."* A hard hit or blow.

- *"Joder."* To fuck. To fuck around.

- *"Jodido."* To be fucked.

- *"No jodas!"* Don't fuck around!

- *"No me jodas!"* Don't fuck around with me!

My Nicaraguan Family

I basked in the warmth and familiarity of these people, their country and their culture.

Every time I returned home from a trip to *La Montaña* or to El Salvador was a holiday. A time to celebrate. Claudia and I would take *La Bestia* to the beach in Masachapa, or just stay home and rejoice in another day of life. This was my drill. Coffee in the morning, beer or rum in the afternoon. Cigarettes all day long. And rock & roll. I blasted music from our stereo and danced with Leonardo, the son of our young maid, Esmeralda.

Leo's own father never rose to the challenge of fatherhood, and I had become somewhat of a surrogate dad. It was like Leo was my own son. I was really bending the rules with our relationship. In Nicaragua, "the help" and their relatives reside in the back of, or in a separate building apart from, the main home. They are not supposed to mix with their employers. They don't eat at the same table. They don't mingle socially.

MANAGUA, Nicaragua – Leonardo, the son of our house assistant, catches some sleep after a day of post-deployment fun with me and rock & roll.

I was not a big fan of these rules. Perhaps because of my own background, I was uncomfortable with the idea that I should not mix with the people who made my life so much easier. So much more enjoyable.

Screw the rules. Leo and I had great fun together. We sang with Bob Seger, declaring that rock & roll would never forget. We got excited with the Pointer Sisters, swore we didn't care no mo' with Phil Collins, shouted sympathy for the devil with the Rolling Stones. Leo and I broke some hearts, stood our ground and never backed down with Tom Petty. We tore down thunder road and raced in the street with Springsteen, sought shelter from the storm with Dylan, and by late afternoon we were runnin' on empty with Jackson Browne. We were unstoppable.

I made tons of pictures of Leo and his mom. (I "make" pictures. I don't "take" them. There's a difference.) We played tricks on Leo's mother. During one of my wild decompress-a-thons, I wrapped the boy in a blanket and hid him from his mother – *only for a few seconds* – in the refrigerator. I opened the door and there was Leonardo, smiling. Esmeralda was not happy.

By early evening I am collapsed, snoring away in a hammock. Leo is fast asleep either on a big green rocking chair, or across my chest in the hammock. Claudia is relieved but exhausted after having policed the day-long antics, barely able to keep things (Leo and me) under control.

Eventually, Esmeralda and Leo shared the table with Claudia and me. I became the boy's godfather.

Carretera de los Locos

Nicaraguans call their country a land of volcanoes, lakes and poets. The women have quick eyes and easy smiles. They point toward one direction or at an object by pursing their lips toward the matter at hand. Their features are round and soft. A favorite Nicaraguan food is rice and beans. They call it *gallo pinto*. They add fresh cream to it, and avocado. They eat *gallo pinto* at breakfast, lunch and dinner, especially breakfast. They eat green mangos sprinkled with salt. They imbibe soft drinks from sealed plastic sandwich bags, biting off a corner of the bag and sucking on it as you would... Well, you know what I mean.

Nicaraguans call it, *"La Carretera de los Locos,"* or the "Highway of Crazy People." Along this highway are "love motels" into which one can drive a car straight into a garage, pull a curtain closed behind the car and step into a bedroom connected to that garage. Minutes later there is a knock on a small trap door of the bedroom.

"Qué quiere?" (What do you want?) a voice asks. And the persons inside the bedroom can order liquor, cigarettes, chocolates, condoms, and so on. There is an exchange of money for goods and neither the management nor the client ever see each other.

The Highway of Crazy People gets its name from the men seen driving down the roadway to the love motel, apparently alone, talking to invisible persons. This invisible person might be somebody's girlfriend or wife, who is crouched down on the front seat of the car so as not to be seen heading with not-her-boyfriend or not-her-husband into the love motel. The men appear to be talking to themselves, hence, the Highway of Crazy People.

Norma. Witches. *"No Pudo"*

Just 27 miles southeast of Managua is a town called Diriomo. The name of the town reportedly comes from the native language of Nahuatlaca, meaning "foreign." It is located on a plateau near the Mombacho Volcano, on rich volcanic soil and lush tropical vegetation. Its inhabitants practice a mixture of Catholicism and Native American traditions dating back long before Europeans arrived.

One of those traditions is witchcraft. Diriomo is known as the capital of Nicaragua's community of *"brujos,"* or witches. Although the craft has become somewhat commercialized over time, many Nicaraguans believe in, and fear, the power of the men and women who practice it. These *brujos* claim to be able to heal the sick, repair broken hearts, make one romantically irresistible, put a curse on a rival. Even kill.

I've spent time in Diriomo and the surrounding area and I can tell you it feels like some place apart from the rest of Nicaragua. It's darker, more humid. The plants seem larger, bolder, somewhat intimidating. Giant green leaves hang low from trees like tongues of monstrous, prehistoric animals. There is something intangible but slightly threatening about the place. I was leaving a party in the area late one night and the host asked if I would drop off one of the guests, a middle-aged woman whom I had never met, at her home. It's along the way, he said.

Hell no, I don't want to take this woman home, I thought. *I just want to get out of here.*

"Happy to help out," I said. "No problem."

So the woman piles into the car. She's sitting in the front passenger seat and I'm driving late at night on an unlit, winding road through steamy, tropical highlands. She starts talking – *to the windshield and in a language that I cannot understand.* It's not Spanish and I don't think it's some indigenous dialect but whatever she's saying really gives me the heebie jeebies. She's either totally drunk or completely insane. Thankfully, she recognizes her village. I drop her off, lock the door and drive on.

One of the Nicaraguans who believed deeply in this *brujo* stuff was Claudia's mother. She told me about an episode that I believe coincided with Danilo's experiences during the war. Norma said she was confronted by a witch who claimed to have been contracted by an unnamed enemy to destroy her. Decades later, Claudia would explain the incident:

> My mother was on the patio of our house when an Indian woman approached and told my mother straight-up that, 'I wanted to meet the woman who had survived all my spells.' The witch came from Diriomo because she could not defeat the aura that protected my mother and was curious to know who my mother was. My mother was very attuned to the spiritual world since she was a child. Someone protected her.

So Norma had prevailed over the witch who was hired to ruin her. *"No pudo,"* Norma told me of the incident. "She couldn't."

It was perhaps because of her resilience and her power of personality that Norma had established herself as the pillar of her family. Her husband, Alberto, revered his wife and followed her lead as a supporter of the Sandinista movement. Claudia, the first of their six children who would become my first wife, inherited much of her mother's strength and certainty.

Norma and I were co-conspirators. She enjoyed my wild irreverence. She grew accustomed to my antics. She fed my most adolescent, mischievous tendencies. After a social gathering in Managua, Norma agreed to drop off two of her acquaintances at their respective homes.

I wouldn't call the two women "friends." In fact, I got the feeling that Norma wasn't comfortable with their very proper, somewhat snooty dispositions, their sense of superiority being part of the class division that undermines Nicaraguan society.

On the way home, Norma sat shotgun in the front seat of *La Bestia* and the two middle-aged women sat on the vehicle's bench seat behind us.

"Faster," Norma egged me on, in English. "Faster."

I rolled on *La Bestia's* power as we tore down the uneven highway, the two women squealing and clutching each other as they rose off their seats, their coiffed hair flattening against the vehicle's roof, as the machine descended each crest of the road with a loud crunch slamming back down to the asphalt.

"Faster," Norma said, as *La Bestia* and I doled out payback for the women's attitude.

On another occasion, I had just returned from a long assignment in El Salvador. I was still wound up from the journey, not yet cooled down after having covered another round of bloodletting there. *La Bestia* and I pulled into the neighborhood where Claudia and I used to live with her family. Her brother Jorge and a few of the local guys are hanging out near the local *chanchera*, or pigsty, sipping beers.

I get out of the vehicle and Jorge and I begin pushing each other around. At first just playing, kind of testing each other. But then something clicks and I'm playing for real. I take Jorge in a bear hug and plow him into the side of *La Bestia*. Her suspension buckles and the vehicle rocks to one side.

The local street urchins don't quite know how to take this and one of the kids runs off to Jorge's home and, seeing his mother, screams, *"Doña Norma! Doña Norma! Estan matando a Jorge!"* (Doña Norma! Doña Norma! They're killing Jorge!)

Norma understood what was happening. She just smiled.

Joe Cool

It is 1986 and I am back in Masachapa, alone, having rented a small room in a tiny seaside motel where I can get away from the city and work on my book of photographs, concentrate, write. Make pictures. I had hauled a table and a stool from Managua and set them up in the room beside the saggy steel bed. The room has one window that overlooks an alley. I can hear the sea from here. *Señora* Matilda, the owner of the Hotel Rex, has given me the room for a reasonable monthly

fee. A couple of faded paintings hang crooked on the wall. The place is lean. Austere. It reminds me of Vincent Van Gogh's painting, *Bedroom in Arles*. Claudia would think this appropriate, I thought. She had once given me a biography of the Dutch artist, saying she recognized some of Van Gogh's searching, existential angst, or madness, in my own behavior. Maybe she wanted to save me. From myself.

It is evening now, and I walk along the beach and see a group of women and children on the shore with their husbands, sons and fathers, near the broken-down skiffs they use to fish in, to feed their families and to defend themselves from the poverty that always lurks like a buzzard at their front door.

I see a small boy who reminds me of the part that I love most about this country. The boy is perhaps five or six years old, wearing a giant T-shirt upon which is printed an over-confident Snoopy Dog with dark, round sunglasses. Underneath Snoopy are the words: "Joe Cool only takes one day at a time."

I see lightening and a thunderstorm coming not far from where I stand. I love thunderstorms. Especially thunderstorms at sea. I stroll along the dark, volcanic beach sand. I am connected to a Walkman, listening to Roger Daltrey of the rock group The Who, singing, longing about love, rain and the sea.

ALIQUIPPA, PA – The Ambridge Reservoir, near the town where I was raised. It was on the paved road to the right of this image that my brothers and I would jog along the water's edge, and where we would commune.

CHAPTER 7.
WALK LIKE A MAN

The Reservoir

The Ambridge Reservoir was built in the 1950s to accommodate the water needs of nearby towns and villages in southwestern Pennsylvania, one of them being the town of the same name. Incorporated in 1905, Ambridge takes its name from the industry and the company upon which its inhabitants once thrived – the American Bridge Company. The town lies right across the river from West Aliquippa, where my mother was raised in Tada's great house along the banks of the Ohio River and a few blocks from the mills. The reservoir fills 405 acres of a valley that rests among pristine rolling woodland which by some miracle has survived the ravages of so-called development and modernity and looks much like it must have looked even before the Presbyterian church and graveyard were built on it some 200 years ago.

It's an extraordinary place. I drive along a winding dirt road over rolling hills through thick forest and I reach the top of a ridge where the reservoir unfolds in front of me. A sparkling body of water blankets the low-lying valley. As I descend into that valley, a cemetery lies

to the left and further down a gravel-stone parking lot lies beside the old church. Parallel to the water's edge is a paved road running 1.5 miles to a nearby highway.

I was introduced to the reservoir by a high school friend who had returned from a few years on the West Coast where he became an avid runner and where he picked up a yellow, smiley-face tattoo on his shoulder while hanging out on a Native American reservation way before tattoos became the rage they are today. We began to visit this place on a regular basis, to jog along that paved road. Tall and slender, Frank took running the same way he took life. Easy. He arched his back as if it were the sail of a small boat and let the wind behind him just push him forward. No pounding feet into the pavement. No bouncing up and down. No fighting his own body. If you put a glass of water on Frank's head while running along the reservoir, it wouldn't fall off. He just glided along, as if he were skating on ice. Easy.

I envied and tried to emulate Frank's leisurely gait, which was so unlike my "at war with everything and everybody" pounding approach to running (and perhaps to life itself.)

I introduced my brothers to the reservoir and over the years, it became a special, sacred place for us. We came here not just to run but to commune. My older brother would call it our "de-militarized zone" where pretenses were dropped and where we let our guard down. It was along this paved road where we would reveal secrets, confess our feelings and discuss our lives and the lives of our family members. Summer or winter. Spring or fall. No matter the weather or how late we stayed up drinking my brother's homemade wine the night before, we found time to jog at the reservoir. My departure for California left some scar tissue between my older brother and me. It had yet to heal.

We were selective about the people we allowed to accompany us to this place to participate in our runs, which were as much about ritual as they were about exercise. I took Claudia here on her first visit to the United States after the revolution. I took my friend Bruno here when he came to visit from Mexico.

On this morning, my brothers and I took Bobby here. Bobby is

Lou's adopted son. My brother and his wife Carol rescued him from an orphanage when he was 10, somewhat old for an adoption. Bobby looks like John Travolta's twin brother. He is a superb, natural athlete, with a spirit, optimism, good humor and bravado largely intact despite years of suffocating existence with tough, problem kids in an orphanage on the outskirts of Pittsburgh. His voice comes from way down deep in his throat and sounds as if he's gargling as he speaks.

Had it not been for my brother and his wife who rescued him, I think Bobby today might have wound up either dead or serving time in prison. He is part of Lou's and Carol's legacy.

On this morning at the reservoir are Lou, my youngest brother Rob and Bobby, who must have been in his early 20s at this time. (My brother David is missing from this memory, as he would be from most

CENTER TOWNSHIP, PA – Lou and Carol's adopted son, Bobby.

other occasions. Somewhere along the way, David decided to follow his own path.)

Bobby challenged me to a race along the paved road. It's 1.5 miles to the end of the asphalt where it meets a highway, then back on the same road for a total of three miles. Bobby sweetens the challenge with a $5 wager. I accepted.

"I'm going to kick your ass, Uncle Bill," he said in his gargle voice, smiling.

"SHEE-it," I said. Then Bobby explodes off the line, taking a quick and lengthy lead.

Pittsburgh Airport

I remember the airport scene so well because we re-enacted it so many times and because I enjoyed it more each time than the time before: My brother is standing in the reception area as I file out of the plane. I'm still wearing khaki pants and a cotton foreign correspondent shirt, French Palladium desert boots and a Banana Republic photojournalist vest. But it's November in Pittsburgh and the world here is barricaded behind sweaters, heavy coats, hats and boots. Lou's got on a long, dark overcoat.

He goes, "How you doin'?" and I go, "I'm alright," and a woman who looks like she's expecting her boyfriend to walk off the same flight stares as Lou and I kiss each other and embrace. She must see that we're brothers, because of the physical similarities, but at the same time she must be figuring out that we have taken very different roads in life. Lou's beard brushes against my face. His cologne smells like fruit. I must look like I took the wrong flight and somehow landed in Pennsylvania instead of an island in the Caribbean or at some jungle outpost. We are an odd couple hustling through the airport, my brother the good guy in a gangster movie and me lookin' like a wanna-be Indiana Jones. I am at ease with this arrangement. I feel secure in it.

We get to the car and my brother reaches under the front seat to pull out his pistol then straps it back onto his ankle. These are the days when he's working undercover for the State Police so that's why the beard and the gun. Just outside the Pittsburgh airport is a long neon boulevard of restaurants, clubs, stripper joints and hotels, and when we slide up to the bar in one of them all we see is naugahyde chairs, lounge lizards wearing leisure suits and big-breasted waitresses with puffy hairdos and we look around expecting Dean Martin to walk up and order a drink.

"Let us have six double Stoly's on the rocks, each with a twist of lime," my brother says, and the bartender just smiles because he's seen it all before, either during one of Lou's undercover exploits or during one of my trips home. I just sit there and let it happen.

"There's nothing like Stoly's," my brother says of the famous Rus-

sian vodka, Stolichnaya. "Not Absolut, not Smirnoff, not nothing."

"I know," I said. "It's a good clean drink. Not like that rum I've been pounding down in Central America." I am reminded of my brother's unnatural capacity to assimilate alcohol.

This is how so many of my trips home began, landing and communing a bit with my brother, and from this point on they vary widely. On this occasion we're bombing down the highway and I'm not sure what's moving faster, the vehicle or my head. We're going to his place, which now is the nucleus, the command center, of our family. Over the years and no matter which city or country that I resided in, by brother's house has always been considered "home."

"You got any matches?" I ask while reaching into the glove compartment for something to fire up another Marlboro and then, pull out an item that clearly is not a pack of matches. "What's this?"

"My guys love that shit," my brother says with a grin. "They can't take it when I put on those glasses and the wig."

And I pull a bright red wig from the glove compartment.

"I gotta get one of these," I say as I put on the glasses and check them out in the visor mirror. The frames are black plastic adorned with huge, plastic eyebrows, making me look like Groucho Marx. But there is one characteristic that really distinguishes these glasses from others. Also attached to the frames, and now covering my own nose, is a large plastic "nose." But instead of a nose, this plastic appendage is a penis.

"Take it," my brother says.

"No. Just tell me where I can buy one."

"Take it," he insists. "I'll get another one downtown next week."

I slip the glasses with a penis nose into my vest.

Our Father's Instructions

My brother, a handful of men and I are standing on the roof of my brother's home, out of which he has cut a huge rectangular hole. We hold ropes attached to the wooden skeleton of one of four walls he

will insert into that hole. He's building an apartment for our mother, exactly what our father would have wanted. One of the men is our former high school football coach. Another is one of my brother's high school teammates. One is a State Trooper undercover agent, a close friend. All of these men are older, bigger, stronger and most of them tougher, than me.

Many of them are also members of the wine-making crew that my brother assembles each year to make his homemade brand. My brother typically made friends with older men, perhaps because he was drawn to their values of family, respect, honor. Or maybe he saw in them traces of our father, who embodied those characteristics, and he, my brother, wanted to fill the void created by our father's early departure.

Our mother has sold the place where she raised her four sons and is moving in with my brother and his wife, Carol. My brother had followed our father's instructions. Complied with his wishes. He was taking care of the family.

It's a hard time for my mother. After my father died she eventually went back to school and obtained a college degree, then a master's degree. She became a schoolteacher and even opened up her own employment agency. But the U.S. economy during the 1980s is flailing, especially in southwestern Pennsylvania, which would become part of the "Rust Belt" as manufacturing jobs fled to Mexico. The livelihoods and the lives of tens of thousands of proud steel workers collapsed. My mother basks in the presence and the support of Lou, Carol and their children, but is frustrated by what she feels is a lack of purpose and relevancy.

That skeleton is halfway up from the ground on its way to the roof but gets stuck along the way and we are straining. Men on the ground push upward. Men on the roof pull up, but the skeleton, about 14 feet wide, eight feet high and made of sturdy 2X4" boards of solid pine, does not move. Faces turn red. Muscles tighten and begin to fail. Ropes cut into our hands. Everybody's barking suggestions and counter-suggestions on what to do. How to get this damn thing in

place and into the freshly cut hole. The wooden frame skeleton still doesn't move.

"Jimmy," my brother calls out to our former football coach, whose position allows him a clear view of the task at hand. "Tell us what to do." Jim D'Antonio played college football and immediately afterward was invited to try out for the Green Bay Packers, at the time coached by the legendary Vince Lombardi. Two weeks into the tryout, Lombardi takes him aside to tell him he did not make the cut.

"You're satisfied to be a member of the Packers," Lombardi told him. "The men who make this team are not satisfied to just be a member of the team. The men who make this team aspire to be the *best* member of the team."

"Jimmy, tell us what to do," my brother calls out.

Jim D'Antonio coordinates the various tasks, and the skeleton moves into place.

I am honored to be in the presence of these men, to share this bonding experience and to relish their camaraderie. Little did I realize, of course, that I would someday conjure up this experience and some of these men to help me get through a long and perilous journey in the tropical highlands of northern Nicaragua.

"Are You a Cop?"

My brother backed his car into the man's driveway, as opposed to head-in. It was a tactic he learned on the job, one that someday might save his life. Lou was working undercover for the Pennsylvania State Police.

The man he had come to see in Erie, Pennsylvania, was Ray Ferritto, a member of the Cleveland crime family and notorious mafia hitman, perhaps best known for having assassinated a rival gangster named Danny Greene.

On October 6, 1977, Greene was at his dentist's office. Ferritto and another hitman had parked a car containing a bomb in the side door, next to Greene's car. When Greene started entering his car, the second

hitman detonated the bomb and killed Greene instantly.

This series of events was portrayed in the 2011 Hollywood film, "Kill the Irishman," starring Ray Stevenson, Vincent D'Onofrio, Christopher Walken, and Val Kilmer. Years after it all happened, my brother was watching television and by happenstance caught the film that he didn't know even existed.

My brother was there in Erie to serve Ferritto with a subpoena to a grand jury. The subpoena was unrelated to the Greene killing.

"I pulled up," my brother recounted. "It was summer in the afternoon. He was in a garden, just like the movies. He has his wifebeater T-shirt on, hoeing the garden. There was a big statue of the Blessed Mother, on a pedestal. There was a table there, with a bottle of wine and two empty glasses. I pulled up. I backed in. I always back in, in case I have to get away because I didn't know what was there. He says, 'I see you backed in. Are you a cop?' I said, 'Are you Ray?' and he says, 'Yeah.' He says, 'What do you need?' I said, 'I got a subpoena for you.' He says, 'Well, you know I'm not gonna appear.' I said, 'Well, we'll see about that.' He says, 'Would you like a glass of wine?' I said, 'I would love a glass of wine.'"

"So we sat down and had a glass of wine. And I try to ask him some questions but obviously he's not going to answer any questions. He just flubbed me off."

My brother's relationships with gangsters were not always contentious. I talk with him today about some of those relationships and there is a tinge of nostalgia in his voice. Some of those men were charismatic. They wielded broad influence and authority in their communities. They were loyal. They took care of people. They kept under the radar. They were never ostentatious.

This respect for some of the men he helped put in prison was mutual, and to this day some of them maintain contact, but at a respectful distance. Maybe that's why my brother is still alive, despite a $10,000 contract that reportedly had been offered for his head by some of the men whom he pursued during his made-for-movies career.

Those "good" wise guys were all about gambling, which funded a

vast array of criminal activity. "Gambling took the place of Prohibition," my brother told me.

These men were products of another time. A time of tradition. A time of family. A time of respect. My brother will tell you that even law enforcement officers who arrested and put men behind bars had a certain kind of respect for them. They were criminals, no doubt, but even criminals in those days had parameters. Guidelines that were never crossed. You could kill a member of an opposing organization over a business deal gone bad, but you never touched his family.

"The new criminal class in the country of today is unpredictable, much more violent," my brother told me. "They have no standards."

Jake

"Twelve cheeseburgers and 12 small fries," my brother says to the machine at the McDonald's drive thru.

"How often do you go up to see Jake?" I ask about a long-time mutual friend.

"Oh, and one large strawberry milkshake, please," Lou says, again to the machine. And then to me, "Not as often as I'd like to."

"Why so much food?" I said, as Lou switches money for meals.

"Because all the other guys mooch from him so he needs to have some handouts."

"How long has he been there?"

"I don't know. Years now."

"You think he'll ever get out?" I ask.

"No. He's done. Finished. And it's a shame. Because if Jake had a good family, he'd never have been there in the first place."

"You think so?".

"Absolutely," my brother says with certainty. "Oh, absolutely. There's no doubt in my mind."

"That *is* a shame," I say as we pull into a long and winding driveway through well-kept grounds toward a sprawling complex of imposing buildings, all dark red brick.

"Jake's a nice guy," I say. "I remember going to his house for my first boxing lesson. He took me down to his cellar and showed me how to hold my hands in front of my face to keep from gettin' whacked and how to hit the heavy bag. And when I won the Golden Gloves tournament, he shows up at the house to congratulate me, because he thought he should get part of the credit for me having won. And you know what? He was right. And I thought that was nice. And now he's in this place."

We're stepping out of the car now, gathering up the bags of food.

"The worst thing about it is that he's lucid enough to know how bad his situation is, and to know that he can't get out of it," Lou says as we walk to the front gate of the mental institution. "He called me not too long ago and said something like, 'You think I don't want the things you have? You think I don't want nice things? A nice home? A nice family? I want them just like everybody else does. But I can't have them.' That's what he said. And that's the worst part. Jake's no dummy. He knows. He knows."

Lou and I are surrounded by a group of men we've never seen before. Jake pulls one of the burgers out of the bag I'm carrying. He takes a huge bite and says through a stuffed mouth, "Where's my shake?"

"I got it," I answer. Places like this always make me nervous and I guess I'm even more nervous because I'm trying to recognize what used to be a pretty good friend through the scars of alcoholism and the haze of mental illness dulled by heavy medication. Jake was a bit of a hero of mine when I was a kid. He was a really good fighter and had won a Golden Gloves boxing tournament, something that commanded a lot of respect and not a little fear in the place and among the people where I come from. But now he's gained weight and moves with a heavy shuffling distinct from his former graceful stride. His face is puffy. It looks like he just stepped out of the ring after having lost a fight. Most of his teeth are gone. His fingers are stained with nicotine. His breathing is heavy, labored. I fumble with the bag and finally hand him the strawberry milkshake.

Jake takes a long pull from the shake and catches a deep, desperate breath. He eyes his fellow patients now crowding around.

"Get outta here!" he barks and goes at the burger again. His voice is clogged with phlegm.

"Share, Jake," Lou tells him. "That's what I bought all this stuff for." Soon there are a dozen patients stuffing McDonald's cheeseburgers and fries into their faces. Jake, though, is the only one with a strawberry milkshake.

Jake is older than Lou and me. His father owned an auto repair shop in West Aliquippa where kids used to hang out. Jake's younger sister, Dorothy, worked in the office behind the repair shop. She helped her dad with paperwork. She was my first crush. And I was younger than 12 because I remember my father was still alive. I used to visit the shop, just to see Dorothy. She had peroxide hair always done up like Dolly Parton. Really white skin and an easy smile. Kind eyes.

Despite my love for Dorothy I understood that Jake came from a "bad family." That meant his father was an alcoholic and his mother was not strong enough to hold him in line. Jake developed a drinking problem in his teens and went downhill from there. One night, he finds his mother hanging from a beam in the basement. He cuts the rope and calls the cops. Jake's been in and out of institutions since then. The one that Lou and I are visiting today will be the last one he'll ever see.

As my brother and I prepare to leave, I go to shake Jake's hand and he fakes a left hook to my head and I pull my hands up to a feigned protective stance.

"You still fightin'?" he asks playfully, smiling for the first time during the visit. And I can see through the dullness of his eyes and just for an instant, the Jake that used to be and the Jake that will never be again.

"I'm too old for that shit, Jake," I say.

Our car pulls out of the complex. I slouch in the seat and give a long sigh as we begin to move.

"You were right," I say, as much to my brother as to no one at all.

"About what?"

"He knows," I said. "He knows."

Wine Day

The annual and intimate ritual of a handful of men pressing grapes and celebrating in my brother's basement to make wine morphed over the years into a sprawling party of family, friends and business associates. The crushing of grapes still is done in the basement of his home, but the party now is held on his property behind the building where he runs his business. Lou had retired from the Pennsylvania State Police, worked for a while as commander of the Pennsylvania governor's drug task force, and now runs his own security and investigative firm.

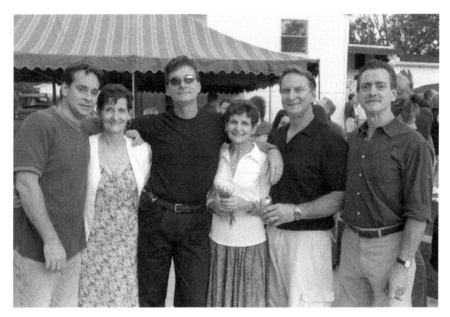

CENTER TOWNSHIP, PA – Wine Day. From left to right, my brother Rob, my mother, my brother David, my mother's sister Aunt Jessie, my brother Lou and me.

Behind the building, recently slaughtered lambs and pigs turn slowly over charcoal fires. Bottles of my brother's homemade wine adorn every table set up under a huge circus tent. A live band plays Italian music and from a balcony on the rear of that building, a middle-aged singer is crooning out Frank Sinatra favorites. Uncle Vince,

CENTER TOWNSHIP, PA – On Wine Day, Esther enjoys the company of Uncle Vince and his wife, Aunt Bertha.

now in his 80s and still envisioning himself the ladies' man, occasionally takes the microphone to sing a song or two before he turns again to flirt with the single, young women who enjoy his attention. Lou's two daughters, Teresa and Lisa, take turns dancing with Bobby. My mother catches up with friends and *paisanos* whom she has known forever but hasn't seen since the previous year's Wine Day. My younger brother David occasionally shows up at these events. My youngest brother Robby is living either in Tennessee or North Carolina but tries to attend when his job and his special-needs daughter permit.

Lou spends this day receiving his privileged guests. This annual event, now attended by hundreds of people, is more than a little reminiscent of the opening scene in *The Godfather* when Don Vito Corleone's daughter gets married. My brother has become the "Tada" of the extended family and his local community. He secures employment for those without it. He dispenses advice to those who seek it. He resolves conflicts between those who need it. It is a happy day.

CENTER TOWNSHIP, PA – Lou's wife, Carol, (left to right) enjoys Easter, also a special holiday, with daughter Teresa, Esther and daughter Lisa.

Ravioli

I'm turning the handle of a machine from another place and another time. My hands, my face and part of my clothing are covered with cooking flour. Somebody hands me thick strips of dough that I feed into one side of the machine and ooze them out on the other side as thinner strips. These strips are carried to another table where a small army of family and friends cuts them into small squares, fills them with a mixture of ground meat, spinach, cheese and spices, then folds the squares over to make ravioli.

Lou and his wife commandeer the whole operation and supply the filling. The foot soldiers include my nieces Teresa and Lisa, and Lisa's own daughters. Because of my escapades as well as my own encouragement, my nieces and their kids no longer refer to me as "Uncle Bill." My new title is, "Tio (Uncle) Thrill." My nephew Bobby, our very own gargling John Travolta whom my brother employs at his firm, participates in the event whenever he decides to grace us with his

presence. Married now with interests and activities of his own, Bobby sometimes can be very aloof.

My mother sits among the troops and rejoices in the company of her clan. She lives in the apartment that Lou had built onto the roof of his and Carol's home.

I am participating in the core ritual of every Christmas holiday. The family gets together on Christmas Eve to make ravioli that we will consume on Christmas Day. I am delighted to be "home." My brother and I fuel this ceremony either with his homemade wine or our favorite vodka which over the years has evolved from Stolichnaya to Grey Goose and finally to Ketel One.

Over time and despite the many triumphs, defeats, joys and disappointments, this ritual never changes. Every member of the family knows that. We know that no matter what happens in our lives, we can always count on this event and the people who made it happen to be there.

And it still is.

Finish Line at the Reservoir

My brother Lou watched with amusement as Bobby and I began our race on the road that straddles the reservoir.

"Billy's gonna beat him but not by much," Lou tells my brother Rob. "Billy's like an old deer who's stayed alive because he knows the trail, how to negotiate it and how to fool the hunters. Bobby will blow himself out before the end of the race."

At the half-way mark where we must turn around for the run back to the church parking lot, Bobby is slightly ahead of me but he's winded, his bravado reduced to a very strained, "Kick your ass, Uncle Bill" as we cross paths making the turnaround.

I start to pull ahead, and I can see in my mind's eye how this will play out. As I overtake him, Bobby plows even more muscle and strain into his step, pounding harder and harder at the pavement, tiring himself out even quicker. I'm taking long strides, with as little effort as

possible. Emulating the gait of my friend, Frank, I arch my back and it becomes a sail.

Downhill, I just let gravity pull me along, simply throwing my feet out in front of myself so as not to stumble. Uphill, I lean forward and take shorter steps. I'm taking long, deep breaths through my nose. I ease past Bobby and take longer strides now as I approach the finish line, beating my nephew who comes in with his head down, defeated and only slightly (and temporarily) humbled.

Men of Respect

On a table in the well-lit sunroom where my brother starts every morning by nourishing himself with coffee and literature, I notice a book with an old, black-and-white photo as its cover. The picture, made in a previous century, shows a group of men, some sitting and others standing behind them, all formal and posing for the camera. These men are nicely dressed. Some wear hats and ties. Some of the men standing in the back row rest a hand on the shoulders of men sitting in front of them.

A cover blurb explains how the author of the book traces the history of the Italian mafia from its beginnings as a group of cattle rustlers in nineteenth-century Sicily to a global crime network.

The title of the book is *Men of Respect*.

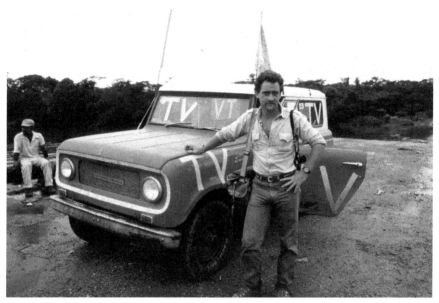

ATLANTIC COAST, Nicaragua – La Bestia and I during a trip to the eastern Atlantic Coast region of the country. I do not know who made this picture.

CHAPTER 8.

MY WAR

Arturo

We had been hanging out with the Sandinistas for only a few days, so we were still fresh, not yet strung out from fatigue, lousy food, exhausting days, uncomfortable nights, tension and fear. We were ready. Or as ready as you can be, to nearly get killed.

Mexican photojournalist Arturo Robles and I were up in the northeastern part of the country following rumors of heavy fighting on Nicaragua's eastern plains that run from the foot of the central mountains to the Atlantic Coast in the department of Zelaya. We had left Managua before dawn, *La Bestia* loaded with gear and supplies. *La Bestia*, my 1969 International Harvester Scout, the muscle machine that got us around the country. This thing had eight cylinders, four-wheel drive, dual exhaust, twin gas tanks, manual gear shift on the floor and a carburetor the size of a nuclear power plant all under a fire-engine red coat of hardened steel. I named it *La Bestia*, (The Beast), after a headline in one of the local newspapers reported an attack by the "*bestias*," or contras, up in the north.

Arturo loved scavenging through the music cassettes I carried in the glove compartment. The music that Claudia and I enjoyed on our trips to Masachapa.

"Quien ponemos?" I routinely asked Arturo. "Who do you want to hear?"

"*Las Hermanas Pointer,*" would sometimes be the response in a voice that sounded croaky, like a frog. "The Pointer Sisters."

We left *La Bestia* at the military training center and base called Mulukukú. This was a particularly sensitive base, more so than others, because it was here where Cuban military advisors taught counter-insurgency tactics to the Sandinista army. And it was here that the Sandinista army kept a fleet of Soviet-made helicopters, most important among them, the Mi-17, Hind attack helicopters, used to whack the contras up in the mountains and across the eastern plains. Wicked-looking killing machines capable of inflicting extraordinary damage, this generation of Soviet gunships became infamous during the Soviet occupation of Afghanistan in the 1970s and 80s. They became a major point of contention between the Sandinista government and the United States, the Reagan administration claiming the choppers were proof that Nicaragua had become a Soviet outpost, and justification for the U.S. Contra War against it.

Arturo and I never had any real problems getting access to the Nicaraguan military, and of course that was key. If journalists wanted access but couldn't get it, they couldn't cover the war. I had been in the country long enough and had the sufficient credentials (mostly my coverage of the 1979 revolution, my relationship with Claudia and her family, plus the muscle and the credibility wielded by *Newsweek* magazine) that the military honchos in Managua allowed me into places like this. And by that time, I had established enough contacts in the Sandinista army that I just rode up to military bases or army patrols and the commanders let me hang around or go on patrol with the troops. *La Bestia* and I were kind of hard to miss.

I had equipped my vehicle with metal bases welded to the roof just above the front windshield. On those trips to the war zones, I inserted

metal poles into those bases. To the poles I had attached white flags made of pillowcases. *La Bestia* had California plates that I never bothered to update or change to a Nicaraguan version. There was a small sticker on the driver side rear window. It said, "Help Wildlife. Give a Party." On the hood and the sides of the vehicle, I had taped gray gaffer's tape to read "TV." All of this was designed to make absolutely clear that the people in *La Bestia* were non-combatant journalists. Most of the commanders and many of the soldiers came to recognize her, as it was the only vehicle of its kind running around the mountains in those days. Sometimes they could hear her and her music, even before they saw her.

A major part of covering conflict in Central America was about getting to the places to make powerful and important pictures. Contacts and logistics were absolutely critical. A photojournalist colleague for whom I have tremendous respect once commented that, "Ninety-five percent of what I do is trying to get to the places where I can work."

He was right. My contacts in Nicaragua dated back to my coverage of the 1979 revolution. I lived in the country for seven years, from 1983 until 1990. I had become the adopted son of a very connected Nicaragua family. Claudia and her parents opened more than a few doors for me. I owned *La Bestia*. Without her, neither I nor the colleagues I routinely hauled around the region as a professional favor would have been able to reach the far-off corners of the country, to cross treacherous rivers and mountain ranges or to make forays into neighboring countries to document the news.

Stephen Kinzer is a former *New York Times* correspondent and bureau chief based in Managua during the 1980s. In a Facebook comment about a story I wrote in 2019 marking the 40th anniversary of the Sandinista Revolution, he wrote:

> There are some fakers in the foreign correspondent game but Gentile was the real deal in Central America. Once I pushed my driver to take me deep off the road

in remotest Boaco, and when we found a few huts the
driver proudly told one resident, "This guy is a jour-
nalist! From America! Bet you've never seen anyone
like that." The guy said, "Well, we once had a photog-
rapher in a jeep playing really loud rock music." Driver
turns to me and says: "Gentile!" (Always pronounced
of course "hen-TEE-lay")

Arturo has Native American features like sharp cheekbones, tight
eyes, dark skin and straight black hair. He's about a head shorter than
me, but powerful, his strength residing mostly in his legs and back.
He had broad shoulders, prompting one mutual friend to call him the
"Latin Rambo." Others called him *Rambito*, or Little Rambo. He had
his own contacts in the Sandinista government. Because Mexico was
one of the only countries in the Western Hemisphere that refused to
join the U.S. economic blockade of Cuba, Mexicans like Arturo were
given special consideration by revolutionary groups in the region.
(Canada was the only other nation in the hemisphere to reject sanc-
tions against Cuba.) Arturo was accepted by the Sandinistas as well as
leftist guerrillas in El Salvador. He was an outspoken supporter of the
Sandinistas, or at least he supported the Sandinista Revolution and
Nicaraguans' right to decide their own destiny.

What mattered to me was that we worked together like madmen.
Arturo was a freelancer associated with a stock photo agency in New
York that I had hooked him up to. He was smart and just about fear-
less and I knew I could depend on him when things got hairy. And we
covered a lot of hairy stuff not just in *La Montaña* but also in the mean
and deadly streets of El Salvador. As a bonus, Arturo had a wry sense
of humor that made him one of the funniest people I had ever met.

Each night at the base in Mulukukú, we went to sleep anticipating
that the following day we would move out with the troops. In the early
morning we hung from our hammocks in the cool moisture of the
savanna just before the sun came up and turned the stuff into steam.
It's all part of the routine. We waited for word that the troops would be

moving out to chase the contras. We got the commander's permission to go with them and then we just waited for it to happen. We lounged around for a couple of days chatting up the soldiers and their commanders, trying to be cool and to keep out of their way, dispensing Marlboros, granola bars and jokes to grease the skids out to a patrol and some action.

At that time the Sandinistas had a couple of contra prisoners who were forced to feed the chickens and work in the kitchen, if you can call a couple of wooden benches under a corrugated tin roof "a kitchen." We weren't allowed to make pictures of the prisoners or of the Soviet attack helicopters. I mostly drank coffee, smoked cigarettes, paced back and forth, and twirled my Swiss Army Knife around my fingers on the end of a camouflage nylon cord.

We were waiting for one of a dozen or so *Batallones de Lucha Irregular (BLI)*, loosely translated as Special Counter-Insurgency Battalions formed by the Sandinista government. These were soldiers without barracks, always mobilized, shock troops who actively pursued the enemy and took them head on, as opposed to other groups like territorial militias organized for local, stationary protection against contra raids. The BLIs were the elite of the Sandinista People's Army. This group was at the base for re-supply. Finally, the word came down to move, and Arturo and I headed out with the troops into the mountains.

"*A la gran puta, hermano*," (To the great whore, brother,) I said as we began to shoulder our gear. "Finally, we're going to see this war."

"*No jodas*," Arturo croaked in his froggy voice. "Before we get to be old men."

Crucifixes, Talismans and Aunt Carmela

I'm not a terribly superstitious person but I think I inherited some awareness and concern of the "other" world from the stories I picked up from my extended family. The unexplainable dream that my grandmother, Nana, had about the killing of her son, Tony, at Normandy.

Aunt Carmela's belief in "the evil eye." The two sisters' devotion to the Catholic Church and all its ritual and hocus-pocus to protect themselves and their families from that evil.

I think journalists who routinely cover conflict – and when I say "cover conflict" I mean they get close enough to actually risk being killed or wounded – eventually become superstitious as a result of having survived near-death experiences. And just to be sure, we take precautions or measures that could possibly help us mitigate that danger and survive those risks. Or, at least, I did.

So, as Arturo and I set out once again to cover this conflict, I am protected.

The crucifix given to me by my older brother is taped into the inside, bottom layer of my photo bag, where nobody can see it. In one of the pockets of the bag is a scapular, which is two squares of cloth held together by cloth bands. The wearer usually places one square on the chest and lets the second square drop down the back. The saints depicted on those patches of cloth are supposed to provide safety. A medal of the Blessed Virgin Mother is pinned to the inside of my belly pack. I'm wearing a gold crucifix and chain around my neck.

I had become accustomed to looking for signs, indicators, of how I would fare during any upcoming, dangerous assignment. The *zanate* was one of them. They look like crows, but they are smaller. Jet black birds that a lot of people found intimidating. Scary. Omens of dark things to come. Bad luck. I found them to be the exact opposite. I welcomed them around the house where Claudia and I lived. I talked to them. Mostly in English.

"Hey, man. Good to see you."

And, of course, there were the numbers. Any sighting or repetition of the number "4" was a good sign. That was my lucky number. So, a street address like "444 Main Street," for example, where I scheduled an interview was a good sign. If the interview was scheduled for 4 pm but delayed until 4:44 pm, that was excellent. And of course, the magazine for which I worked, *Newsweek*, was headquartered at 444 Madison Avenue in New York City. I'll take it! My lucky number!

But even before we set out to join these soldiers, I had alerted and engaged my most potent guardian and protector: Aunt Carmela. It had become my habit to telephone my aunt before heading to risky assignments in Nicaragua and especially in El Salvador, to ask that she keep me in her prayers. "Protect me from the evil with which you seem to be so familiar. Ask your saints and The Almighty Himself to protect me as I walk through that valley of the shadow of death." I envisioned my Aunt Carmela not only as my most potent talisman, but also as the only one to whom I could reach out to for protection. Carmela's sister, my grandmother, Nana, had died years before, and even if she still were alive, I wouldn't burden her with this kind of request. And my mother would be worried sick if I called her to ask for her protection. So, it was up to Aunt Carmela to keep me in one piece.

None of the Sandinistas, or contras, for that matter, wore bullet-proof vests. Nobody wore helmets or protective goggles. I had absolutely no protective gear. I had no health insurance policy. No death insurance policy. I couldn't afford them. I didn't believe in them. I had no ironclad guarantee that, if I got hurt, somebody would come to my rescue.

But I had Aunt Carmela and her connections to the other world. She was a key component of the arsenal I had assembled to protect me. Or at least to sustain the illusion that I was protected – an illusion without which I could never have done the things that I did. I also had family and I had Claudia. They were waiting for me. I had to make it back.

The Decision

Key to heading into any combat situation is the decision I had to make before going there. I prepared myself for the consequences of doing so. Am I physically and emotionally prepared for this? Can I accept the consequences of the decision to put myself, and others, in a dangerous situation? Do I accept the fact that I could get permanently injured or even killed as a result of this decision?

It is absolutely critical that I had this conversation with myself because if I fail to do this and get caught in a life-threatening bind, I run the risk of falling apart. I could freeze up. Or panic. And that will endanger not only me, but also the people around me. I will become a liability.

I have seen this happen. Men frozen under fire. Unable to respond. Paralyzed by fear. And then full of remorse for not being able to react.

So even before I grab my cameras and head for the field, I made the broader decision about the entire endeavor. And early on in my coverage of the conflicts raging across Central America, I had concluded that the story was so important that it was worth the risk. I was convinced that my country's intervention in these poor, developing countries needed to be addressed and challenged by the institution whose responsibility it was to do so: journalism. The media. My ticket and my tool. I had decided to accept the consequences of my actions.

The charms, the medals, my connections with Aunt Carmela and the otherworld, the hard questions, all of these are part of the imprecise, mysterious calculation on covering conflict. Or not. The final ingredient to this alchemy is this: What does my gut tell me? What does my gut say? I learned to listen to my gut. When my gut tells me not to go, I don't go. I stay home. Most of the time at this stage of my personal and professional life, my gut says, "Go."

Epigmenio Ibarra and I stand at the far end of a street in El Salvador with a gaggle of journalists covering one of the spasms of violence bleeding the country during the 1980s. A powerfully built Mexican with a full black beard, Epigmenio is a one-man television production crew known for his connections with the revolutionary movements convulsing the region and for his valor in covering them.

At the other end of that street, we hear spurts of gunfire and we pause to discuss whether or not we should walk the four or five blocks to what looks like a dead end and check it out. Epigmenio asks me, *"Qué te parece, Bill?"* I have tremendous respect for Epigmenio. He's been around. He's super smart. He's effective. He gets the job done.

"What do you think, Bill?"

I understand what is at stake here. If Epigmenio and I decide to

go down this street, our colleagues will follow. Epigmenio and I have reputations. We are considered seasoned veterans. We've seen it all. We've been in combat. We've seen people fight and die. The colleagues waiting for our decision will follow us, for better or for worse. They trust us.

They wait for my response. I look down the street and see nothing. Nobody. No moving cars. No shopkeepers greeting customers at the entrance to their stores. No kids kicking a soccer ball. Nobody peering out into the street from behind a half-closed door. Nobody looking out through a window. Not even a dog scrounging around for something to eat. I must choose my words with extreme care. I know that my response must be decisive as well as diplomatic.

"No fuckin' way I'm walkin' down this street, Epigmenio!" my gut says. "Are you out of your mind?"

My mouth says, *"No, mi hermano. Demasiado riesgo."* (No, my brother. Too risky.)

Nobody walked down that street.

It was soon after my return to Nicaragua to live and work with Claudia when a visiting, New York-based photographer asked if he could accompany me to cover the conflict up in *La Montaña*. He had never been to Nicaragua and never covered conflict. Especially in my early days, I was overly generous about showing the ropes to the less-experienced, new arrivals, and so I said OK.

So, we're on a lonely dirt road, way up in the mountains and some civilians in a pickup truck heading in the opposite direction stop us and tell us there's fighting ahead and maybe we should turn around and go back. This, of course, is the antithesis to what journalists, especially visual journalists, do. We run *toward* conflict. Not away from it.

As we plodded forward the New York photographer is getting really nervous and he starts to repeat, "I'm not ready for this. I'm not ready for this." Perhaps a bit late, but his gut was telling him, "No." Luckily, civilians in another vehicle traveling away from the fighting are willing to take him back to Managua. He and I say goodbye and I continue down the road, alone.

We both had made the right decision.

Ambush

As anywhere else in the world, the light in Nicaragua is best in the morning right after sunrise and in the late afternoon right before sunset. Those are the times when a photographer really has to hustle. We call this "the golden hour." Arturo and I got up before dawn to make pictures of the troops pulling their gear together and moving out of Mulukukú into God only knows what. I don't know how many times I've been on patrol with who knows how many government troops or anti-government rebels in who knows how many countries in who knows how many conflicts from Latin America to the Middle East, but I begin every one of them with the same queasy, half-sick feeling in my stomach that I did that morning with these Nicaraguan kids.

It's a combination of excitement and dread. It would sound trite if I said the excitement was about the chance to make stunning images of

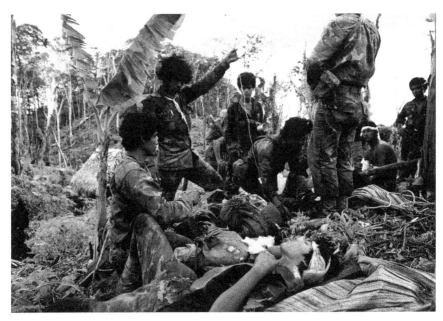

ATLANTIC COAST, Nicaragua – On patrol with members of the Sandinista People's Army, Mexican photojournalist Arturo Robles and I fall into an ambush by anti-Sandinista contra rebels.

war, hone my craft and enhance my career. Because it's so much more than that. It's about the chance to see and touch other human beings in the most profound and telling moments of their lives – when they are fighting to save them. There is no contact more intimate, more moving than contact between men in battle. *Period.*

I think back of that image in *LIFE* magazine during the Vietnam War, the picture that I believe planted the seed of my interest in the world beyond my immediate confines, in photojournalism and in conflict.

In a piece published decades later, Ben Cosgrove described that image as a "searing illustration of the horrors inherent in that long, divisive war and, by implication, in all wars. In (Larry) Burrows' photo, commonly known as *Reaching Out*, an injured Marine Gunnery Sgt. Jeremiah Purdie, a blood-stained bandage on his head appears to be inexorably drawn to a stricken comrade. Here, in one astonishing frame, we witness tenderness and terror, desolation and fellowship and, above all, the power of a simple human gesture to transform, if only for a moment, an utterly inhuman landscape."

I have always wanted to make a picture with that much power. That much intimacy. Maybe I will do so today.

The dread part of moving in with the troops is multi-faceted. First, this is really hard work, walking all day rain or shine, humping all my gear. Walking and working while I do it. I start working before the soldiers do and I work all day, moving while these young men move, take a break, suck water out of a canteen, have a smoke or just sit there and sweat, trying to build up enough steam for the next round of walking. They're getting tired just walking the patrol and carrying their gear. I've got to walk, carry my own gear *and* make pictures.

Then at the end of the day I've still got to be on my feet, moving up and down and all around, while they set up for the night. This is not easy. Most of the soldiers were peasants, generally 15 to 20 years younger than me, and already accustomed to long days of hard work under a punishing sun, a steady diet of rice and beans, and sleeping just a few hours on an uncomfortable surface. And because they're

younger, they recuperate after only a few hours of sleep. These guys get up in the morning and they're like brand new. For me, not only are the conditions debilitating, but their effect is cumulative. The longer I stay out there, the tougher it is. And the longer it takes to get over it. Depending on how many days I had spent in the mountains on any given mission, it would take me twice the amount of days to get back to normal. To get my stomach right and my guts used to decent, un-contaminated food and water. To allow my body to recuperate.

The other part of the dread, the more important part, is this: I'm out here to make pictures of war. I'm here to document the war. War is not just guys walking around in the mountains. That's part of it, par-ticularly this war, but war, real war, is people shooting and getting shot at. Wounding and getting wounded. Killing and getting killed. And that's what I came here for. I came here to see these men at war. And I want to see combat. That's as cold and as hard and as truthful as I can put it. I don't actually wish for anybody to get hurt, to get killed, but I do wish for some action, and I wish it would come soon, before I'm too wiped out to be able to make pictures of it. Before my flash goes out because I smashed it when I tripped on a rock, before my camera bodies go down because the rain got to them, or before my legs go out because I just ran out of steam.

I've spent days and weeks walking through the mountains of northern Nicaragua with the Sandinistas and with the contras. Days and weeks of slopping through mud. Days and weeks of getting rained on. Sleeping cold, wet and hungry. Eating cold, soggy rice and beans and monkey meat. (The trick to eating monkey is to never watch dur-ing its preparation. When the skin is pulled off, the animal looks too much like a human child.)

One night everybody's hanging in their hammocks, wet and cold, and one of the soldiers turns on his transistor radio. It's Elton John singing, "I Guess That's Why They Call It the Blues." Precisely! Days and nights without ever hearing a single shot being fired. That's *ex-actly* why they call it the blues. I get a lot of nice pictures of soldiers and contras walking on patrol. Sharing cigarettes. Taking breaks on

the side of the trail. (I also lost a lot of weight.) Nice pictures, but where is the war that I came here to document? To denounce? Is this what *Newsweek* magazine wants to use in next week's publication? No. I need the real stuff. I need "bang bang." I need war.

Arturo and I took our positions in line, in single file and just behind the *exploradores*, or scouts. In the early days of covering the war I used to walk right up front with the scouts. But after having been pinned down once with my face buried in the dirt and my heart in my mouth, I moved back into the line. The soldiers are organized in progressively larger groups, from squads to platoons to companies that make up the battalion. A battalion normally stands at about 450 to 500 guys, depending on how many were killed or wounded in recent action, and how inefficient the pencil-pushing military clerks and honchos have been in replacing them. The lines can stretch out for a mile or so depending on how many guys there are.

I'm making pictures and looking into the woods for contras. I'm looking for a gun barrel sticking out of the foliage. Or a set of eyes peering out from behind a tree. Or the top of somebody's head sticking up from the bushes. Every valley we walk through is a potential graveyard. Every open space a potential killing field. Every river a duck pond where the enemy can take us out as if we are in a shooting gallery. My mind drifts home to Claudia. It's mid-morning now and she's at work at the newspaper. She's probably worried about me. When I get back we'll go to the beach together, to Masachapa, drink some beers on the way, listen to Jackson Browne as we bomb down the highway in *La Bestia*. I'll spend days resting up and eating decent food. I'll blast music on the stereo and dance with Leonardo.

Lou's probably riding around in the State Police car, chasing bad guys, fightin' crime, as he calls it. Keeping law and order. Or maybe I'm stalking deer with him in the mountains of Pennsylvania. But I pull my mind back to here and now, and look for places to take cover, routes to escape. If they open fire from the top of this hill, I'll duck behind this tree. If they come at us from around that bend, I'll jump behind this mound. If they start firing from that tree line, I'll crawl

sideways across the field. Pay attention. Don't get lazy. Don't get careless. Don't get hurt. Don't get killed. Don't wreck my mother's life. She's waiting for me.

"Jodido!" I said over my right shoulder, pulling Arturo back from his own place of refuge that we all drift into during long hours of patrol. "Don't fall asleep."

The forest at the top of the hill explodes and everybody either throws himself to the ground for cover or falls to the ground because he is hit. I hear somebody shouting orders and Arturo and I follow guys up the hill, all of us slipping and sliding over the soft mud, the soldiers crouched over and weapons facing upward, nobody knowing what we're moving toward because it's like the trees and the bushes are shooting at us. Where is the enemy? I'm mostly seeing soldiers' asses moving up the hill, and a tree line beyond the asses. I'm trying to compose pictures. I turn around and make some images of the kids scrambling up the hill. Some of them are not scrambling very much. Some of them are just hunched down into the dirt trying not to get the tops of their heads shot off.

I look at these pictures now and they really don't convey the emotion, the fear, the violence. There's one picture of a kid, he can't be more than 17, lying on his stomach and looking right up at me, eyes as big as tennis balls, sweat squirting out of his forehead, just staring at me as if I know what to do next. Maybe if the color photographic slides in my archives could emit sound, maybe if viewers could hear the shooting and the screaming, or even just the sound of my own heart as it tries to break out of my chest. Maybe then people could understand.

I'm catching my breath (way too many Marlboros) and Arturo comes up from behind and passes me. We both move up the hill, trying to make pictures of young men at war. But the fighting really doesn't last that long. Maybe eight minutes. That's the nature of ambushes. Surprise the opponent, inflict as many casualties as possible without placing yourself in too much danger, and split while the opponent is still trying to recuperate from the damage you just laid on

him. Leave a couple of guys behind so that if the ambush victims try to be tough guys and chase you, your couple of guys can whack 'em as they approach. Your opponent doesn't know the terrain where you're headed. You do, and if you're smart you can whack 'em at every turn. And if you leave him plenty of dead and wounded to deal with, which is precisely what an ambush is all about in the first place, you'll be long gone before he gets his shit even halfway together.

The top of the hill is a mess. There's a kid on his back with his eyes closed, bleeding real hard from his neck. Another kid with long bushy hair is holding a bottle of saline solution and a white plastic tube goes down into the forearm of another kid who's shot in the stomach. A "medic" is crouched over him. ("Medic" in this war means a kid the Sandinistas taught how to put gauze on a wound and how to stick a needle in somebody's arm.) And behind that is a husky, dark-skinned boy with white gauze wrapped around his head and right arm. He seems to be more amused than shaken by the whole scene. Perhaps dazed. But there are no dead.

Arturo and I have dumped our backpacks and we are working as hard and as fast as we can. This is why we walk around in the mountains for days. This is what we risk our lives for. For just a few minutes to be able to work, to make photographs, to make a testimony of what's happening in this country. We are conscious of each other's movements. We try not to get in each other's pictures. We want to freeze these moments in time, on film.

We're alive and unhurt so our worst nightmares have not materialized. Not yet anyway. And thank God all these kids will live. For now. They're busted up but they'll live. It's been a good ambush. A damn good ambush.

Arturo and I get a bonus. We not only can leave early but we can also make photographs on the way out. The wounded have to be evacuated. I've got another picture in my book of photographs showing the kid who was shot in the stomach being carried across a stream by two buddies. The Sandinistas cut down a long tree about four inches thick and get the guy's hammock and string it on the pole. The ham-

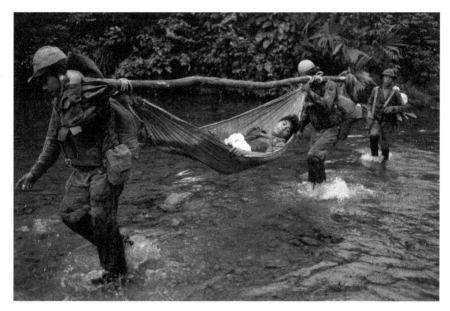

ATLANTIC COAST, Nicaragua – Sandinista soldiers evacuate wounded colleagues from the battlefield using hammocks strung from slender trees.

mock is usually a nylon sack used to ship coffee beans. It is split open and with rope attached to each end of pole. That's how they carried the wounded out of the mountains. It reminds me of those Tarzan movies I used to see when I was a kid, with the white big-game hunters, and the native porters carrying a dead tiger slung along a pole.

We get back to Mulukukú and some peasants approach us and say contras killed one of the local militiamen the night before. The militiaman is laid out in a hut right up the road and please won't you come and see? Arturo and I had just come off a really good mission and we're tired, dirty and giddy with excitement to get home to clean clothes, cold beers and warm women, and at first it's like, ah, we're tired, and nah, we've already got good stuff and, I don't know, we've got to get back to Managua. But I look these people over and these are the most humble of the humble, and they are asking us to see what is happening to their country, to their communities, to their families. Not just to see but also to share. And it is these people, the poorest of the poor, who are the most generous in Nicaragua. I think it's

like that all over the world. The poor are always the most generous. These Nicaraguans, the poor peasants, see us journalists as elements of hope. Our presence here makes them feel like what they were going through will not go unnoticed, that they are not alone. That their dead and their wounded would not remain anonymous. That somehow we would get the word out, we would show the world what was happening, that we could somehow help to make it all stop. And especially because we are photographers, we can actually *show* the world what is happening here. Not just *tell* the world.

They understand our power. These heartbreakingly poor, illiterate, unsophisticated peasants. They ask Arturo and me to help. They know they are being victimized, used, for reasons that have absolutely nothing to do with them and over which they have absolutely no control. And we, as foreign journalists, have a moral obligation toward these people, regardless of how tired, or how hungry or how late for a deadline we are, to reciprocate in some fashion. Not to do so would be *"una falta de cariño. Una falta de respeto."* (A lack of caring. A lack of respect.) We would go to their wake.

"Qué te parece, Arturo?" (What do you think, Arturo?) I ask. *"Diez minutos."* (Ten minutes.)

"Está bien," he says. Fine.

"Show the World What Happened Here"

I think maybe because of his indigenous blood, Arturo feels a special closeness to these people. He has a deep respect and even a reverence for them, so he needs no convincing to stick around and do the right thing. We dump some of our gear in the back of *La Bestia* and follow the peasants to some rows of shacks made of poles and draped over with sheets of black plastic. At this point we're dragging and want to get on the road quick so that we're not caught up here in the countryside driving around in the dark, a dangerous, stupid thing to do. We approach the shack, it can't be more than 15 feet long and 12 feet wide, and I don't know what to expect.

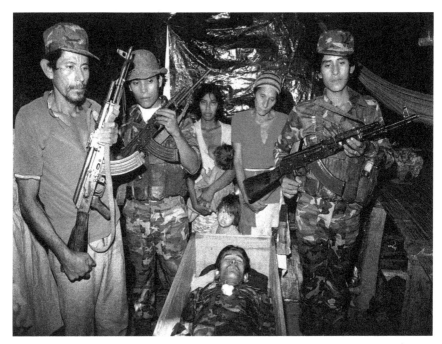

MULUKUKU, Nicaragua – A Sandinista militiaman lies dead in a wooden coffin as his family crowds around. With an infant to her breast, the dead man's wife stands behind him, as does his young son. The wife's mother-in-law stands at her side. The older man is the militiaman's father.

One of the peasants pulls back the black plastic to allow us inside. They had been waiting for us. In the middle of the shack is a rough, wooden coffin holding the dead militiaman, dressed in camouflage and with cotton stuffed into his nostrils and his ears. His hair is oiled and parted in the middle and combed to the sides. His head is propped up on a black pillow. I am standing at the militiaman's feet. Just behind his head and across the coffin from me is the militiaman's family. His mother is standing to the right. She is light-skinned and lean, kept that way by the rigors of survival in this part of the world. She wears a red pullover shirt open at the neck and an apron patched together from rags. The apron is soiled. To the left is the militiaman's wife. She is a dark woman, shorter than the mother, with rounded features. Clearly, she is of pure indigenous stock. She is wearing a pink

pullover dress. The neckline is pulled down, and at her left breast a young son who is cradled in her arms suckles. Just below this child is another son, standing just behind his father's head, and if he wants to, the child can reach over and touch his dad. Maybe he had. Or would. I just didn't see it.

The honor guard flanks the coffin. To the left are two men, one young, dressed in camouflage and holding an AK-47 at his chest. Standing in front of him and closer to the camera is the dead militia-man's father, a peasant, dressed in civilian garb. He is unshaven and his too-long sideburns flip up from underneath his camouflage hat, which is askew. A dark blue pullover shirt hangs over his light blue pants. The zipper appears to be damaged. He stares neither straight ahead nor down to the floor but somewhere in between. And a thousand miles away. I can tell he is more comfortable holding a machete or a hoe than he is holding his assault rifle. His left hand clasps the barrel and he cradles the butt of the weapon in his right hand. It looks awkward. I suspect he is asking himself what will become of his family now, as his son lies dead in the coffin beside him. To my right is another young militiaman, looking just as ill at ease holding his weapon as is the father. He holds the rifle parallel to the ground and out toward the camera, as if he were holding it on display.

I pull out a 24mm lens to be able to capture the whole scene. A 28mm won't capture it all. It's just not wide enough. I put on a flash and bang out a few shots. There's not too much I can do with this besides a straight-forward portrait of the whole scene. As I'm looking through the camera, composing the shots, and these people are posing there for us, making their statement, I see that the wife of the dead militiaman is staring straight at me. She is the only person in the group who makes eye contact with me. And it's more than just a stare. It's a piercing connection that cuts past everything else in the picture. I look at the picture today, in my book, and her stare completely dominates the page. And I can hear what she's saying to me, then and now, this woman whose husband and very much a part of her entire life is lying dead in a wooden box in front of her. She's talking to me, this

person who has had her existence and that of her children devastated in a single day. And maybe I'm so shaken, then and now, because I seem to have been in this room before, heard the words before, felt the sadness before that presses against me again like the heat under this black plastic roof. This is what she said:

"Look what they've done to my life. Show the world what happened here."

Arturo and I head out of Mulukukú, over the dirt road that in a few hours of leaning as hard as I can on *La Bestia* will connect us to the Pan American Highway where we will head south to Managua. It is our habit *never* to play music on the back roads of northern Nicaragua. The last thing we want is to be listening to Phil Collins *a todo volumen* (at max volume) and drive right into a firefight or an ambush that we can't even hear. I can drive for hours at a time and neither of us will say a word and it's OK. It's one of the gratifying aspects of our relationship. We don't feel compelled to fill every minute of our time together with mindless blabber. But the drive out today is even more quiet than usual. Maybe it's because I don't want to interrupt that peasant woman in the shack.

I still hear her talking to me. And I answer her.

"Yes." I say to her. "I promise. I will show them."

Danilo

The year after his nighttime appearance at our cottage door while conducting *"vigilancia revolucionaria,"* Claudia's youngest brother, Danilo, is back in the Sandinista army, this time in the *Batallón de Lucha Irregular (BLI) Rufo Marín.* He's stationed in the municipality of San Juan del Río Coco, in northwest Nicaragua along the border with Honduras.

From what I understand, Danilo initially was eager to return to military service, perhaps to seek revenge for the killing of his 12 high school friends. Perhaps out of a sense of duty. That eagerness, however, at some point turned to ambivalence, and Danilo asked his parents,

my future in-laws, if they could get him placed in the navy instead of the army. They apparently could not.

In November 1984, a young Sandinista soldier shows up at Danilo's house and tells his parents that he is a member of their son's army unit. The young man is recovering from a slight wound he received during a recent firefight with contra forces. He tells Norma and her husband, Alberto, that Danilo was seriously wounded in that battle and was in the *Hospital Pedro Altamirano* in La Trinidad, a small town sprinkled along both sides of the Pan American Highway in northern Nicaragua, south of the city of Estelí. I drive Claudia and her parents to La Trinidad. The "hospital" is a one-story, nondescript affair with a handful of rooms and beds, only rudimentary equipment and facilities, and a dire shortage of medical professionals who might know how to use them.

Danilo is covered with shrapnel wounds from a contra mortar round. The most serious of the wounds is the one that penetrated the left side of his skull and entered his brain. It took three days for his comrades to carry him out of the field in a hammock slung from the ends of a long pole. By the time he arrived at the hospital, maggots had invaded the wound in his head. He is clinging to life. For some reason, Danilo recognizes me immediately, but not his father, mother or sister, who try to communicate with him. Danilo is capable only of repeating his full name, Óscar Danilo Baca Vaughan, as printed on his dog tags. Claudia believes this repetition is a survival mechanism.

At the hospital is someone I'll call Jose, a Cuban brain surgeon who had been taking care of Danilo. Jose is one of many doctors and teachers sent by Fidel Castro to assist the Sandinista Revolution. Jose had stabilized Danilo, but now insists that Danilo be transferred, immediately, to the *Hospital Militar* in Managua, where equipment and personnel can take better care of him. Claudia's father, Claudia and I return to Managua that evening so that Alberto can arrange for Danilo's transfer. Norma refuses to leave, instead staying in Danilo's room to keep vigil at her young son's side.

In the middle of the night, Norma is sleeping on a chair next to Danilo but awakens suddenly, alarmed. Her son has stopped breathing. She tells the nurses to run and find Jose at his dorm where other Cuban doctors stay. Jose returns to Danilo's side to see that the boy's breathing is obstructed by mucus and puss. His skin has turned blue for lack of oxygen. There is no equipment to clear the passageways. Instead, Jose puts his own mouth to Danilo's mouth and nose, then sucks out and spits to the floor the mess that blocks Danilo's breathing. He removes Danilo's head bandages and stitches. Danilo's brain is swollen.

Norma is horrified by this scene and would weep openly years later as she recounted it. Torn by the agony of her son's struggle and wanting to free him of more pain, she tells Jose, "*Ya. Déjalo.*" (Enough. Let him go.)

But Jose will not "let him go." He continues to work on Danilo and finally pulls him back from the edge. By morning Danilo is transferred to the hospital in Managua after surviving a technical death. Jose would later say Danilo's partial blindness was caused by this episode. Part of his lower brain was damaged by lack of oxygen.

Jose became a dear friend of the family, especially after he was reassigned from the hospital in La Trinidad to other duties in Managua. He and Claudia's father would spend long stretches of time playing chess, a favorite pastime of Claudia's father. At some point Claudia and I had left her family's home and rented a house of our own. Along with Claudia's family and a newly acquired Sandinista "*compañera*" (female companion), Jose would visit our house in Managua.

Danilo would never be the same.

"We Sometimes Forget"

I was on a flight from somewhere in Central America back to my base in Managua. In the seat next to me was a print correspondent heading to Nicaragua to do a story. She was critical of the policies that the Sandinista government had imposed in response to U.S. in-

tervention. She couldn't understand why the leaders of this tiny and impoverished nation of about 3 million people could respond so harshly in the face of outright aggression from the most powerful nation on earth. Educated in one of the finest universities in the United States and essentially a good, decent human being, this correspondent couldn't understand why the Sandinistas had imposed a military draft, closed anti-government news outlets, imprisoned critics and lashed out at domestic and foreign opponents. Really?

After we landed in Managua, I told the correspondent I wanted to check in with Claudia's parents, so I suggested we swing by their house for a quick visit. But what I really wanted was to have my colleague meet Danilo, who had been so badly wounded fighting the contras.

Danilo was a wreck. On top of the wound he had suffered in his early days of military service, the mortar round had inflicted profound and permanent damage to his body, his brain and his mind. The fingers on one hand were disfigured from the shrapnel that tore through them. His skull was still healing. He was drifting into total blindness. He suffered severe seizures. He moved around the house slowly, stupefied by his wounds and by the anti-seizure medicine they gave him, negotiating his way around furniture and people he could barely see. He communicated in short, sometimes single-word sentences. Danilo suffered psychological and emotional trauma, the depths of which we would never understand.

"If this were your brother," I wanted to ask my colleague on our way out of my Nicaraguan family's home, "what kind of measures would you take to defend your people from U.S. policy?" But I didn't ask. I thought the lesson from what I'd shown her was plain enough.

As we left, the correspondent said something like, "I guess we sometimes forget what war is about, the human toll that these conflicts extract from people like Danilo and his family."

And I thought, "What did you think war is about?"

Fight or Flight

Patrick Hamilton is a combat veteran of the Vietnam War. He joined the U.S. Marine Corps in 1968 and was sent to Vietnam the following year as a member of the Long-Range Reconnaissance Patrols (LRRP). He's from San Antonio, Texas, and speaks in a soft but firm voice with a distinctive southern drawl.

I knew Hamilton because we both lived in Mexico City in the late 1970s, when he was a staff photojournalist for the Associated Press and I was a stringer for United Press International. I reached out to him in January 2020 to help fill in my patchy memory of a decision we made four decades previous, and to include his recollections in this book.

During a long phone conversation, Hamilton explained his role in Vietnam. He said he was "picked out of boot camp" and assigned to the LRRPs "based on physical abilities and emotional makeup."

"We were like the Marine Corps version of the Navy SEALs," Hamilton said when I called him from my home in Washington, DC. "Long-Range Reconnaissance Patrols. That's what I did. Six or seven-man patrols for seven, eight days at a time, way out deep" into enemy territory.

The LRRP's job was to locate Viet Cong forces and feed information about them back to U.S. commanders who would attack with artillery, helicopters, ground forces or all of the above. Of all the U.S. military units in the Vietnam War, the LRRPs suffered some of the highest casualty rates.

"By the time I was 20 I was a patrol leader and a platoon sergeant, not because I was a great Marine but because I was still alive," Hamilton told me. "Still around."

When I drove around in a war zone in northern Nicaragua with a guy like Hamilton sitting shotgun, I had a sense of security that I did not enjoy if riding around with some everyday John Doe. And as I did with the Swift Boat commander-turned-*Miami Herald* correspondent Guy Gugliotta, I paid special attention to any information or insights

EL SALVADOR – Vietnam veteran-turned Associated Press photojournalist, Patrick Hamilton (farthest left with sunglasses) accompanies colleagues and military officials while covering the civil war in neighboring El Salvador.

Hamilton volunteered because the Contra War was so much like the Vietnam War.

"It was quite a bit similar," Hamilton said. "It was a guerrilla war. Guerrilla warfare. It was very similar."

And it was during one of those excursions with Hamilton that re-inforced my conviction that the consequences of every decision made while covering conflict is amplified precisely because people's lives are at stake. Everything is magnified. Stay or leave. Help or don't help. Fight or flight.

Hamilton and I were cruising along in *La Bestia* over dirt roads in *La Montaña* looking for stories and photographs that would help explain the conflict. A group of peasants flagged us down. The con-tras had staged an attack and one of the Sandinista militiamen took a bullet to the chest that came out through his back. He was just a kid, about 18 or 19 years old.

"They asked us if we wanted to take a picture of them burying him," Hamilton said during our phone conversation. "They thought he was dead, but he was alive. One of us asked if there was a doctor and they said 'No' and I kind of volunteered to take him to the hospital."

So, this was our dilemma and these were our options: (1) Hamilton and I go on our way down the road, in which case the kid probably will bleed out and die. (2) We put the militiaman in my vehicle and drive him the two and a half hours back to the city of Ocotal where there's a hospital. If we do this and get stopped by the contras, they most likely will kill the militiaman and, as a bonus, they might kill Hamilton and me, as well.

"It's an ethical question in a conflict without ethics," Hamilton said during our conversation. "Without rules."

We decided to take the kid to the hospital. We slung up the militiaman's hammock and hung him from the interior roof of my vehicle. Hamilton drove *La Bestia* while I held onto the kid, trying to cushion his ride on the bumpy dirt road to Ocotal.

Along the way, there was a roadblock, Hamilton remembered. "They are *muchachos*. They are Sandinistas." We said, "We have a patriot here and he has to go to the hospital."

The Sandinistas let us proceed. When we arrived at the hospital in Ocotal, the militiaman was still alive.

This incident becomes part of my creed on covering conflict or any kind of traumatic event. In addition to the already existing First Commandment of "Do no harm," I add: "If a person needs help and there's somebody around who can assist, let that somebody do it. But if nobody's around who can assist, drop the cameras and go back to being a human being. Assist."

We Are One

I'm pulling out onto the *Carretera Norte* with the sun coming up over the shantytowns on the northern edge of the capital. The smell of

early-morning wood fires tells me the poor are awake and preparing for another day of struggle. Eight cylinders hammer out controlled explosions inside *La Bestia's* engine block. I hear them roar under the hood as they blow their breath out the dual exhaust. I shift gears on this classic machine, which can muscle her way through just about anything and take me anywhere I ask her to.

There is something visceral, sensual and exhilarating about driving a powerful vehicle in which everything is manual. No automatic steering. No automatic transmission. No automatic windows. In *La Bestia*, I feel every curve in the road. I shift her gears to climb hills, to slow down as we descend them, and to roll her power on as we take the open highway. In the mountains I can feel the dirt roads, the rocks and the potholes through her suspension. My hands wrestle her steering wheel and the gear shift while my feet juggle the clutch, the gas pedal, the brakes.

I once listened to an Olympic equestrian champion describe the exhilaration of what she called the "one-athlete" connection between horse and rider. It's when the two are in perfect synchronization. When the horse is the muscle and the rider is the brain, and the two work perfectly together as "one athlete."

My relationship with *La Bestia* is even more organic. More physical. Precisely because everything in her is manual as opposed to automatic, I am not only the brain of the operation but part of the muscle, as well. I don't just issue commands for her to execute. I actually initiate her action by taking physical action myself. She responds to my physical commands, all of them issued through my eyes, my hands, my feet.

And she executes them faithfully.

After one particularly grueling trip to *La Montaña* where we braved chest-high river waters and treacherous roads that challenged her brakes and suspension, *La Bestia* limped back to Managua where Arturo and I headed straight to the shop where my brilliant mechanics Domingo and Jose always managed to do their magic to put her back on the road.

"Regresa herida pero regresa," Arturo said in his croaky frog voice as we pulled into the shop. (She gets back wounded but she gets back.)

Yes, she does.

On this morning, I am strapped into this beast of a machine, my bag of precision Nikon cameras sits near a mug of coffee on the metal console beside me. Another Marlboro. I am young. I am strong. I am free. It is a new day. I am on my way to *La Montaña* where I will use my talent and my tools to document major events in a spectacularly beautiful country and to explain not just this country and her people to the world, but also to show how U.S. foreign policy is wrecking the lives of so many here. I understand all this. I relish all this. I am not pushing my way north to the mountains. *La Montaña* lures me in. She pulls me into herself, like a beautiful, powerful, dangerously intoxicating woman. I can smell her, feel her, taste her. I am no longer just an observer. I am part of her. Caught in her embrace. We are one. *La Montaña* and I.

El Cuervo and "FEEEL KOLeeenz."

I often go to the mountains alone, compelled by a need to make pictures. I am jealous, envious and protective of anyone who might share the intimacy I have established with *La Montaña*, with the conflict, with the troops, and with myself.

I often hook up with *El Cuervo*, the Military Counter-Intelligence guy who previously warned me not to clip my fingernails before heading into *La Montaña*. *Cuervo* spent a lot of time in Matagalpa and Jinotega, both cities being gateways to free fire zones in the northern and eastern parts of the country. Once he and I became friends, I could go anywhere in those sectors and move around with relative impunity. And we had fun. *Cuervo* particularly enjoyed roaming around in *La Bestia* and scouring my music selections to blast out some sounds on the International Harvester Scout's speakers. He loved to play the "air drums" to the sound of Phil Collins, leader of the group, Genesis.

He pronounces the name, "FEEEL KOLeeenz."

Cuervo and I spent time scouring the mountains looking for war, despite the fact that he was deeply torn by the conflict. I got the sense that his exposure to the violence was taking a toll. He was becoming disillusioned. Deeply emotional. And reckless.

On one visit, I needed gasoline for the always-thirsty, eight-cylinder *La Bestia* but, partly as a result of a U.S. trade embargo, gasoline was scarce. So, I picked up *Cuervo*, who took me to a military base on the outskirts of Matagalpa. We pulled up to the gate of the base and there was a young kid checking IDs.

"Go ask your commander who I am," *Cuervo* said, not even looking at the kid, who then let us through to fill up with gas. *Cuervo* wielded that kind of attitude and authority. And little by little, *El Cuervo* was becoming more and more well-known. A phenomenon recognized by commanders and foot soldiers alike.

I came to see him as a tragic figure in this conflict. What I waste, I thought, that his intellect, his energy and his talent were being spent as a cog in the machine of war designed to kill his fellow Nicaraguans.

Claudia is a good judge of character, and I often deferred to her as a final arbiter of others. Claudia liked *Cuervo* but she was wary of him, understanding that his addiction to the conflict fed my own attraction to it.

There is nothing like the exhilaration of having survived the near-death experience of combat. Nothing. I think maybe it's because fear forces us into our innermost selves. Makes us come into contact with ourselves to deal with the situation at hand. If we deal with the situation to our own satisfaction, we feel a calm ecstasy once the crisis is over. If we don't deal with it appropriately, we are filled with dread.

Although *El Cuervo* and I never discussed the conflict in these terms, I think we connected so deeply precisely because we shared these dynamics relative to it.

War changes not just what is inside us, but also the aura around us. Among men, and I suspect among women as well, there is a regard, a respect, even a reverence, for men who know war. Participation in conflict, as a combatant or as one who documents combat, is a

permanent tattoo. We are marked forever. Most men who know real combat are reluctant to discuss it. We don't need to. But it's there. It's always there. On us. Around us. It follows us wherever we go.

"He landed on Omaha Beach during the Normandy Invasion," people remarked when my Uncle Pat walked into a room upon his return from serving in the U.S. Army during World War II.

"He's a combat veteran of the Vietnam War," others would comment when one of my Vietnam vet-turned-journalist colleagues showed up at a press conference.

"He covered the wars in Nicaragua and El Salvador, in Iraq and Afghanistan," I suspect people say of me now.

In the blockbuster Hollywood film, "The Gladiator," Russell Crowe portrays Roman general Maximus Decimus Meridius. Maximus becomes a gladiator and fights his way through the arena to avenge the murders of his family and his emperor. In one scene during which he rallies his troops for battle, Maximus tells them, "What we do in life echoes in eternity."

It does. What we do in life echoes in the hearts and minds of those who know us. Of those who hear of us. Of those who read of us.

Captain Avilés and *El Correo*

Captain Filemón Avilés is a light-skinned, hulking *campesino*, or peasant, who the Sandinistas taught not just to fight, but also to read and to write. FSLN founder Carlos Fonseca is said to have instructed his followers: *"También enséñenles a leer."* (Teach them to read, as well.) Avilés commands various companies of the Simón Bolívar Battalion.

Avilés' troops fall into a contra ambush and I spend the first five minutes of the firefight kissing the ground, so none of the pieces of metal cutting through the bushes and trees above can touch me. Leaves and branches torn apart by bullets drift down around me. I hear men screaming.

Aunt Carmela, wait for me. Bring me back.

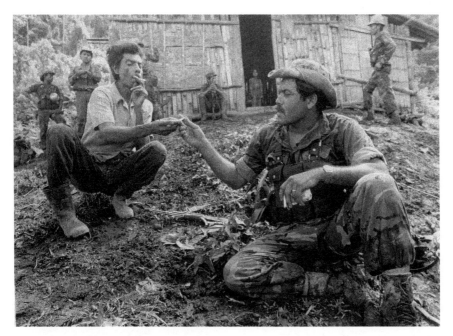

LA MONTAÑA, Nicaragua – Sandinista army Capt. Filemon Aviles shares a cigarette with poor peasant in northern Nicaragua.

On another day I am walking single file with Avilés' troops. As usual, I'm just behind the explorers, or scouts, who had taken a young *campesino* boy prisoner on suspicion that he was a *correo*, or "runner" for the contra forces infiltrating the area. These runners were this conflict's version of Patrick Hamilton's LRRP unit, "running" information about enemy location and movement back to commanders who, in turn, would stage an attack. I suspect this kid, like many other Nicaraguan peasants, was coerced into service by the contras.

The soldiers had tied the boy's hands with cord to the post of a shack. He looks like a frightened animal, his eyes peering up at his captors, asking, "What will you do to me?" I begin to make pictures of the kid, who probably is about 15 years old. His beat-up, ankle-high boots are covered with mud. He wears no socks. Avilés comes up in the line and, disturbed that his men allow me to make pictures of this, orders his men to untie the prisoner and take him away.

There is no violence in the images I made of this young peas-

LA MONTAÑA, Nicaragua – Sandinista soldiers retain a young peasant boy suspected of being a "correo," or "runner" for contra forces in the area. Runners are used by both sides of the conflict to inform on the opposing force's position, therefore enabling an attack.

ant boy. There is no blood. Not even a bruise. None of the soldiers is threatening him. He is in no apparent pain.

Harmless, right? Not so sure. There is something about it that disturbs me even to this day. I think it's the helpless look in his eyes. A fearful look of what might happen to him. I immediately understood the impact this image would have if I publish it for distribution around the world. The contra propaganda machines in Honduras and Miami, and their ideological paymasters in Washington, DC, would understand the value of this image. This peasant kid would become a poster boy for contras branding the Sandinistas as violators of human rights. "Look what the Sandinistas do to our poor peasantry," would be the cry of the contras.

And, full disclosure, I understood that the image could burn me and the trust that I had established with not only Captain Avilés but

with the entire Sandinista army and government. One picture, a single snapshot with little or no context in a broad and complex conflict, could be misused by one side and misconstrued by the other side of that conflict.

I still have the picture but I had decided not to publish it. Until now. In this book. It was one of those decisions I made when considering the consequences of my actions in time of war.

Days after the incident, after not having seen the boy, I ask Avilés what happened to him. He says his men took him to Managua for interrogation. I hope he is telling me the truth.

"Una Chanchada" (A Pigsty)

Avilés sends a platoon of his men down a mountain path to check out reports of an enemy encampment and asks me if I want to go with them. We have been in the bush for over a week now and I'm ready to go back to Managua on a re-supply helicopter that's been promised for days.

"I think I better stick around because I don't want to miss the helicopter," I tell Avilés.

Two hours later I'm still waiting for the helicopter when the platoon, or what's left of it, comes stumbling back to camp. They remind me of the cargo bearers in old Tarzan movies. They are paired up, their shoulders connected by long poles, hammocks hanging between them. They look like porters carrying tigers killed by big-game hunters in Johnny Weissmuller films. But these men are not carrying tigers. Instead, they carry their dead and their wounded.

"*Una chanchada,*" (A pigsty.) the platoon commander describes the ambush to Avilés. "*Fue una chanchada.*" (It was a pigsty.)

The soldiers line up the dead in a neat row and cover them with blankets and ponchos. They collapse to the ground, exhausted, sweating, pallid, the blood sucked out of their faces by adrenaline and fear. I make pictures of the wounded but the soldiers snarl and bark when I move to photograph the row of dead comrades. There can be no negotiation with this. I back off.

The helicopter finally comes in for a landing but even before it touches down it takes groundfire from contra positions nearby. The enemy is *that* close. My cameras hang from my shoulders as I help the soldiers load their dead and wounded. It's a frenzied affair. We are in the air now. I'm sitting near the open door of the Soviet-built chopper and the bullets crack and whiz as they miss us. The ship sways in the air from one side to the other, its pilot trying to make us a more difficult target for the contras still firing at us from the ground below. Helplessness invades me. I am suffocating. I inhale deeply through my nose, down into my stomach then filling my lungs, and exhale through my mouth. The fuel tank in these helicopters is actually *inside* the aircraft, within arm's reach of the passengers. I am thankful that the contras don't have ground-to-air missiles – yet. The sun is going down over the mountains. Inside, the hull is piled full with bodies of dead Sandinista soldiers. The wounded sit crouched along the metal walls.

We apparently are out of range now. The helicopter no longer sways from side to side. Maybe it was here that my Aunt Carmela's contacts with the beyond saved me. Or maybe it was my brother's crucifix. Or the scapular. Or perhaps the Blessed Virgin Mary medal.

I breathe normally again.

"Agresión Norteamericana"

I had responded to reports of a fire devouring a small factory just off the *Carretera Norte* connecting the capital city of Managua with the international airport. By the time I got there, the flames had died down and local civilians had joined firefighters and police scouring the charred remains of the property to save whatever they could.

This happened at a time when the United States had ramped up its aggressive policies toward Nicaragua, imposing economic sanctions, mining its harbors, funding and training the contra forces invading the country from camps located in its northern neighbor, Honduras. I don't remember that the cause of the fire ever was determined, but the

immediate assumption was that the blaze was set by infiltrators loyal to the anti-Sandinista contras and their U.S. sponsors.

As I made pictures of the damage, a young woman turned to me and, with eyes shiny with tears and trembling in frustration, pointed an accusatory finger at what once was a place where scores of working-class Nicaraguans labored to earn money to support their families, said, *"Agresión norteamericana!"* (North American aggression!) This loosely translated into something like, "Why can't your country just leave us alone?"

Ashamed, embarrassed, and guessing she was right, I said, *"Yo sé."* (I know.)

This happened sometime in the early 1980s. It was a time when I could still argue that the United States of America had a functioning, albeit imperfect, democracy. I could argue that U.S. policy toward Nicaragua was an aberration that did not reflect the will of the American people. What I did not understand then was that the United States government was under assault by corporate and special interests that wield extraordinary power in ruling the country. I understand that now.

My exchange with the woman was also a measure of Nicaraguans' generosity of spirit. They recognized the difference between American (U.S.) people and American (U.S.) policy, and they allowed me to work relatively freely in their country. I don't think most Americans under similar assault would be so generous, as the reaction to the 9/11 attack on the World Trade Center and the Pentagon would later prove. Just think of the violence unleashed against Muslims in the wake of those incidents.

The Procession

It was 1987 and I was deeply involved in generating images for my book of photographs, *Nicaragua*. Then Vice President of Nicaragua Sergio Ramírez Mercado had agreed to a series of interviews that would become the epilogue of my book of photographs. His participa-

tion in the project secured my access to people and places that other journalists could only dream of.

My field notes dated Saturday June 27, 1987, place me in the northern city of Matagalpa:

> I had just left the army's Public Relations Office with a letter giving me unprecedented access to helicopters; the Regional VI command base; and the military hospital at Apanás, where most wounded Sandinista soldiers were airlifted from the battlefield to be put back together by Cuban doctors.
>
> Up ahead on the busy main street was a procession – all too familiar these days in Nicaragua – a funeral. A white pickup truck led some 200 people down the narrow street. The red and black flag draped the coffin riding in the back of the vehicle. Cars pulled over to let the mourners pass by. Soldiers walking in the procession and the red and black Sandinista flag draped over the coffin showed the dead was a Sandinista soldier fallen in combat.
>
> The intensity and significance of this scene will never leave me. It is a measure of the character of the Nicaraguan people.
>
> As the mourners passed, there was a realization between us. They knew that my hair and skin were too light to be Nicaraguan. And the license plates on my International Scout say, 'California.' An American. And I knew them: Friends and relatives of another one of some 20,000 Nicaraguans killed during the U.S.-funded Contra War.
>
> My eyes touched those of the young soldier driving the pick-up truck. I touched eyes with those of another soldier walking alongside the vehicle. Then with those of a tall, slender young woman. And there were

the older women. Probably immediate family. We all saw each other.

But there was no hostility. No hatred. No animosity. No bitter accusations. No venom.

Americans who work and live in Nicaragua often hear: 'We don't have any problems with the American people. Our problem is with the American government.'

I think they really mean it.

Sailboats

I lie on my back on the deck of a small sailboat gliding across the waters of Miami, Florida. Murry Sill, the *Miami Herald* photographer who accompanied me on the trip into *La Montaña* hunting for contras on Green Mountain, is an accomplished sailor. He's hosting some friends on his craft.

It's visual overload. The blue water. The multi-colored sails. The soft contours of the vessels and the sharp angles of the sails. After months of seeing tropical highlands, the dark green of the forest, the camouflage of soldiers' uniforms, the dark brown of the earth and of Nicaraguans' skin, all of what I see here refreshes me and reminds me of a previous lifetime, and perhaps how removed from that lifetime I am now.

Some of the habits I picked up in my tropical, guerrilla-infested world stick with me here. Even as I walk along Ocean Drive in Miami Beach, painted with pastel colors and Art Deco buildings populated by "beautiful people," my eyes are drawn to bushes, street corners or open windows where danger might lurk. I'm still scanning the area for assailants and looking for places to take cover.

I can dash into this alley. Duck behind the engine block of that car. Run back around that corner.

"Look at You!"

Early morning in Manhattan. The city yawns at the sight of a new day. I'm walking along Madison Avenue to visit *Newsweek* headquarters to review my work and to re-connect with editors. I'm wearing a long "duster" coat, like the ones you see in cowboy movies, and a glowing face that leaves no doubt about my excitement to be here.

"Look at you!" a panhandler says from his spot on the sidewalk. "You got it all, man!"

In a way, I did. I had clawed my way to the top of the mountain. I had worked longer and harder than ever before. I had risked more, and more often. I had sacrificed more to earn a place at the table. I had used the visual talent that my mother bequeathed me.

In another place and at another time, I had a discussion with a colleague, whom I will call, "Johnny." He came from a "good" family, all respectable folk, with successful siblings. He had attended some of the finest universities in the land and was a respected member of our guild.

"You can't understand where I'm coming from, Johnny," I told him. "You grew up assuming you would be successful. Knowing you would be successful, because there is a precedent and an expectation in your family history to be successful. I could never assume that I would be successful," I told him. "I never had that assurance. I never had that foundation to build on. I had to construct my own foundation."

There were no Harvards, Yales or Oxfords in my family. There were no presidents, governors or senators. No doctors or lawyers. No journalists. It was the men who fought and sometimes died in foreign wars who prepared me for the conflict zones across Central and South America, the Persian Gulf, Africa, Iraq and Afghanistan. It was the steel mills and the shipyards that equipped me for the hard and sometimes dangerous work in the merciless mountains and deadly back streets of war. It was the men and the women who made things with their hands, lured food from the land and never gave up. Never backed down. It was the women who called upon their saints and their

saviors to keep me safe. These were the people who set the standards for me to emulate. It was upon their example and their support that I built the foundation of my own success.

The photo department of *Newsweek* magazine in the 1980s was a wonderland. Rows of cubicles filled with books, computers and smart, ambitious, sophisticated people dedicated to filling the weekly publication with powerful images made by some of the most talented and bravest photojournalists in the world.

That panhandler was right. I had it all, man!

Separation

The discotheques along the *Carretera Norte* and on the road to Masaya were hot spots for men looking for women who were looking for men. I do not pretend to have been a doting, faithful partner for Claudia. I was not.

I don't recall that Claudia and I broke up because of any specific argument or dispute. It was more like I was caught in the hurricane-force crosswinds of violence, happiness, despair, temptation, confusion, opportunity and remorse.

As I loaded my belongings into *La Bestia*, Claudia's *doméstica* (domestic assistant or maid) wept at our front door. I drove away.

SOUTHERN HONDURAS – Arturo Robles (center) Rod Nordland (right) and I in a contra camp in Honduras before heading south into Nicaragua for a three-week long journey with the anti-Sandinista rebels.

CHAPTER 9.

"WHAT'S HAPPENING TO ME?"

Xiloá

The volcanic lake of Xiloá is a short drive from Managua. It's where a lot of working-class Nicaraguans who don't have the means to hit the Pacific Coast beaches gather on weekends to spend time with family. Its cool, deep waters are a favorite for windsurfers and for Nicaraguans who just want to beat the oppressive summer heat. It's also where Arturo and I go to escape the pressure cooker of Managua, to have a few beers and to survey the swimwear of the season's local *señoritas*.

As we pull out of the parking lot for our return to Managua late one afternoon, a trio of musicians hold their thumbs out, hoping for a ride back to the capital. The three had been wandering around the lake shore all day, playing their tunes for anyone who would cough up a few Nicaraguan *córdobas* in exchange for the entertainment. I suspect these guys had already burned up their profits on beer or rum, as they were pretty well lit up by the time I pulled over to the side of the road to pick them up in *La Bestia*. Arturo and I watch with amusement as they stumble *ping, pam, pum* into the back seat. They squish in with their guitars and an accordion. Arturo is riding shotgun.

"Reach into the glove compartment and hand me my glasses, please," I ask Arturo. He clears his throat, apparently in an effort to suffocate laughter, because he knows where I'm going with this. "I can't drive anymore without my glasses."

So Arturo hands me the plastic glasses with the penis nose that my brother Lou had bequeathed me on one of my trips to Pennsylvania. I put them on and then turn to the back seat where the musicians are packed in, and they explode with hysterical, howling, squealing laughter made even more hysterical when, still wearing the glasses, I pull over to ask a middle-aged woman on the side of the road, "Where is Managua?"

After the separation from Claudia, Arturo and I shared a house on a hillside overlooking the capital. It was a monster of a house, two stories with large patios surrounded by a high wall and equipped with a heavy metal entrance gate, all shaded by giant mango trees. It came with two Nicaraguan maids and a groundskeeper by the name of Alcides, a shy, thin man in his late 50s or early 60s with the high-pitched voice of a 13-year-old. A lovely fellow and a bit slow.

I had moved in when Arturo and his Australian girlfriend, a filmmaker, needed a housemate. During a long trip back to Australia, the girlfriend called the house while Arturo and I were up in the mountains. Alcides answered the phone. When Arturo and I returned from the mountains, Alcides informs Arturo that his girlfriend had called.

"Where is she?" Arturo wants to know, hoping she might be on her way back to Nicaragua. "Maybe she's in London making a connection that will deliver her back to our big house on the hill."

It is perhaps because Nicaraguans are so accommodating that they feel compelled to provide an answer, even if the answer may be wrong, when asked any question. Particularly if the question is posed by a foreigner, for whom Nicaraguans have a high, though sometimes misplaced, regard.

So, when Arturo asks Alcides where his girlfriend is, Alcides must respond. Knowing that the girlfriend is a filmmaker, Alcides comes up with the only possible, logical, sensible response.

"Hollywood!" he says. Arturo's face nearly falls off. He just turns and walks away.

We hosted a lot of parties, the mere attendance at which often sparked speculation about a woman's moral judgement, standing or wisdom. In the morning after one of the particularly rum-soaked events, one of our maids, a shy, late-20s woman of peasant background, approaches Arturo.

"*Don Arturo*," she says, using the Spanish title meaning "lord," "gentleman," or "sir."

"*Qué pasa?*" Arturo says, his voice even more croaky this morning as he tries to pull himself out of an alcohol haze.

"There are women's underwear hanging from branches of the mango trees," she said. "What should we do with them?"

"*Déjalos allí,*" Arturo says. (Leave them there.)

Arturo, *Newsweek*'s Mexico City bureau chief Joe Contreras, and I are in *La Bestia* heading north on the Pan American Highway to cover some event in the department of Chontales. I slam on the brakes when I see it in the middle of the road. Somebody's pig had plunged its head deep into a brightly colored plastic bucket, apparently to reach something to eat, and now the bucket is stuck on the pig's head. The animal is furiously shaking its head back and forth in the middle of the highway, but the bucket just won't come off.

"*Mire este hijo de puta,*" Arturo says in the way that only Arturo can say it. (Look at this son of a whore.)

I drive around the pig, trying not to crash because we all are laughing so hard. We continue heading north.

Arturo's girlfriend never returned to Nicaragua. I eventually reunited with Claudia.

"Please Don't Kill the White Guys"

We shuttled from one store to another trying to put together the last pieces of equipment needed for what we all expected to be a long, arduous, perilous journey. Tegucigalpa, the Honduran capital city,

didn't have much to offer. Luckily, I had acquired most of the stuff in preparation for the many previous excursions I staged into Nicaragua's northern mountains with Sandinista forces.

It was the spring of 1987 and I wanted this to be *the* trip to define the contra forces that the Reagan administration funded, trained and directed to overthrow the Sandinista government. Something that hadn't been done before. And something nobody ever would do again. Other journalists, including James LeMoyne and Christopher Dickey, reporters for *The New York Times* and the *Washington Post*, respectively, had teamed up to make a long trip with the contras before, but I wanted this one to be longer, tougher and more consequential.

The timing was perfect. The U.S. Congress had just thrown $100 million at the contras despite persistent accusations of human rights violations. Contra leaders had announced a major spring offensive and incursion into Nicaraguan territory. Americans wanted to know what their money was being used for. It was my job to show them.

I had pitched the idea for this journey to my *Newsweek* editors in New York and they were all for it. I had broached the idea with Contreras, then the Mexico City bureau chief, and he had, very wisely, declined. Joe was way too smart to think that this was the kind of assignment he would excel on. He had a wife and two kids. He wasn't terribly physical, and he knew enough about the mountains in northern Nicaragua to understand that he was not a good match. I respect him for having the courage to say "no," which very often takes more guts than a "yes" that could jeopardize his and others' safety.

But I knew I needed a correspondent on this trip to ensure that the story would get good play. I could make all the great pictures in the world, but they would never get the kind of space and display in *Newsweek* magazine without the supporting story provided by one of the magazine's trusted staff correspondents. That's just the way it works.

I contacted Rod Nordland. A guy about my age who came from a tough side of Philadelphia, Nordland was a star correspondent with the well-deserved reputation of covering some of the most challeng-

ing stories in the world. He also was acceptable to the folks in the U.S. Embassy in Tegucigalpa. It was the embassy people who ran the contra project in eastern Honduras and into northern Nicaragua, without whose blessing we could never have been able to accompany the contras on what was being hailed as a major offensive against the Sandinista People's Army.

Nordland agreed to come on the trip.

So, after having cleared the trip with our U.S. Embassy handlers, Arturo, Nordland and I were in Tegucigalpa putting together the last components of what we would need for a weeks-long trek into *La Montaña*, the anvil that was Nicaragua's northern mountains, or tropical highlands. We scoured sporting goods and hardware stores for the final ingredients. Arturo and Rod were putting on the finishing touches of their gear.

On trips like this there are some essentials critical for a successful journey. A good pair of boots is absolutely key. They need to be at least ankle high to provide critical support on slippery, muddy slopes and rocks that could otherwise cause a serious sprain or even a fracture. And forget about "waterproof" boots because the first time I walk through a creek, stream or river that's deeper than the boots are high, they fill up with water and my boots turn into two miniature swimming pools in which I'm stuck walking around in for the rest of the day. I took wool socks. Cotton socks absorb and hold water to skin, which causes blisters that are incredibly painful. Wool socks pull moisture away from skin and reduce the risk of debilitating blisters.

I took a professional hammock to provide my body with enough rest to recuperate from the long march. Most of the combatants in this conflict were 18 or 19-year-old peasant kids who grew up sleeping in coffee-sack hammocks, or on rickety beds or dirt floors, which means they can sleep just about anywhere and wake up ready to go after just a few hours of shuteye. At the time of this trip, I was in my mid-30s, and therefore my body needed more hours of decent sleep to recuperate at the end of every day.

I took a backpack to accommodate all my stuff but that wouldn't destroy my spine or cut into my shoulders.

I had already called my Aunt Carmela and asked her to be in touch with her heavenly contacts, something I could never ask of my own mother because I wouldn't burden her with the worry that her son might perish covering a war in a place she had barely heard of. Aunt Carmela said she would take care of it. I had gathered my talismans and good luck charms and stowed them among my gear. I carried all that stuff to keep me safe, or to sustain the illusion that I would be safe. Soldiers and the journalists who cover them become pack animals trudging through the mountains, each carrying memories and *momentos* of our own world and hopes to return to that world in one piece. I had to return. A lot of people were waiting for me.

The following are some of the verbatim notes I jotted down as we prepared for the trip. While editing this book, I inserted some [**bold text in brackets**] for clarification:

> Thursday 16 April: This is the day. [**senior contra official Adolfo**] Calero notified us yesterday, Wednesday, that we'd go in today.
>
> Called [**my older brother**] Lou last night. Told him I was in good physical and mental shape. Told him I was wearing the crucifix he gave me. Called Claudia last night & told her I was going in. She called back at 2:00 am this morning to say she loved me etc.
>
> Pacheco [**contra operative whose first name I do not remember**] picked us up at hotel Maya at 5:30 am. The ride to Juticalpa was pretty serious for the most part. Nordland and I discussed what the impact would be if one of us were killed while with the contras. Upon entering Juticalpa, we saw a nice chick & Arturo suggested we ask her if she'd rent us her pussy for the trip. [**Arturo pronounces it, "POOO-see."**]
>
> We're going to an air strip in Catacamas for 30 minute flight to the Coco River where it meets with the Bocay River. From there a boatride to the forward

contra camp. The camp at Coco-Bocay is San Andrés.

The next day I wrote:

Friday 17 April: The rain started this morning before dawn. This could really fuck the trip up, if it keeps up like this.

The boss here is a guy named Víctor; he's former NG [**National Guard**]; the cook also is NG; as well as Chicle, former boss of Banco Grande and now head of logistics here on river.

This place is nothing more than supply depot, rest area, transport spot. It's a system of bamboo huts, many with green plastic roofs. Some refugees.

Guys sit around playing checkers with boards almost completely worn out and pieces that are really bottle caps. Who knows what they dream of.

The plane drops come in on a nearly daily basis. There are walkie talkies all over the place. Seems to be quite a bit of organization.

These guys belong to the San Jacinto Regional Command. Víctor is the head of a Task Force.

Renato is head of the San Jacinto Regional Command.

Some decent pictures of contras standing along the Río Coco separating Nica. from Honduras. Contras boarding supply boats, etc. *Special attention to single contra stranding in front of two supply boats in river.

Some shots of contras and civilians – all refugees from the war – at hut along river border. A lot of shots surrounding that scene, which is religious ceremony.

Contras atop hill overlooking border. They seen with 12.7mm, Soviet-made machine gun for use as anti-aircraft.

Having serious problems with light. The light me-

ter (hand-held ambient) will read 250 at 5.6, for ex-
ample, but camera meters will give 250 at 4, or even
2.85 or even 2.8! Two stops difference.

A few hundred miles to the south in Managua, Claudia grew in-
creasingly alarmed. The Sandinistas had gotten intelligence that the
contras were preparing a major incursion from Honduras into Ni-
caragua and they, the Sandinistas, shifted into high gear to meet the
contra forces head-on. It was shaping up to be one of the few major,
conventional-style confrontations of the war. The Sandinistas, espe-
cially, would be able to unleash the massive firepower they had ac-
quired from the Soviet Union, particularly the Mi-17 attack helicop-
ters and heavy artillery.

Claudia understood that Arturo, Nordland and I could be caught
in the middle of it. She would not tell me of this incident until years
later, but here's how she said it played out. She understood that Nor-
dland and I would stand out from the contras, most of whom were
peasants and workers who were shorter and whose skin was dark
brown because of the sun, their genes or both. Nicaraguans referred to
people with skin as light as mine and Nordland's as, *cheles*, or "white
guys." Claudia also understood that Sandinista fighters taking part in
the counter-offensive against the contras might train their sights on
us, mistaking us for CIA advisers.

Across the street from our home at the time lived a young Sand-
inista functionary named Jaime. Jaime's wife and Claudia worked at
the same newspaper. So Claudia goes to Jaime and asks him to contact
the appropriate military authorities about our trip and to pass along
this special request to commanders in the field: *"Por favor, no maten
a los cheles."* (Please don't kill the white guys.) Claudia's plea extended,
of course, to Arturo as well, despite the fact that he is not exactly a
chele.

Jaime complied with the request. (As of this writing in 2020, Jaime
Hermida is the Sandinista government's ambassador to the United
Nations.)

It was a tough journey. Always suspicious of journalists, the contras' distrust of us grew as the trip unfolded. I was open about my relationships, both professional and friendly, with Sandinistas. Even before we embarked on this journey, U.S. Embassy personnel in Tegucigalpa had questioned my relationship with Claudia, with her family and with Sandinista officials in Managua. I was open about all of it, knowing that trying to hide those relationships could turn out even worse than full disclosure beforehand.

About halfway through the journey Arturo and I were getting on each other's nerves. He decided to cut the trip short and walk back north into Honduras with some of the contras heading the same way. Nordland and I stuck with the contras, and I was lucky to make some pictures of them firing off mortar rounds but we didn't see a lot of real combat. Nordland spent time caring for peasant kids afflicted with the feared "mountain leprosy," the parasite that eats human flesh.

It was toward the latter part of this journey that I had to reach for support back to the times that forged me. I searched for sustenance to get me through it. The numbing march over mountain paths. Quick-running rivers and streams. Scorching hot days. Damp, cold nights. Rice and beans. Disrupted sleep. It took a toll. My body turned into itself, scouring itself for any source of fuel to keep itself moving. I ran out of holes in the belt keeping my pants clinging to my waist. My shirt hung off me as if I were a scarecrow. In daytime my clothing sucked moisture, salt and fat from my body. At night I shivered inside the soggy, stinking, dirty mess. My stomach and intestines were waging their own private war against me, seeking vengeance for my having dumped contaminated water and awful food into them.

I thought of the men whom I admired most, my older brother and the men he selected for his annual ritual of making wine. Among them was Jim D'Antonio, our former high school football coach. I recalled his lecture about turning the drudgery of work into the benefits of exercise. Don't think of it as work, Jim said. Think of it as exercise and breathe into it. Get motivated by it. Feel yourself, imagine yourself, getting "bigger, stronger, tougher." These attributes, of course,

were the goal of nearly every young man in the time and the place where I come from. Bigger. Stronger. Tougher.

It was my connection to these men and their stories that fortified me. That helped me get through this trip. As I marched through those mountains like one link in the long chain of contra fighters, with my body sick and consuming itself, I envisioned my muscles and my spirit becoming "bigger, stronger, tougher" – just like Jim said. I was motivated.

By the time Nordland and I had spent nearly three weeks and 100 miles tromping through the tropical highlands with the contras, we actually began to be concerned about our own safety – not because the Sandinistas would blow us up but because the contras might be tempted to do so. They had bumbled around the mountains for weeks, not beating up any Sandinista troops and apparently not having won any of the peasants' hearts or minds, either. They understood that Nordland and I were going to publicize this. Their suspicion of us was turning into resentfulness. Rod and I noticed more whispered conversations, just out of earshot, between the contra commanders. What's to stop them from taking us out and blaming it on the Sandinistas?

Nothing.

We reached a dirt road running through a hamlet deep in the mountains, bid the contras farewell and hitched rides with anyone heading toward Managua.

A day after our arrival in the capital, Nordland headed back to the States via Miami and I went to the office of President Daniel Ortega's official spokesman. I told him that I entered the country illegally from Honduras with the contras and that *Newsweek* is planning a major piece on our trip with them.

The next day Claudia comes into our bedroom where I'm catching up on sleep and says there are two guys from State Security at the front door and they want to see me. I go out to meet them, and they make no effort to hide their displeasure over my "lack of respect" for Nicaragua by entering the country without passing through normal immigration and customs check points and if it ever happens again

there will be serious "consequences." I explain and apologize but they don't want to hear it.

The following day a guy from Nicaragua's Defense Ministry shows up and asks if *Newsweek* would like to see "the other side" of this conflict and invites Nordland and me to accompany Sandinista troops back to the mountains to document the Sandinista counter-offensive.

I jump on the phone to my *Newsweek* editors in New York and then to Nordland in Miami, and soon we are back in Nicaragua being flown to the front on a Sandinista military helicopter. They fly us in a Soviet-made M-17 attack helicopter up to the *Rio Coco* separating Honduras and Nicaragua and I make pictures of dead contras laid out on a riverbank and partially covered with the long leaves of a banana tree.

Along the way we cross paths with a group of journalists being carted around by the Defense Ministry but getting none of the special access that Nordland and I are getting and they seem to be, as Nicaraguans might phrase it, *"mordiendo sus propias espaldas,"* (biting their own backs) with envy.

We then are inserted into the Simón Bolívar Battalion with a bunch of soldiers with whom I had previously invested significant time in the field.

Rod and I spent a few days with these guys in the mountains. He and I get back to Managua. He leaves the country. I wait for his article to hit the streets.

BOOM! It's a cover story about the contras in *Newsweek's International Edition,* titled, "Why They're Not Winning." *Newsweek's International Edition* was distributed out-

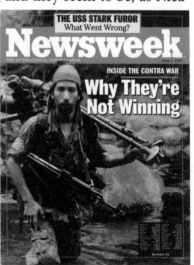

This is the cover of Newsweek's International Edition. This edition uses rough paper inside and can print only black and white pictures.

side U.S. territory. The magazine's Domestic Edition also published our story, but did so on the inside pages, not on the magazine's cover. Nordland wrote:

> These were the "new contras." Their war was on again, kick-started by the $100 million in aid finally reaching the troops, many of them trained – legally now – by U.S. advisers. After months, even years of idleness in Honduran camps, they were eager to prove themselves with an all-out spring offensive. The stakes: the next round of money from a skeptical Congress. That's why, for the first time in five years, the high command of the contras' main group, the Nicaraguan Democratic Front (FDN), agreed to let two American journalists accompany their forces deep inside Nicaragua for an up-close look at their war. And it is why, when we finally reached Managua, the Sandinistas took us right back out – to see the same war from their side of the lines.

The sub-title for Nordland's story was: "Back in battle, but losing the war for the people's hearts and minds." And from there, it all went downhill. Nordland described how the contras roamed aimlessly in the mountains, strong-armed peasants to guide them along the way, devoured peasants' food and livestock with no recompense, avoided combat with Sandinista forces. In other words, the contras seemed to be incompetent militarily as well as politically. In any guerrilla war, winning the hearts and minds of the civilian population is absolutely essential. And the contras we spent time with were incapable of doing either. The Sandinistas, Nordland wrote, were a different story:

> The conduct of the Sandinistas made a striking contrast with the contras. Their discipline held firm after many months in the Isabelia Mountains – even

though the Simón Bolívar Battalion was made up mostly of draftees on two-year tours of duty. Where it had taken a mere three weeks for the contras we accompanied in the same mountains to turn into an unruly scourge, Sandinista troops on the march never even stopped at a peasant's house, except with permission from an officer – and then only to wait outside to wait for drinking water.

The official Sandinista newspaper, *Barricada*, splashes the translated story, pictures and all, on the front and inside pages – word for word – in its entirety. Everybody I knew in Nicaragua read the piece. Colleagues. Friends. Claudia's family. Government officials. Everybody. It was a measure of one outlet's power before the internet shattered the old structure. It's hard to describe the sense of achievement and the pride I felt as a result of this story. And all of it was true.

The Sandinistas had seized the publication of our work as a major propaganda victory. Not long after the piece was published, I ran into the same State Security guys who showed up at my door to read me the riot act. We all just smiled.

I called family members in Pennsylvania to advise that I was OK. My brother Lou, my mother and Aunt Carmela were at the top of the list.

The official Sandinista newspaper, Barricada, *published our story and pictures beginning on the front page and into the inside pages.*

INTERNATIONAL

The New Contras?

Back in battle, but losing the war for the people's hearts and minds

BY ROD NORDLAND

A heavy rain blotted out the sliver of new moon and plunged the night march into pitch darkness. Deep in the mountains of northern Nicaragua, we groped along blindly, slipping and falling. Each of us held onto the backpack of the man in front of us—all 60 of us, a human centipede covered in mud. None too quietly, we passed a closed-up shack where a cook fire glowed through cracks in the walls. Dogs barked and the children inside started crying; nervously, a woman sang to them to still their fear. *The contras were passing, bringing the war past the door.* For five hours we sought our ambush site, a road used by Sandinista troops, until finally we all flopped down in the muck of a cow pasture—hopelessly lost. The officers berated our guide, a local peasant they had strong-armed into showing us the way. But they, too, settled in, neglecting to post sentries or even send out a rear guard. Soon many of the men were gabbing loud enough to be heard in Managua. They struck matches, lit flashlights. The three girls they brought along began giggling uncontrollably, as one of them pondered aloud which man she would sleep with that night. To no avail, the officers pleaded for a blackout and silence. We spent the night like that, near a place called El Bote. We were more like rabble on the loose than a guerrilla army in enemy country.

These were the "new contras." Their war was on again, kick-started by the $100 million in aid finally reaching the troops, many of them trained—legally, now—by U.S. advisers. After months, even years of idleness in Honduran camps, they were eager to prove themselves with an all-out spring offensive. The stakes: the next round of money from a skeptical Congress. That's why, for the first time in five years, the high command of the contras' main group, the Nicaraguan Democratic Front (FDN), agreed to let two American journalists accompany their forces deep inside Nicaragua for an up-close look at their war. And it is why, when we finally reached Managua, the Sandinistas took us right back out—to see the same war from their side of the lines.

For nearly a month, NEWSWEEK photographer Bill Gentile and I slogged up rivers,

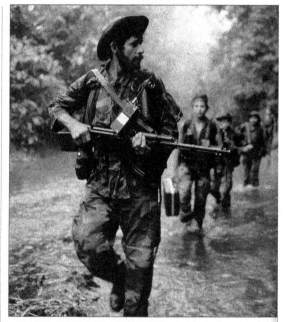

On the march: *Rebel column slogs through a jungle in Sandinista territory*

climbed mountains and clawed through jungles with the FDN's Nicarao Regional Commando. During the droughts of April and the rains of May, through parts of three provinces in northern Nicaragua, we shared with them the ordeals of the march. In the first days before we reached that soggy pasture nearly 100 miles from the Honduran border, these contras were impressive. American officials who briefed us in Central America before we left said the contras showed promise on three critical fronts: establishing themselves perma-

nently in Nicaragua, taking the war to the Sandinistas by attacking military targets and, perhaps most important of all, winning over the Nicaraguan peasant majority. As we soon saw, they really were inside the country in unprecedented numbers, perhaps as many as 10,000; their morale seemed high, their new backpacks burst with up-to-date matériel, the skies droned with the motors of C-47 cargo planes dropping ammo to them, courtesy of the CIA.

They also seemed single-minded about their cause, at least at first. One day, after a

PHOTOGRAPHS BY BILL GENTILE FOR NEWSWEEK

Though our story did not make the cover of Newsweek's *Domestic Edition, my color pictures made the inside of the magazine. Black and white versions of the same pictures were published in the International Edition. The story covered five pages of the magazine. These are just a few that made up the overall spread.*

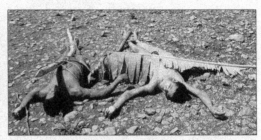

Defenders of the Forward Command Post: *Two rebels killed at Amaka*

week in-country, the march began at 5 a.m. The men waded a mile up the bed of a chilly, hip-deep stream, then climbed a nearly vertical trail into the furnace of the jungle day. Just ahead of me in the column was a contra, 30 years old going on 50, stooped under the 100 pounds of a mortar tube and a pack full of shells. Before the war he had been a peasant, a *campesino*, like most low-ranking contras. Here he was: sweat pouring off his brow and thick neck, groaning as he high-stepped over a fallen tree. Only a believer could work so hard, it seemed. The contras all pick a pseudonym, a *nom de guerre*, and use it to the exclusion of their real names. This one had chosen "Ronald Reagan," after he heard the president's famous remark, "I'm a contra, too." He had one more bullet wound than

his namesake, and many fewer teeth.

They started off armed with an infectious self-confidence. The commander of the 150-man task force that led us in, a 28-year-old former student leader who calls himself Attila, boasted that they would win this year—a common contra refrain. Along the path, we ran into Toño, one of the most fabled and capable of contra commanders, at the head of 1,200 men. He said they had just spent four months in the field, fought 35 engagements and been resupplied 19 times by airdrops from the gray-bellied C-47s. His casualties, he said: nine dead, 12 wounded. His prognosis was more reserved. "If we can do our best this year, we can win the war in Washington for more aid. This war is much easier—just put an ambush all the time. If aid is renewed, we can win by next year."

'Not to fight': Attila and his lieutenant, Black Eagle, had set out from the contras' new Forward Command Post, 25 miles into Nicaragua as the crow flies, with clear orders: to join other groups for an attack on the Sandinista artillery base near San José de Bocay (map). Attila even had copies of U.S. aerial reconnaissance maps showing Sandinista positions in such detail that the location of every latrine was noted. On a portable Datotek computer, the radioman decoded messages from headquarters: "All units head toward your assigned objectives with all due speed." But the Sandinistas had reinforced San José, we learned, so we would attack the Waslala turnoff instead. Later, there were too many Sandinista patrols on that road, so officers decided without orders to attack the San José road instead. We headed for that objective with Black Eagle and 60 men, until we bogged down at that pasture. En route, at Santa María del Cua, we lay in ambush near an unsuspecting Sandinista unit, much smaller than ours—but never attacked. "Our goal is to reach the objective," Black Eagle explained. "Not to fight along the way."

They did have their moments. The best

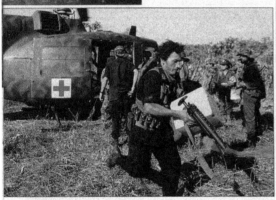

Inside Nicaragua: *In Red Cross disguise, a contra chopper ferries military supplies*

Robby

NICARAGUA – Rob takes a break while on assignment in Nicaragua. I don't recall who made this picture.

One day I'm working in Managua with a huge panoramic camera on a tripod making one of the nicer photographs that would survive the final cut into my book of photographs, *Nicaragua*. It was a street scene of Managua. The photograph captures a long stretch of wooden houses and each house has its own little story going on. On the left there are two kids who just woke up peering out the door with their wrinkled little faces still half asleep. Farther to the right there's an old guy reading the morning paper and then to the far right of him there's a scene with a couple of little girls, one of them picking stuff out of the other's hair.

I'm set up there and really enjoying with all my heart watching life play out and relishing the fact that these people are OK with it. They seem to be into the attention that I'm giving them as much as I'm into enjoying the intimacy they grant me.

It's a wonderful exchange. A beautiful dynamic. One of the things that made working in Nicaragua such a gratifying experience. Because Nicaraguans like who they are. They are not insecure about themselves. They don't mind people getting close to them, intruding in their lives. I think they're even a little arrogant about who they are. Nicaraguans have an exaggerated sense of their own importance.

Maybe it goes back to what Sergio Ramírez says of their geographic location, that is, the site of a potential interoceanic canal like the one in Panama, and the subsequent political importance that this bestows on their tiny nation.

Not stuck up but just a little full of themselves. It's their own sense of humor, and the ability to direct that humor even at themselves, that saves them from themselves. Nicaraguans allowed me to get close to them, and I gave them the attention that they enjoyed. That was the exchange. That was the deal.

So my youngest brother Robby drives up on all this. And it's cool because I've got *La Bestia* parked just a few feet away and I'm doing one of the things that I most enjoy doing in my entire life and here comes the Rob in his white Toyota Land Cruiser, rounds the corner and pulls up to check out what I'm up to. And then he goes about his way.

Robby is absolutely transparent. And what you see when you look into him is a man whose intentions are innocent and pure. You see a clean heart. You see an honesty of purpose. You never have to guess what Robby's intention is because it is always right out in the open. Robby's one of these guys who you like to be around, because he's cool enough with himself that he doesn't have to compete with you to feel good about himself. Unlike his three brothers, Robby never aspired to be a tough guy. So you end up feeling good and comfortable and safe around him. That's the joy of being around my brother.

My youngest brother came to Nicaragua in the wake of a divorce and in search of a lifestyle different from the corporate job he held during his failed marriage. Robby and I worked together on a couple of assignments, always heeding the advice of our older brother, Lou, to never expose ourselves to the same danger at the same time.

Before Rob arrived at our residence, Claudia and I had an additional room and bath added to our home. He lived with us for about a year. Esmeralda and Leonardo lived in the maid's quarters. Claudia and I were expanding our own little community, an open-air house situated on a street corner with a nice patio in the side yard.

Robby was the perfect elixir for the spiritual malaise in which I found myself when he arrived. I was successful. I was on contract for *Newsweek* magazine, one of the most influential media outlets in the world. I was working on a book of photographs about a country and a people that I loved. I had a supportive family in the United States, and another in Nicaragua. Claudia, my *compañera*, loved and understood me.

At the beginning of the bloodbath that was the Contra War, I was in a gang of media covering the funeral of a young Sandinista soldier killed in the conflict. The boy's family led a procession through the streets of Managua toward a cemetery.

The boy's father turns to the journalists and says, "Please don't turn my son's death into a political event."

I turned and walked away. Ashamed.

At the beginning of that war I could barely stand the sound of wailing mothers, sisters and daughters weeping openly, violently, from a place at the very core of their being and from a time, perhaps, when the Spanish *conquistadores* first invaded their land. It is a cry whose pitch of sadness is unique to Nicaraguan women mourning their loved ones killed in the conflict. I sometimes stepped away, desperate to escape their pain.

That was in the beginning. But not now. Now I need these pictures to tell this story. Now I make these images to explain the human cost of the conflict. Now I am difficult, intolerant, hard-edged, abrasive, mean. I bully my way to the front of the line. *"Prensa Internacional!"* (International press!) I berate a young woman in the government press office for having neglected to advise me of an important news conference. I bribe my way onto airplane flights to arrive on time for an assignment. I protect my territory against all competitors. I drink too heavily and sometimes act the fool.

The Visit

It is no coincidence that this part of the book proves to be the most difficult, and one of the very last components, to write. Around this time my brother Lou comes to Nicaragua to visit Rob and me, to see how our lives are going. The visit is a disaster.

Perhaps as a result of the natural competition between brothers, the sense that I had abandoned the family to take on a life of adventure, the distance in geography and in time that separated us, our own uncertainties and insecurities, almost nothing went right.

The only good memory I have of the visit was our trip to Masachapa, where the bar owner Lorena fed us some fresh fish and cold beers. My brother Robby watched the kids swim around in the surf and marveled how their sleek, brown bodies navigated the water.

"They look like baby seals," he said.

Aunt Carmela

Aunt Carmela woke up and told her daughter, Joanna, of a dream. She had been preparing a pot of spaghetti, but the pot of water was boiling on the stove, something my aunt took as a dark omen.

"Somebody's going to die," Carmela alerted her daughter.

Not long after that dream and during a routine checkup, Carmela's doctor feels a mass in my aunt's stomach and schedules exploratory surgery. After the surgery and consultation with her physician, Carmela met with Joanna.

"I told you somebody's going to die. It's me."

My Aunt Carmela died two months later, in September 1988. She was 75 years old.

In my journal around this time, I wrote:

> Had a very weird dream last night. The torture of a woman by guys who put her into a caged pit of water with layers of oil setting oil on fire and explosion blow-

ing her out of exhaust tunnel.

She lying there after explosion. Child on her stomach (fairly grown kid) both on back; both horribly burned; she still barely alive; looks at me often. Eyes blink.

Some guy with distorted hands guides me on to "see more."

I have no idea what this means.

"What's Happening to Me?"

I am in Aliquippa visiting family when Claudia's father calls from Managua. He had never before reached out to me like this, so I know something important has happened. It's *Cuervo*, he said. *Cuervo* had responded late one night to a contra ambush on the Pan American Highway in northern Nicaragua. *Cuervo* was killed in action. He was 28 years old. He and Aleyda have three children.

"I knew this would affect you," Claudia's father says.

It did affect me, but not in the way Alberto expected. I walked away from that phone call feeling disconnected. Disconnected from *Cuervo*. Disconnected from friends and family. Disconnected from myself. I wasn't terribly affected by the loss of a friend. *Cuervo* was a soldier, I reasoned. He got in too deep. It was only a matter of time.

I was more affected by my reaction to that loss. I was affected, worried, confused, precisely because I was *not* affected by that loss.

"What's happening to me?"

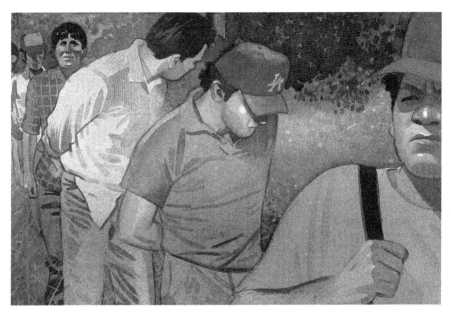

UPPER HUALLAGA VALLEY, Peru – A Newsweek *artist's rendition of the abduction by Peruvian drug traffickers shows correspondent Joe Contreras (with blue, "LA" cap) and photojournalist Bill Gentile (in light-colored shirt behind Contreras) before being turned over to members of the terrorist group, Sendero Luminoso (Shining Path).*

CHAPTER 10.

WALKING ON A THIN LINE

I Never Liked El Salvador

I never liked El Salvador. It had extracted too much blood from too many people and too many of its victims were my friends and colleagues. John Hoagland, my "suicide stringer" friend from Nicaragua, was only one of them. A tiny and overcrowded country, El Salvador had a menacing, sinister feel about it. Death squads prowled the streets at night and frantic, heartbroken family members combed the city dumps each morning in a desperate search for their loved ones.

Even the Metropolitan Cathedral in the capital San Salvador made me uneasy. Its interior walls were unfinished concrete, giving the place a cold, cavernous, medieval feeling. The gray exterior was graceless and looked nothing like "the house of God" where my Italian immigrant parents took me to mass every Sunday as a child.

Archbishop Óscar Arnulfo Romero had refused to invest in the cathedral's refurbishment, arguing that the money could be better spent on helping the poor. So he conducted Sunday mass at the nearby Basilica of the Sacred Heart. It was during a Sunday sermon at the Basilica that he famously ordered the armed forces to "stop the repres-

sion." Today referred to as Saint Óscar Romero, he was assassinated on March 24, 1980, and canonized in 2018.

I spent a lot of time in El Salvador covering the civil war and elections there. I had to. Not only was El Salvador a part of my immediate area of coverage, but it was linked organically to Nicaragua. In fact, every country in Central America was linked to others in the region. Almost nothing happened in one country without rippling into others: weapons, training camps, fighters, spies, refugees, wounded and, eventually, cocaine. Although I could suggest coverage to *Newsweek* editors in New York, it was my job to respond to breaking stories in the region.

The Reagan administration saw Nicaragua's Sandinistas, and behind them the Cubans, and behind them the Soviets, as the reason for the war in El Salvador. In the spring of 1989, although the end of the Cold War was only months away, the wars in Central America were still hot, and still very deadly.

Every time I traveled to El Salvador, my stomach tightened from the minute I touched down on the airport tarmac until the time I was on an outgoing flight leaving Salvadoran airspace and asking the flight attendant for another glass of just about anything with alcohol in it.

In a sense, El Salvador was over-covered. The bulk of the foreign press corps and some of the domestic news media were based on the second floor of the Camino Real Hotel in San Salvador. Wire services. Major magazines. Television networks. All these people and their organizations had their own network of contacts who would call in information from around the country, which was so small and so accessible that we could literally get a report in the morning about fighting on the other side of the country, drive to the area and cover the event, then return to the capital, file our information and actually be in time for a late lunch.

Too many journalists. Too tight a space. Not enough personal freedom. The competition was stiff and sometimes dirty. Journalists eyed their colleagues for any strange or quick movements. If I saw a television crew running out the door with their gear, I knew some-

thing was up and sometimes I didn't even ask questions, I just followed them. Colleagues conspired among themselves, and sometimes against others, to work on stories. Colleague A once invited Colleague B to work together on a story. Colleague A had gotten his hands on some privileged information and together they could flesh out the story for their respective news outlets, which were not in competition with each other. But Colleague B slipped the tip to Colleague C, cutting Colleague A out of the story.

"When I found out I was so pissed off that I cried," Colleague A told me years later.

Nineteen eighty-nine was an awful year. I started off working on a Salvadoran pre-election cover story for *Newsweek*, spending a lot of time hanging out with the key players in the upcoming vote. That meant making pictures of some of the presidential candidates, church leaders, government troops and guerrillas.

Covering conflict in El Salvador was extremely dicey. It's one thing to be embedded with the Sandinistas or with the anti-Sandinista contras. Either side protected me precisely because I was embedded with them. They protect themselves as best they can and, by doing so, they protect me as well. It's quite another thing to arrive at an ongoing firefight and insert myself deep enough into the fight to make powerful images.

And that's exactly what I did. El Salvador is so small and the conflict so ubiquitous that, after hearing a radio report about fighting in just about any corner of the country, I could jump into a taxi and haul ass down the road to cover it. I had become a full-time photojournalist for *Newsweek* magazine, dropping my previous "strings." Unlike print correspondents who can do their work from a distance or by following up after an important event, visual journalists have to be on site and on time when and where the shit is actually hitting the fan. Because that's where the pictures are.

INTERNATIONAL

A Murderous Cross-Fire

Salvadoran rebels ignite the fiercest fighting in 10 years, prompting the massacre of six priests

BY CHARLES LANE

Shortly after nightfall, more than 1,500 rebel troops began to pour into San Salvador from strongholds along the country's northern border. For the next 48 hours, guerrillas of the Marxist-led Farabundo Martí National Liberation Front (FMLN) set up positions in sprawling slum areas along the northern edge of the capital. They immediately began mounting barricades and digging trenches. Some rebels took over tall apartment buildings to use as sniper posts or to harass government aircraft with machine-gun fire. In some densely packed slums, they slipped from point to point through the sewer system—entering through holes opened in the floors of their supporters' homes.

The war exploded in San Salvador's streets. Artillery pounded and the crack of sniper fire reverberated as the rebels and the U.S.-backed Army slugged it out from middle-class residential areas to working-class warrens. The government's main counterattack was a savage aerial bombardment. Thick smoke rose into the sky, mixing with the whiff of rotting corpses. "The airplanes were rocketing and the guerrillas were shooting, too," said Lucía María Escobar Figueroa, 30, as she stood in the charred ruins of her family's one-room shack. "After four days we escaped, waving white flags over our heads." Other civilians, caught in the middle, huddled trembling in their basements or fled in droves to parks and schools; even so, hundreds were killed or wounded along with nearly a thousand confirmed military casualties on both sides.

Then, before dawn on Thursday, Salvador's infamous death squads made their own vengeful contribution to the chaos. A score of armed men burst into a Roman Catholic university's dormitory. They killed two Jesuit priests and shot the school's cook and her 15-year-old daughter

48 NEWSWEEK : NOVEMBER 27, 1989

in their beds. The gunmen then dragged four more Jesuits outside and blew their heads off with high-powered rifles. The men's scooped-out brains were left by their bodies as a gruesome signature. "They were assassinated with lavish barbarity," said the Rev. José María Tojeira, Central America's Jesuit leader. Among the dead was Ignacio Ellacuria, the university's well-known leftist rector. During the rebel offensive angry callers to a government radio network had demand-

A startling assault, a savage counterattack: Paratrooper fires into a working-class barrio, rescue workers carry away injured children, offering prayers over the body of a murdered priest

IVAN MONTECINOS—AFP WESLEY BOCXE—SIPA

SAN SALVADOR, El Salvador – The opening pages of a spread on fighting in El Salvador.

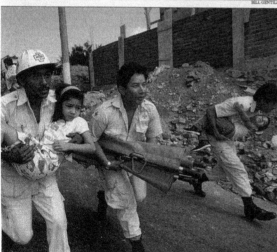

ed reprisals against Ellacuria, and the area surrounding the priests' residence was under military control in the hours before the massacre.

Last week's fighting was the fiercest in 10 years of civil war. Broader in scope and longer in duration than the failed "Final Offensive" of 1981, the rebels' onslaught in San Salvador and six other major provincial towns made a mockery of government claims that the rebels were a spent force. Despite more than $4 billion in U.S. aid aimed at defeating the rebels and building a viable political center, El Salvador has suddenly returned to the bloody, polarized days of the early 1980s.

No uprising: For the United States, the only solace was that the FMLN did not topple the government of President Alfredo Cristiani. The masses did not rise to support the offensive as the rebels had predicted. By the weekend, the Army seemed to have contained the FMLN, pushing back the guerrillas into the city's northern barrios. The Bush administration also gained points in its campaign against Nicaragua's Sandinista government, apparently involved in supporting the rebel offensive. But new evidence of failure for their troubled El Salvador policy was the last thing U.S. policymakers seemed prepared to deal with (page 55).

The FMLN also made political and military gains. Their posts in the barrio gave them a new front in the capital; the government's aerial pounding of San Salvador and the apparent right-wing terror against the priests damaged its international standing. A negotiated settlement seemed more urgent than ever to many Salvadorans. "The government of Cristiani is no longer viable. This will take a total rearrangement through serious negotiations," said a senior official of the opposition Christian Democratic Party.

With the hawks of both left and right controlling their respective camps, a settlement or even a cease-fire seemed unlikely. Cristiani rejected church calls for a cease-fire, saying that rebel conditions—his resignation and that of the entire military command—were unacceptable. Meanwhile, FMLN spokesman Salvador Samayoa told NEWSWEEK in Mexico City: "There is no possibility of dialogue. The only alternative is the overthrow of this government and the leadership of the Army. What is happening in El Salvador

Gear in the Mirror

I pull hard on a Marlboro and look down from my hotel window to the streets below. From the window I can see the demonstrators assembling for their scheduled protest march across the capital. These things are always tense because they start out as protest marches but there's never any guarantee they won't end up as running firefights in the streets of the capital.

The first time I was in Salvador was in 1979, three days after government troops opened fire for no apparent reason on demonstrators at the Metropolitan Cathedral downtown. About 20 people were shot to death. When I arrived, blood was still caked on the cathedral steps where the demonstrators were cut down trying to run for cover inside the place of worship. I never knew what one side or the other would do. Neither did either of the two sides. I've covered perfectly peaceful marches when some wild card throws a bomb or fires a shot and in seconds, I'm caught in the middle of an urban street fight.

The phone rings. *"Halo,"* I say into the receiver.

"Oye, hen-TEE-lay." (Hey Gentile.) A colleague, using the Spanish-language pronunciation of my last name, wants to know what time the demonstration begins.

"Como a las once," I say. Around 11 o'clock.

These things normally started around mid-morning so there was plenty of time to get ready and drift on out to the streets. I had showered and my hair was still damp and slicked back. A towel draped over my neck. What was left of breakfast was sitting on a tray waiting for the Camino Real room service to come and retrieve it. I was finishing up with coffee and cigarettes. I caught my face in the mirror.

"El pueblo unido jamás será vencido." (The united people can never be defeated.) I hear the students assembling for the rally, chanting the chants of the 1980s in El Salvador. I had become conditioned to associate these chants with violence in the streets. They were the precursors of trouble. The mere act of repeating these revolutionary slogans emboldens the protestors, the excitement of challenging the regime

feeds on itself until it sometimes becomes a frenzy. And the troops who are there to keep the event under control feel this. I see them grip their weapons tighter and tighter as the protestors get louder and louder, more and more in their faces.

It's time to begin the ritual with the gear. Not to exaggerate but every time I ready to go out into the streets of El Salvador to cover a protest, I feel like a soldier preparing for battle. A gladiator steeling himself for the arena. A boxer preparing to enter the ring. And the ceremony with the gear allows me time to pull my thoughts together, to go over contingency plans. To concentrate. To focus. How will I cover this demo? It begins where and ends where? If this thing turns violent, is there refuge along the way? What are the photographic possibilities? What is the message I want my pictures to convey? I feel my stomach tighten as I prepare. I had watched, listened to and learned valuable survival skills since the Sandinista Final Offensive in 1979. Now it was 10 years later, and I employ those skills.

Covering urban combat in El Salvador is probably the most stressful thing I've ever done as a photojournalist. It's not like going into a combat situation with one group or another for a conventional battle. I go into the mountains with the Sandinistas and I've got a battalion of guys around me that, if I get hit, I know somebody's there to try and help me get out. I go into the mountains with the contras and at least I have a support group of a couple hundred guys. In Salvador, I can go into a combat situation with the troops and at least I'm *with* somebody. There's some organization. Some rhyme and some reason to what's going on. I'm covering *them*. I can move with them. Take cover with them. Make pictures of them without them freaking out because I'm pointing a piece of black metal at their faces. If I go into a bad scene with the guerrillas, again, at least I'm *with* somebody, I'm covering somebody, and I can move among them. This in itself is some measure of protection. And a good deal of it is psychological protection.

When I'm in the street and everything falls apart, I'm all alone. I'm not with the street protestors who suddenly pull out weapons and

become combatants because they're too fast, I can't keep up with them and they don't want me around because I just draw more fire. Anyway, I don't *want* to be with them because they're always outgunned by the military. And I'm not with the military because they don't want me around either. I can't wait till a firefight breaks out in the middle of the street and then run up to the soldiers and say, "Hey, is it OK if I hang out with you guys?"

So, I'm out there on my own, hoping one side doesn't mistake me for the enemy, hoping that nobody on either side aims badly and hits me by mistake. Hoping that one of the fighters on one side or the other doesn't just say, "Aw fuck it," and takes me down simply because he feels like popping a journalist that day – something that happens more often than a lot of people might think.

I snuff out the Marlboro and begin.

The stuff is all laid out on the bed. Three black Nikon bodies. Nine lenses ranging from a 24mm to 300mm. A flash. Batteries. Dust brush. Chamois cloth. Film. I turn the black Domke bag upside down and check the crucifix and chain that my brother Lou gave me. They are taped to the inside bottom of the bag. My Aunt Carmela died a few months back, so I have nobody to call and ask for protection. I check the items that I hope will function in her absence. The scapular is folded in the belly pack. The medal of the Blessed Virgin Mary is pinned inside. I'm still wearing the crucifix on a gold neck chain.

I whack the dust out of the bag and replace the internal dividers that separate compartments for the respective lenses and camera bodies. Then I take each piece of equipment, first brushing then wiping them with the chamois.

The lenses come first, and I start with the 300mm, a telephoto lens and not one of my favorites because it's big and slow and heavy but when I need it, I need it, otherwise I just don't have the reach to really get close and tight. Next is the 180mm, one of my favorites. Fast. Sharp. And ergonomic. Just a pleasure to touch. To handle. This lens on the Nikon F3 and a motor drive are partly why I became a photojournalist. It's a sensual pleasure just to work with this gear, not

to mention the quality of the images you can create with it. I take this all the way down to the 24mm, another of my favorite lenses because of its ability to capture so much in a single frame without distortion. But photojournalists really have to be careful with this lens. A lot of us overuse it precisely because we *can* get so much in the frame, but we forget about getting really close and tight.

"*El pueblo unido jamás será vencido.*" The chanting is louder now, and I can feel the edge in my stomach building with the tension outside my hotel window. I lean into the mirror and peer into my own eyes. I reach for another Marlboro and my Zippo. I fire up and take a sip of coffee.

The camera bodies come next, beginning with the FA, which synchronizes with the flash at 250th of a second, allowing me to fill with light the shadows created by the white-hot Salvadoran sun. With the sun at their backs and without the fill flash, the marchers become silhouettes and the pictures are useless. Unpublishable. Next are the F3s, Nikon's gift to guys like me. They are tough. They are reliable. They are beautiful. They feel good in my hands. I open the backs of the cameras and remove the dust and dirt with the brush, blowing lightly across the shutter and the mirror. With the chamois I wipe the steel lens mounts, removing any grit that could wear the metal surface when it is joined with the matching mount of the lens. On the FA I mount the 85mm lens. On one of the F3s goes the 180 and on the other goes the 24. With each one, precision steel meets precision steel, and I work the F stop rings back and forth to lock lens and camera body together. They make a sweet sound like tumblers on a heavy safe. The cameras are lined up neatly on the bed and now I take canisters of film and load each body. New film rides along sprocket teeth across the black steel focal plane. I close the camera door with a click of metal, and with the 180mm I focus on my own face in the mirror. I fire three times to advance the film to its proper place. *Kzzing. Kzzing Kzzing.* I love that sound.

I begin to saddle up. A small belly pack with batteries, the brush and chamois at the waist. The plastic buckle makes a sharp click as

it locks into place. The FA and its flash over my neck, hanging at the center of my chest. The F3 with the 180mm on my left shoulder. The black Domke bag on the right and the other F3 with the 24mm over that on the right shoulder. I put on sunglasses, held on by an elastic band that stretches across the back of my neck. I reach for another Marlboro and the Zippo, then turn again to the mirror.

"Mah man," I say to my own image, then fire up the Marlboro and exhale into the mirror. "*You*, are ready." And as the scene widens from a tight shot of my face in the mirror to a wider shot of the entire room, we can see that, except for the photographic gear, I am completely bare-ass naked.

Dancing with Guerrillas

Access to the Salvadoran guerrillas could be a little trickier than hooking up with protesters or government forces for a lot of different reasons. The Salvadoran government had an official press department for foreign and domestic journalists. There were official channels through which I could set up interviews with the government or the military, and could always just drive up to whatever military base I wanted to around the country and ask to see the local commander, "*Mi coronel.*" The military types had a certain vested interest in cooperating with the media. They wanted to show that their soldiers really were fighting the communists and therefore needed continued U.S. military assistance and that, "No," we don't kill innocent civilians like all you foreign journalists accuse us of doing.

It was different with the guerrillas, who supposedly were "clandestine" and didn't exactly have a press office set up in the capital where journalists could go in and sign up for interviews or for the opportunity to go out with them during one of their attacks on a military base. I could go to towns and villages occupied by the rebels, or to areas where I knew they hung out, and if I was convincing, I'd get in to work. Sometimes it wasn't that easy. It took contacts. Time. Luck.

I once went to a place called Tiger Mountain, not far from the cap-

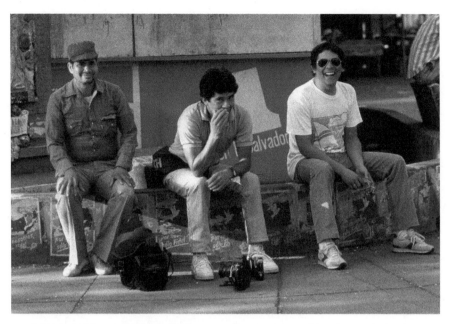

EL SALVADOR – Mexican photojournalist Arturo Robles (center) shares a moment of levity with Julio Romero (right with sunglasses), my faithful driver, fixer and friend in El Salvador. I don't know who the man on the left is.

ital, because a journalist friend of mine told me the guerrillas maintained a pretty significant presence there. So, I drive out to the place, get stopped at a guerrilla roadblock, and explain what I'm doing. They bring me into their camp and I work all day making pictures of them living their clandestine lives. Bingo. But it wasn't always that easy, especially if I wanted to get access to the higher levels of command.

So, I'm banging away at the cover package for *Newsweek,* trying to make compelling photos to show all important aspects of the ongoing civil war. I've done the politicians. I've done the Catholic church. I've done some demonstrations. And I've chased reports of bodies lying around the capital after having been taken out by death squads, so I've got some gore. But I didn't yet have any good material of soldiers or any guerrilla material for a balanced report.

Arturo shows up in El Salvador, saying he can get us into an important guerrilla camp. I say, *"Vamos!"* Let's go!

We head out the next day. Everything in El Salvador is only a few hours drive from the capital, and the guerrilla camp where we end up is no exception. We pass through a few military roadblocks, then as we enter guerrilla territory we pass a rebel roadblock, and the insurgent commanders seem to be waiting for us. That night I made pictures of guerrilla fighters dancing with some local girls.

On Patrol

Still working on the comprehensive package for the magazine, on Tuesday, January 3, 1989, I hooked up with a patrol of government forces near the eastern city of San Miguel, and this is what I wrote in my daily planner:

> On patrol: Day Rate. I pulled out of the San Miguel cuartel with a couple of truck loads of Salvadoran soldiers and we took a dusty ride that lasted an hour or so to a town nestled in the foot of a volcano looming over the Salvadoran countryside and, of course a special guest, I got to go inside a house used by the commander of the mission to share a table and then later a piece of the floor with the heads of the operation while the rest of the soldiers ate from cans and slept on the ground outside. The captain wakes me at 4 o'clock in the morning and we begin to walk in darkness so thick that I have to literally touch the soldier in front of me to keep from falling and I'm still only half-awake until finally the sun comes up and we are at the base of the volcano and it's about 6:30 maybe 7:00 in the morning when the soldiers start to take resistance from the guerrillas. Somewhere the soldiers had come up with a kid they said was a guerrilla and they made this kid, he looked like he was 15 or 16 years old, they made him walk point on the patrol up the mountain to pick

out the guerrillas' home-made anti-personnel mines planted along the path up the volcano to the guerrillas' base camp – and there was a joke for shit like this, the kid being a "Salvadoran mine detector" but I guess he really must have been a guerrilla collaborator because he actually did know where the mines all were and he went up in front of the soldiers pointing them out for disarming and I've seen what these things can do to a man, I've been in the military hospitals where 60 percent, that's right 6 out of every 10 wounded, are in there because of mines. They take off your foot, it's just like as if you put your foot in one of those "chippers" that some folks use to make mulch out of the trees they cut down in their back yards, it's just like if you stuck your foot in one of those. And sometimes they fuck up the other leg as well, burn the shit out of it, splatter it with shrapnel. I have pictures from all of this. The guys in the hospital, most of them without feet from the knees down. So all the while we're walking up the side of that volcano I'm stepping in the bootprint of the soldiers in front of me, the rationale being that if they did it without losing parts of legs, then it's safe for me. And this was hard going. We're hauling ass up a ravine on the face of this volcano, I mean a dry ravine, in most parts just a few yards wide, the bottom of it filled with rocks mostly about the size of softballs and up, some of them huge boulders. It works like this: The guerrillas set up the land mines on the approach to, and in the actual perimeter of, their own position. Once you get through that perimeter, of course they can't have any more land mines around because their own guys would be stepping on them. And this is where we were about a quarter of the way up the volcano. By the time we had gotten to the ravine we were through the perime-

ter and now were inside rebel territory and the soldiers were fighting their way up the ravine for every inch they advanced. They fought the rocks, they fought the terrain, they fought the uphill climb, they fought a sun that by now, just past mid-morning, was beginning to pound our heads soft, they fought the fatigue from not having slept well the night before and they fought the guerrillas. Small arms fire. Rocket-propelled grenades. The troops inched and clawed their way up the hill, finally making it to the rebels' base camp. I've got this set of eerie pictures, taken in the half-light of a camp partially hidden by trees, rays of light cutting down through the foliage onto the scene of soldiers wrecking, pillaging and finally burning the rebel camp, with an undisguised lust on their faces, they were orgasmic. I always had a feeling of unease around these soldiers, despite the fact that I had slept alongside some of them, had shared the long, dangerous walk up the side of the volcano, had shared the same fear during the fighting – experiences that normally cement relationships between men or at least serve to erode barriers between men – none of that happened here with these soldiers and it was clear that these guys were as uncomfortable having me around as I was being around them. I still was not trusted. And the feeling was mutual. I've got pictures of these guys, them, me, all of us exhausted, coming down from the volcano, walking through cotton fields with golf-ball sized blotches of white still on the bushes, walking back to the troop trucks with the volcano in the background, all of us wiped out from the lack of sleep, from the long, uphill walk, from the expenditure of energy so accelerated by the fear associated with combat, from the lack of food, from the sun that by now sucked the vitality from us

right through our clothes and through our skin…I am still alive, with two eyes, two hands and two feet.

Emergency Sex

I had saved the piece of paper she stuffed into my photojournalist's vest that day in the plaza. Julio drops me off at her house in San Salvador and waits for me in his taxi. This won't take long. She's petite but aggressive and pulls me into her room and soon my body is arched over hers, clenched in a long, deep spasm, purging itself of the tension, the anxiety and the fear. I am spent now. I straddle her body. I pant into the folds of the sheet.

"If You Don't Intervene, We're All Going to Die"

Cornel Lagrouw and I never were really great friends, mostly just friendly colleagues who might have become closer if time had allowed. He was a big, tough-looking Dutch guy with rugged features, hair that always looked like he had just messed it up with his fingers (which is what he did because he was always scratching and rubbing his head), a big laugh that came from deep in his stomach, easy from his good nature and raspy from too many cigarettes. He had a big nose, a small mouth with thin, pursed lips and nicotine-stained teeth. He was about 30. Cornel was another member of a small corps of young, energetic journalists who had come to Central America fueled by a desire to succeed covering revolution. Cornel was cool.

I don't remember the breakfast at my home in Managua, but Esmeralda, the woman who worked as an assistant in our home and whose son, Leonardo, would become my godson, says she remembers that morning in great detail. Cornel had come to our home for breakfast, Esmeralda says, and we were talking about the upcoming elections in El Salvador. I was concerned that El Salvador had not drawn blood from the press corps in quite a while, and that the place would

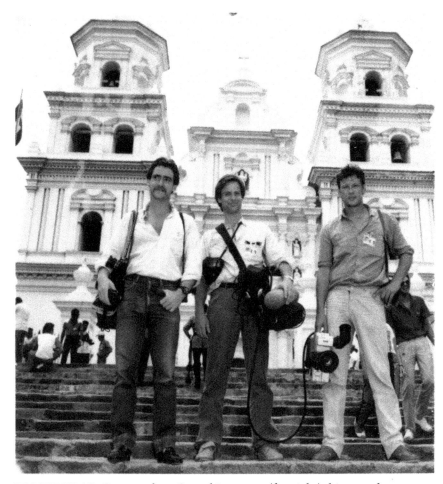

ESQUIPULAS, Guatemala – Cornel Lagrouw (far right), his sound person (middle) and I pose for a picture in Esquipulas, Guatemala, during regional peace talks. A peace plan was signed by five Central American presidents in 1987.

take advantage of the upcoming vote to do so.

Not long after that breakfast I was on a plane heading to El Salvador, and on the same flight was an American television producer and I tell her that I have a bad feeling about going there.

"It's been a while since Salvador extracted blood from us," I said. "It's been a while since it took one of us."

As stated earlier in this book, at least 18 journalists were killed covering Central America between, and including, Bill Stewart in 1979 and John Hoagland in 1984. That's 18 dead journalists in five years. Of that total, 12 were killed in El Salvador.

On the morning of March 19, 1989, Arturo Robles, Scott Wallace and I were out covering the much-awaited elections. Julio, the Salvadoran whom I trusted and routinely hired as my driver in El Salvador, hauled us around in his taxi. The guerrillas did not launch an offensive that day but they did seize the hamlet of San Francisco Javier, a dusty little one-street village off the country's main highway about 30 minutes down a dirt road. We heard there was fighting between rebels and government troops there and headed straight for it.

Scott is a couple years younger than me. He comes from upstate New York. He wears gold, wire-rimmed glasses and preppy clothes. Scott and I were the antithesis of each other. Like many of my colleagues, Scott was thoughtful and soft-spoken. I was visceral and rough. They were methodic and cautious. I thrived on passion and instinct. They made friends easily. I was reckless with my life but careful with friendship. I had a lot of friendly colleagues but few close friends.

One of the few things Scott and I did have in common was a juvenile sense of humor. We reinforced each other's adolescent immaturity. We told stupid jokes.

Guy walks into his doctor's office for a follow-up on recent exams.

Doctor says, "I have bad news and good news. The bad news is that you have cancer. You have maximum six months to live."

"Jeez," the guy says. "If that's the bad news, what's the good news?"

Doc says, "Did you notice my secretary when you came in, the girl with the big tits and long legs?"

Guy says, "Yeah, so what?"

Doc says, "I'm fuckin' her!"

We played dumb pranks on each other.

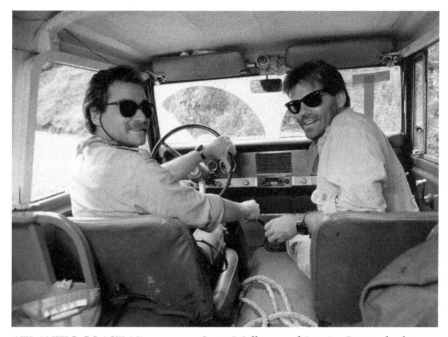

ATLANTIC COAST, Nicaragua – Scott Wallace and I in La Bestia, looking for stories. (Photo by Murry Sill).

During "down" time preceding the U.S. invasion of Panama, the slew of journalists assigned to cover the event spent afternoons waiting for the Americans at the hotel poolside in the capital. Waiters and waitresses rushed drinks and food to the always-thirsty, ravenous media types lounging in the equatorial sun. With boundless generosity, I invited numerous colleagues to drinks and food – forging a signature and signing the bill to the room occupied by one Scott Wallace.

Days later at checkout time I reviewed my own hotel bill, only to find that Scott had executed exactly the same subterfuge, forging my signature and signing a rash of receipts to the room occupied by one Bill Gentile.

During an extended journey to Nicaragua's Atlantic Coast, Scott has to take a leak so I pull *La Bestia* over to the side of the dirt road. Nobody in sight, but this is contra territory, and one never knows what or who might jump out of the bushes.

"Stop playing with yourself!" I yell at him.

As he takes care of business, I drive 30 yards down the dirt road. Scott thinks it's funny and we both laugh. He approaches the vehicle, only to watch me pull away again. It's not so funny now, but I repeat the foolishness, allowing him to approach even closer to *La Bestia* before pulling away.

He yells a few obscenities and I finally let him in. And we both laugh.

There was no laughing this morning in San Francisco Javier as we pulled into the village at around 8:30 am. It was like walking up to a smoking gun. Dead government soldiers scattered in the streets. Teenage rebel fighters drained from the pre-dawn struggle to take the hamlet, sitting on stoops drinking warm Cokes. Townsfolk still shaken from the bang bang but walking around checking out the damage.

So we did what we're supposed to be doing. Scott is sticking microphones into people's faces while Arturo and I point camera lenses at them when a car rolls up the main street and we see white faces inside. It's Cornel and company, so we go up and exchange hugs. Cornel plays catch-up for a while as we tell him where to find the bodies and this goes on for about another 30 minutes and I'm getting nervous. On a video tape that somebody shot that day (it might have been Cornel's tape) we can hear me say something like, "Our time is quickly burning up here guys, let's get out of here." Which we did not do.

As we all filmed, photographed and interviewed rebels and civilians in the aftermath of battle, the Salvadoran army returns with reinforcements to re-take the town. New fighting breaks out.

We are fucked—caught in a crossfire between two armed forces—the absolute worst place we could be. I turn a corner during the chaos to see Cornel lying in the dirt and it is here that the lessons that Guy Gugliotta shared with me during the Nicaraguan insurrection 10 years earlier kick in. The response to an emergency has to be reflexive, immediate, pre-programmed and I had tried for a long time, through numerous close calls, to steel myself for a situation like this.

I tear off the cameras from around my neck and throw them into

the back seat of Julio's taxi, and tell him to take Scott and Arturo down the dirt road, out of town. I stay with Cornel, his girlfriend and his team, loading Cornel onto the rear, open door of their station wagon. Eventually we take the same escape route out of town, Cornel's girlfriend and I hanging on to the vehicle, trying to keep him from falling out onto the dirt road.

We stop once, pulling off to the side of the road near a peasant family's hut, hoping the shooting would stop. It does not. It becomes more intense.

While crouching underneath the tailgate door of the station wagon upon which Cornel laid, I can see the helicopter gunner above us. And this is something that I've never before written about and I've discussed only once, with my youngest brother, Robby, I guess because of events I'll describe later in this book.

As I crouched underneath that tailgate door, my mind "saw" my father's face and I told him, in words that I remember precisely to this day: "If you don't intervene now, we're all going to die." I've always thought the use of the word "intervene" was curious but appropriate for this situation.

Maybe my cousin Joanna was right when she told me, "The people who you have a close attachment to, they're always with you. You talk to them. When you're in trouble you talk to them." That day I certainly was in trouble. And I talked to my father.

The helicopter gunner stops firing and the chopper pulls away. On the station wagon door Cornel lay dead from a single bullet wound to the thorax.

We gather ourselves and a peasant woman emerges from the hut and approaches me, saying I should get rid of my dust-covered shirt because the soldiers might think I was somehow involved fighting alongside the rebels who had taken the town. She hands me a clean, yellow and white soccer jersey. One of her eyes looks straight at me but the other wanders off upward and to one side, something that I find deeply unnerving. Spooky. I take the jersey. I am dazed, still processing what just happened.

This story is not over yet. Cornel's killing made international news. We conducted a press conference about the event and CNN covered it. We were all shaken by this incident, but it was perhaps Julio who was in danger even after it was over. As it is with so many of these cases, we foreigners can jump on a plane and head home when a situation gets too hairy, but people like Julio can't do that because they already *are* home.

Recalling this event years later, Claudia said, "We were all in shock. You brought Cornel's blooded clothes to our home and Esmeralda had to wash it to get rid of the death smell. Many months later I gave those pieces to Cornel's best friend, Jan Schmeitz."

Julio and his wife Rosa were concerned that there might be repercussions because of her husband's association with foreign journalists denouncing governmental abuse of human rights. El Salvador at this time was a place where gunmen could kill student demonstrators, labor union leaders, opposition politicians of any stripe, journalists, nuns, priests, even a popular archbishop, and get away with it. So, why not Julio, a relatively unknown taxi driver whom nobody but his immediate family would miss?

I think Rosa also was motivated by the realization that life in El Salvador was not going to get any better anytime soon. She didn't want to raise her son in this place.

I tried to get Julio a visa to the United States but the folks at the U.S. Embassy in San Salvador turned us down. So, at the suggestion of Harold Crooks, the screenwriter of *The World Is Watching*, whom I met during the filming of that documentary, I traveled to San Jose, Costa Rica, where I appealed to officials at the Canadian Embassy. Harold had advised them of the situation, and they were gracious enough to consider the case. Canada granted Julio, his wife Rosa and their son, political asylum, flew them to Vancouver, gave them housing and set Julio up with a job.

Dutch journalist Jan Van Bilsen was a close friend of Cornel's. Years after Cornel was killed, Jan went to the village of San Francisco Javier to lay a plaque commemorating his fallen friend. Van Bilsen

told me he tracked down and spoke with the helicopter gunner who could very well have killed us all that day. Jan was not terribly specific about the conversation and I didn't want to press him on a difficult subject. He told me that the gunner said he just didn't feel it was a good idea to kill us.

At this writing, the jersey given to me by the wall-eyed peasant woman rests in a closet in my Washington, DC, home. I've never worn it, but I cannot discard it, as that might bring bad luck. The number on that jersey is 44 – my lucky number.

"Get Me Out of Here"

There were more terrible days in 1989. El Salvador wasn't finished with us.

On November 16, one of the Salvadoran army units that had been trained and advised by the U.S. murdered six Jesuit priests at the Central American University campus in San Salvador, along with their housekeeper and her teenage daughter. The priests, including the rector of the university, had advocated peace talks.

The next day, during the Salvadoran guerrilla offensive that month, Arturo Robles and I go to the *Mejicanos* neighborhood of the capital following reports of heavy fighting that morning between government forces and the guerrillas. We get there and everything is over. At least it seemed that way. Soldiers are in position at an intersection, but they look relaxed. Some are walking around. Pedestrians are walking through the intersection. We get out of the car to look around and there's another group of journalists there doing the same thing. One of those journalists is David Blundy, a British reporter working for *The Sunday Correspondent* newspaper of London.

A single shot rings out and Blundy, who was standing in the middle of the intersection, collapses. Then there's a couple bursts of gunfire and it's over. Everybody in the intersection hits the pavement and, if possible, gets behind anything that offers cover. Arturo, a couple of colleagues, a Salvadoran civilian and I move up to Blundy.

"Get me out of here," was the last thing I heard David say as we carried him to a nearby vehicle and rush him to a hospital in a van commandeered by a group of Spanish journalists who had arrived on the scene. David did not survive his wound, a single shot to the rib cage.

The killing sparked an investigation by London's Metropolitan Police, International and Organised Crime Branch, New Scotland Yard. In a five-page letter complete with a hand-drawn map and dated 10 December 1989, I responded to a query from Detective Inspector Robert Webster about Blundy's killing. In the letter, I detail the various scenarios regarding the mystery of the who and why of David's death.

> Finally, consider the atmosphere in which the incident took place. As in many other places where we work – but even more so in El Salvador – journalists are routinely accused of manipulating the truth. During the rebel offensive that began Nov. 11, pro-government media accused foreign journalists of alleged sympathy for the guerrillas. A week or so after David's killing, a Salvadoran photographer working for Agence France Presse (AFP), was cut down by gunfire – almost certainly from government troops – while working in a conflictive zone accompanied by other journalists and by Red Cross workers, the group clearly identified as non-combatants.

> Having said all of the above, I feel that David was killed by Salvadoran government forces. But I stress, these are my recollections under a tense and very rapidly-moving situation. Please do not interpret these recollections as complete in detail or decisive in ascertaining the truth. One of the saddest – and perhaps the most maddening – aspects of El Salvador is that so many killings like this one go unsolved and unpunished.

Reporter shot by government troops inquest is told

THE journalist David Blundy was wearing a dark blue shirt similar to those worn by rebel troops when he was shot, probably by government soldiers, while covering fighting in El Salvador, an inquest in London was told yesterday.

Bill Gentile, a US photographer for *Newsweek*, described the moments before the death of Mr Blundy, of *The Sunday Correspondent*, on a video played at St Pancras coroner's court. "I believe David was killed by government forces," he said.

Although based in Washington Mr Blundy, aged 44, frequently travelled to Central America. Mr Gentile said that on last November 17 he encountered Mr Blundy in Mejicanos, a working-class district in San Salvador. Government troops were trying to maintain control after a big guerrilla offensive.

"The government-controlled zone was very tense," he said. The two of them, with four other foreign journalists, began walking towards the government commander for information but then "a single shot rang out and was followed by a short burst of automatic weapon fire". Mr Blundy was caught in an unprotected position in the middle of a crossroads. His 6ft 4in frame and dark blue shirt made him an easy target.

Mr Gentile said the others tried to get Mr Blundy to safety. "I shouted 'journalists, journalists, don't shoot' in Spanish and we waved white flags in the air. I heard David say 'get me out of here', and

this was the first and last thing I heard him say." A Spanish television crew was took Mr Blundy to a nearby hospital. He was operated on but died later that day.

Dr Peter Vanezis, a pathologist, said Mr Blundy died from two gun shot wounds, to the chest and abdomen.

Mr Gentile said although they were "in a very tense and rapidly moving situation", they were clearly identifiable as journalists from their equipment and white flags.

He did not see Mr Blundy being shot but he believed the sound of fire came from an area held by the government troops. He said the government troops "had accused foreign journalists on a regular basis of being sympathetic to anti-government rebels".

An investigation was carried out by Det Insp Robert Webster, attached to the International and Organised Crime Branch, New Scotland Yard. He said he was hampered because a number of government troops he would have liked to have spoken to were being held in jail in connection with the murder of six Jesuit priests. It was impossible to find out the identity of the gunman, he said.

The coroner, Dr Douglas Chambers recorded a verdict of misadventure on Mr Blundy, who was divorced with two daughters and came from Slinfold, West Sussex. "This is the most clear example of someone in the course of duty entering a course of conduct which is dangerous," he said.

A hand-drawn map (opposite), plus correspondence to and from British officials, regarding the 1989 killing in the Salvadoran capital of British correspondent David Blundy. The complete versions of these documents are available on WaitForMeBook.com.

Article in The Times of London newspaper regarding the killing.

10 Dec. 1989

Bill Gentile
Managua, Nicaragua

Tel: 505 2 70089

Detective Inspector Webster
International and Organized Crime Branch
Metropolitan Police
New Scotland Yard
Broadway
London Southwest 1
Great Britain

Dear Mr. Webster,

The following is in response to our recent telephone conversation about the killing in November of Mr. David Blundy. For the record, I am Newsweek Magazine's Contract Photographer in Latin America and the Caribbean. An American citizen, I've been working in Latin America since 1977, and have been based in Nicaragua since 1983.

The following are my best recollections of a stressful, rapidly-changing incident. Please do **not** interpret these recollections either as Newsweek Magazine's official response or as a complete version of what happened that day. These are the details as I remember them:

On the morning of David's death, myself and two colleagues arrived at an intersection in the "Mejicanos" working-class district of San Salvador, the capital of El Salvador, shortly after 7 a.m. With me in a rented taxi were a Mexican and a Chilean photographer. Just minutes after our arrival, a second group of journalists -- Mr. Blundy and two American correspondents -- arrived at the same intersection. The two groups were separate but aware of each other's presence at the intersection. We were dispersed at the scene.

The intersection and surrounding area that morning had been the scene of fighting between government forces and anti-government guerrillas. At least two cars were strewn in the intersection, apparently having been used by guerrillas as barricades during the clash. When we arrived, there was no shooting, but government troops who controlled the zone were tense.

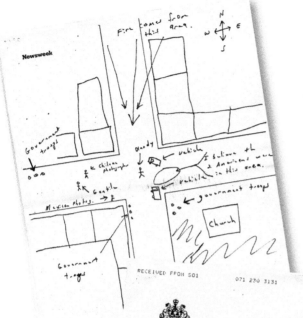

RECEIVED FROM S01 071 230 3131 08.06.90 14:36 NO.02

METROPOLITAN POLICE
International & Organised
Crime Branch
New Scotland Yard
S01(1) Branch
Room 1501
Broadway SW1

Mr Andrew POCOCK
British Embassy
3100, Massachusetts Ave NW
Washington
USA

7 June 1990

Dear Sir

Re: WITNESS BILL GENTILE

With reference to our telephone communication on 6 June 1990. I forward to
you a copy of Mr Gentile's letter which he sent me in respect of the shooting
of British Journalist Mr David BLUNDY, who died in SAN SALVADOR, EL SALVADOR,
17 November 1989.

I would ask that prior to Mr Gentile giving his account of the incident by way
of video recording, he be allowed to refresh his memory so that the statement
he makes is as factual as possible; he would conclude by stating that the account
he has given is true to his knowledge and belief.

At the commencement of the recording Mr Gentile should introduce himself, state
his age and occupation and who he is employed by and for how long. Then explain
why he happened to be in San Salvador at the time of the incident, then state
his recollection of the incident, would he explain how he knew David BLUNDY,
and the conflict in El Salvador particularly during the month of November, leading
to the day David was shot.

Points to cover:

1) Mr Gentile when referring to organisations (eg AFP) should give the
 full title - Agence France Presse.

2) Describe the area "Mejicanos" slogans and signs of battle and if a
 guerrilla stronghold.

3) Did he see David BLUNDY fall to the ground, if not when did he first
 see or realise David had been shot and what action was taken, if any, by
 members of the Armed Forces at the scene.

4) Bill should quote what he put in the letter in the recording, as it is
 quite a comprehensive report.

5) Avoid too much heresay.

6) When referring to the diagramme could Bill hold it up to the camera and
 point things out as the Inquest Jury will have copies to help follow his
 evidence.

I had a copy of the letter delivered to David's daughter, Anna Blundy, and soon after received a note from her. "I am glad there were at least people with Dad and that you did your best to help," she wrote.

In response to my letter to Detective Inspector Webster, the British Embassy in Washington, DC, invited me to visit for an interview, to be videotaped, which I did in the summer of 1990.

An article dated July 3, 1990 and headlined, "Reporter Shot by Government Troops Inquest Is Told," *The Times of London* quoted my taped testimony.

"Bill Gentile, a U.S. photographer for *Newsweek*, described the moments before the death of Mr Blundy, of *The Sunday Correspondent*, on a video played at St Pancras coroner's court. 'I believe David was killed by government forces,' he said."

The Times article continued:

"An investigation was carried out by Det Insp Robert Webster, attached to the International and Organised Crime Branch, New Scotland Yard. He said he was hampered because a number of government troops he would have liked to have spoken to were being held in jail in connection with the murder of six Jesuit priests. It was impossible to find out the identity of the gunman, he said."

That's too often how things worked in El Salvador. It was only one shot aimed at one person in that intersection that killed one person. Maybe because David was 6' 4" tall, towering above the others in the area, and that made him an easy target. I'm only 5' 10" so I might have been harder to hit. Maybe it was the color of the shirt David was wearing. Or maybe he was just in the wrong place at the wrong moment and the wrong person had the opportunity to hurt someone for some unknown reason. The shooter could have killed one of the other journalists. He could have killed me. But he didn't.

One last detail: *The Times* article pointed out that David Blundy was 44 years old. 44. My lucky number. Again.

"Because They're Going to Kill Him"

It was around this time that some of my friends, colleagues and family members began to reach out, to try and pull me back from the dangerous precipice that I was standing on. They followed the news. They had seen the pictures in *Newsweek*. They tracked my behavior.

From his home in Miami, Murry Sill, the *Miami Herald* photographer with whom I spent days in the mountains during a failed Sandinista offensive against contra forces, called me to suggest that my pictures of combat in *Newsweek* alarmed him, that I might be taking too many risks. I would find out later that Juan Tamayo, my former supervisor at UPI in Mexico City, had contacted Sill and encouraged him to speak with me.

From the southern Mediterranean island country of Malta and in a hand-written letter to me, Rod Nordland, who accompanied me in the weeks-long journey in the mountains with the contras, wrote of El Salvador:

"That fucking country is just bad damn luck. I also couldn't help but feel worried for you, and I can imagine how tough it must be on you to see colleagues take it in your vicinity. It also scared the piss out of me to see that picture (in Nwk last week) you took that seems to indicate the photographer was <u>in front</u> of the shooter. I'm sure there was cover there or something, but still – sorry if this all sounds preachy – I hope you'll just watch your ass."

My picture of Salvadoran soldiers firing down a street in the capital was published in the November 27, 1989 edition of *Newsweek* magazine. Nordland's letter was dated December 4, 1989, less than three weeks after Blundy's killing.

In the world of conflict coverage, our colleagues often are considered "the canaries in the coal mine." When the little birds begin to drop dead while accompanying miners deep underground, the workers know they are dealing with undetectable but lethal gas – and it's time to get out of the pit. When we journalists notice erratic, out-of-control or foolish behavior by our brethren, it is our duty to sound the alarm.

At a meal with a bunch of colleagues in an open-air restaurant, one of them joked that nobody wanted to go to the field with me anymore because I seemed to be a magnet for danger. If they did go out with me, he said, they might not come back alive. Nobody laughed.

Back in Managua, Claudia's father follows the news and talks to his wife about my frequent trips to El Salvador, the latest round of violence and my proximity to it.

"*Gentile no debería regresar a El Salvador,*" he says, referring to me by my last name, with the Nicaraguan pronunciation, hen-TEE-lay. (Gentile shouldn't go back to El Salvador.)

"*Porqué no?*" Norma asks. (Why not?)

"*Porque lo van a matar,*" is his answer. (Because they're going to kill him.)

Joe Contreras and Sendero Luminoso

Joe Contreras and I step off the plane in the Peruvian jungle town of Tingo María, located in the heart of Peru's Upper Huallaga Valley. It is 1989, when the area is considered the world's largest source of coca leaf used to make cocaine. At the time, Contreras is *Newsweek* magazine's bureau chief in Buenos Aires, Argentina, responsible for covering all of South America. Our assignment is to explore the connection between cocaine traffickers and the leftist insurgency that is tearing Peru to pieces.

We get the story – and nearly lose our lives.

Many Peruvians refer to the years between 1980 and 2000 as "the time of fear," brought on by the Maoist insurgent group *Sendero Luminoso* or, Shining Path. The group announced its 1980 debut by hanging the corpses of slain dogs on lampposts and by burning ballot boxes during a national election. *Sendero Luminoso* was led by Abimael Guzmán, a professor of philosophy at the University of Ayacucho, a city in the central Peruvian Andes, who had visited China and was deeply influenced by the ideas of Mao Zedong. Guzmán left the university in the mid-1970s, went underground, assumed the nom de guerre, *"Presidente Gonzalo,"* and began a rebellion to eradicate the country's capitalist system and replace it with a communist regime.

The group's members wasted anyone who got in their way. That meant the army and police. Government employees. Other leftist groups. Workers and peasants who failed to support their anti-government campaign. Members of the middle class. The rebels eventually controlled vast rural territories in central and southern Peru, and even some of the slums ringing Lima, the nation's capital.

Some observers refer to the Shining Path as the Khmer Rouge of Latin America because of its Maoist origins as well as the terror it sowed among the Peruvian populace. According to the authoritative InSight Crime foundation that studies organized crime in Latin America and the Caribbean, "The group's methods were particularly brutal, including stoning victims to death, or placing them in boiling water. The Shining Path carried out massacres of peasant communities perceived as being against their struggle, as well as attacking the security forces and other representatives of the state. They quickly gained ground, and were present across vast swathes of Peru by the end of the 1980s."

When it was all over, a Truth and Reconciliation Commission would estimate that some 70,000 people died in the conflict, approximately half of them at the hands of the Shining Path and a third at the hands of government forces. In 1992, Peruvian authorities captured Guzmán in a Lima dance studio. As of this writing, he is serving life in prison.

Directed by John Malkovich and starring Javier Bardem and Laura Morante, the popular 2002 film, "The Dancer Upstairs," is based on the story of Guzmán's arrest.

Actually, it still is not "all over." In April of 2020, InSight Crime reported that, "The Shining Path no longer presents a serious threat to the stability of the Peruvian state, but the guerrillas' continued activities continue to pose a challenge for the government. The Huallaga faction, however, is thought to have been drastically weakened since the capture of its leader, Florindo Eleuterio Flores Hala, alias 'Camarada Artemio,' in 2012. He was the last leader in the field who remained loyal to Guzmán. Now there is no link between the rebels still in the field and the high commanders in prison."

Newsweek magazine correspondent Joe Contreras at work on Nicaragua's Atlantic Coast in the early 1980s.

At the time of Contreras' and my visit, the *Sendero Luminoso* was very much alive and well in the Upper Huallaga Valley. And it was not exactly a place friendly or welcoming to outsiders. Especially outsiders from the United States. The U.S.-sponsored "War on Drugs" and the Shining Path insurgency were piling up bodies faster than anyone could count them. The Drug Enforcement Agency (DEA) was assisting Peru in its struggle against cocaine trafficking by dumping herbicides over broad stretches of Peruvian territory used to cultivate coca plants. Peasants complained that the chemicals were contaminating their land, their rivers and streams, and their people. The cocaine traffickers were pissed off because the program was cutting into their profits. The insurgents apparently were equally pissed off because they depended on taxes of those profits to finance their war on the Peruvian government.

According to a report by the Associated Press, Todd C. Smith, a reporter for *The Tampa Tribune*, was last seen alive in the Upper Huallaga region on November 17, 1989, while on a reporting trip. His body

was found shortly after in the remote town of Uchiza, with a placard nearby denouncing "North American spies." An autopsy revealed his neck had been broken and found evidence he had been beaten. Authorities said he was killed by the Shining Path. Smith was 28 years old.

So this is the context into which Joe Contreras and I land that day.

Joe is one of the smartest guys I know. A Chicano raised in Pico Rivera, a city located in southeastern Los Angeles County, California, he won a generous scholarship to Harvard University, worked on the university's newspaper, *The Harvard Crimson*, and graduated magna cum laude. Joe is gifted with an extraordinary memory, capable of recalling incidents or just his daily routine decades ago. He's also one of the funniest guys I know – even though his humor is sometimes unintentional. Joe never boasts of his extraordinary athletic prowess – because he has none. And this is part of what makes him so funny.

We first met when Joe came to Nicaragua in the fall of 1983. As the Reagan administration bore down on Nicaragua with a trade embargo, the mining of its harbors, the support of contras based in Honduras who staged bloody incursions into Nicaragua, and threats of outright military invasion, Contreras showed up in Managua to report on the story.

He and I were out one night cruising around Managua to report on the trenches that Sandinista leaders had encouraged citizens to dig, just in case the Reagan administration decided to unleash the dogs of war. On a dark street that neither Joe nor I was familiar with, Joe surmised that, "These trenches can be really daaaaangerous," as he proceeded to fall into one of them.

The relationship between print journalist and photojournalist can be:

A. a profound and mutually gratifying and effective bond.
B. a throbbing, non-stop pain in the butt.
C. something in between.

Why? Because correspondents too often see photographers only as appendages of their own careers, who little understand the nuances of stories they are covering, and because photographers too often see correspondents as self-important pansies void of the guts or the heart to get to the core of a story or to the core of the people who are living that story. Too many correspondents considered photographers as adrenaline-thirsty cowboys (some of us were), and we saw too many correspondents as Banana Republic Hemingway wannabes afraid to get dust in their hair (some of them were).

Print journalists take pride in maintaining an "objective" distance from a story. Photojournalists take pride in immersing ourselves into the heart of the story. For me, that's the real gratification of our craft – the connection we make with other human beings. The privilege of learning and disseminating their stories in the hope that by doing so, we can have a positive impact on that person and on the world we live in.

I take great pride in my connection to the people involved in these conflicts. It was for them that I did my work. And I think some of my colleagues came to understand that. Joe was one of them.

Contreras and I were a house on fire from the very beginning. He never referred to me as "my photographer" and I never questioned or challenged his intelligence, his integrity, or his take on a story. He is a brilliant reporter. And a terrific writer. We were a team.

So, we get to Tingo María and hire a taxi to take us north into the valley. It's Sunday. As we make our way through the valley on a two-lane, paved road, Joe and I stop at each town or village to interview anyone of authority who might advise us on the safety of continuing forward. Police. Priests. Ordinary citizens. And they keep saying, "*Todo bien!*" (It's all good!)

But somewhere there is a disconnect between these sources and reality on the ground because early that afternoon Joe Contreras and I find ourselves pulling into an outpost – it isn't really a town or a village – designed exclusively to collect and transport coca leaves used to make cocaine. Young men on dirt bikes immediately surround our

taxi. They want to know who we are and what we're doing in "*nuestro lugar.*" (Our place.) That place is called Ramal de Aspusana.

It is about 1 p.m. that Sunday afternoon. Joe and I found our cocaine traffickers. They would soon introduce us to the Shining Path.

The young men on the bikes demand identification. They take us to a shack where a bunch of very drunk older men begin the interrogation. They offer us a drink. (Actually, they demand we take a drink of some unidentifiable alcoholic substance.) Then the men on bikes take us for a little walk in the woods. They rifle through our belongings. Joe's satchel. My camera bag. Our passports. They look for anything that might identify us and our intentions.

Then they find my identification card issued by the Salvadoran military. Joe has a different recollection of this detail. He remembers that it was a business card of then Peruvian President Alan Garcia's press secretary that set these guys off. In any case, not even the numerous stamps on my passport documenting the multiple entries and exits from Sandinista-ruled Nicaragua can convince them that we are journalists and not CIA spies or DEA agents. They are suspicious.

There are few experiences more unsettling than being abducted. At least I don't know of many. Not even the extraordinary stress of actual combat can compete with the hopelessness of being held against one's will. In combat, at least I have the ability to respond. To move. To get out of the way. But not when I've been abducted and held prisoner. It's like suffocation. I can't breathe. I have no control over anything. People whom I have never met get to decide whether I live or die. It's awful.

After the interrogation our captors take us to the edge of a river. They tie our hands behind our backs and, before depositing us in an outboard motorboat, tell us that some people on the opposite side of the river want to meet us. And if you are what you claim to be, one of our captors tells us, everything will be alright. "But if you are what we *think* you are," he said, "*Lamentamos lo que les va a pasar.*" (We're sorry about what's going to happen to you.)

My heart sank. Images of my family flash through my mind. My

mother. Brothers. Claudia. They are waiting for me.

It's getting dark now as the rickety little craft makes its way across the quick-moving river. I'm scared as hell that this boat will flip and dump us into the water, me with my hands tied behind my back and my cameras sinking to the bottom. We get to the other side and our captors lead Joe and me down a dirt path. In the distance I see people's silhouettes. They are holding guns.

At the end of the path is a small group of rebels, led by a young woman, whose nom de guerre is "*Flor.*" (Flower) In an effort to normalize, or humanize, the situation, I ask Flor to have somebody loosen the ropes binding Joe's and my hands.

"It hurts," I tell her. She orders her comrades to remove them. Contreras and I are now in the village of La Morada. (Joe would eventually find that the village had been designated a prohibited "red zone" by U.S. officials.)

For the next two days, Joe and I are held in a shack, apparently used in normal times by peasants to hold farming tools. Though I am allowed to keep my camera bag with me, I don't dare make a single image during our captivity, or even to pull one of my cameras out of the bag, a move that could cost us our lives.

During those two days in the guerrilla camp, Joe and I meet with members of the group whose rank in the organization seems to elevate. They do not torture us. They don't beat us. They don't threaten us. They shepherd us, along with the rebels, through daily activities that include standing in line for meals. It's eerie. Nobody speaks. Nobody acknowledges anyone else. The rebels move around like zombies. Programmed. Emotionless.

Underneath this routine is the inescapable subtext that the leaders of this group are in the process of deciding what they want to do with us. Kill us, hold us for ransom, or set us free. And it's here where fear can be the worst enemy. Fear is a virus. And if I let it spread, it can hollow us out. It will completely demobilize us. As Joe and I go through this process, I feel the fear rising in my gut, and I fight hard to tamp it down. I don't want to infect Contreras with this sickness.

I was not alone in my concern about our situation. In his original

dispatch to *Newsweek* magazine editors in New York, Joe wrote of our abduction:

> But there were two important bits of information about Shining Path that I had gleaned from my readings and which I kept repeating silently to myself throughout our two-day stay in the camp. They had never harmed any of the precious few journalists who had made contact with guerrillas in the field and only rarely did they execute captives without a previous warning...Though the circumstances were less than ideal we were able to gain a rare insight into Shining Path's goals and mindset through extended discussions with several of the guerrillas.

Joe wrote of our lunch the day after our arrival:

> It was typical campesino fare – rice, beans, a smattering of potatoes – and under the watchful gaze of "Flor" about 15 youths sat down at a wooden table with benches placed under the roof of what used to be the defunct cooperative's lumber mill. Like regimented drones from some Orwellian tableau they ate their lunches in silence, periodically looking up from their red plastic bowls to catch glimpses of the pair of unexpected visitors in the camp.

There were a few light moments during our stay.

> Shortly after sunset guerrillas and village residents alike filed into the warehouse to watch an old black-and-white Western about the Apache Indian chief Geronimo starring Chuck Connors in the title role. The youngsters clearly identified with Geronimo and

his braves as they repeatedly eluded and confounded the U.S. cavalry and Mexican army units chasing after the Apaches. The kissing scenes featuring Connors and the Indian woman who later bears Geronimo's heir predictably brought a rise of nervous giggles from the audience...Towards the end of our stay, we sat around a table littered with one-liter bottles of Pilsen beer and talked politics with "Tomas," a stocky man in his mid-40s with a gold bridge in his lower set of teeth who appeared to be the highest ranking official of the Communist Party of Peru in the area.

We apparently had graduated from low-level combatants to local military commander to regional political commander. I remember that this interview was lengthy, and I understood that it was this man, the *político*, who would decide whether Contreras and I would live, or if the cocaine traffickers across the river would "feel sorry" about what had happened to us.

And it was here that Contreras seals our fate and negotiates our freedom. Toward the end of the interview Joe says, "Even Mao granted interviews to American journalists." And Tomás seems to understand that, in fact, Mao Zedong in 1936 did grant a series of now-famous interviews to American journalist Edgar Snow. Those interviews became the basis of Snow's classic, *Red Star Over China*, an account of the Communist Party of China when it was still an obscure guerrilla army relatively unknown to the West. And Tomás surely remembered that "*Presidente Gonzalo*" had visited China and had come away deeply influenced by Mao's ideas. Maybe this was the rationale for his decision on our fate. When Joe said this, it was as if a light in his head clicked on. Shortly after Joe's comment, Tomás ends the interview and Joe and I are led back to our shack.

Early the next morning one of the rebels opens the door and says, "Let's go." He's 15 or 16 years old and is holding a 9mm pistol. (You can imagine what I'm thinking now.) He walks us to the river where Joe

and I crossed two days earlier and stops along the way. The kid pulls an orange from a nearby tree, throws it in the river and tries to hit it with the pistol. He misses.

So get this: I ask him if I could try and *he actually hands me the loaded gun!* Having been a hunter and gun owner since I was 12 years old, I know a little about weapons. So I take the pistol, throw another orange into the river – and actually *hit it* with the first shot. The kid, Joe (and I) are impressed. I hand the gun back to the kid.

Joe and I make it to the other side of the river and walk toward the place where the *narcos* originally abducted us. Some of them walk past us in the opposite direction, staring straight past us but so close that their shoulders nearly touch ours, in a move apparently intended to intimidate. Other guys look at Joe and me like they are seeing ghosts. Nobody, but nobody, thought they would ever see us alive again.

Joe and I get a ride back to Tingo María where we contact *Newsweek* magazine. The taxi driver who first delivered us to the *narco* outpost apparently had advised another group of journalists working in the area that we had been abducted. Those journalists alerted *Newsweek* headquarters in New York of the abduction. So by the time Joe and I were released, *Newsweek's* chief of correspondents Bob Rivard was discussing with other administrators how to get us free.

Joe's story made the cover of *Newsweek's International Edition*. The domestic edition featured an artist's rendition of Joe and me, hands tied behind our backs, being escorted through the Peruvian jungle by Shining Path rebels. Both editions included a single picture I made just before we were abducted.

To this day, I still do not completely understand why Tomás, the *político*, decided to let us live. But Joe Contreras and I got our story, as well as an intimate look at the inside workings of Latin America's most feared terrorist group. I believe we are the only American journalists to have done so, and to have lived to tell about it.

INTERNATIONAL

With the Shining Path

A rare and risky encounter with Peru's fanatic guerrilla movement

BILL GENTILE FOR NEWSWEEK

Streets of the stronghold: *Pro-rebel graffiti in the Upper Huallaga town of Tingo María*

BY JOSEPH CONTRERAS

"César" was preaching revolution across a table littered with beer bottles. "We are building the new state," he said. Had he been wearing a business suit rather than jogging pants, this cleanshaven rebel with the nom de guerre might have passed for any one of the ambitious professionals who work in Lima, 230 miles away. Instead, he was talking about the imminent overthrow of the Peruvian government: "We are approaching the brilliant prospect of the seizure of power," he lectured, an AK-47 assault rifle resting on his lap.

NEWSWEEK photographer Bill Gentile and I had come to Peru's 150-mile-long Upper Huallaga Valley in search of the Shining Path, the fanatically Maoist guerrilla movement that prowls much of this coca-rich, but otherwise impoverished, nation. Rebel forces, estimated to be between 3,000 and 6,000 strong, had been waging a brutal, rural-based insurgency that has claimed the lives of 15,000 Peruvians since 1980. For all César's talk, Shining Path seems at least several years away from seriously threatening to seize power. But its guerrilla columns are advancing steadily. The Up-

per Huallaga Valley was now a principal Shining Path stronghold; the soldiers and police of Peruvian President Alan García rarely ventured there anymore. Few journalists had come close to their hideouts either. Though not exactly the guerrillas' prisoners of war, we had most assuredly become their captive audience.

We had left the town of Tingo María early Sunday morning, April 9, and shortly after noon arrived in Ramal de Aspusana, a rough-and-ready trading center for what is indisputably the largest coca-growing region in the world. As our taxi stopped, we were approached by a man with a scraggly Fu Manchu mustache who abruptly piled into the back seat next to Gentile. "This is a red zone!" he snarled. "It is totally prohibited to come in here!" By his look and talk, he had to be one of the thousands of drug traffickers who preceded Shining Path into the Upper Huallaga but have since been obliged to forge an uneasy coexistence with the guerrillas. By the time Shining Path began to move into the area six years ago, Colombian drug lords had transformed it into a badlands of lawlessness and rampant killing. These days Shining Path champions the cause of the valley's coca-growing *campesinos* and assesses "people's taxes" on shipments of cocaine paste.

The man in the Fu Manchu would not listen to our apologies and would not let us go. Suddenly, we were surrounded by a throng of unfriendly faces. We were urged out of the car and into a nearby house, where a heavy-set and obviously drunken man began bellowing questions about "our mission" and who had sent us here to investigate. No doubt we looked a lot like informants dispatched by the U.S. Drug Enforcement Administration. Since 1987 the DEA has maintained a complement of 25 to 30 agents and American contract employees in Tingo María. The head of the DEA office in Lima called it the agency's "most dangerous operation" worldwide. In February the DEA gave in and suspended all operations in the valley north of Tingo María.

After the grilling in Ramal, we were led out of town and into a wooded area where several men frisked us and painstakingly reviewed our passports and press credentials. Inwardly I was relieved that I had left behind the business card of the U.S. Embassy official I had lunched with in Lima the previous week; any perceived link to the U.S. government could have been a death sentence. One of the interrogators, a dark-skinned campesino in mud-splattered polyester slacks, was introduced as the local "delegate," the man chosen by Shining Path to serve as liaison between guerrillas and local residents.

Apparently satisfied that we were neither DEA agents nor informants, the locals escorted us back into town and onto an aluminum boat. For 20 minutes we sped down the mud-brown Huallaga River, then suddenly veered toward the left bank. Though we had been held against our will since arriving in Ramal, until that moment we had not been physically threatened—no guns, no handcuffs, no blindfolds.

Strictly political: But after we clambered ashore, our custodians promptly tied our hands behind our backs and marched us up a grassy trail. A half mile later, we were greeted by a woman guerrilla named "Flor" who carried a Belgian-made FAL

Newsweek published the story of the abduction of Joe Contreras and me in the domestic edition. The story began on page 44 – my lucky number.

JULIAN ALLEN

Into the valley of coca: *With camera bag confiscated and hands bound behind their backs, Contreras (second in line) and Gentile (third) are escorted to the rebel camp*

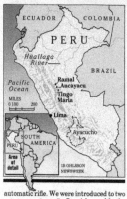

IB OHLSON
NEWSWEEK

automatic rifle. We were introduced to two more *compañeros* (in Spanish roughly the equivalent of comrade). Though they, too, bristled with weaponry—U.S.-made hand grenades, G-3 and FAL automatic rifles—I could scarcely conceal my sense of relief. Unlike our menacing hosts back in Ramal, these, I could sense, were people whose motives were strictly political. Within minutes of our arrival at a campesino's house, the guerrillas untied our hands.

That night, as we tried to fall asleep on a foul-smelling mattress, I ran through all the grim stories I had heard about Shining Path. Throughout the 1980s, as the guerrillas fanned out from their original redoubts in the mountains of Ayacucho Department 350 miles to the southeast, they have displayed a penchant for brutality that has inspired comparisons with Cambodia's Pol Pot. In an unprecedented interview published last July, the movement's shadowy leader, a 54-year-old former professor named Abimael Guzmán, acknowledged that excesses had indeed taken place in the past. Regrettably they have not ended; last month a Shining Path column descended on the village of Carhuapampa in Ayacucho and killed 27 peasants suspected of collaborating with the government.

At daybreak on Monday we awoke to survey a village of one-story houses that was now home to 100 guerrillas. For the next 24 hours we moved about as though on an invisible leash: at times we had the run of the village, but at no time could we leave. Later in the afternoon, what had begun as an interrogation evolved into a beery dialogue on one of the village porches. Most of the rebels were males ranging in age from 16 to 21; most were outsiders from other parts of the country. In the morning they lined up in neat rows on the village soccer field to perform calisthenics and shout revolutionary slogans. The late afternoon was taken up with political instruction. Some had a passing familiarity with party doctrine, while others were clearly newcomers to Guzmán's brand of Maoism.

Guiding beacon: Our hosts confirmed that in the "People's Republic of the New Democracy," the "social imperialists" of the Kremlin would be as unwelcome as the "Yankee imperialists" of the White House. No matter how great the pressures from the United States, the guerrillas swore never to repeat the errors of Fidel Castro, who had become addicted to the U.S.S.R.'s largesse. They would especially keep in mind the mistakes of the Sandinistas in Nicaragua, who had failed to completely stamp out that country's middle class. Politically, the Peruvian revolution would emerge as the guiding beacon for other Maoist revolutions. Linguistically, to unite the country,

NEWSWEEK : APRIL 24, 1989 **45**

Artist version of Joe and me with Shining Path in Peru

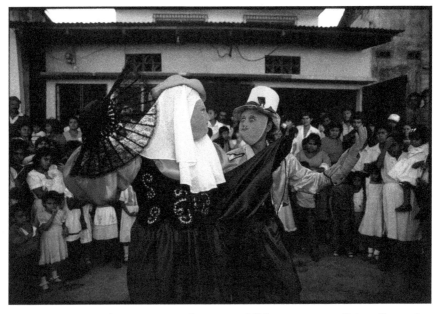

NICARAGUA – The Güeguense dance is a folkloric event traditionally used by Nicaraguans to ridicule Spanish conquistadores. It is practiced to this day.

CHAPTER 11.

MOVING ON

The *Güegüense*

The event took place in a dusty field bordering a town an hour or so from Managua. By this time, in the final days leading up to Nicaragua's historic February 1990 presidential election, I had covered scores of these opposition rallies.

But this one was different.

Peasants and workers, some with their families, seemed genuinely excited. I sensed a visceral rejection of the ruling Sandinista government. One of the attendants openly referred to Nicaraguan President Daniel Ortega as, *"Ese hijo de la verga."* (That son of a dick.)

I came away from this event convinced that I had just witnessed the flipside of Edén Pastora's 1978 raid on the National Palace. That raid captured Nicaraguans' imagination. It allowed people to believe they could actually defeat the dictatorship. After that raid, there was no turning back. The dictatorship was doomed.

The same was happening at this rally but in the opposite direction. It was presidential candidate Violeta Chamorro, *Doña* Violeta, who this time struck a chord with so many Nicaraguans. She was the wid-

ow of Pedro Joaquín Chamorro, the assassinated editor of *La Prensa* newspaper, a relentless critic of President Anastasio Somoza. Gunned down on January 10, 1978 while driving to work, Chamorro became a national hero. Now *Doña* Violeta was a leading critic of Sandinista rule and a serious presidential hopeful.

With me that day was Josetxo Zaldúa, a colleague and friend from the Basque region of Spain. He was the Managua bureau chief of the French wire service, Agence France-Presse (AFP). Josetxo and I left the rally. In the back seat of *La Bestia* was a young activist, also from Spain, who had asked me for a ride back to Managua. She sat silently listening as Josetxo and I discussed my reaction to the rally.

"The Sandinistas could lose this election," I told him.

Josetxo and I felt the resentment boiling up in the back seat. The woman's silence invaded the vehicle like a dark cloud taking over. She hardly spoke, and when she did it was in brief, acidic responses to questions or comments from Josetxo or me. Like too many Sandinista loyalists, she rejected out of hand anything negative about the revolution or its leaders, always with the self-righteousness and absolute certainty of a true zealot. I dropped her off at her requested destination. She got out of *La Bestia*, clearly disgusted with the foolish gringo behind the wheel, never bothering to say, "*gracias*" for the ride. As Rude *Señorita* disembarked, I noticed a tuft of thick black hair protruding from an armpit. And I was proud of myself for having held my tongue, resisting the urge to suggest that she might need a little shave.

"Go fuck yourself," I mumbled as she drifted off in my rearview mirror while *La Bestia*, Josetxo and I pulled away.

My analysis of the upcoming election got a lot of reactions similar to that of Rude *Señorita*, and from people close to me. Claudia's father, Alberto, was not one to sugarcoat his response to my analysis of the upcoming vote.

"How could you even *think* that we could lose?" he demanded of me.

One of my colleagues, a seasoned British correspondent, laughed out loud and in my face when I told him that the Sandinistas could

lose the election. He had been attending Sandinista rallies, he said, where tens of thousands of Nicaraguans gathered to cheer on Daniel Ortega for another term as president.

No way the Sandinistas were going to lose the election, he assured me.

"*El cuadro está pintado,*" one high-ranking Sandinista official declared just days before the vote. "The painting is complete," he said, assuring me with blithe confidence that the Sandinistas would crush the opposition.

Perhaps as a result of my extended interview with Sergio Ramírez for my photo book project, I understood a bit about the *Macho Ratón* character in the Güegüense drama. It's a traditional Nicaraguan comedic, folkloric dance, and a symbol of the Nicaraguan spirit, or attitude toward life.

In the dance, local indigenous men dress in elaborate costumes and hand-crafted masks ridicule their Spanish conquerors. It is a means of tolerating the shame of conquest and the scars of repression. The Spanish conquerors, oblivious to the real meaning of the performance, allowed the locals to practice the dance over the centuries. The dance is still practiced to this day.

Was it possible that today's Nicaraguans were hiding their true feelings about the Sandinistas behind those same historic, cultural masks? Will they dance their way to the voting booth and then cast their ballot against their rulers?

The 1990 Vote

It was a landslide, a historic, stunning defeat for the Sandinistas and a measure of how completely the leadership was disconnected from their own people.

The morning after the vote, Managua felt like a city that had sinned. The streets were empty, most residents holed up in their homes waiting for the reaction to their balloting. Perhaps in their wisdom, Nicaraguans voted the Sandinistas out of power after more than a decade

of their rule. Many feared that another six years of Sandinista government would mean six more years of U.S.-sponsored war.

Washington had made it perfectly clear it would keep up economic pressure, at least, until Ortega was ousted. The Contra War already had claimed the lives of some 30,000 people, in addition to a similar number lost during the 1979 revolution. Perhaps Nicaraguans felt that was enough.

The Sandinista government accepted the results and, with no small amount of urging by former President Jimmy Carter who monitored the vote, handed over power to a new government. It was the first time in Nicaragua's history that a sitting government peacefully handed over power as the result of a legitimate, internationally recognized election.

At a news conference recognizing their loss, Sandinista leaders, including ousted President Daniel Ortega, showed up pallid and drawn, like someone had drained all the blood out of their faces. Most of the international press corps also was stunned by the results. And I could not help but wonder how Rude *Señorita* reacted to the vote.

I drove around Managua for a while, scoping the place out, looking for reaction, finding none and trying to assess Nicaragua's new reality, as well as my own. The Gypsy Kings blasted through loudspeakers as *La Bestia* and I drifted alone on empty streets through the Nicaraguan capital.

Claudia, who valiantly supported and protected me as I worked to understand and document her country and who had such high hopes for her beloved revolution, lay exhausted and curled up on the bed in our home. She had been covering the election through the night. She watched with deepening gloom as the results rolled in.

"Now it's me who needs your support," she said, her voice cracked with emotion after hearing Ortega's press conference that morning.

At a rally not long after the election, Ortega promised his followers, "We will rule from below." In other words, the highly organized

Sandinista party would flex its muscles and get its way no matter who was president.

It was time for us to move on. Claudia and I finally married in a civil ceremony in our home. We left Nicaragua for Miami.

Disney World and *Hurt Locker*

Journalists follow the news as it happens. So when peace came to Central America at the beginning of the 1990s, I knew it was time for me to leave. The story that had dominated front pages and the nightly news for more than a decade dissipated almost overnight.

In any case, I was ready to expand my work from Latin America and the Caribbean to more distant frontiers and Claudia, now my Nicaraguan wife, was glad to escape the pressure cooker of a country mired in perpetual crisis. Miami offered a blend of developed and developing countries, where I could cover major national stories, where my fluency in Spanish would be an asset, and from where I could cover not just the United States, Latin America and the Caribbean, but also stories far beyond.

From my new post in Miami, I made frequent trips to Cuba and major stories in South America. The big one, however, was the Persian Gulf War. During two deployments to the region in 1990 and 1991, I spent a total of four months covering the buildup and invasion by allied forces into Iraq and Kuwait. Between *Newsweek* and the re-sale of pictures via the Sipa Photo Agency with which I was affiliated, I made a ton of money, enough to drop a down payment on a house in Miami Beach for Claudia and me. We proceeded to remodel it.

From Miami, Claudia worked as a stringer for Agence France-Presse (AFP), the Chilean newspaper *El Mercurio*, the Spanish paper *El País* and *Reforma* of Mexico. She covered Cuba and the 1994 U.S. invasion of Haiti. I was proud that she had become a seasoned foreign correspondent.

But almost overnight, I had gone from covering revolutions, guerrilla warfare, national elections and devastating natural disasters to

making pictures that would accompany stories about nude sun bathers, the transformation of Miami's South Beach district and the latest events at Disney World in Orlando. It wore on me.

In the stacks, footlockers and boxes of Reporter's Notebooks and loose papers of various sizes that constitute my "journal," is an entry on *Newsweek* stationery. In part, it reads:

> I certainly think that part of the difficulty of being here in this country and trying to adjust to all this is the fact that virtually nothing, I mean nothing, that I've learned and am best at during the past 17 years, nothing that I'm able to associate myself with, none of the things I can do best, are applicable here. It's not only, not just the feeling that life here is somewhat 'pedestrian,' and it's not just that I don't fit in, but on a much more practical level, the things I've previously, up till now, have devoted myself to, I just can't apply here. How many times do I have to bullshit my way through a military roadblock in the United States? When was the last time I had to use the knowledge that I had accumulated in dozens of excursions into the mountains? Knowledge about what kind of clothing to wear? The right type of protective gear, plastic and so forth for the cameras. The boots, the hammock, the knife, the stuff sacks, the film, the knapsack. Where to walk in line with a company of soldiers. How far in front should you be to be able to get pictures of fighting once it starts but how far back do you have to be to keep from getting killed? Where to walk with the soldiers to keep your legs from getting blown off by guerrilla mines?"

By the end of the 1980s and especially at the beginning of the 1990s, the craft of photojournalism was contracting. Smart phones meant that digital photography was becoming accessible to everyone;

social media began to compete with the old mainstream operations, and 24/7 cable channels meant legacy outlets like *Newsweek*, my employer, became the platforms of old news before the magazines even hit the street stands. I saw the writing on the wall. And it was not good.

There's a scene in the 2008 film, *Hurt Locker*, that resonates deeply with me. Russell Crowe plays a specialist in the deactivation of the infamous Improvised Explosive Devices (IEDs) that killed and maimed so many U.S. servicemen and women during the occupation of Iraq. Crowe's character is back home in the United States after a recent deployment and he's cleaning out the soggy, wet, cold leaves clogging the rain gutters of his humble home. It's a cold, gray, sloppy day that bears an uncanny resemblance to the days I remember in Aliquippa, Pennsylvania. The days of my youth.

In the film, Crowe is wondering what he's doing back in the drudgery of daily life. I can't think of a better example of how I felt during this period after I left Central America. Disruptions in the craft and in my own identity, plus financial difficulties as my work with *Newsweek* began to dry up, conspired against Claudia and me.

In another entry in my journal during that difficult period, I describe a discussion between Claudia and I the previous evening. In part, it reads:

"She's worried. She's sitting there looking at me last night & says I look different. That I am different. She says I look harder, tougher, than I ever have. 'You're not the same, Bill,' she said. She said I'm not happy anymore. I guess she's right. I guess I'm not very happy at all anymore. Neither is she."

By the mid-90s, Claudia and I had separated and eventually were divorced in what was one of the most unspeakably painful chapters of our lives. She went on to work as book editor and production manager in Miami for the Spanish publisher Santillana, and then was recruited by McGraw-Hill to run their book production in Mexico City.

I was in a creative black hole. I was stuck. I was facing, once again, the yin and yang of my chosen profession. The struggle between the

security of a full-time, staff job with regular salary and benefits but limited freedom versus the highly insecure, often poorly paid life of a freelancer with no regular salary or benefits and total freedom to go broke.

There was more. I was tired of living my life on the periphery of other people's words or actions. I wanted to be my own person. My own man. Live my own life, and not just document the lives of others. I left *Newsweek* magazine, a move that shocked many of my colleagues. A number of my associates reached out to me with offers of support, knowing it was a tough move. And this is when I began to figure out who my real friends were and those whose "friendship" was strictly transactional.

With few exceptions, I cut myself off from everyone from my Central America days. I mostly abandoned the previous "me." I did not belong to that clan, to that era, anymore. I had to re-create myself. Re-invent myself,

This period offers an important lesson about how journalists build an identity around their work and how difficult it can be when that identity is challenged.

Video Journalism

I moved to Philadelphia for a full-time gig with Video News International (VNI), the first company in the nation to use new digital cameras to generate television content.

Relative to still photojournalism, the creative possibilities of video journalism simply exploded. I no longer was confined to communicating in two dimensions, width and height of black and white, or even color photos. Now I could tell stories, primarily with images, but also with movement, sound, narration, music, beginning, middle and end. And I was good at it, primarily because, by the time I moved into video, I had already acquired the skills needed to properly execute the craft of video journalism.

HELMAND RIVER VALLEY, Afghanistan – After my long stretch in Central America, and after leaving Newsweek *magazine, I shifted to videojournalism and freelanced as an independent documentary filmmaker. This picture was made during a 2008 trip to Afghanistan's Helmand River Valley where a produced* Afghanistan: The Forgotten War, *finalist for a national Emmy Award.*

Powerful images. Got it. Clear writing. I had become expert in writing coherent, cogent and compelling captions for the pictures I generated for *Newsweek*. Plus, as a freelancer, I often wrote lengthy analyses for newspapers and magazines. Narration. Done. I had been a freelance radio correspondent for ABC News and NBC News in Mexico and Central America, respectively. I was the whole package.

"These Are My Ancestors"

I'm standing in a deep indentation in the rocks jutting up from a sea of sand in the unforgiving Sahara Desert of Chad, a landlocked country in north-central Africa. I'm here on assignment for *National Geographic Television*, documenting a photographer/writer team

working on a cover story for *National Geographic* magazine about this desolate part of the world.

The photographer is making pictures of rock art, paintings and drawings that adorn the rock formation that once was a dwelling for people long gone. The paintings feature plants and animals that no longer exist in what now is barren desert.

What was it that compelled those ancient artists to make these paintings and drawings? Was it some innate need to express themselves? Are these artifacts some kind of statement? Are they a message to those who might find them hundreds or even thousands of years later? Did the artists think that, by documenting their lives, they might extend their own mortality?

And it occurs to me that the authors of these images are my ancestors. My ancestors in terms of visual communication. I am driven by some of the same instincts that motivated these men or women to express, to document, to make a statement on these rocks. They were telling their stories. They were speaking the visual storytelling language.

There exists an abundance of research on the power of stories and storytelling. A quick and easy Google search on why we love storytelling comes up with:

Storytelling "boosts our feelings of things like trust, compassion, and empathy. It motivates us to work with others and positively influences our social behavior. Because of this, stories have a unique ability to build connections."

On the importance of storytelling:

"Stories create magic and a sense of wonder at the world. Stories teach us about life, about ourselves and about others. Storytelling is a unique way for kids to develop an understanding, respect and appreciation for other cultures, and can promote a positive attitude to people from different lands and religions."

Here are some of the stories that I've had the privilege to tell:

I am in the desert of Saudi Arabia to cover the imminent invasion by Western forces to eject Iraqi troops occupying Kuwait. The sun

creeps up over the horizon, silhouetting the attack helicopters used by the 101st Airborne Division, with whom I am embedded for *Newsweek* magazine. The rotor blades of the choppers droop down almost to the desert floor, making the machines look like giant, sad insects. One American soldier listens to a shortwave radio, as a BBC anchor announces, "And the onslaught has begun." I fly into Iraq with the troops.

I am in Rwanda two years after the 1994 genocide that left nearly a million members of the Tutsi ethnic group as well as moderate Hutus slain by Hutu militias. A colleague and I are on assignment for *ABC's Nightline With Ted Koppel*. We are interviewing Alfonsin, a young Tutsi woman who was gang raped and mutilated during the 100-day blood fest. She and many thousands of "survivors" like her are now ostracized by other Rwandans who regard them as "soiled," somehow complicit in the acts that destroyed their lives.

"We have no one to tell how we are feeling, or to try to tell us women how to survive," Alfonsin says. "If you cut into my heart you will see how we are feeling." She makes a slashing motion across her chest. And then she weeps.

I am aboard the Keldysh, a Russian mother ship carrying the two deep water submarines, Mir 1 and Mir 2, featured in James Cameron's epic blockbuster film, *Titanic*, starring Kate Winslet and Leonardo DiCaprio. I'm on assignment for *National Geographic Television*. Teams of scientists take turns in the subs exploring volcanic activity on the floor of the Arctic Circle off the coast of Norway. One of the subs has emerged from a deep dive, and its occupants wait inside for the crane to lift them out of the water and into fresh air on the deck of the ship. But a powerful storm has arisen and the Russian swimmers are unable to attach the huge crane hook onto the sub, which rises and falls with the angry sea. The air inside the sub is depleted and the occupants have only minutes to live before suffocating. Finally, the swimmers make the connection and the scientists survive.

I am in the Helmand River Valley in southern Afghanistan, embedded with the 24th Marine Expeditionary Unit. Captain Sean Dy-

nan and his men have just taken control of a town once dominated by the Taliban. Kids laugh and squeal as they see themselves in the viewing screen of my video camera.

I am in the U.S. state of Maine. I'm interviewing the mother of a young Marine who just returned safely from the conflict in Iraq.

"I'm just proud of him," she says. "Worried about him. I'm thankful he's home. I feel bad for all the other families that their kids didn't come home. You know when he first came home from Iraq, you know it was like seeing him for the first time, even from like when he was born. I couldn't wait to actually be able to touch him and know that he was safe and you almost want to count his fingers and toes and you're so proud, but you're so guilty. You feel so bad that, you feel like you know all the others that were there with him and I just hurt so bad for those other families, but I thank God for my son coming home."

And then she collapses into long, hard, breathless sobbing, different from the wailing of Nicaraguan mothers at their own sons' graves. But the same.

I am in the Ecuadorian Amazon, where a member of the Kichwa Native American tribe laments the changes brought about by so-called modernization and progress.

"It used to be that young women would be attracted to men whose faces were beautifully painted...a man who was a good hunter. But not now. What young women want now is a man that can get a good job. A man that can get a house. A man who can buy a car."

I am in an underground flood control tunnel straddling the border between the twin cities of Nogales, Arizona, and Nogales, Mexico. The tunnels are used to smuggle drugs, weapons and humans. Accompanied by a squad of heavily armed Mexican policemen, one of my graduate students and I are producing a one-hour documentary on freelance foreign correspondents.

I am in Havana, walking around the colonial district with a Cuban friend. I call him "*Super Flaco*," or Super Skinny, because he is. He's also super funny. For the third time today, we run across one of his friends wandering the streets. *Super Flaco's* arms, in fake surprise, ex-

plode straight out from his shoulders. They look like thin sticks with open hands attached at their ends.

"You're like Jesus Christ!" *Super Flaco*, with arms still splayed out, tells his friend. "I see you everywhere!"

These are some of the stories that journalism, especially visual journalism, have allowed me to tell. They all are part of the tapestry that is my life story. It is a story of longing and love. Of hope and despair. Of violence and tenderness. Of triumph and defeat. I tell them from places across Latin America and the Caribbean, plus the Middle East, Central and Southeast Asia, Africa and the United States.

But Nicaragua never left me. And I never left Nicaragua.

MANAGUA, Nicaragua – During a visit to Nicaragua in 1979 marking the 40th anniversary of the Sandinista Revolution, I attended a rally in downtown Managua. I was uneasy. I felt that I was being watched by too many people from behind dark sunglasses.

CHAPTER 12.
REVOLUTION BETRAYED

The World Stopped Watching

White Pine Pictures is a Canadian documentary film production company whose members in 1986 produced *The World Is Watching*, about coverage of Nicaragua's Contra War by Western media. I was one of the featured journalists. Sixteen years later, White Pine contacted me to ask whether I would be willing to return to Nicaragua to film a sequel.

"Absolutely."

I proposed scanning a handful of images from my photo book, *Nicaragua*, and publishing them in the country's newspapers. We'd ask people to contact our producer in Managua if anyone recognized the people in the pictures, then we'd follow up on their life stories since I photographed them during the Contra War.

It worked. Sandinista soldiers. Contra fighters. Peasants. Laborers. Our producer's phone rang off the hook. And in the end? I found myself trying to explain how terrible those days had been, in large part because they failed to advance the Sandinistas' plan to create a more equitable Nicaragua than they inherited from the Somoza dictatorship.

Calling the sequel, *The World Stopped Watching*, the White Pine filmmakers produced a documentary explaining how the absence of international media loosens the restraints on extremist forces because we, the international observers and watchdogs, are not around to hold them accountable. And that's exactly what had happened, at least in part.

Malign Neglect

Anthony Quainton was Distinguished Diplomat-in-Residence in the School of International Service (SIS) at American University in Washington, D.C. He spent 38 years in the U.S. foreign services as a diplomat in Nicaragua, Peru, Kuwait and the Central African Republic. He also served as Coordinator of the State Department's Office for Combating Terrorism.

At a 2019 conference, Quainton delivered a keynote speech titled "Managua and Washington in the Early Sandinista Revolution," calling his assignment as ambassador to Nicaragua in the early 1980s "Mission Impossible."

He argued that, had the United States made a major and long-term commitment to the social and economic development of the region and backed off from its support for corrupt regimes, "some of the problems we are now encountering might have been avoided or at least ameliorated. Unfortunately when the Sandinistas were eventually voted out of power in 1990, the United States largely lost interest in the region. We are reaping the whirlwind of that neglect in the refugee and gang crises we are now facing."

Quainton was referring to the flood of Central American refugees pounding on the gates of the U.S. southern frontier with Mexico in a desperate bid to escape corruption, gang violence, drug trafficking and environmental catastrophe.

Both sides could not see beyond their ideologies. Neither could escape from its respective history. Quainton's argument is one of many put forth by diplomats, journalists, academics, politicians, activists

and observers of every stripe trying to explain what happened to the promise of the Sandinista Revolution to break the cycle of violence and corruption that has plagued Latin America for over five centuries.

"Opportunities to create a more stable Central America existed four decades ago," said Quainton. "They were lost...The Sandinistas believed that they were a vanguard party and that history had entrusted them a revolutionary mission. ... They could not escape from the troubled history of Yankee intervention. We could not escape from Vietnam and the experiences of the Cold War. Bridging the historical, ideological and emotional divide between us was more than I or my colleagues could do. Try as we could, the Mission was always impossible."

I met Anthony Quainton when he was ambassador to Nicaragua. I've interviewed him. I always thought of him as an earnest, sincere diplomat trying to do what was right. But like so many analysts like him whose arguments are balanced and cogent, Quainton presumes there was some kind of parity in 1979 between a little country devastated by earthquakes and wars with no tradition of good governance, and a stable, global, functional democracy and superpower some 200 years old.

And I believe this is a mistake.

Prior to 1979 much of the Sandinista leadership lived in *La Montaña* and in clandestine cells. They had little or no institutional foundation to build on. No Harvard, Yale or Oxford background to draw from. No Washington, Jefferson or Lincoln to emulate.

Instead, they were forced to cope with political, economic and military aggression by the single most powerful nation on earth. To justify that action, Ronald Reagan warned a group of conservative supporters in 1986 that defeat of the contras would create "a privileged sanctuary for terrorists and subversives just two days' driving time from Harlingen, Texas." He warned that "feet people" trudging north would be "swarming into our country" to escape communism.

But if Central Americans are headed north in huge numbers, it's because of the complete failure to address their hopes, their needs and their safety.

Having said all that, none of this justifies what Sandinista rule has become.

I've seen a lot of hard things in Nicaragua since first arriving there to cover war in 1979. But what I saw during a four-day visit there in the summer of 2019 was just as unsettling.

During the Sandinista "final offensive" that toppled the Somoza dictatorship, I photographed charred corpses set on fire to reduce the spread of disease and then torn apart by animals scavenging for food. I watched national guardsmen pile like cord wood the ravaged bodies of Sandinista rebels, like rag dolls, their clothes and their bodies shredded by high-powered weapons and explosives. I made pictures of Red Cross workers inspecting bodies of men tortured and killed.

During the 1980s Contra War, a young combatant told me coldly how he and his colleagues dispatched some prisoners they had taken while fighting in the northern mountains.

"They had faces like dogs," he said, as if that explained everything. As if that were true. As if that could make him feel better about it.

I photographed families on both sides of the political divide traumatized by the death or injury of their young men sucked into a war that would benefit neither side.

They were times of great hardship, but they also were times of great hope. Hope for a new beginning in a country tired of living for too long in the grip of a U.S.-backed dictatorship.

I returned to Nicaragua in July 2019, in part to witness the July 19 celebration of the 40th anniversary of the Sandinista Revolution, and to be clear, none of the things I saw during my trip measure up to the horrors of the 1979 insurrection or the decade-long Contra War. But what I found was the foundation for a new cycle of violence.

Discontent with their Sandinista rulers has been festering for years among many Nicaraguans fed up with the corruption, nepotism, arrogance and lies of a government led by former Sandinista guerrilla leader and now once again President Daniel Ortega and his wife, Vice President Rosario Murillo.

The top blew off in April 2018 when students conducting peaceful protests of government pension reforms were met with lethal force

by government troops and pro-Sandinista thugs known as "turbas," who killed at least 325 people and wounded 2,000 others, according to the Inter-American Commission on Human Rights. Following the violence, some 60,000 Nicaraguans fled the country out of fear for their personal safety.

Ortega was a member of the five-person Junta of National Reconstruction that took power immediately after the overthrow of the U.S.-installed Somoza dictatorship. He was elected president in 1984 after clean, internationally supervised elections, in which he faced only token opposition after his primary competitor withdrew from the race. Nevertheless, the election inspired nearly universal support and hope that his country would break the banana republic tradition that had become the rule for so many years in so many Central American countries. He was voted out in 1990 and, as noted previously, for the first time in Nicaragua's history, relinquished power in a peaceful handover to a successor, in this case Violeta Chamorro.

After years of "ruling from below," Ortega and the Sandinista party won the presidency again in 2007, and since then have cut Machiavellian deals to perpetuate their hold on power with some of the most abhorrent sectors of Nicaraguan society. He rigged the constitution to potentially allow him to be president for life. He and his family now control the vast majority of news and information outlets. His policies allow the rich to get richer—this in the second poorest country in the Western Hemisphere. To win the backing of the Catholic Church, he passed legislation banning all abortion, even when the mother's life is at risk by proceeding with childbirth.

I attended a rally in the main plaza of the capital city of Managua. And although the plaza and the avenues leading to it were packed with tens of thousands of people, I saw a different Nicaragua there, a Nicaragua seemingly devoid of the altruism and the idealism I saw in the early days of Sandinista rule. I saw a Nicaragua deeply divided between supporters and opponents of the Sandinista regime. I felt uneasy. Too many people watching me from the corners of their eyes or from behind dark glasses.

I rode through the neighborhood where Ortega and his wife live, and saw a cordon of concrete, steel, and men with guns barricading traffic to the presidential house from at least five blocks away in every direction.

I saw government paramilitaries dressed in black, guarding a radio and television station raided and sacked by government forces who also jailed the station's owner. I visited a church where government forces and their thugs killed two protesters who had taken refuge with dozens of others after being pursued by police and pro-Sandinista mobs. I saw where bullets had slammed into the church, putting my fingers into deep, jagged holes gouged by the bullets into the concrete walls, and imagined the horrific wounds inflicted on protesters not protected by those walls.

I watched a seasoned war correspondent fight back tears while describing the April 2018 uprising and how government forces and their allies killed with abandon on the streets of the capital city of Managua.

Journalists told me they are attacked online and in the streets, just for doing their job. Many have fled the country. I saw articles published in opposition newspapers openly referring to the Sandinista government as a "dictatorship" and calling Ortega and Murillo "dictators." I read venomous online posts by government supporters threatening critics of the Sandinista regime.

I saw the giant decorative steel street ornaments erected across Managua on the orders of Vice President Murillo, about 150 of them all over the country. Each reportedly costs about $25,000. I heard reports that the importation of steel to make the trees, the installation of lights on each of them, and the guards needed to protect them against citizens who see them as the embodiment of poor governance and corruption, all are handled by businesses owned by Ortega's and Murillo's children. And about half of them have been torn down by protesters. Again, all this in the second poorest country in the Western Hemisphere!

I visited shopping malls, restaurants, bars and hotels, now largely devoid of foreign tourists who once flocked here to bask in the tropi-

cal sun and to enjoy the warm, good-humored hospitality this country is known for. The violence drove them away.

I listened to one former Sandinista supporter voice deep concern that current government policies could spark yet another round of violence, meaning all the blood and sweat of the past 40 years were spilled for nothing. When all peaceful means of change are met with violent repression, this person said, a violent response becomes inevitable.

In conversations with Nicaraguans, I listened carefully and waited for some signal of their political leanings, wary not to offend. The Sandinistas still have support in Nicaragua. Critics argue, however, that the Sandinistas purchase that support with special privileges, material favors, or the security of a decent job.

I asked one ardent Sandinista supporter how Ortega could allow things to get so out of control.

"*Ortega no controla ni verga!*" this person said of the then 73-year-old president (Ortega doesn't control a fucking thing!), instead blaming the current state of affairs on the president's wife, a version of events that I heard repeatedly during my trip.

As I toured this country that I have learned to love, I wondered what Augusto César Sandino, or the founders of the Sandinista National Liberation Front (FSLN), would say of today's system called "*Sandinismo.*" I wondered if they would think today's version of *Sandinismo* is a valid reflection, or an ugly mutation, of their original ideals.

On the morning of my departure from Nicaragua, I packed my bag and paced the hotel room. Through the hotel windows I watched palm trees sway in the summer breeze, the sky outside a joyous, bright blue utterly inconsistent with the gloom in my heart. I paced some more, trying to process all the hard things I had seen here. I sat on the edge of the bed, contemplating the specter of another national convulsion of violence.

For this trip, I had seen enough.

ALIQUIPPA, PA – Esther and I stand on a wooden platform at the Ambridge Reservoir where we are married. Our eyes are closed, perhaps because we refuse to awaken from our dream come true.

EPILOGUE

Esther

On the impossibly beautiful and unforgettable day of July 7, 2000, a crisp sun sparkles off the rippling waters of the Ambridge Reservoir near my hometown and a summer wind toys with the hair of a beautiful young woman dressed in white. She wears a classic, 1950s-style dress purchased for this special occasion. On her head is a bonnet of tiny, yellow and white daisies, my father's favorite flower. Nothing fancy. Just simplicity, plain beauty and grace. As he was then. As she is today.

It is on this day that Esther María Mas Farias and I are married during a civil ceremony on the shore of the sacred waterway of which she now is a devotee. We had met while I was on assignment for *Newsweek* magazine in Havana, Cuba, the city and country of her birth. We stayed in sporadic contact after she moved to Venezuela and later to Puerto Rico. She came to live with me in 1999.

My mother glows alongside my new wife. Like my mother and my first wife, Esther is an immigrant. My mother had re-married and would enjoy a few years of relative happiness with a man she met at a

ALIQUIPPA, PA – Esther and I embrace after the official wedding ceremony.

PITTSBURGH, PA – Esther and I at the reception on the New Orleans-style, paddlewheel riverboat.

ALIQUIPPA, PA – Left to right, Brother Lou, Mom, me, Esther and Brother Rob.

PITTSBURGH, PA – Lou and State Police friend, Jerry Fielder, one member of the select wine-making group. This is one of the happiest pictures I've ever seen of my brother.

PITTSBURGH, PA – Esther dances with Uncle Vince.

ALIQUIPPA, PA – Wedding picture with left to right, brother Rob, me, brother Lou, nephew Bobby.

dance hall. I loved watching as she and her new partner glided across the floor to Frank Sinatra's classic song "Summer Wind."

Esther and I hold the wedding reception on the deck of a paddle-wheel tourist boat cruising up and down the confluence of the three rivers that form ground zero of Pittsburgh, Pennsylvania. The sprawling, black monster steel mills that once breathed fire and smoke from these rivers' shores are now nearly all gone, having migrated to Mexico or China. My college roommate, Rocco Shively, manages the river boats and has reserved the upper deck for our guests, who include Joe Contreras, Scott Wallace and two of Scott's three sons.

The Perfect Medicine

It is around 3 a.m. on January 27, 2016, and a team of emergency physicians and assistants work desperately to save the 56-year-old man dying from a massive heart attack at a hospital in Gastonia, North Carolina.

The men and women on the team move in perfect synchronization like disparate components of a finely tuned machine designed to save human life. The resuscitation efforts last for nearly half an hour as the team hits the man with Cardiopulmonary Resuscitation (CPR), defibrillator paddle shocks, multiple doses of epinephrine and four amps of bicarbonate, this last measure to counter the buildup of acid waste materials in the body. But the man has no pulse and is unresponsive. He has "flatlined." His organs begin to collapse and irreparable damage to the brain is just around the corner. Having exhausted every tool and technique in their arsenal of life-saving emergency measures, the team is ready to "call" this patient, to note the time and the cause of death, and to move on to the next case.

But not Dr. Shiddhi Patel. For reasons that she does not yet understand, Dr. Patel presses forward even after this patient slips into a coma.

The man on that table is my youngest brother, Robby, the "perfect medicine" for our father's failing physical and spiritual health. Rob's

heart attack is a shock to the extended family. Rob never smoked. Never abused drugs or alcohol. He never was overweight. He never ate junk food. In fact, we used to tease him about his diet and called him "Mr. Granola." He exercised and stayed trim.

We can attribute the heart attack only to the stress associated with his always-on-the-road job as a sales representative for an international steel corporation and his constant, meticulous, selfless care for his special-needs daughter, Maria Grace, to whom I am godfather. Rob and his wife, Melanie, had taken on the Herculean task of personally caring for Maria Grace at home after the child was diagnosed with Rett Syndrome, a rare neurological disorder that occurs almost exclusively in girls and leads to severe impairments affecting the ability to speak, walk, eat, and even breathe easily.

Whatever the cause, Rob's heart attack opened doors for my brother that he had not known even existed.

In his own book. *Quarks of Light,* Rob writes:

> The second morning after coming out of my coma, a beautiful, young, petite Indian woman with glistening brown eyes approaches my bed. She gently sticks out her hand to greet me, but then, realizing I can't reach up, she places her hand on my arm and pulls up a chair. I'm thinking, What tiny looking mouse hands this woman has.
>
> Instinctively, I clasp her hand and curl it snuggly as she begins to introduce herself. "I'm Dr. Patel, I was the doctor on call the night you came into the emergency room. I can't tell you how happy I am to see you alive."
>
> Neither of us can hold back our emotions as she talks about how many times she almost lost me, and she relates some of the procedures.
>
> Then, abruptly, almost anxiously, the conversation gets personal. She clears her throat and says, "My father and I were very close, almost to the point of

knowing each other's thoughts. I was pregnant with my first child, a boy, and my father couldn't wait to see his face. But six months before my son was born, my father died suddenly from a brain aneurysm. My heart's been broken. That connection to him seems lost. I've been bitter about that, my faith shaken, but seeing you alive gives me hope that maybe, just maybe, there's something more out there.

The perfect medicine.

Months later, Rob would receive a heart transplant at the University of Chicago Medical Center. The period between heart attack and heart transplant is challenging. Patients must be "critical" yet "healthy" at the same time to receive a heart, which are in extreme demand. Stated differently, a patient has to be at risk of dying without a transplant, but his/her other organs, as well as his/her frame of mind, must be in good enough shape to receive a heart. The system

Rob Gentile, my goddaughter Maria Grace and Melanie.

is not going to give you a much-in-demand heart if you're going to die anyway. So, if your liver is shot, you're not getting a heart. If you have cancer of the lungs or the prostate, you're not getting a heart. If you don't enjoy strong and consistent emotional and spiritual support from family and friends, you're not getting a heart. My brother's time at the Medical Center was all about keeping him, his organs and his mind alive and well until a good heart was available.

To do this, my brother signed on to the experimental use of the NuPulse, a machine plugged into his damaged heart and powered by a lunch box-size motor hanging on a strap from his shoulder. Procedure after procedure, my youngest brother endured the physical and psychological pain that allowed him to live.

Rob's wife and members of our extended family and friends took turns at Rob's side during this period because no matter how good, how devoted, how professional a hospital and its staff may be, every patient needs an advocate at his or her side to take care of the details, to make sure their loved one is properly cared for. To make sure that nobody misses anything. That nothing falls through the cracks.

The operation to insert and connect the support machine to Rob's heart would take more time than the actual transplant and was more painful. We watched Rob grimace as doctors and nurses inserted needles into his arms and his neck. We looked on as staff came in to check the wound dug into my brother's side so the heart-assist device could keep him alive. We helped him move from the bed to the shower still connected to the device and to numerous leads and lines into his chest, arms and neck. Just watching some of these procedures was agony. I cannot imagine having to undergo them.

On June 6, 2016, roughly five months after his heart attack, Rob got a transplant. In many ways he continued to be "the perfect medicine" for our family. We all marvel at how Rob and his wife support Maria Grace, and how they cope with my brother's own health challenges. My brother is a model of grace under pressure.

It turns out that, in many ways, Robby is the toughest of the four brothers, something he never aspired to be.

Wine Day

Lou's Wine Day that he held the year prior to Rob's heart attack included 375 friends, family members and business associates. Because of the time, money and effort diverted to Rob and his family, Lou did not schedule a Wine Day in 2016. In fact, and even though he continues to make wine, he celebrates the event on a smaller scale similar to the early days. There never was another Wine Day like the ones he hosted at the peak of his wine-making career.

My Nicaraguan Family

In Managua, as of this writing in the summer of 2020, Danilo spends most of his time in a hammock, in a rocking chair or in bed. He has neither short nor long-term memory. He is legally blind and takes multiple medications to prevent seizures. He requires assistance to bathe and to clothe himself. He cannot conduct a coherent conversation. He is unreachable in any real sense of the word. He has permanent caregivers who tend to him 24/7. He is living testimony to the human cost of the 1980s Contra War.

Claudia's mother, Norma, died of heart attack on June 13, 2017 while visiting relatives in San Francisco. It was an unex-

Seated is Danilo, a stark reminder of the human cost of the U.S.-backed Contra War against Nicaragua's Sandinista government. Standing from left to right are brothers and sisters, Jorge, Johanna, Gabriela, Guillermo and Claudia.

pected and crushing blow to the extended family.

Claudia is at her home in Managua where she commands and co-ordinates a brave and determined struggle to care for Danilo and her father, Alberto, who suffers dementia.

On the last night of my 2019 visit to her country, Claudia dropped me off at my hotel. As I moved to open the car door she said, "I love you, Bill."

I turned to her and said, "I will always love you, Claudia." I watched the taillights of her car disappear into the night.

Masachapa

On the night of September 1, 1992, a deadly tsunami triggered by a nearby earthquake struck the Pacific Coast of Nicaragua with little or no warning and slammed into my beloved Masachapa. Media reports said a wave measuring nearly 50 feet high crushed, then swept away houses, boats, vehicles, and anything else in its path, including people.

It was like a giant, liquid hand arose from the ocean, pounded onto the shore, then clawed all that it could back into the deep. Reports said the earthquake and tsunami killed at least 170 people, injured 500 more, and left more than 13,500 homeless. The tsunami caused most of the damage, demolishing my favorite restaurant, Bar Lorena, and the Hotel Rex boarding house. I don't know if Lorena, *Señora* Matilda, or 12-year-old Juan José survived. Or not.

El Hombre

Don (Secret Weapon) Leonardo Lacayo Ocampo, whom we once called, *El Hombre,* passed on October 1, 1991. *Que descanse en paz, mi buen amigo. Un abrazo.* (May you rest in peace, my good friend. A hug.)

Jose

Jose, the Cuban brain surgeon who saved Danilo's life, has long ago returned to his homeland. And every time I travel to the island, I make sure to drop by his home for a visit. During one of those visits in 2019, he recounted the events that night in La Trinidad as he labored so furiously to bring Danilo back from the edge of death. In the dining room of his home in Havana, Jose told me why he refused Norma's plea to "let him go."

"He was too young," Jose said. "He had a nice face."

I was tempted to ask Jose, in light of how difficult Danilo's life has been, if he regrets having rejected Norma's plea to "let him go." Maybe, because of the *bruja* (witch) in her, she could see how compromised Danilo's life would be. But I couldn't ask.

Jose and I stared down at the table.

Julio

My former Salvadoran driver, fixer, friend and confidant, Julio Romero, continues to live with his wife Rosa and their son in Vancouver, Canada. He and his son own heavy trucks and manage their own hauling business.

Harvard

It was at an International House of Pancakes in Los Angeles, his father's favorite restaurant. An only child, Joe Contreras was hosting his father for breakfast. I was there because Joe had asked me to be godfather to his second daughter, Francesca, an honor that I accepted with great joy.

It was January 1990 and Joe Sr. was 87 years old at the time. He had separated and divorced from Joe's mom years before. The elder Contreras had parked his car in front of the restaurant. It was kind of dusty and dull. A big car, one that, as a kid, I would have referred to as "a boat," a 1973 Chevrolet Chevelle Laguna.

My sense was that Joe's relationship with his father was somewhat strained, or at least not as close as his ties with his mother. Perhaps his son's work as "foreign correspondent" was something the father could not quite wrap his head around. He wore a dark sports jacket adorned with cat hairs.

After breakfast, Joe and I stood on the curb and said our goodbyes to his dad. It was then, as the old boat and its driver pulled away, that I noticed the sticker on the rear window.

It said: "Harvard."

Joe's father is gone now. Joe left *Newsweek* after 28 years of successful work with the magazine. He did a decade or so with United Nations peacekeeping missions in Africa. He now is retired and lives in Miami.

"A Little Bit of Alzheimer's"

I was numb after our appointment with the specialist. I had taken my mother to see him as her memory and awareness seemed to be in sharp decline. My mother had divorced her second husband and was living alone so, on one of my trips from Washington, DC, I took her to a neurologist in Pittsburgh. He administered a brief test in his office. As we left the doctor's office, I asked my mother if she understood what he had told us.

"I have a little bit of Alzheimer's," she answered. A little bit of Alzheimer's. As if it were a little bit of high blood pressure. Or a little bit of a cold. Or a little bit of a sprained ankle. In reality, it was a little bit of a terrible death sentence. My family witnessed the steady decline of my mother's memory, cognitive ability and general health as the disease attacked her. The most painful part of it all was the fact that, at least in the beginning, she knew what was happening.

"I'm losing my mind, aren't I?" she asked me more than once.

"No, Mom," I lied. "You're just getting older and some memory loss is normal. It happens to everybody."

Even the rock-solid faith of my sister-in-law, Carol, plus the fortitude of my older brother, were challenged by the disease, and my mother was placed in an assisted living facility for about six months.

On one visit to the facility, I took my mother for a stroll in a wheelchair over the grounds and into a sunny day with a light breeze. My mother, even after her years-long struggle with the disease that ravaged her mind, still basked in the gift that we call life. She turned her face to the sky to feel the warm autumn sun.

"Oooh," she cooed like a dove on my windowsill. "Life is lovely."

On the final day of December 2010, and with Lou, Rob and me at her bedside in Lou and Carol's home, our mother passed.

"You've done your job," my older brother told her. "You can rest now."

Esmeralda and Leonardo

Esmeralda eventually married Jeff Perkell, a photographer colleague and friend of mine from the early days of the revolution. Esmeralda and Leonardo joined Jeff in Boston, where she bore him a son, Max, and where she founded a wildly successful childcare center and school.

Jeff died in 2018.

La Bestia

Upon departure from Nicaragua I sold my faithful *La Bestia* to my colleague, Josetxo Zaldua. She has passed through a number of hands since then, the latest apparently being a Nicaraguan who is investing vast amounts of time and money to "restore" her. My only hope is that the process does not rob her of her original, classic design and beauty.

Processing

It is December 21, 2020. Esther and I are back home in Washington, DC, after a visit with my brother Lou, his wife Carol, and their daughters' families. True to tradition, we all got together to make ravioli for the Christmas meal. Because of the pandemic, my brother erected in his backyard the huge tent he once used during his winemaking heyday. So with masks, social distancing and kerosene-burning heaters, our small family unit can be "outside" in fresh air but cozy and protected from infection by the virus.

Esther and I both cherish these times together, she perhaps because her parents died when she was a teenager and me because I know there are far fewer Christmases ahead of me than there are behind me.

I drove the five hours from Lou's home back to ours yesterday, mostly in silence. As I cross over the Allegheny Mountains on the Pennsylvania Turnpike, I leave behind the colder, rainier, darker climate on the west side of the range, with its gloom coming down from the Great Lakes. Once I cross the peak of those mountains, it's an easy slide eastward and downward into the less hostile weather coming up the East Coast from the south.

It's 4:55 a.m. now. Esther is asleep.

During our weekend visit with family, I filed my final scores for young journalists competing for annual fellowships handed out by the Overseas Press Club (OPC) Foundation. It's one of the most prestigious journalism awards in the country, and one of my duties as a member of the OPC Foundation Board of Directors is to help with the selection. This means reviewing cover letters, resumes and work samples submitted by this year's 150 applicants, taking rigorous notes on each application, and deciding with other board members which 17 of the competitors win a fellowship. Most of the aspirants still are in undergraduate or graduate school. Some are already working the craft as professionals.

A few years ago, I was inducted into the Hall of Fame of my former high school. I attended a dinner to accept the award and to de-

liver a brief speech. This was the first time the award was handed out to honor former students, and many of my instructors at the school from which I graduated in 1969 also attended the event.

"You've institutionalized the notion that young people who come from small, ordinary towns like ours can legitimately aspire to do extraordinary things," I tell the school officials. "And that, in itself, is truly extraordinary."

My brother Lou and one of his daughters were in the audience.

A ticket and a tool. I had grabbed the ticket and travelled around the world. And now I was using my craft as a tool to impact the lives of others.

In my classes as a university professor and during journalism workshops and public appearances, I get a lot of questions about how to cope with prolonged exposure to conflict, violent death and other traumatic experiences.

I always wanted to travel and to meet other people and to learn and to grow, I tell them. This is the "ticket" component of my "ticket and tool" analogy regarding aspiration. And this is, in fact, what happens in the early stages of one's career. We grow. But these same experiences can limit us, trap us, as well. And that's because, as we accumulate those experiences, and as they become part of the tapestry that is our life, we become isolated. We become cornered by our own experiences because fewer and fewer of the people outside of our immediate circle share those experiences.

We go home after a major assignment and our friends and family ask us what it was like "over there" or "down there," and after three minutes they want to talk about the upcoming football game or their daughter's graduation or the deck they just built onto the back of their home. They can't relate to our experiences. And it's not their fault. They have real, legitimate concerns about their jobs, their children's educations, the high cost of living, their family's future. Our concerns are not theirs.

On another level, I tell my questioners that I cannot allow myself to be immobilized by my own experiences. I've seen this happen to

colleagues. They get so affected by what they've seen, experienced and documented, that they don't function very well anymore. They are immobilized. If they allow that to happen, they cease to be what they set out to be in the first place. They're not a journalist anymore. At least, they're not an effective journalist anymore. They're a casualty of their own profession. And, as I explain to my questioners, I refuse to be a casualty.

So, where do journalists and journalism fit into all this? How do I see my role? Four decades after my first arrival in Mexico City, have I helped bring about positive change? Did I do any good in Central America and in other places where I've worked? Have I complied with the "tool" component of my aspirations? Am I doing so now?

I certainly hope so. I hope the images I created and published via UPI, *Newsweek* magazine, my Nicaragua book, plus the information I've passed along in the documentaries in which I appear, in workshops and classrooms I have taught, in books and articles I've published, in American University's Archives and Special Collections of the university library, have contributed to the chronicle of certain times and places in history. It's important to remember that, at the time when I was most active in the field, there was no Facebook, no Google, no Instagram, no email. There was no Internet! Television was limited to ABC, CBS and NBC. CNN was just beginning. Fox News did not exist. So most of the world relied on a handful of magazines including *Newsweek, Time* and *U.S. News & World Report, Life* and *National Geographic,* for its visual and full-color explanation of the world. Major newspapers like *The New York Times* and *The Washington Post* published only black and white pictures back then.

A tiny handful of women and men, including myself, were privileged to be part of a small cadre of visual journalists entrusted with the mission of providing the world with a graphic explanation of itself. And we did so despite sometimes risking great peril.

Today, my most recent documentary film, the pilot episode of an ongoing series, *FREELANCERS with Bill Gentile,* is distributed by the *Walt Disney Company* affiliate *National Geographic TV,* across Latin

America and the Caribbean, home to some 659,000,000 people. The film takes viewers to Mexico, where I started in this craft four decades ago, and explains how freelancers like myself are filling the void left by mainstream media outlets retreating from foreign news coverage.

I was instrumental in forging the relationship between American University's (AU) School of Communication and the Pulitzer Center on Crisis Reporting. I oversee that relationship, which sponsors overseas reporting fellowships for students aspiring to become foreign correspondents. I am a member of the Pulitzer Center's Campus Consortium Advisory Board. I helped found, and am the faculty advisor of, the AU student chapter of the National Association of Hispanic Journalists (NAHJ), the organization's first student chapter in the nation's capital. I created and teach the first and only non-English-language class at AU's School of Communication. My Backpack Documentary en Español class is a favorite among Spanish-speaking students. In addition to being a member of the Overseas Press Club (OPC) Foundation Board of Directors, I am an advisor to the Foreign Press Correspondents in the USA. I take deep satisfaction in supporting and promoting the next generation of young journalists.

In many ways, I have achieved what I intended to.

But there is another dimension to what we do, perhaps just as important as our impact on the wider world. It is this: The mere act of practicing our craft, of searching for and disseminating Truth, defines and validates us. Like *La Montaña* for the Sandinista guerrillas, journalism for us is the anvil upon which we test, forge and mold ourselves into what we aspire to be. There is value in our struggle. There is dignity in our struggle. There is purpose and meaning in our struggle.

And I am at peace with that.

Esther

In 1991, Esther left Cuba, where her older brother and younger sister still live. Esther headed to Venezuela where she lived for seven years before we re-connected. She moved to Puerto Rico for a brief period and landed in Pennsylvania in 1999, one year before we were married.

I had left Philadelphia after the collapse of Video News International and was still in a transition period, working at my older brother's security firm, catching a freelance documentary assignment from time to time and figuring out what to do next. At the time of our marriage, Esther and I had finished restoring a 19th century property on the North Side of Pittsburgh.

I got a message from Gary Kieffer, a friend from my Central America days, who advised me that Kent State University was looking for a faculty member who can teach the various skills that I had acquired over many years in the field. At the time, the term used to characterize such a person was "platypus," a semi-aquatic, egg-laying mammal endemic to eastern Australia. The term was used to describe journalists who could move between print, visual, audio journalism. I applied for the job and taught for three years in Kent, Ohio.

Having been born and raised in Havana, Esther is highly responsive to the weather. More specifically, to sunshine. Or the lack of. The heaviest piece of clothing any Cuban might own is a sweater or light jacket, to be used in the evenings of that they call "winter." The tropical sun bathes them nearly all year 'round.

Esther came to me on yet another dreary morning and announced that she can't take it anymore. We have to move to a place where the sun actually shines.

"Get on the Internet and find a university where the weather is good and where they are looking for somebody like me," I tell her. Three days later, Esther comes back with a list, at the top of which is American University. True story.

My Uncle Vince took a special liking to Esther. Perhaps because she reminded him of the Old Country. Her old ways. Her love of family. Her respect for elders. Or maybe it was because of her extraordinary capacity for love.

At our wedding reception held on the upper deck of the paddlewheel tourist boat, Esther and I had placed tiny seating name cards on the back of which we printed the final paragraphs of Gabriel García Márquez' novel, *Love in the Time of Cholera*. A review in *Newsweek* magazine had called the international best-seller, "A love story of astonishing power."

It is the story of young love disrupted by circumstance but rekindled after decades of separation and longing, a story line that Esther and I have likened to our own. At the end, the two lovers are cruising up and down a river on a paddle-wheel boat similar to the one Esther and I occupied for the reception. Here's how the novel ends:

> The Captain looked at Fermina Daza and saw on her eyelashes the first glimmer of wintry frost. Then he looked at Florentino Ariza, his invincible power, his intrepid love, and he was overwhelmed by the belated suspicion that it is life, more than death, that has no limits.
>
> "And how long do you think we can keep up this goddamn coming and going?" he asked.
>
> Florentino Ariza had kept his answer ready for fifty-three years, seven months, and eleven days and nights.
>
> "Forever," he said.

Of all the guests at our reception on the deck of our paddle-wheel boat, only one had recognized and commented on the message printed on the back of the seating cards. You guessed it: Joe Contreras.

And now, Esther and I still ride that virtual paddle-wheel boat, "coming and going" on the river of life. She acquired a master's degree

at American University where I continue to teach. She teaches at the University of Washington, DC, and works as editor and assistant producer on many of the documentary films that I produce and direct.

Lucas

We named him Lucas, in honor of, and hoping that he would embody some of the qualities that made my older brother Louis (Lou) and Esther's older brother, Luis (Louis in English), what they are today. Stand-up guys whom we love and admire.

On a routine checkup at Esther's sixth month of pregnancy, the technician looked at the ultrasound scan and said, "I don't see life here."

As Esther and I scattered our son's ashes in the waters of the reservoir, I questioned whether Lucas's death might be payback for my having lost all trust in the world on the night my mother told my brother, "Daddy died."

I still don't know the answer. What I *do* know is this: The world today is a smaller, meaner, rottener place than it would have been had it allowed Lucas to live, and Esther to nourish him from her bottomless well of love.

The Reservoir

My brothers and I no longer run at the reservoir. Nor do we hunt deer anymore. I am thankful for still being alive and in one piece, and for this "demilitarized zone" where we have either resolved or decided to let rest the sometimes painful issues that haunt us still.

Esther and I occasionally visit this place where our story began in earnest two decades ago. We sometimes walk the three miles from the old church to the highway and back again.

It is in these waters, I tell her and my brothers, where I want my ashes to be strewn when I die and when, perhaps, I can run to the arms of those who waited for me.

ACKNOWLEDGEMENTS

This book is mostly for, and about, the people who have meant the most to me, who have always been there for me, and who have had the greatest impact on me. The ones who waited for me: My Family.

My father, with whom we never had enough time. My mother, who, after my father's untimely death, became two parents. She is the rock, the foundation upon which this family is built. My older brother, Lou, the pillar of the family, with the physical, moral and spiritual strength and clarity to support its weight. My younger brothers David and Rob, each a vital component to the rich diversity of the family unit.

Of course, there is Claudia, my Nicaraguan wife and still my friend, my ally and my compañera; her entire family, whose members took me in as one of their own. Her parents, Dr. Alberto Baca Navas and Norma Vaughan; and Claudia's brothers and sisters, Jorge, Johanna, Guillermo, Gabriela and Danilo.

Former Nicaraguan vice president Sergio Ramirez Mercado contributed a series of interviews that formed the epilogue to my book of photographs, *Nicaragua*. I drew on those interviews to inform this

book. The extraordinary generosity of the people of Nicaragua allowed me the privilege of telling their stories. Colleagues from around the world became close friends.

From Ohio University where I achieved a master's degree in journalism, Dean John R. Wilhelm arranged, and Professor Byron Scott supported, an internship in Mexico that proved to be pivotal in my career and in my life. Mary Louise Dittler, my partner at the time, was a key supporter.

Mexico City bureau chief of United Press International (UPI), Jack Virtue, first hired me as a stringer. UPI photo editor Lou Garcia influenced my transition from print correspondent to photojournalist; my immediate superior at UPI, Juan Tamayo, great friend Bruno Lopez Kupitsky, and photojournalist Oscar Sabetta, plus the entire Mexican crew of technicians and editorial assistants, all enriched my professional and personal life.

The *Newsweek* magazine team included Karen Mullarkey, Jim Colton, Guy Cooper, John Whelan, Hillary Raskin, Dave Wyland, Meg McVey, Jim Kenney, Stella Kramer and others whose names I simply don't remember, were more than just colleagues. More than friends. They were my "third family." They instructed me. Promoted me. Defended me. They waited for my return from dangerous assignments from Central America to the Persian Gulf. Former *Newsweek* correspondent Joe Contreras saved both our lives during an excursion into Peru's *narco-* and guerrilla-infested Upper Huallaga Valley.

Alon Reininger encouraged me to create my first book of photographs, *Nicaragua*. Some of the images in that first book appear in *Wait for Me*.

My cousin Joanna Liberatore and her husband Marty, plus my cousins Dave D'Eramo and Antoinette Mancing, provided critical family information as I closed down the writing component of this project. Angela and David Shetter located and sent me the picture of my grandmother, her sisters, Carmela and Sunta.

Toward the end of the process of writing *Wait for Me*, I relied on some of these allies to steer the work to its final product. Claudia,

once an editor for the McGraw-Hill publishing company, combed through the entire manuscript pointing out errors and misstatements. Joe Contreras, Bruno Lopez Kupitsky and Juan Tamayo each read the manuscript to correct errors of fact, memory or history, and to make suggestions that made the book a better document than it had been before their involvement.

Since the fall of 2003, I have been honored and privileged to work with smart, devoted and supportive colleagues at American University's School of Communication, where many of whom have become friends.

Students in my Visual Literacy class of spring semester 2021 helped design the covers of the book. Though the entire class contributed ideas adopted in the final version of the book, designer Bruce Jones and I drew most heavily from the group whose members were Allison Brophy, Du Cheng, Talia Pantaleo and Olivia Wallack.

Taylor Mickal, my wildly talented former student, made the photographs for the front cover and inside flap. And they are terrific.

Nick Ray, also a former student, built the WaitForMeBook.com website, a key component of this project.

My friend, Doyle Cowart, assisted on the social media outreach previous to the book's release.

Special thanks here to my long-time friend and collaborator J. Bruce Jones, whose decades of experience, expertise and creative energy colluded to make this book a more effective and more accessible document than it would have been without him.

Guayi Fernandez, an accomplished designer and artist, generously contributed her time and opinion on some critical issues of display relative to imagery and text.

And now, there is Esther. She waited for me, too. And she is with me still.

Thank you all.

BILL GENTILE

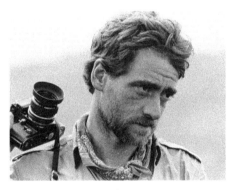

Bill Gentile is an independent, national Emmy Award-winning journalist and documentary filmmaker teaching at American University (AU) in Washington, DC. His career spans four decades, five continents and nearly every facet of journalism and mass communication.

He covered the 1979 Sandinista Revolution and the U.S.-backed Contra War in Nicaragua, as well as the Salvadoran Civil War in the 1980s; the U.S. invasion of Panama in 1989; the 1994 invasion of Haiti, the ongoing conflict with Cuba, the 1990-91 Persian Gulf War and the subsequent wars in Iraq and Afghanistan. He's worked across Latin America and the Caribbean, and in Tajikistan, Ivory Coast, Guinea, Sierra Leone, Chad, Angola, Rwanda and Burundi. His book of photographs, "Nicaragua," won the Overseas Press Club Award for Excellence, Honorable Mention.

(Photo by Murry Sill)

He is the director, executive producer and host of the documentary series, *FREELANCERS with Bill Gentile.* The series pilot, filmed in Mexico, is distributed by the Walt Disney Company affiliate, National Geographic Television, across Latin America and the Caribbean. The film also is broadcast across the Arab-speaking countries of the Middle East and North Africa (MENA).

He is a pioneer of "backpack video journalism" and author of the highly acclaimed "Essential Video Journalism Field Manual" and its Spanish-language version, "Manual Esencial de Produccion Video Periodismo." He teaches the first-ever Spanish-language class at AU's School of Communication (SOC), "Backpack Documentary en Español."

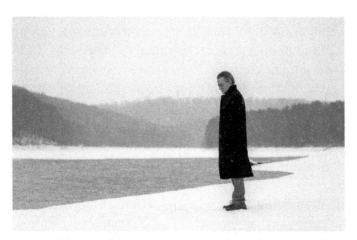

For additional content, including photographs and soundtrack, visit WaitForMeBook.com.

(Photo by Taylor Mickal)

Praise for
WAIT FOR ME

"Now, in his vivid memoir, *Wait for Me, True Stories of War, Love and Rock & Roll*, Bill Gentile turns back the clock to the 1980s and thrusts us into the mountains of Nicaragua and the slums of El Salvador to offer what he calls 'a firsthand, frontline account of the human cost of war'. He succeeds for two simple reasons: he was willing to take serious risks and, more pertinently, he survived to tell his story when so many around him—soldiers, rebels and photojournalists like himself—were killed. It was, to put it bluntly, a murderous time."

– Alan Riding, former *New York Times* Mexico and Central America bureau chief.

• • •

"Like thousands of journalists and filmmakers from around the world, and so many others who wanted to experience a revolution first hand (unlike Vietnam, Nicaragua was a war you could drive to), I returned time and again to the Sandinista Revolution. But despite my humble attempts to understand what was going on there, I was little more than a voyeur of someone else's suffering. Bill Gentile chose to live in Nicaragua, committing his heart and soul to documenting the tragedies of human conflict and the thrills of creating a new society. Gentile's book is a revelation of life on the front lines, of living on a knife edge, risking everything to capture that one image that, he hoped, would shake the conscience of Americans and their horribly misguided government."

– Peter Raymont, Canadian Documentary Filmmaker, Director of *"The World is Watching"* and *"The World Stopped Watching"*

"From the Steel mills of Pittsburgh to the frontlines of Central America's wars of the 1980s, Bill Gentile's '*Wait for Me*' is a riveting hard-to-put-down memoir of unforgettable people in sometimes unendurable situations. This book reveals both the personal evolution of a world-class photojournalist and why some reporters still put their lives at risk to record 'the first rough draft of history.'

Read '*Wait for Me*' for the pleasure of its prose, the gift of its insights on family, love and war but mostly to see the world through Bill Gentile's unique lens, one that calibrates accuracy and empathy across a truly adventurous life."

– David Helvarg,
author of *Saved by the Sea* and *Rescue Warriors*

• • •

"If most pictures are worth a thousand words, Bill Gentile's are worth more like ten thousand. From the jungles of Central America, to the deserts of Iraq, to the classroom in Washington, D.C., Gentile has faithfully served the people whose stories he promised to tell."

– Norman Stockwell, publisher, *The Progressive*

CPSIA information can be obtained
at www.ICGtesting.com
Printed in the USA
BVHW021139180621
609902BV00014B/261

9 780578 919560